WOMEN IN EARLY INDIAN SOCIETIES

READINGS IN EARLY INDIAN HISTORY

General Editor
B.D. Chattopadhyaya

Women in Early Indian Societies

edited by
Kumkum Roy

MANOHAR
2005

The editor and the publisher are grateful to the copyright owners for permission to reproduce their papers. Every endeavour has been made to contact copyright owners and apologies are expressed for any omissions.

First published 1999
Reprinted 2001, 2005

© Individual contributors, 1999

All rights reserved. No part of this publication may be reproduced or transmitted, in any form or by any means, without prior permission of the editor and the publisher

ISBN 81-7304-062-1 (Series)
ISBN 81-7304-136-9 (Hb)
ISBN 81-7304-382-5 (Pb)

Published by
Ajay Kumar Jain *for*
Manohar Publishers & Distributors
4753/23 Ansari Road, Daryaganj
New Delhi 110 002

Typeset by
A J Software Publishing Co. Pvt. Ltd.
New Delhi 110 005

Printed at
Print Perfect
New Delhi 110 064

Distributed in South Asia by
FOUNDATION
BOOKS
4381/4, Ansari Road
Daryaganj, New Delhi 110 002
and its branches at Mumbai, Hyderabad,
Bangalore, Chennai, Kolkata

To
Kanchana and Uma

Contents

GENERAL EDITOR'S PREFACE … IX

ACKNOWLEDGEMENTS … xi

LIST OF ABBREVIATIONS … xiii

Introduction
Kumkum Roy … 1

Section I
ISSUES AND PERSPECTIVES

The Position of Women in Hindu Civilization:
Retrospect and Prospect
A.S. Altekar … 49

Beyond the Altekarian Paradigm:
Towards a New Understanding of Gender Relations
in Early Indian History
Uma Chakravarti … 72

Women Under Primitive Buddhism:
Laywomen and Almswomen
I.B. Horner … 82

Section II
WOMEN AND THE ECONOMY

Proprietary Rights of Women in Ancient India
N.N. Bhattacharyya … 113

Turmeric Land: Women's Property Rights in
Tamil Society since Early Medieval Times
Kanakalatha Mukund 123

'Rural-Urban Dichotomy' in the Concept
and Status of Women: An Examination
(from the Mauryas to the Guptas)
Chitrarekha Gupta 141

Aspects of Women and Work in Early South India
Vijaya Ramaswamy 150

Section III
SOCIO-SEXUAL CONSTRUCTIONS OF WOMANHOOD

Polyandry in the Vedic Period
Sarva Daman Singh 175

Prostitution in Ancient India
Sukumari Bhattacharji 196

Woman and the Sacred in Ancient Tamilnadu
George L. Hart, III 229

Section IV
RELIGIOUS BELIEFS AND PRACTICES

Urvaśī and Purūravas
D.D. Kosambi 255

Women's Patronage to Temple Architecture
Harihar Singh 286

The World of the Bhaktin in South Indian Traditions—
The Body and Beyond
Uma Chakravarti 299

BIBLIOGRAPHY 327

CONTRIBUTORS 337

General Editor's Preface

There are many reasons why a series of Readings purporting to introduce various dimensions of early India will only have an inadequate coverage without a volume of writings on women. It is not simply that gender today is in the air or that there is suddenly a tremendous spate of research on women. It is more the way social history is becoming more intelligible through recent studies on women than simply the quantum of writing on gender.

The dominant discourse of women in early Indian society, derived mostly from brahmanical normative texts, has remained confined to women within the household. As daughter, wife, mother and in other capacities, women constitute a practically undifferentiated group, with a fixed set of norms and duties they are seen to have adhered to. The historical perspective in this discourse is in tracing their fall from an ideal, exalted position in Vedic times, reflected in their participatory scholarly and ritual status, to stages of decline of that status. In this essentially patriarchal discourse, with women as adjuncts, it is women alone as women who seem to have been casualties of upheavals in society. As adjuncts, women are neither active agents in societal process nor can they represent variant profiles. Separate studies on women outside the bounds of family bond do exist, but it is the concern about the 'position of women' as such which has largely determined how women in early Indian society should be written about and generalized. This approach inevitably leads to stereotyping, and stereotyping of early Indian women has picked on the by now internalized attributes of natural physical weakness requiring male protection, deeper religiosity, proneness to impurity and so on.

That the historical perspective which has been brought to bear upon studies on women itself has its roots in the ideology of patriarchy is being recognized now. This relationship is evident from an almost uncanny consensus converging in the particular focus on

women in terms of chosen themes and explanatory positions running through varieties of publications. The consensus would even extend to rationalization of particularly vicious modes of women's subordination in ancient texts, which would appear incongruous to the sensitivities of sections of patriarchal elites of the nineteenth and the twentieth centuries.

The title of Kumkum Roy's collection of writings on women is by itself a suggestion toward the need for a much larger space than has so far been accorded to women in the academic discourse. The historical experience of India, in combination with contemporary ethno-sociological realities, does indeed point to the need to explore plurality and to strive towards fresh perspectives on gender relations. If the early Marxist writings brought out both the hidden patterns outside patriarchy-dominated society as also the basic structure of the subordination of women within the hierarchized order of brahmanical patriarchy, these pioneering efforts are now being carried forward to a more refined understanding of the 'structural framework of gender relations'. Thus, even within that segment of Indian society which is bounded by the patriarchy of the *varṇa* based social order, *strīdharma* or the ideal of womanhood is an historical product, emerging out of patriarchy's necessity to subordinate women through the social and ideological control of sexuality. It is not natural proclivities of women or their biologically determined dependence on males that would define *strīdharma*.

Gender relations in historical societies within the overarching frame of patriarchy are inevitably becoming a major focus of the social history of such societies. It is hoped that the present volume by Kumkum Roy will be received not simply as an introduction to the 'passive' world of early Indian women but as an essential initiatory guide to the complex social world of early India.

<div align="right">B.D. Chattopadhyaya</div>

Acknowledgements

I would like to thank Prof B.D. Chattopadhyaya for creating space for this volume within the present series, and for his unqualified support in its planning and execution.

My brother Sumanto has been generous in offering critical comments at a number of points, my father has been encouraging, while my mother has been a constant and consistent source of strength, sharing my concerns and enriching them with her own perceptions. Bankim, Kubisha, Rina and Santosh have been supportive in a variety of ways.

Some of those whose contributions are included in the volume were interested in what is now defined as women's studies long before the term became fashionable. Despite their own academic and other commitments, they have responded with patience to my queries and to my claims on their time and expertise. I am particularly grateful to Prof Sukumari Bhattacharji and Prof N.N. Bhattacharyya for their support. Dr Chitrarekha Gupta and Dr Vijaya Ramaswamy, friends of long standing, have shared ideas and their work with characteristic enthusiasm. Dr Padmini Swaminathan, Madras Institute of Development Studies, and the librarian, Newnham College, Cambridge, responded promptly to my queries.

Mahalakshmi R. and Lakshmi Kannan helped me sort out the intricacies of diacritical marks for Tamil. I wish to thank Madhu Kishwar for giving permission to reprint material from *Manushi*. I would like to thank Bharati Sud, Ratna Kapoor, Rekha Basu and Teresa Vijayan who discussed the introductory essay and offered valuable criticisms, comments, and encouragement. I am especially grateful to Kanchana Natarajan and Uma Chakravarti. Many of the ideas which have been worked into the introduction (and much else besides) have grown out of our shared thoughts and discussions over a number of years, and it is to them that this volume is dedicated.

New Delhi Kumkum Roy
March 1997

Abbreviations

AB	Aitareya Brāhmaṇa
ADS (ApDS)	Āpastamba Dharmasūtra
Aiñ.	Aiñkuṟunūṟu
Ak.	Akanānuṟu
Aṅg.	Aṅguttara Nikāya
A.R.E.	Annual Report of Epigraphy
Artha.	Arthaśāstra
B.D.S.	Baudhāyana Dharmasūtra
Bhikkhunīvibhaṅga Cmy.	Bhikkhunīvibhaṅga Commentary
B.K.I.	Bombay-Karnataka Inscription
C.H.I.	Cambridge History of India
CV.	Cullavagga
Dhp.	Dhammapada
Dhp. Cmy.	Dhammapada Commentary
E.C.	Epigraphia Carnatica
E.I.	Epigraphia Indica
E.R.E.	Encyclopedia of Religion and Ethics
I.H.Q.	Indian Historical Quarterly
Jaim. Br.	Jaiminīya Brāhmaṇa
JAOS	Journal of the American Oriental Society
J.P.T.S.	Journal of the Pali Text Society
J.R.A.S.	Journal of the Royal Asiatic Society
Kāt. G.S.	Kātyāyana Gṛhya Sūtra
Kauṣītakī Br	Kauṣītakī Brāhmaṇa
Kur.	Kuruntokai
Majjhima	Majjhima Nikāya
Manu.	Manusmṛti
Mhp.	Mahāparinibbānasutta
M.S.	Maitrāyanīya Saṁhitā
Parāśara S	Parāśara Smṛti
Pur.	Puranānuṟu

LIST OF ABBREVIATIONS

ṚV	Ṛgveda
Saṁvarta S	Saṁvarta Smṛti
Saṁy. Nik.	Saṁyutta Nikāya
ŚB	Śatapatha Brāhmaṇa
SBE	Sacred Books of the East
SCS	Smṛticandrikā, Saṁskārakāṇḍa
SII	South Indian Inscriptions
Skanda P	Skanda Purāṇa
SLAI	Sexual Life of Ancient India
SV	Sāma Veda
Sutta Nipāta Cmy.	Sutta Nipāta Commentary
TA	Taittirīya Āraṇyaka
TB (Tait. Br.)	Taittirīya Brāhmaṇa
Therīgāthā Cmy.	Therīgāthā Commentary
V.	Vinaya Piṭaka
V.D.S.	Vāsiṣṭha Dharmasūtra
Viṣṇu.	Viṣṇusmṛti

Introduction

Kumkum Roy

The inclusion of a volume on *Women in Early Indian Societies* within the present series is in a sense symptomatic of the position of women's studies and questions of gender within the discipline. On the one hand, it marks a welcome recognition of the importance of this particular field of study. On the other, it also recognizes the possibility of situating women's history within the broad perspectives of social history, which in turn permits of the raising of a range of questions.

Yet this is by no means unproblematic. Access to and incorporation within certain disciplinary spaces implicitly precludes the possibility of exploring and extending analyses of gender relations in other contexts, such as histories of the state, agrarian systems, or exchange networks for instance. While there have been attempts to contextualize analyses of gender relations in terms of specific political and economic formations (and some examples are included in the present collection), these have still not made their way into mainstream history.

One can, as has been done often enough, attribute the invisibility of such perspectives to long-standing biases within the discipline, both theoretical and methodological, as well as those of individual, predominantly male practitioners. As has been pointed out recently (Crosby 1991: 1), fascination with both History and the 'woman question' was typical of the middle classes in nineteenth century Britain. These were, in a sense, interrelated, as 'man' was constituted as the subject of historical processes, whereas questions about women were framed in terms of their nature, which was, by definition, unchanging, and hence to some extent ahistorical. This disciplinary legacy is still with us.

But this seems to me to provide only a part of the explanation. It is important to remember that by the end of the nineteenth century, the suffragette movement provided both a visible and vocal

contestation of the divide between History and the 'woman question' as women were claiming access to political rights which were located within a specific historical context. As such, by the beginning of the twentieth century, spaces for investigating women's histories were opened up.

More specifically, in the Indian context, while the interest in both History and the 'woman question' derived from the colonial encounter, they were also refracted in this situation. Thus, there was no simple replication of the concerns or perspectives which emerged in nineteenth century Britain. What we find instead is that both the existence and the nature of the Indian past were viewed as contested domains.

Even at the risk of oversimplification, it is perhaps worth drawing attention to the broad contours of these domains. On the one hand, the colonizers attempted to define the entire colonized population, including and especially its males, as feminine. Amongst other things, this involved denying and/or denigrating the past of the subject population in order to naturalize and rationalize the colonial enterprise. In this situation, one of the responses of the Western educated indigenous elite consisted of attempts to reclaim and reconstitute their past.

Within this context, the discussion on the 'woman question', while not entirely disassociated from the problem of woman's 'nature', was, at the same time, historicized. To an extent, this was related to the understanding that the 'position of women' was an index of civilization. We will return to the ways in which this was worked out later. What is less apparent but none the less likely is that this somewhat precocious focus on women's history had to do with the challenge posed to indigenous masculine identities. One defensive strategy in the face of charges of effeminacy may have been to focus on the separate histories of men and women.

Thus, we have the phenomenon of the persistent visibility accorded to women within certain kinds of histories of early India. As has been stated in a different context, 'Women made an irreversible entry into political discourse as symbolic pawns in a complex ideological background' (Kandiyoti 1988: 220). In a sense, this is best illustrated by Altekar's *The Position of Women in Hindu Civilisation* (1938, 1978) which represents the culmination and consolidation of a definition of the 'woman question' which was designed to meet the requirements of a specific historical agenda. Altekar, who was a prolific scholar,

produced a treatise on *Education in Ancient India* (1934) and another on *State and Government in Ancient India* (1949, 1958), apart from more specialized works. The author envisaged these, along with *The Position of Women*, as works which would appeal to both the general reader as well as to the scholar (Altekar 1958: v). This preoccupation with the more immediate past and the present explains why such histories often end by laying down an explicit agenda for the future.

In fact, two of the three works with which we introduce the present collection, Altekar's *The Position of Women in Hindu Civilisation* and Horner's *Women Under Primitive Buddhism*, date to the 1930s. Neither was an isolated intellectual venture: we can trace their predecessors through the preceding decades. What distinguishes Altekar's and Horner's works from earlier studies is their internal coherence and the wealth of detail. As such, they have remained influential even after six or seven decades.

In contrast, much of the subsequent scholarship on the theme has tended to focus on what are relatively narrow areas of investigation, chronologically, spatially, and in terms of categories of analysis. As such, we have insights into some historical contexts, but not into others. Besides, the connections amongst the areas of investigation require to be worked out. Consequently, the impact on the discipline has tended to be fragmented, and the possibility of an intellectual upheaval remains as yet unrealized.

Most attempts at historical analyses confront and attempt to circumvent certain fundamental problems. One of these pertains to situating women *vis-à-vis* what are identified as major historical processes. We can observe two broad possibilities which are often combined, either explicitly or implicitly. The first envisages historical developments as by definition autonomous, and focuses on the impact they had on women. In other words, women are viewed as passive receptacles, with their 'status' or 'position' changing to reflect the state of the world around them. As a corrollary, variations in the status of women are then treated as indices of relative barbarity or civilization. The second possibility, which has been articulated both less frequently and less systematically, envisages a certain degree of agency for women *vis-a-vis* historical processes.

Women's history in particular and history in general are implicated in contemporary political discourse. As such, evaluations of either of these explanatory strategies or attempts to combine them do not remain questions of pure epistemology, but feed into a range of

problems relating to positions within the women's movement, strategies for women's studies, including the complex interaction between activists and academics as well as positions outside the movement. It is with these possibilities in mind that we need to explore the implications of adopting alternative explanatory strategies.

Altekar's work and those modelled on his framework are most representative of the first perspective. He identifies two contradictory long-term trends influencing the position of women: (1) a decline in their familial status, religious rights, and in their participation in public life, and (2) an increase in their proprietary rights. Of these, the first is thought to outweigh the second. Thus, within an overarching commitment to the definitional primacy of History as determining the position of women, in effect, certain spheres or institutions are isolated as being particularly relevant to women. Of these, the family is clearly privileged, as the discussion on women within various familial relations occupies more than half the text. Besides, even the discussion on religious practices and women's access to property are located within the context of the family. Almost inevitably, this implies a homogenized understanding of a single, unitary type of family, which is idealized as a counterpoint to what are implicitly or explicitly understood to be the institutions of the degenerate West. It also means that there is a tendency to create hierarchies amongst indigenous familial forms, and to marginalize those which appear to deviate from strictly patrilineal models (Chakravarti and Roy 1996).

As is evident from the aforesaid, Altekar locates his history of women along two axes of comparison, one, within Indian history, and second, with other known societies or civilizations. Within this framework, what he identifies as the oldest known society in the Indian context, that ascribed to the early Vedic age, is also conceived as the best from the point of view of women. This is substantiated in terms of access to education, a relatively high age of marriage, monogamy, the absence of seclusion and *satī*, and possibilities of widow remarriage. These indices of status are viewed as interrelated— thus it is suggested that as ritual education became more complex, women had to remain unmarried for longer spells in order to acquire it. This was by definition impossible, as such there was both a decline in access to education and a lowering of the age of marriage.

In the case of almost all these criteria, one can argue that the evidence is more complex than Altekar suggests. For instance, while references to women seers in the Ṛgveda are regarded as an indication of access to education, this does not take into account the number (a handful out of thousand) and the nature of the compositions attributed to them. Moreover, while Altekar treats education as monolithic and positive, and understands it as leading to access to the prestigious domain of ritual and religion, it is obvious that in any historical situation there would have been more than one definition of education, as indeed there would have been of religion or ritual. If one envisages a situation of multiple and possibly contending systems of education and/or socialization, historical explanation may become somewhat less facile. In other cases, such as the age of marriage, tangible data to argue for trends of lowering or raising the age are extremely difficult to come by.

Another problem with identifying a set of criteria is that this is then mechanically applied to different historical situations. For instance, access to property may be regarded as an index of women's status. If this rests on a definition of property which is treated as absolute and invariable, without being qualified or contextualized (see Section II which follows), it can lead to ahistorical analyses. Besides, the possibility that there may have been a relative shift in the nature and significance of specific criteria is often not recognized. Consequently, the historical analyses offered have a curiously static and repetitive quality.

Even more problematic is the broader causal nexus within which these criteria are embedded. While Altekar makes a casual reference to women's involvement in production in the Vedic age as being partly responsible for their high status, this is not carried through. Instead, their high status is also and more consistently connected with militarism and expansionism, the consequent shortage of women, and the need for producing warrior sons. Low status on the other hand is viewed as stemming from a relatively peaceful situation, where a luxurious lifestyle is at a premium, and where women are sex objects rather than instruments of procreation. The possibility that such roles are not mutually exclusive and that there may have been other roles which were combined with these, remains unexplored.

More insidious is the equation between high status and what is understood as the predominance of the Āryan woman, low status hinging on the influence of the śūdra woman on the former.

Besides, foreign invasions are invoked time and again as an explanation for certain restrictions on women. As such, the low status of women is viewed as extrinsic to the indigenous social order. Thus, the explanatory framework is coloured by casteist and, occasionally, communal overtones. Apart from these obvious political implications, such explanations are simplistic, as the interaction between indigenous and extraneous peoples was complex. In fact, both populations would have been stratified rather than homogeneous. Hence, the relations between the two categories was not necessarily always sharply polarized.

Another dichotomy which is often invoked for explanatory purposes is that of the renouncer *versus* the householder. A variety of 'social ills' are attributed to the growing importance of asceticism. This ignores the fact that the renunciatory orders opened up new spaces for women.

It is to these spaces that Horner draws attention. Hers was not the first attempt to locate women within Buddhism: in 1927 B.C. Law published a monograph on *Women in Buddhist Literature*, which he believed to be 'the first of its kind' (Law 1981: i). While his work was less detailed and less focused than Horner's, he felt that women had 'advanced' within Buddhism and that 'the advance was the work of the women themselves. . . . It was women who made men and their churches recognize them' (ibid.). Incidentally, both Horner and Law were situated within a different disciplinary tradition, that of Buddhist and Pāli studies as opposed to History.

Horner's categories of analysis are twofold, viz., lay women and almswomen. She focuses in particular on the latter. While familial relations are recognized as important for the first, as well as, to an extent, for the second category, Horner also explores the category of the woman worker, not necessarily located within domestic spaces. The definition of work and workers is somewhat eclectic, including agriculture, spinning, the maintenance of cremation grounds, and categories such as acrobats, musicians, dancers, slaves and courtesans. Clearly, the criterion underlying the selection is the ability of such women to support themselves, and occasionally others, rather than questions of the extent to which they were part of productive processes. Possibilities of a sexual division of labour and its implications are not raised, although they are implicit in the evidence which is presented. While this may appear to be somewhat limited, it is none the less valuable in recognizing the existence of women outside

domesticity. To some extent it seems that the opening up of these areas of investigation was possible because Horner was not constrained by the requirements of conforming to the disciplinary norms of History, whether of the colonial or the nationalist varieties.

Horner raises and explores a different set of questions with respect to the order of nuns or *bhikkhunīs*. Here she argues for a two-way relationship between women and Buddhism. On the one hand, she accepts that Buddhism opened up a certain space for women. At the same time she suggests that women not only shaped the contents of that space, but that, in doing so, they redefined Buddhism to a certain extent. In other words, she attributes a degree of agency to women within this particular framework.

Horner attempts to substantiate her hypothesis by exploring the avowed reasons behind women joining the order. She also works through the evidence for the creation and consolidation of a predominantly woman-centered community and produces an account which is rich in detail. At another level, she explores the specific forms of self-expression and the articulation of the experience of enlightenment attributed to the *bhikkhunīs*.

What is interesting is that in the process Horner revaluates certain stereotypical notions which recur with monotonous regularity in accounts of women in early India. This is most obvious in the treatment of the theme of dress and ornaments. Conventionally, this provides the framework for locating women within the realm of aesthetics or fashion, and of extending this to trivialize women by implying that these are amongst their major concerns. Horner deals with the theme, but within the context of the dress code prescribed for the *bhikkhunīs*. As such, it is explored as an index of notions of female sexuality and as a mode of containing it rather than as a superficial preoccupation with the decorative.

Horner's notion of women's agency, which underlies her analysis, can be called into question from the standpoint of more nuanced understandings (e.g. Sangari 1993) which would suggest that it is somewhat simplistic to conceive of women's agency in direct, unmediated terms. Nevertheless, her work is valuable in opening up the possibility of recognizing the existence of certain spaces within which the active participation of women in the historical process was likely.

I am inclined to connect Horner's ability to conceptualize, identify and to an extent substantiate her notion of women's space, no matter

how circumscribed, to the environment within which she worked and lived. She was associated for a number of years with Newnham College, one of the few centres for women's education in Cambridge, and shared an enduring and close relationship with women friends, including her companion of thirty years, Elsie Butler.

It is also likely that her ability to envision women's space was possible because of her relatively limited frame of reference—her interests centered on the formative phase of Buddhism, whereas Altekar attempts a more ambitious synthesis. However, there are other indications of a more fundamental difference in perspective.

To an extent, this is reflected in their handling of the related problems of periodization and sources. It is a truism that an implicit or explicit understanding of significant historical changes underlies the adoption of one or the other scheme of periodization. Conventionally, a number of possibilities have been available to historians of early India. These include the relatively simple dynastic periodization, where major ruling dynasties are recognized as historically distinct from one another. Given that women have rarely had direct access to positions of rulership, this form of periodization is particularly inadequate for conceptualizing gender relations. A second possibility for periodization is based on the availability of different kinds of sources for reconstructing the past. This rests on the assumption that certain kinds of texts in particular were composed or compiled in distinct historical settings. A third and more complex attempt at periodization aims to reconstruct socio-economic phases, located implicitly or explicitly along an evolutionary axis. Clearly, the question is not simply one of chronology, but of assumptions about events or processes which are regarded as historically significant.

Altekar's periodization explores the second possibility. This has certain general problems, including dating texts and working out their mutual relationships. Besides, there are other difficulties which are specific to their treatment of questions of gender. Most of the texts are prescriptive, brahmanical works, with an inbuilt gender bias. In other words, they represent the perspectives of high-status men. As such, women have no direct voice in the composition, compilation, preservation and transmission of such texts. In this situation, the texts need to be used for reconstructing gender relations with a certain degree of caution, and with an awareness of the inherent bias. However, Altekar does not recognize these implications and uses the texts to arrive at an unproblematic, literal

reconstruction. As in the case of his explanatory framework, this has a certain methodological directness which has an obvious appeal. This is evident from its adoption by other scholars, especially Sanskritists, who summarize references to women from a variety of texts such as the *Yājñavalkyasmṛti*, *Manusmṛti*, etc., somewhat uncritically and mechanically.

In a sense, although Horner's historical agenda is more limited, she shows greater sensitivity to the complex nature of the texts she draws on. Her awareness of the variations, which may have been introduced during the writing down of oral traditions, and of the process of transmission through teachers and monks, with the possibility of a misogynist bias, are remarkable, given that her work was first published in 1930, although these insights are not systematically developed in the way she makes use of individual texts.

The heirs and heiresses to Horner's legacy, if they may be so-called, have opened up new areas of investigation within the framework of Buddhism. Some, such as Chakravarti (1981), have attempted to contextualize the emergence of early Buddhism, and women's place within it, in terms of contemporary socio-economic formations. Others, such as Paul (1985) and Shaw (1994) have focused on specific forms of Buddhism such as Mahāyānism and Tantrism. In other cases (e.g. Sponberg 1992 and Richman 1992), readings of Buddhist texts have been extended well beyond the somewhat literal analyses offered by Horner herself. It appears that, precisely because her work is less closely structured than Altekar's, her influence has proved stimulating rather than stifling.

Turning to the specific question of women's agency, we find that unlike Horner, Altekar tends to view this as problematic. This is especially evident in his views on śūdra women, who are regarded as disruptive, corrupting the pure speech of Āryan women. As mentioned earlier, the former are consequently regarded as being responsible for the decline in the latter's status. These, and other problems inherent in what has been characterized as the Altekarian paradigm, are highlighted in Chakravarti's critique (this volume).

While Altekar's neat formulation can be called into question, his attempt to connect gender and *varṇa* identities is interesting. More recently, Chakravarti (1993) has worked out an alternative framework. As she points out, this is tentative. She situates gender relations within a context of caste and class relations and explores the extent to which the control of female sexuality is central to the creation and

maintenance of caste identities in particular. Besides, she draws attention to enforcement mechanisms, including the state. This is useful in that it shifts the focus of attention from the status of women to questions of patriarchal socio-political formations.

Chakravarti provides a panoramic sweep from prehistoric times to early state societies. She locates prescriptive constructions of women's nature within this framework. As she observes, these are marked by an element of tension. On the one hand, we have definitions of *strīsvabhāva* or women's nature, which is regarded as inherently problematic and untameable. On the other hand, we have attempts to achieve the near impossible through prescriptions of *strīdharma* or the duty of the ideal wife, who was expected to be totally devoted and subservient to her husband (*pativratā*). She also points out that such definitions were probably crucial for the brāhmaṇas on the one hand, and male members of ruling clans on the other. Control over the sexuality of the wife was perhaps the most important means of maintaining masculine identities for such groups, related as these were to the transmission of material and social attributes from one generation of men to another. In this context, although caste and class identities did not coincide, they probably overlapped in many instances. Chakravarti's approach can be characterized as broadly Marxist-Feminist, implying as it does that gender relations are parallel to and interact with, and are in some senses constitutive of class relations (Connell 1987: 46). What requires further investigation is both the content and the internal articulation of specific formations, as well as their contextualization and mutual relationship.

Although these perspectives have proved fruitful, they are by no means unproblematic. Perhaps the most serious unresolved issues stem from the use of the category of 'woman'. Thus, we encounter essentialist, ahistorical statements about women's nature as being determined by concerns of reproduction, or as being more religious than men, all of which envisage women as constituting an un-differentiated, changeless category.

It is obvious that we need to be sensitive to the meanings implicit in the term 'woman' as used by different authors in different contexts. Is the term used to refer to all those who are biologically female? Or is it explicitly or implicitly restricted to upper caste/class women of a specific region, more often than not the mid-Ganga valley? Does it apply to women within the brahmanical framework or

are women supportive of heterodox traditions included within it? How, if at all, is the term 'woman' qualified? Is the definition in terms of caste, class or occupational groups or in terms of locations within kinship structures or procreative or sexual status? And how important are such definitions to the arguments advanced? Are these definitions viewed as immutable, or are they regarded as constructions which are subject to change?

In a sense, these multiple definitions of 'woman' are symptomatic of the complexities of women's history. In spite of all the efforts at uniformity, the varied meanings of the term slip through. While this plurality complicates matters, it can also be viewed as a reflection of the rich potential of the field.

What we also need to come to terms with is the fact that there are and have been regional variations in gender relations. Some of the studies included in the present collection focus on regions, especially present-day Tamilnadu, and in doing so provide us with a rich and varied understanding of the specificities of gender relations. However, other areas are yet to receive identical attention. These include areas where one would expect variation, such as the northeast, for instance, which has a strong living tradition of matrilineal societies. Given that our understanding of regional histories has been sharpened in recent decades, especially for areas such as Orissa, it is to be hoped that attempts will be made to focus on gender relations within such frameworks in future.

As important is the fact that vast chronological expanses remain unexplored from the perspective of women's histories. For instance, the millennia assigned to prehistory, and, to a lesser extent, protohistory, as well as the early medieval period require investigation. In the absence of detailed studies, the possibility of attributing the origins of gender stratification to the remote past, in particular, remains temptingly open. This is a tendency which has been observed in other contexts (Conkey 1991), especially within the discipline of archaeology. The quest for origins tends to divert attention from the specific features of gender relations in different historical situations, and needs to be embarked on, if at all, with caution.

Meanwhile, what we have, more often than not, are sweeping generalizations about the position of women in early India. While readers will inevitably find a number of such statements in the present volume, they would do well to bear in mind that these require qualification, which is best done by focusing on the

perspectival, spatial and chronological location of the sources on which the author bases himself/herself.

II

The material structure underlying gender stratification has been the focus of considerable attention for decades, if not since the last century. This in turn has involved attempts to identify crucial elements within such structures and to work out their gendered nature. It is in this context that one can locate the concern with the question of women's access to property.

In the article included in the present collection, Bhattacharyya argues that the preoccupation with the nature and contents of *strīdhana* (literally woman's wealth) can be understood within the framework of colonial legal discourse. This is valuable, insofar as it enables us to contextualize the contemporary interest in women's proprietary rights. While property in general was conceived of, in absolute, universal terms, which was somewhat ahistorical, women's wealth or *strīdhana* was carefully defined in terms of movable goods such as utensils, ornaments, etc.

What permitted the classification of this assortment of goods under a single term seems to have been their distinctive relation to productive processes. Virtually none of these goods could have been directly used for production. In other words, any notion of economic empowerment through access to such resources was obviously limited. Besides, in economic contexts where monetization may have been weak, the possibilities of converting *strīdhana* into productive resources may have been limited. As such, the focus on *strīdhana* as women's legitimate property could also mean restricting their access to other kinds of resources.

Bhattacharyya also draws attention to the fact that customs or norms governing inheritance are not uniform but reveal variations over space and time. Mukund (this volume) points to the social nature of such variations, arguing that access to property would have varied 'across regions/sub-regions/castes/classes/families' (p. 123).

At another, related and more fundamental level, definitions of property are subject to change. As Bhattacharyya points out, notions of property have a history; for example, in the early Vedic context, absolute rights to land do not seem to have been important. Thus,

what constitutes property is in itself variable as are definitions of legitimate and illegitimate uses of and access to property. In this situation, the process of codifying laws regarding property (as indeed other laws) can be viewed as both representative of and embedded in changing notions of property and its control. As such, they may not necessarily directly reflect the prevalent system governing relations to property.

Bhattacharyya's and Mukund's focus on the means whereby women could legitimately acquire property is also interesting. They point out that these included gifts which were to be exchanged between kinsmen and women, as opposed to resources acquired through direct participation in and control over productive processes. In other words, ideally women's wealth was generated within and restricted to certain domains. In a sense this can be viewed as the logical corollary of the emphasis on *strīdhana* as women's sole legitimate property. Clearly, women were not expected to earn through labour, or through participation in trade or productive processes.

At another level, one can compare gift exchanges which were legitimately open to women with other forms of gifts such as *dakṣiṇā* or *dāna*, which evidently constituted an important element of social, material and ritual transactions in early India. These can be situated within broader systems of distribution. As Acker (1988: 477-8) argues more generally, differential access to distribution/distributive processes may in fact be as constitutive of class relations as relations of production. This can then provide us with a more nuanced understanding of the implications of the rights of women to property, as recognized within prescriptive Sanskritic traditions.

Within this framework, Mukund draws attention to the conventional perception in Tamilnadu that *devadāsīs* were the only women who had proprietary rights. While we will be focusing on the courtesanal tradition subsequently (Section III), we may note that Mukund's own investigation, as well as that of Gupta (Section II) and Singh (Section IV) would indicate that other categories of women had access to and could dispose of property as well.

Mukund uses inscriptional evidence pertaining to economic transactions involving women. Apart from the evidence on women who made donations to religious institutions and implicitly controlled resources they transferred, she includes data on women buying and selling land and receiving assignments of land revenue. Besides, she

attempts to categorize women through a combination of caste/ class/occupational characteristics recognizing women belonging to ruling families, those of the landed elites, and the *tēvaraṭiyār* or temple servants, who would have included the *devadāsīs*. The breaking down of economic transactions and of categories of women involved in them opens up possibilities for a more complex understanding of women's proprietary rights, as opposed to homogenized, simplistic generalizations. This enables Mukund to substantiate her argument for variations both amongst women on the one hand, and between prescriptive statements and operative transactions on the other.

Mukund examines the system of *mañcal kāṇi* or turmeric land which evidently passed from mother to daughter on the latter's marriage. This was literally meant to provide turmeric, regarded as one of the symbols of auspiciousness in Tamil society. The size of the land could vary according to family status and the number of siblings (personal communication, Kanchana Natarajan). Mukund suggests that these land rights may be connected with the prevalent regional kinship and marital system, which privileged cross cousin marriage or marriage with the maternal uncle. This is an interesting instance of a matrilineal system of inheritance embedded in and coexisting with a predominantly patrilineal structure. It also implicitly points to the question of post-marital residence, which has been regarded as an important factor in determining the extent to which women exercise effective property rights, especially over immovable resources such as land.

Mukund contextualizes her data in terms of the growing importance of the temple centered agrarian economy in early medieval Tamilnadu. She draws attention to the relative paucity of such transactions during earlier and subsequent phases. This is an interesting connection which has been tested in other regional contexts as well (e.g. Parasher and Naik 1986, Singh 1990). What also requires exploration is the extent to which the transactions women were involved in converge with or diverge from those of the categories of men through whom they establish their identity. This would enhance our understanding of the context within which such transactions may be located. As Whitehead (1984: 176) observes more generally, property relations are not so much about people and things as about people and people. In other words, it is the differential access which different social groups have to specific resources rather than any autonomous or intrinsic value these

resources may have, which endow such relations with social meaning.

Another interesting point, which Mukund touches on in passing, is the relationship of women belonging to mercantile categories to property. She points out that while women in Chettiyar families evidently controlled and managed property in the absence of male members of the household who were engaged in long-distance trade, the former had no rights to inheritance. What is implied is that issues such as inheritance/control/management are not synonymous, nor do rights in one sphere necessarily translate into another. Given that we have a variety of evidence for the existence of trading networks in early India, involving long-distance voyages over land and sea in many cases, the role of women within such activities or in terms of them can be fruitfully investigated. It is likely that this can provide a context for exploring a different intersection between gender relations and economic processes.

Chitrarekha Gupta's essay on rural-urban dichotomy raises a number of interesting questions on the relationship between women's status and what are conventionally identified as major turning points in socio-economic history. She focuses on what is often termed the second urbanization in Indian history, that of the Ganga valley, beginning in the mid-first millennium BC and attaining its greatest development between the second century BC and second century AD. Combining inscriptional evidence with textual sources, she argues that the rural-urban divide was probably not as sharp as is commonly visualized, and that there was a degree of interpenetration between the two domains. As such, certain relatively conservative values, which she associates with rural society, persisted even within the urban context.

Gupta suggests that the interaction between the rural and urban sectors and its complexities are reflected in the strategies women adopted to define their identities, evident in votive inscriptions. Many women identified themselves in terms of their place of residence. This, Gupta argues, would point to a degree of autonomy from kinship structures, which may have been possible within the relatively fluid social context of urban centres. However, she points out that such trends are by no means simple or unilinear. In some urban centres such as Mathura, women continued to identify themselves in terms of kinship categories or in terms of the occupations or professions of their husbands. The evidence for women being identified in terms of their own occupations is relatively limited.

Moreover, women do not seem to have exercised control over productive processes in either rural or urban areas.

For the subsequent historical phase, identified with the Gupta empire, she cautions against its acceptance as a golden age in Indian history, suggesting that this may not have marked any improvement in the situation as far as women were concerned. In fact, it is the period from which we have the first definite epigraphic reference to *satī* from north India.

Gupta's work opens up the possibility of investigating women's relationship to the economy from a distinctive perspective. She focuses on what are conventionally recognized as phases of growing economic complexity and reinvestigates them from the perspective of women's history. What emerges is an understanding that such socio-economic phases may have had a different meaning for men and women.

Implicit in some of these arguments is an understanding that the class position of women needs to be problematized rather than assumed. This is not necessarily identical with that of the men to whom we are related as daughters, wives, mothers, sisters. This is a possibility which requires further development and investigation. Besides, class relations were not identical in urban and rural areas. As such, the analysis of each will pose specific problems, and require specific methodologies. Tentatively one can suggest that as there is ample evidence for changing/different patterns of landownership in early India, one can explore the implications of such differences in providing the material underpinnings for varied gender relations in situations where agriculture constituted by far the most important of economic activities. Besides, as suggested earlier, one can analyse specific economic activities in terms of both relations of production and distribution in order to uncover their gendered nature more fully.

Vijaya Ramaswamy's article focuses squarely on the theme of women's labour. Like Gupta, she draws on both textual and inscriptional evidence. The textual material is particularly rich and has the advantage of not being prescriptive. The vast corpus of Caṅkam literature, which Ramaswamy explores, has been tapped by predominantly male historians for decades. They have used it to describe political, economic or social conditions, within which women generally figure in a somewhat typical ornamental capacity, as objects of beauty and desire (Hart's article, Section III,

is exceptional). Ramaswamy's exploration would suggest that this conventional notion of women is inadequate. She finds evidence for women's participation in a range of activities including those associated with agriculture such as planting, weeding, husking, winnowing, keeping watch over the ripening grain, etc. Apart from this, women were engaged in pastoral activities, in processing milk, in weaving and especially spinning, in making pots and baskets, in extracting oil, salt and toddy. Others were engaged in a range of services including cooking, acting as nurses and entertainers. Some served the king in various administrative and military capacities, whereas others were temple servants. Besides, we have references to serving women and slave women.

Ramaswamy's account indicates the varied occupational possibilities open to and exercised by women within a single region. Given that the evidence spans a long time-frame—from the first century BC to the thirteenth century AD—it can be contextualized in terms of major socio-political transformations. These range from a situation of chiefdoms or early states associated with the beginning of the Cankam era to more complex regional polities such as those of the Pallavas and Colas. It is obvious that each of these socio-political formations would have been embedded in and in turn engendered distinctive relations of production and distribution. Consequently, the value assigned to women's (and men's) labour in different spheres of productive activities/production may have varied.

Given the near invisibility of women from economic histories, there has been an understandable preoccupation with documenting women's presence in a range of activities. In a sense, this is a necessary first step. However (and this ties in with the earlier discussion on property), as important is the question of the control or lack of control which women exercised over their labour and its produce. In contemporary contexts, it has been demonstrated that while women's labour is tapped for agricultural and other activities within peasant households for example, they have little or no control over the produce generated through such activities. In other words, we need to explore whether participation in productive and other activities translated into economic or social power or not.

The other question which requires further exploration, although Ramaswamy touches on it in some cases, is that of the sexual division of labour. Divisions of labour, sexual or otherwise, can be either pragmatic or prescriptive, or alternatively, the two may be combined

or may shade into one another (Leibowitz 1986:43). Pragmatic divisions often rest on the mutual convenience of participants in labour processes, and are not necessarily fixed. Prescriptive divisions, on the other hand, are likely in a situation of unequal power relations, where dominant social categories may impose restrictions on participation in specific activities for both men and women. Such prescriptions may be perceived as being derived from custom or tradition. While divisions of labour are nearly universal, their specific form and content are subject to historical variation in different contexts. Ramaswamy restores labouring women to a much deserved visibility. This can provide the basis for an analysis of the extent to which such labour was viewed as gendered in specific cases. This in turn may lead to a fuller understanding of the significance attached to women's labour in this context.

While a number of interesting issues are raised and examined in the essays, there are certain central themes which remain relatively unexplored. These include the nature of the household which obviously constituted an important locus through which relations of property and relations of labour were structured. As such, our understanding of these questions, even in terms of specific areas, remains somewhat limited.

Focusing on the household would require us to recognize its variability, as well as its internal dynamics—to explore relations of production, consumption and distribution of resources within the domestic sphere, instead of treating it as a residual and somewhat homogeneous category. Given that in pre-industrial societies the household constituted one of the most important loci of production, and given that its members would have had gendered identities, intra-household relations require investigation.

We also need to recognize that intra-household relations are not necessarily altruistic (Agarwal 1994: 53-60) but may in fact be structured along hierarchies of age and sex and in terms of positions within the kinship structure. Besides, it has been suggested that households need to be understood in terms of an on-going relationship of bargaining amongst members who stand to benefit if they cooperate, but not in identical ways, hence there is always the possibility of conflict. These conflicts, moreover, may vary—certain issues may be regarded as beyond dispute in a given historical context, whereas others may be open to negotiation, some possibilities may be accorded greater legitimacy than others, some members

may have greater bargaining power than others, possibly derived from extraneous sources of support. Relations within the household, then, would be shaped through a complex process involving material and ideological resources, and of course people.

Another area which requires investigation is the extent to which access to productive and other technologies in agriculture, craft production, food processing, etc., may have been gendered. The fact that food processing has a history and a context has been rendered invisible owing to our preoccupation with accepted definitions of major historical themes. Impressionistically, there is evidence to suggest that in many societies productive equipments such as ploughs or looms are regarded as being out of bounds for women. We need to explore the circumstances within which such prohibitions are located, variations if any, the extent to which they are implemented or contested, and the implications of such prohibitions. At another level, we need to be prepared to question the assumption that technological innovation is almost by nature a male enterprise. This has been attempted by feminist archaeologists such as Gero and Conkey (1990) while analysing technologies for making stone tools, which constitute an important element of archaeological assemblages for prehistoric periods (and even subsequently). They point out that there is little archaeological evidence to suggest that tool making was a masculine activity. However, the tendency of predominantly male archaeologists to project nineteenth and twentieth century gender role stereotypes into the past made them regard all tools as representations of masculine innovation.

This also brings into focus the extent and forms in which economic processes including production and distribution are ascribed gendered meanings (Acker 1988: 478). Such a perspective can enable us to move beyond a definition of the economy as determining gender relations to a more complex relational definition of economic processes as being gendered.

Perhaps one of the most serious lacunae in our focus on women, in relation to material conditions, has been in our inability to come to terms with reproduction as a historical process. Reproduction itself has been defined in a variety of ways, ranging from a broad maximalist definition in terms of social reproduction which includes biological procreation, the reproduction of daily life through activities such as housework, and the reproduction through socialization into distinct and multiple roles and relations. More minimalist definitions

focus on biological reproduction, which in itself is a complex process, involving physiological changes which are socialized in a variety of ways.

As O'Brien points out (1981: 47), the physiological process can be split up into a number of moments. These include menstruation, ovulation, copulation, alienation (of the male seed/sperm), conception, gestation, labour, birth, the appropriation of the child, and nurturing it. Some of these are visible, whereas others are not, some are involuntary whereas others are not. As such, each of these moments can be and has been invested with a range of meanings. For example, legitimate procreation is encapsulated within a complex context including the age of marriage, its duration, the control or regulation of pregnancies, and childbirth. While we may not have quantitative data on these questions, even tracing out attitudes towards them may be illuminating.

It has been argued that part of the reluctance of feminist scholars (including historians) to engage with the issue of reproduction stems from fears of being caught up in naturalist categories of analysis. After all, procreation is commonly understood as woman's natural if not only role, and as such, drawing attention to it might reinforce stereotypes about women and gender relations. What is often lost sight of is that historicizing the issue may reveal immense variations in practices surrounding menstruation, copulation, childbirth, etc., and may in fact provide the basis for a more complex understanding of reproduction.

In the context of the early historical situation in the mid-Ganga valley I have argued (Roy 1994a) on the basis of brahmanical literature, that attempts were made to structure biological reproduction and locate it within a specific social context. On the one hand, legitimate reproduction was linked to marriage. What is more, the wife was constructed as an instrument of procreation with her procreative powers being appropriated through a variety of rituals. As such, she was expected to participate in procreation but her claims to the offspring produced was subordinated to those of her husband. As an extension of this, children, especially sons, were ritually connected with their fathers, to ensure that sons belonged to fathers and *vice versa*. Besides, rituals, *mantras* and learning were often depicted as being superior means of producing offspring, as opposed to the physical process of copulation. This was reinforced by portraying related processes such as menstruation and childbirth

as polluting. In a sense, this culminated in the privileging of the *upanayana* or initiation, which was regarded as a second, spiritual birth. This was viewed as better than the first, physical birth. At the same time, there are indications that this ritual construction of procreation was by no means uncontested. We have references (although derogatory) to varieties of less legitimate offspring, and to men who did not get the *upanayana* performed, even though they were eligible for it.

Even a cursory glance at later prescriptive Sanskrit literature would indicate the rich potential of the field (if that is indeed the right metaphor). Amongst the numerous themes on which the texts focus is that of defining procreation as involving the woman who is construed as a field, both symbolic of the fertile earth, and a possession, and the male who is envisaged as the possessor of seed. This is then extended to argue that the seed determines the nature of the offspring. As such the analogy is accorded justificatory value and becomes a mechanism for appropriating the offspring by or for the father and his lineage. While this is a fairly neat theorization, it seems to have been complicated by the fact that biological and social fatherhood did not necessarily coincide. This was resolved by according priority to the latter. What is evident none the less is a certain tension involved in incorporating children (especially sons) within the lineage. It would be fruitful to explore whether this has resonances in other kinds of sources, as well as the extent to which this construction was accepted or contested.

It would also be useful to explore the ways in which child rearing is treated. As will be obvious, we should not expect a monolithic system. The principles and practice of child rearing would have varied across space and time, and also in terms of social categories. The extent to which child rearing was viewed as a gendered activity, its contents, and especially the gendering of children through the process, need to be opened up to investigation. Asking such questions would help us to focus on the broader definition of social reproduction, mentioned earlier, more meaningfully.

This in turn would permit us to reflect on the connection between changes in relations of production and in reproductive relations. There has been a tendency to argue that the former has a certain determinative status. Within this framework, there has been a focus on prescriptive texts which incorporate women within definitions of property (e.g. Sharma 1983). This status as object would have

certainly been a reality for many women, including slave women. However, one can envisage the relationship in more complex terms, which can provide us with a richer understanding of economic processes.

Focusing on reproduction, moreover, may provide us with a better understanding of women's relations to other resources of production. Most women (and men) may not have had direct access to and control over such resources in most known historical situations, and would have participated in production, primarily, if not solely, as labourers. As such, the weight of reproductive responsibilities, and the attempts to appropriate the produce of reproductive labour, viz., children, may provide us with a better understanding of the gendered nature of specific productive processes. In other words, focusing on reproductive relations may transform our understanding not only of the relationship of women to the economy, but of the economy itself.

III

The centrality of marriage in structuring gender relations is often accepted as a given. In the early Indian situation this seems both plausible and justified in view of the well-known śāstric statement (e.g. *Manusmṛti,* II.67) equating marriage for women with the *upanayana* or initiation prescribed for men belonging to the three higher *varṇas*. More generally, marital status constitutes by far the most important element of women's identities in most known societies. As such, we introduce the discussion on socio-sexual constructions of womanhood by focusing on marriage.

Yet, marriage is by no means a unitary institution in early India. While certain forms of marriage are fairly well-known from a range of texts (prescriptive and otherwise), others are relatively unexplored and are often perceived as problematic. Sarva Daman Singh's work (excerpted and included in this volume) is unusual and significant in drawing our attention to polyandry.

While Singh surveys a vast wealth of information on the institution, we concentrate here on the evidence he marshalls from Vedic literature. This is useful, as it shifts the focus from that enigma in the *Mahābhārata,* Draupadī's wedding with the five Pāṇḍavas, which often springs to mind as the sole, and indeed most spectacular representation of polyandry in early Indian literature.

Singh discusses a range of sexual unions, not all of which are explicitly or necessarily polyandrous. These include the attempt to achieve a brother-sister alliance, the theme of the dialogue hymn between Yama and his twin sister Yamī (*Ṛgveda*, X.10). As in the case of most Vedic hymns, analyses of the dialogue have varied from cosmogonic, mystic or naturalistic interpretations, to a more literal understanding in terms of parallels in the human context. Singh supports the latter possibility. He also lists evidence for incestuous relationships between other deities.

While there is no explicit connection between polyandry and such relationships, the data open up the possibility of viewing sexual relations as varied rather than structured along any single pattern. These variations are evident between normative and recognized sexual relations on the one hand, and within each of these categories on the other. The significance of such variations can be fruitfully explored in specific cases.

Some of the other mythical references Singh collates are more obviously polyandrous. These include references to the Maruts and the Viśvedevas, collectivities of gods who each share a common wife, and to Sūryā, the daughter of the Sun god, and the archetypal bride in the Vedic marriage hymn (*Ṛgveda*, X.85) with the twin gods, the Aśvins, as her husbands. This is reinforced by another verse from the same hymn which refers to the divine husbands of the human bride, including Soma, the *gandharvas* (celestial beings, the masculine counterparts of the *apsaras* who figure in Section IV), and Agni. The fact that verses from this particular hymn have been incorporated within marriage rituals provides us, in a sense, with a bridge between mythical and human realms. Thus, a certain routine acknowledgement of polyandry within a symbolic frame of reference is apparent, even as its implications need to be worked out.

At another level, Singh draws attention to kinship terminology such as *devṛ*, the younger brother-in-law of the bride. The *devṛ* was evidently invested with the role of a surrogate husband, especially but not only for the childless widow. In this context Singh focuses on the institution of *niyoga* or levirate, whereby a childless widow was expected to produce an heir for her husband's lineage through intercourse with her surviving brother-in-law or a specially appointed male, preferably a kinsman of her husband. One can argue that *niyoga* constituted a form of serial monogamy for the woman and was not synonymous with polyandry. Moreover, the meanings of *niyoga*

may be context-specific. In a recent work on the near-contemporary situation in Haryana, for instance, Chowdhry (1994) suggests that the local equivalent of *niyoga* ensured the control over the wife's sexuality which was exercised by her husband's lineage even after his death and was not necessarily unproblematic from the point of view of the woman. Investigating the overlap between *niyoga* and polyandry, and similar intersections between other marital forms can provide us with a more complex understanding of the reproductive and/or sexual implications of such variations for both men and women.

Other kinship terms, which are of interest, include references to fathers-in-law (plural) in connection with a single woman. Singh treats this as a somewhat literal indication that each woman had more than one husband, and that each of these men had separate fathers. However, there are other possibilities as well. Apte (1978: 22) for instance suggests that the use of the plural may have been an honorific. On the other hand, Vedic (and later) texts frequently refer to a plurality of wives. These are, more often than not, taken at face value as indications of polygyny (ibid.: 25). Clearly, the underlying assumption is that a plurality of men and a plurality of women, even if grammatically equivalent, carry different sociological weight.

This raises the question of the gendered nature of language, a crucial element in social construction, as yet virtually unexplored. Given that we have evidence for a plurality of languages in early India (as indeed later), there are rich possibilities for examining the extent and form in which different linguistic components are gendered. At an obvious level, semantic analyses of kinship terminology (in both Sanskrit and other early Indian languages) which locate specific terms in relation to others instead of focusing on individual examples may prove fruitful. One can explore the extent to which terms for masculine and feminine kinsfolk are identical and/or complementary, as well as asymmetries, if any. For instance, in later Vedic texts, while we have specific terms for three generations of male patrilineal ancestors, equivalent feminine terms are extremely rare. Focusing on such variations can enrich our understanding of gendered social relations.

At the same time, we need to bear in mind that variations in kinship terminology need not always be directly equated with different marital or social practices. Also, we should guard against assuming that uniform or identical kinship terminology automatically

reflects identical social situations. In some cases at least, the use of similar kinship terminology may in fact conceal different and/or changing social relations or practices (Kapadia 1995: 68).

Incidentally, Singh touches on the issue of metronymics, the fact that fairly important well-known men in society were identified in terms of their mothers. The debate on metronymics has tended to be sharply and somewhat fruitlessly polarized. On the one hand, it has been explained in terms of polygyny: in a situation where one man had many wives, children were identified and probably ranked in terms of their mothers. On the other hand, it has been viewed as a reflection of matriliny if not matriarchal institutions, and, by extension, of the relative independence, if not dominance of women. What has complicated matters further is the tendency to view metronymics as equivalent irrespective of context, and to look at them in isolation. We need to locate metronymics more carefully—both in terms of the contexts within which they occur as well as in terms of alternative forms of identification which may have co-existed. This will probably enable us to substantiate the meanings of motherhood in different historical situations.

Singh attempts to explain the existence of polyandry in terms of the prevalence of warfare and aggression in Vedic society. To some extent, this is a variation on the Altekarian paradigm. The argument is that the need for warriors as well as the shortage of women encouraged polyandry. This is an argument which requires qualification. Polyandry was by no means the only or even the most important marital practice in Vedic society, and militaristic tendencies alone cannot be invoked to explain all forms of marriage. Also, we need to be wary of homogenizing polyandrous societies and be sensitive to the possibility that meanings of polyandry (as well as polygyny and monogamy and other sexual relationships) are context-specific.

This is suggested by recent ethnographic studies of polyandrous societies (e.g. Schuler 1987, Levine 1988). These indicate that specific instances of polyandry are related to forms of social stratification which are apparently more flexible than caste hierarchies. Besides, these are embedded in a distinctive division of labour where, for men in particular, seasonal migration for trade or herding is fairly routine, while women, in charge of most agricultural activities, tend to be sedentary. The coexistence of polyandry with patriliny and primogeniture, moreover, means that there is no

necessary equation between polyandry and high status for women. In other words, polyandry is not a mirror image of polygyny.

As mentioned earlier, different marital practices often coexist in societies, being considered typical of distinct socio-economic strata. In the case of the Nyinba (a polyandrous people of Nepal) examined by Levine (1988), we find that slave households are monogamous, uxorilocal (i.e. the married couple resides in the wife's natal home), and small, while citizens' households are polyandrous, virilocal and large. In fact, in societies where polyandry is valorized, it is viewed as a means of maintaining fraternal solidarity as well as a unique symbol of group identity. What needs to be borne in mind is that polyandry and most other forms of marriage are as much about the relationship of men to one another as they are about women and men.

The context of polyandrous and other forms of marriage thus includes relations amongst and within social categories including *varṇa* and *jāti*, kinship systems, and gender relations. Elsewhere (Roy 1994) I have explored variations along these lines which emerge from a comparison of prescriptive *śāstras* and the epic descriptions of the marriage ritual. Apart from rituals, the eight forms of marriage referred to in the Gṛhya Sūtras and the Dharmaśāstras have been examined by Sharma (1983, cited in Section II). He uncovers the principles underlying the ordering of these eight forms—pointing out that those which are considered best and suitable for the highest *varṇas* reinforce patrilineal bonds and consequently tend to objectify women. As such, distinct forms of marriage, their variations and histories, are not simply about a restricted, private domain, but impinge on and are embedded in wider social, economic, and political networks.

While polyandry in particular and varied forms of marriage in general can and have provided one entry point into the constructs of womanhood in early India, another construct which has attracted considerable attention is that of the woman as prostitute. One of the earliest monographs on themes related to women was on prostitution (Basu and Sinha 1929). Details of the practice of prostitution in different situations have continued to excite the imagination of scholars, as is evident from Moti Chandra's *The World of Courtesans* (1973). This provides us with a variety of references from a range of literary sources, focusing on the physical attributes of the women in question and on the picturesque, if somewhat stereotypical, references to seductresses. The notion of the seductive woman attributes a

degree of agency to the courtesan/prostitute which, as we shall see, has proved extremely resilient in spite of its limitations.

In fact, by and large, historians have tended to treat prostitutes as either a scandalous or a frivolous topic of research (Otis 1987: 1). Some of these pitfalls can be avoided if one adopts a somewhat more precise definition of the institution as 'a phenomenon in which a *socially identified group of women earn their living principally or exclusively from the commerce of their bodies*' (ibid., emphasis original). In all likelihood, an urban context provides a necessary but not sufficient condition for its existence (ibid.: 2-3). More specifically, it rests on a differential construction of male and female sexuality.

Urbanism in early India has had a long and complex history, beginning with the precocious, if somewhat isolated, developments associated with the Harappan civilization. Subsequently, in the first millennium BC, we have evidence for early historical cities from different regions of the subcontinent, including the mid-Ganga valley, the north-west, and coastal and peninsular India. While the changing nature of urbanism from the mid-first millennium AD has been the subject of debate, it is obvious that individual urban centres have had histories, rising into pre-eminence and declining in importance due to a range of factors. As such, the suggested link between prostitution and urbanism can provide us with a basis for contextualizing the institution more meaningfully.

In the article included in the present collection, Sukumari Bhattacharji, one of the most prolific scholars on women in early India and a Sanskritist who tends not to be overwhelmed by the tradition, collates textual references to various forms of sexual promiscuity from the *Ṛgveda* onwards. However, she distinguishes these from prostitution, pointing out that the latter is embedded in a cash economy.

Bhattacharji suggests that women may have been drawn into prostitution in a variety of situations—owing to marital problems, especially in a polygynous situation, and/or as victims of sexual violence. In a sense, these stemmed from the propensity to treat women as objects, who were part of a range of gift exchanges. Incidentally, one of the forms of marriage which is consistently valorized within the brahmanical tradition involves the gift of a virgin, the *kanyādāna*. More broadly, she suggests that the breakdown of tribal societies and the growth of trade and commerce would have provided the context within which sexual relations were

institutionalized along these lines. By opening up these possibilities, Bhattacharji prepares the ground for viewing the institution of prostitution in social terms rather than as the inevitable outcome of the promiscuous 'nature' of either men or women.

At another level, the wealth of evidence, Bhattacharji marshalls, supports her argument that there were variations in the status of prostitutes. These depended on skills and physical attributes amongst other things, as well as on the social categories from which women were drawn. Besides, age was a crucial factor. In this context, the problems of old age acquire a particular starkness. The author also distinguishes between contexts of prostitution, including temple and courtly settings. Related to this, she explores the question of training, and focuses on the manuals which purport to delineate the scope and content of such education.

Bhattacharji also focuses on the economic relations woven around prostitution, including relations to the state, provisions for taxing prostitutes, and the somewhat unique financial status of prostitutes in comparison to other women. As we have seen (Section II), the notion of the prostitute as the most visibly prosperous woman, so dominant in literary tradition, requires qualification in the light of epigraphic evidence. Nevertheless, even if this is a literary stereotype, its implications are interesting. What is suggested is that women whose social status was legitimate, did not have equivalent legitimate access to an independent economic status, whereas women whose socio-sexual status was ambivalent at best, were more easily recognized as economically independent actors. While one can view such constructs as being imposed by literate upper caste/class men, it is also likely that they were shaped through lived social practice.

To an extent, this is supported by the fact that literary and epigraphic evidence does not always diverge. While texts prescribe and occasionally describe courtesans making donations to religious institutions, this is corroborated in inscriptions. It is likely that such offerings were a means open to prostitutes (and others) who wished to acquire social acceptance and participate in the relations of power and prestige which were centered on such institutions.

Related to the economy of prostitution is the question of clients. Bhattacharji attempts to examine this often-neglected question and thus opens up the possibility of reconstructing the web of socio-economic relations within which the institution was embedded,

instead of focusing on the prostitute in isolation. At another level, it leads to the question of double, if not multiple standards of morality.

Bhattacharji also explores the supportive structures available to the prostitute, including kinship networks, especially the mother-daughter bond. This is useful in drawing attention to the wider ramifications of specific socio-sexual relations, and in pointing to the existence of matriliny within an overarching patrilineal framework. At the same time, she points to the limitations of such structures, evident in the fact that the prostitute could be subject to violence and that her sexuality was a contested domain.

It seems likely that certain questions and possibilities raised by the author can be pressed further. We need to be more sensitive to the social, economic, regional and chronological differences amongst those whom we tend to homogenize under the single category of prostitutes or sex workers. The profusion of terminological variants for the profession, painstakingly documented by Bhattacharji, opens up possibilities of contextualizing such variants to focus on their distinct implications. Also, this is one area where the problem of perspective is particularly acute. The marginality of such women from the point of view of the dominant Sanskritic tradition, and the ambivalence evident in the treatment accorded to them, imposes limitations on our understanding. Thus, while on the one hand prostitutes are condemned, they are also viewed as symbolic of fertility and are incorporated within diverse ritual contexts.

Specific categories of sex workers who have received attention over the last decade or so include the *devadāsīs*. Characteristically, their treatment has varied in the literature. While most contemporary scholars eschew moralistic or voyeuristic positions, there is a marked divide between Indian, broadly Marxist scholars (e.g. Singh 1990, Parasher and Naik 1986, cited in Section II), who tend to locate the institution within a nexus of economic and ritual relations centering around early medieval temples (see also Mukund, this volume) and Western scholars whose understanding is often Orientalist. This perspective is apparent, for instance, in Marglin's (1985) discussion on present-day *devadāsīs* in Puri. She sees them as symbols of fertility on account of their sexual activity, and as being responsible for the prosperity of the realm. Somewhat paradoxically, Marglin draws on indigenous perceptions, especially those of men and women involved in the practice, to establish her case. While this is then projected as

an insider's view, it obscures the fact that this view, as all others, is located within and derives from a complex, changing socio-economic context.

More recently, it has been argued that courtesanal traditions, far from reinforcing patriarchy, represent a circumvention of it and provide women with a refuge of sorts (Oldenburg 1991). As this argument has been advanced with respect to the courtesans of nineteenth-twentieth century Lucknow, its validity or otherwise needs to be examined in that context. What also needs to be borne in mind is that there may be a variety of axes of comparison in any given historical situation. In other words, the dichotomies on which Oldenburg concentrates, viz., courtesan/wife, courtesan/client, need to be contextualized in terms of other social relations/possibilities. Besides, while it is necessary to focus on hitherto marginalized groups, rehabilitation need not necessarily mean glamorization.

Discussions on prostitution inevitably slide into the tangled realm of sexuality and women's nature. Very often, this provides a fertile ground for ahistorical, essentialist formulations. A recent example of this is provided by Jamison (1996: 17) who argues for the existence of a figure called the 'Indic seductress', possessed of qualities such as the 'energy, dedication and intelligence necessary for prodding a reluctant and passive partner into sex'. Interestingly, this figure is located not within the framework of prostitution, but within that of marriage.

The discussion on *strīsvabhāva*, the nature of women, is routine within Sanskritic tradition, even if it is not always valorized as Jamison suggests. Woman's nature, defined at length, was perceived as problematic and hence had to be controlled through the insistence on woman's duty or *strīdharma* (see Chakravarti 1993, cited in Section I, and Leslie 1986). The preoccupation with reiterating both the problem and its solution would point to either the intractable and incorrigible nature of women, or alternatively to the difficulties in enforcing specific constructs of womanhood in a range of historical situations.

The last theme on which we focus in this section, and which has resonances with the next, is the construct of woman as sacred within early Tamil society. Hart, like Ramaswamy (Section II), draws on the rich tradition of Caṅkam literature. This has the advantage of not being prescriptive: as such, although it operates within a system of literary codes and conventions, its perspective is distinct from the top

down view typical of prescriptive texts. Caṅkam literature, as Hart and others have pointed out, operates within two distinct but complementary realms, the *akam* or inner domain and the *puram* or outer world. Women are represented, although in different capacities, in both.

Hart argues that early Tamil notions of the sacred are inextricably bound with notions of malevolence. As such, the sanctity ascribed to women, evident in the definition of *aṅaṅku* within the tradition, is marked with an inbuilt ambivalence. In such a situation, women's powers are at once recognized and sought to be contained through menstrual taboos as well as through ritualizing childbirth and the first occasion when the child is introduced to its father.

Hart draws attention to the fact that such taboos led to the avoidance of women, including nursing mothers. While this can be viewed as a recognition of women's sacral power, it meant, in terms of everyday relations, that the husband could turn to courtesans for sexual gratification. In this context, it seems to me that the attribution of sacrality to women is not entirely unproblematic.

More recently, Reynolds (1991:38) has focused on the *cumaṅkali* (Sanskrit *sumaṅgalī*), the auspicious woman who is by definition married, whose attributes derive from her association with men rather than being intrinsic to womanhood. Thus the auspicious powers of women are embedded in a situation of social circumspection and subordination.

The problem of women's sacrality is brought into even sharper focus in the context of *satī*. As is well-known, the earliest evidence for the suicide or death of the widow following that of her husband comes from Tamil literature and inscriptions. Hart argues that this was a means of controlling her sacral power as were the restrictions imposed on the widow who opted for life instead of death (for a different interpretation of *satī*, see Kosambi, Section IV). What Hart does not highlight, although this is evident in the data he presents, is that in this situation, any sacral power attributed to or claimed by women, instead of empowering them in lived, social situations, could prove destructive for women rather than for men, and literally lifethreatening.

At another level, the definition of *aṅaṅku* adopted by Hart has been called into question by Rājam (1986). She argues that while *aṅaṅku* carries implications of feminine sacrality in some contexts (especially in later Tamil epic literature), this is not its sole or even

dominant significance. In earlier Tamil literature it could evidently be applied to women, men, animals, and nature, and had connotations of strength, vastness, sexuality or even undesirable qualities which had to be removed.

The other construct Hart draws attention to is that of female chastity or *karpu*, a complex concept which was expected to be manifested through a variety of physical and verbal practices or often negatively through restraint. This is a persistent theme in Tamil literature (and presumably in society as well) where, in the Kampan *Rāmāyaṇa* for instance, Rāvaṇa is depicted as being unable to touch Sītā, the emblem of the chaste wife. Hart argues that while the Sanskritic notion of *pātivrātyam* or loyalty to the husband is seemingly similar, *karpu* had broader connotations. For the heroine in Tamil literary tradition, for instance, falling in love was synonymous with marriage insofar as it represents entry into a permanent, unchanging relationship, even if it was not sanctified through rituals. As such, the category of the unfaithful wife (almost stereotypical in some strands of Sanskrit, Prakrit or Pāli literature) is, according to Hart, non-existent in early Tamil literature.

Hart also focuses on the specific construction of the female body and the meanings and power inscribed onto the female breast and genitalia. This is represented most dramatically in the *Cilappatikāram*, where the devoted but wronged Kaṇṇaki tears out her breast and hurls it, setting the city of Madurai on fire through the power she literally embodies and releases.

Hart contrasts the Tamil definition of female chastity with that available in the brahmanical tradition. He suggests rituals such as the *varuṇapraghāsa* which could be performed annually and which included, amongst other things, a questioning of the wife of the sacrificer as to her chastity, would point to an understanding of women as potentially unchaste. The prescriptions and descriptions of *niyoga*, moreover, are viewed as constituting a tacit acceptance of women having sexual and procreative relations with a number of men. This is explained in terms of a valorization of procreation rather than chastity.

The different weightage accorded to female chastity in these two situations can be interpreted in a variety of ways. On the one hand, one can suggest that the valorization of *karpu* in early Tamil society was so completely internalized by women and uncontested that the existence of unchaste women was impossible. On the other hand, it

can be linked to the differences in the dominant kinship structures and marital practices in north and south India (Uma Chakravarti, personal communication). Given the privileging of exogamy within the caste system in north India, the ideal bride was an outsider whose chastity and loyalty would have been suspect. As opposed to this, the preference for cross-kin marriages in Tamil society meant that the typical bride was not a stranger. As such, her chastity would have been valued but not questioned to the same extent.

Besides, as I have suggested in other cases, while cross-cultural comparisons have a certain validity, it is also useful to compare specific values within each society. Within the brahmanical tradition for instance, the emphasis on *brahmacarya* (male chastity/abstinence from sexual intercourse) can probably provide a more meaningful yardstick for understanding notions of chastity within societies which were more or less Sanskritized.

Hart argues that the specific definition of female chastity, he focuses on, evolved within Dravidian society, was absorbed by brāhmaṇas and hence travelled northward and was incorporated within Sanskritic traditions. While this is certainly plausible it oversimplifies historical complexities. Dravidian society is characterized as unstratified and unchanging, both of which can be questioned in the light of more recent investigations (e.g. Sivathamby 1974, Gurukkal 1989). Besides, while Hart refers to Sītā in the Kampan *Rāmāyaṇa*, one misses references to Sāvitrī, an equally important symbol of the powers of female chastity, exalted in Sanskrit literature. Hart argues that the southern influence is evident in the increasingly stringent strictures against widows, and in the condemnation of *niyoga*. Once again, we need to remember that these developments are not unilinear. *Niyoga*, for instance, has had a long and complex history.

Recent ethnographic studies of Tamilnadu (e.g. Good 1991, Kapadia 1995) would indicate that even within a single region, notions of sexuality, purity and their implications for caste or social identities are not uniform, monolithic, or static. While it may not be easy for us to retrieve the dynamism of such notions in the early historical context in its entirety, an awareness of the possibility of variations may provide for more nuanced historical understandings.

What Hart does not explicitly focus on, but what runs through many of the texts he cites and translates, is a celebration as well as expressions of female sexuality. The rich documentation of a range

of situations and emotions points to another dimension of our textual traditions, deserving of independent investigation.

Apart from the areas we have focused on, a number of other constructions of womanhood have been analysed elsewhere. These include studies on the epics (e.g. Hopkins 1972, Shah 1995, Erndl 1992, Shulman 1992) and the Jātakas (Chakravarti 1993, Roy 1996b), the *Kāmasūtra* (Roy 1996a) as well as analyses of specific facets of womanhood such as motherhood (e.g. Bhattacharji 1990). Besides, concepts such as androgyny (O'Flaherty 1981) and transsexualism (Goldman 1993) which have obvious implications for definitions of sexuality, have been explored in imaginative and innovative ways. While these rely on textual evidence, inscriptional evidence on women's and men's identities has also been explored (Roy 1988). Many of these focus directly or indirectly on questions of representation, which I hope to explore more fully elsewhere (Roy forthcoming).

A related question which has, unfortunately, received less systematic attention is that of the availability of specific constructs of womanhood and manhood, i.e. of the audience towards whom these would have been directed or addressed. Besides, we need to raise and develop questions about enforcing or contesting such constructs, including discussions on legal mechanisms which move beyond accepting legal prescriptions at face value.

Another major area of investigation pertains to the nature-culture dichotomy. As MacCormack (1980: 9) points out, we need to move beyond this to focus on the ways in which women (and men) mediate between nature and culture in terms of producing and socializing children, converting raw food into cooked substances, participating in processes of production and domestication.

Some of the powers Hart attributes to women in the early Tamil context may in fact be derived from such mediating roles. In present-day Tamilnadu for instance, non-brāhmaṇa women are valorized both as agricultural labourers as well as producers of children (Kapadia 1995: 26). While there may be no necessary continuity between the twentieth century and the early historical situation, an awareness of possible connections can help us to ground notions more meaningfully.

At another level, while MacCormack may be right in suggesting that treating the nature-culture relationship as dichotomous effectively masks complex realities, our own version of the dichotomy,

the *puruṣa-prakṛti* (literally man/masculine and nature/feminine) duality within early Indian philosophy requires analysis (Natarajan 1995). Besides, a range of treatises, medical, legal, and literary, can be tapped to arrive at a more detailed understanding of masculinity and feminity.

Some of our repeated questioning of the data and existing analyses can be located within what Ortner and Whitehead (1981: 2) refer to as culturalist and sociologistic perspectives on meaning (which are by no means exclusive). They suggest that at one level, any attempt to derive the meaning of a specific symbol requires that we locate it within a context of other related symbols. At another level, they require to be located within social contexts. In a recent ethnographic study, Kapadia (1995) integrates analyses of kinship, caste and class relations, and explores their implications for constructions of gender. Maintaining analytical distinctions while recognizing interconnections enables her to locate gender relations at a number of levels. She points out, for instance, that caste identities have different meanings for men and women—while both may share a certain commonality in external relations, *vis-à-vis* other castes, internally, relationships of men and women within each caste are structured along lines of difference. Such analyses suggest that a contextualized exploration of women's identities contain rich possibilities for scholars interested in looking at the social history of early India afresh.

IV

Perhaps one of the most complicated problems in understanding gender relations in early India is posed by the near ubiquitous goddesses or, if one prefers, multiple manifestations of the great goddess. The wealth of evidence pointing to the existence and popularity of the goddess, both iconographic and textual, is immense. Thus, her presence and importance is established without doubt. What has proved more problematic are attempts to interpret the data in social or historical terms. While histories of specific cults have been traced, problems surface in attempts to translate and/or equate the divine situation with the human. Clearly, the relationship between the two tends to be complex.

Myths pertaining to goddesses often (though not always) focus on

sexual roles and relationships. In this context, it has been suggested that 'goddess mythology to a great extent is probably a means by which the Hindu tradition has thought about sexual roles and sexual identity. Many goddess myths seem to take particular delight in casting females in roles that appear contrary to the social roles of females as described in the Dharmaśāstras' (Kinsley 1987: 4).

If the sexuality of the goddess tends to be seen as problematic, so also is her motherhood. In some present-day formulations we find that femaleness and motherhood have been intrinsically equated and are regarded as synonymous (e.g. Dasgupta 1977: 105), whereas in other cases the distinctive and occasionally non-maternal character of the goddess has been focused on (e.g. Gatwood 1985). It is obvious that understandings of the goddess in terms of social roles vary considerably, depending on the extent to which motherhood is valorized. Moreover, as we will see in the specific case we explore (Kosambi) motherhood itself may have been conceived in a variety of not necessarily benevolent ways. As such, focusing on goddesses, motherly and otherwise, can be and has been juxtaposed with more straitjacketed śāstric definitions of womanhood.

At another level, the equation of the mother goddess with the human mother is often viewed as representative of a relatively simple, even 'primitive' situation, where women are in control of the economy, and where marriage is non-existent (Dasgupta 1977: 43). Very often this relatively egalitarian social situation is counterposed with class-divided patriarchal society (Bhattacharyya 1996: x). Consequently, worship of the goddess is viewed as typical of tribal societies based on simple agriculture. Thus, there is a certain pre-occupation with notions of fertility which are traced within a range of cults, beliefs, and practices. In other words, a neat equation is established between material conditions and systems of belief.

While this has proved to be a fairly enduring and popular framework within which to locate the goddess, it has been implicitly called into question by recent work on Harappan religion (Atre 1987). Atre argues that the principal deity of the Harappan civilization was female, an embodiment of diverse manifestations of fertility (ibid.: 204). Given that civilization presupposes the existence of fairly complex social and economic relations, the centrality accorded to a female deity would run counter to a single uniform pattern connecting goddess worship to simple societies. In fact, it may be useful to point out, as Tiwari (1985: xi) does, that the worship of

goddesses has followed diverse courses, and at best one can talk in terms of a 'loose federation of cults'.

Another perception, which one frequently encounters, is that of the goddess as embodying a vision of gender relations rather than a literal reflection of reality (e.g. Beane 1977: 269, Ganesh 1990). While this seems to be justified in view of the powerful imagery which clusters around the goddess, it enables the historian to put the problem at arms length rather than resolve it: visions are rarely universal and decontextualized. One can, if one wishes, distinguish between two levels of experience and communication respectively. The vision can be an intense, personal and unique experience which may not lend itself to representation. The second, more social level, relates to the transmission and communication of the vision. While the representation of the spiritual vision may be viewed as impoverished, it is this which is socially and historically relevant, as this is what is available to a wider audience. Such representations may be visual (e.g. sculpture) or aural or written.

If these representations do not reflect reality, but are none the less embedded in it, then do we view them as contestations of a gender-stratified reality, and as consequently potentially empowering, or are they, as has often been suggested, compensatory, meant to divert attention from grim, routine, existential problems? Also the problem of determining the access specific social groups may have had to particular envisionings remains acute for the historian.

Kosambi's stimulating treatment of the varied constructions of the story of Urvaśī and Purūravas, a celestial nymph (*apsaras*) and a warrior king respectively (included in this volume), focuses on some of these issues. He traces the domestication of a somewhat ambivalent mother goddess into a romantic heroine, and the concomitant transformation of Purūravas from a sacrificial victim into a polygynous king. Implicit in his account is the question of representational contexts, which range from Vedic rituals to courtly drama. These transformations are documented with wide-ranging textual and visual illustrations. The textual material is drawn from the Ṛgvedic version of the myth to Kālidāsa's reconstruction of the story in his well-known play, the *Vikramorvaśīyam*, while the visual imagery, Kosambi taps, ranges from Harappan archaeology to local mother goddess cults. Although it has not been possible to include all the details, the broad contours of his argument can be followed through.

The Ṛgvedic hymn of Purūravas and Urvaśī is one of the few

dialogue hymns that survive. The dialogue was probably enacted in a ritual context. As mentioned earlier (Section III), Vedic hymns can and have been interpreted in terms of natural phenomena. But, as Kosambi points out in his characteristically trenchant critique, such analyses do not take us very far. Kosambi follows Geldner in tracing various versions of the story—Vedic, epic, and Purāṇic, and points out that many of these end with the death of the hero, even though the cause of his death tends to vary.

The death of the hero thus emerges as intrinsic to most versions of the story. Kosambi suggests that this represents a surviving reference to the fate of the male protagonist involved in a form of sacred marriage which required cohabiting with and then being sacrificed to a goddess. That this is not entirely fanciful is evident from the etymological parallels Kosambi mentions—including those with the horse of the *aśvamedha* sacrifice.

Having established the equation of male protagonists with the sacrificial victim, Kosambi explores the nature and significance of the mother goddess. He draws on the association of the *apsaras* in general and Urvaśī in particular with water, one of the most constant symbols of female generative power and fertility. What is more, he probes further to argue that water goddesses demand and receive human sacrifice. One of the most well-known instances he cites is that of Gaṅgā and Śāntanu in the *Mahābhārata*, where an anthropomorphized Gaṅgā is represented as imposing a condition of implicit infanticide on her infatuated husband.

Kosambi attempts to trace the historical fate of the goddess. He argues that Vedic mythology contains indications of a conflict between Uṣas and Indra. According to him, Indra's almost predictable victory represented the defeat of matrilineal, matriarchal, mother goddess worshipping people. Yet, the defeat was by no means complete—as such, mother goddesses tend to re-emerge in the oddest of places—in genealogies of kings for instance, where Śakuntalā, the half-*apsarā* mother of Bharata, the ancestor of the heroes of the *Mahābhārata*, has a place of her own.

Almost inevitably, Kosambi confronts the question of the origins of the goddess cults, and traces these in pre-Vedic civilization. Unlike Atre's more recent synthesis, he identifies elements of feminine divinity instead of a single unitary principle. These are represented by the use of water for ritual baths, and female figurines. He also suggests that the appropriation of the cult was complex, and was part

of a broader socio-economic transformation. In the economic sphere, women's crafts such as weaving, the manufacture of pots, and hoe agriculture were appropriated and/or modified. Sociologically, practices which Kosambi identifies with group marriages or polyandry gave way to prostitution and *satī*. The death sentence for the widow was apparently meant to ensure that she did not try to revert to earlier cultic practices and sacrifice her husband instead. Yet symbols of the goddess tend to proliferate, typified by the *kumbha* or pot, symbolic of the womb, and an essential prerequisite for a wide range of rituals including rites of passage.

Some of Kosambi's arguments are sweeping and we may be uncomfortable with the ease with which he traverses through centuries or even millennia in search of ritual or social parallels. Nevertheless, the connections he suggests between myth and ritual, ritual and social practice, and social practice and material conditions remain invaluable. While our understanding of these relationships needs to be refined and tested in specific contexts, these can provide us with a framework for understanding the connections between goddesses and women more meaningfully.

At another level, the developments Kosambi traces can be viewed as an example of what Gatwood (1985) describes as the process of spousification of an autonomous female principle which she identifies as the *devī*. This involves the conversion of an independent goddess into the wife of a male deity, generally Śiva, and a consequent delimiting and containing of her powers. According to Gatwood, this is a specific manifestation of the process of Sanskritization in the sphere of religious symbolism. The spousified goddess is regarded as representative of the high caste woman, while the more autonomous *devī* is viewed as typifying low caste women, for whom sexuality and chastity are thought to be less problematic. This provides the framework for exploring the histories of individual local and regional goddesses. Variations in their attributes can be located in terms of the degrees in which their worshippers are autonomous, or alternatively are integrated within caste hierarchies. In specific cases such as the acceptance and incorporation of Tāntric cults within the brahmanical tradition, she argues that this was a means of building bridges with tribal populations, and masked attempts to appropriate their land and labour.

The social context of spousification is thus related to the growth and expansion of caste-stratified society. Drawing on ethnographic

data, moreover, Gatwood points out that while the Devī-spouse dichotomy corresponds with caste divisions, it is less obviously structured along lines of gender. In other words, while upper caste men and women tend to worship manifestations of the spouse goddess, lower caste men and women are devotees of the *devī*. While Gatwood perceives gender and caste as relatively autonomous, her evidence suggests that these are intersecting and mutually reinforced constructions of social identities.

Goddesses are obviously gendered symbols. However, as mentioned earlier, we need to be wary of attempts to accommodate the profusion of female divinities documented in early India within any single explanatory framework. As Bynum (1986: 2) observes in a more general context, 'Gender-related symbols, in their full complexity, may refer to gender in ways that affirm or reverse it, support or question it, or they may, in their basic meaning, have little at all to do with male and female roles.' A sensitivity towards these multiple possibilities may help us to tap our rich, diverse traditions more meaningfully.

At another level, as is implicit in Kosambi's work, we need to contextualize specific goddess cults in terms of alternative, coexisting and occasionally conflicting systems of belief and practice. This may help us to work out the significance of these cults and their powerful symbolisms, and their implications for gender relations in non-religious contexts more fruitfully.

Women's relationships with the goddess constitutes one particularly spectacular example of the complex connections between gender and religion. Another, less spectacular but more tangible, aspect is that of women's patronage of religious institutions. Singh's discussion (this volume) focuses on the question in the context of the temples of south India.

Drawing on inscriptional evidence, dating from the third century AD onwards, Singh points out that women belonging to most major ruling dynasties (as well as a number of minor ones) made grants to religious institutions. At one level, then, his documentation parallels Mukund's account (Section II). At another level, it opens up other possibilities. As is well-known, the status of major and minor dynasties was not permanent—dynasties and ruling families rose and declined in importance in terms of one another. Given this situation, it would be useful to locate women's patronage of religious institutions in terms of such dynastic histories. This may enable us to

explore the secular significance of such grants in more complex ways.

Within the broad chronological framework on which he focuses, Singh mentions certain interesting variants. In the case of the Ikṣvākus of Andhra Pradesh, while the kings patronized brahmanism, the women of the royal family supported Buddhist institutions. Singh suggests that this may be an indication of a liberal attitude; it is also likely that there were other compulsions as well. The resources of women and men may have been deployed differentially to ensure a broad and diverse support base for the new state. It is also likely that the grants made by men and women were by no means equivalent.

In the case of the Cālukyas of Vātāpi and Kalyāṇī, Singh attempts to situate women's patronage of religious institutions in terms of their visible access to positions of status within political structures. This is an interesting suggestion which can be tested in other areas or dynasties as well. Another variation in patronage is in terms of religious institutions. These range from Buddhist and Jain to brahmanical institutions and sects. In the case of Akkādevī of the Rāṣṭrakūṭas, we are told that she patronized all religious institutions. Once again, variations and their significance can be explored within specific historical contexts.

Another feature of the evidence presented is that while some grants are made to established institutions, others are memorials to kinsfolk. In such instances, different social, political, as well as religious notions seem to be at work. As interesting is the fact that, occasionally, the principal deity of the new shrine is named after the donor or after her spouse. The implicit deification of the ruler and his wife, and the extent to which this practice prevailed, as well as its context can be fruitfully investigated.

There are indications of other kinds of religious endowments as well. These include wells and tanks. While these are explicitly recognized as a means of acquiring religious merit, it is obvious that once built, these could be used for more mundane purposes as well. Investigations along these lines could help us to look at the divide between the religious and the secular more carefully.

While Singh's major focus is on south India, he summarizes evidence from northern, central, western and eastern India. As such, he provides us with a panoramic view of the extent of such endowments. Singh interprets the evidence of women patrons as an index of their high familial and social status. Besides, the endowments

indicate that they had direct access to resources. He also takes such donations at face value, as an indication of the generosity of the donors. While such interpretations are obvious and indisputable, other possible interpretations need to be explored as well.

The evidence Singh compiles can be contextualized along a number of lines, as is evident from the recent work of Talbot (1991). Focusing on Andhra Pradesh in the thirteenth century, she argues, for distinguishing between large and small temples, suggesting that they may have been functionally distinct. What is interesting is that this correlates with the sex of the donors to a remarkable extent— women donors tend to be associated with the larger shrines. Besides, women tend to donate livestock rather than land—this may have to do with the kind of resources which were under their control. Talbot's careful classification of donors (both men and women) in terms of social identities provides insight into patterns of patronage. It is thus evident that the question of women's patronage of religious institutions can move well beyond the fact of establishing the existence of women patrons, although that is an essential prerequisite.

At another level, the use of resources for religio-political purposes, obvious in acts of patronage, can be contextualized in terms of competing claims on such resources. Thus, they can be located within competing systems of distribution, especially those associated with prestigious transactions. For instance, while the performance of elaborate Vedic sacrifices may have been an alternative open to male aspirants to power, this would not have been accessible to women. In this situation, the significance of investing in alternative forms of religious activities and the extent to which this was gendered, requires exploration.

We conclude with Uma Chakravarti's survey of women within the tradition of *bhakti* or devotional religion in early south India. She uses hagiographies as well as the compositions attributed to women to reconstruct the histories of Avvaiyār, Kāraikkāl Ammaiyār, Āṇṭāḷ, and Akkāmahādevī, focusing on the interrelated themes of self-hood, gender relations in particular and social relations in general, and understandings of the body. Chakravarti views the *bhakti* tradition as providing a space within which social meanings could be questioned and reconstituted. Consequently, her focus is less on the rich, mystical outpourings this tradition generated and more on the social configurations which are represented.

Avvaiyār is located within a tradition of wise women, and is

associated with the Caṅkam age. Chakravarti traces the complex and multiple social origins ascribed to her in terms of the castes of parents and foster-parents. According to tradition, Avvaiyār's mother was an outcaste, whereas her father was a brāhmaṇa, while she was brought up by a family of bards. One can view this as a means of staking claims to diverse traditions of learning, as well as to the ability to transmit and impart a wide range of knowledge.

If Avvaiyār's location within the caste hierarchy is ambiguous, so is her position within gender relations. She avoids marriage by the simple expedient of becoming old and motherly. On the one hand, there is a denial of wifehood, on the other hand, there is an appropriation of motherhood. In the process, the notion of an inevitable connection between the two statuses is called into question.

This liminal status evidently translated into social power. Avvaiyār is regarded as defining ethics, as evolving a system of learning the alphabet, and of addressing and advising kings. Avvaiyār does not emerge as typical of the *bhakti* tradition, which, in any case, acquired widespread popularity somewhat later. In fact, she is regarded as being preoccupied with the concerns of the world rather than with spiritual pursuits. Nevertheless, her avoidance of marriage and her abandoning of the home for a wider arena are themes which are played out in the lives of women who are more squarely located within the tradition, although the specificities tend to vary.

At another level, Chakravarti contrasts the story of Avvaiyār with that associated with her brother, Tiruvaḷḷuvar, the reputed author of the *Tirukkural*. She points out that the tradition portrays Tiruvaḷḷuvar as working within a domestic context, and achieving fame with his devoted wife Vāsukī, typifying the attributes of the ideal wife. As opposed to this, Avvaiyār's achievements were implicitly regarded as impossible within the context of domesticity, a telling comment on the gendered nature of the domestic space and its constriction of women's self-expression.

Hagiographies of Kāraikkāl Ammaiyār construct her as a devotee of Śiva. She was initially a beautiful woman, Punītavatī, who opted to become old and horrific after her husband was unable to appreciate her devotion. As Chakravarti observes, the conflict between conjugality and devotion is posed and resolved somewhat differently in her case. In a sense, the denial of female sexuality envisaged in the case of Avvaiyār is carried to its logical conclusion in the case of Kāraikkāl.

Āṇṭāl, according to Chakravarti, symbolizes a different resolution

of this tangled theme. She is represented as a devotee of Viṣṇu, and is thought to have proclaimed her love through erotic imagery, some of which survives in the two works attributed to her, the *Tiruppāvai* and the *Nācciyār Tirumoli*. In her case, female sexuality is celebrated and transformed into bridal mysticism, in tune with the hagiography, which portrays her as merging into the image of her beloved deity.

Finally, Chakravarti focuses on Akkāmahādevī, who is portrayed as a devotee of Śiva. As in Kāraikkāl Ammaiyār's case, an unhappy marriage provides the frame for Akkāmahādevī's contestation of domesticity, but unlike the former, in Akkāmahādevī's case, the story culminates in a celebration of the divine as erotic, in an eroticism moreover, which is not constrained within a marital idiom.

Thus, a relatively flexible devotional context provided the space for envisioning a variety of gender relations between a masculine deity and his female worshippers. Chakravarti outlines the broad contours of the context within which these diverse expressions of female experience may be located. These include, at one level, a shift to popular religiosity as opposed to intellectual formulations on the essence and meaning of religion, a certain distancing, though not a separation, from brahmanical norms and ideals. Besides, the regional social context, not fully understood, evidently provided a conducive setting for exploring alternatives. While some of these women can be located within traditions specific to communities, for example Akkāmahādevī within Virāśaivism (Mullatti 1989, Ramaswamy 1996), in other instances, institutionalized support is less obvious.

In a recent, imaginative reconstruction of the history of Mīrābāī, who in a sense constitutes the archetypal woman devotee within the *bhakti* tradition, Mukta (1994) contextualizes her along a variety of axes. These include changing political contexts and the fate of Rajput male elites, concerns of patriarchal and familial honour, and the histories of low status groups such as weavers or leather workers. While pointing to the difficulties in reconstructing the history of Mīrā as an individual, she focuses instead on the histories of those who have preserved the memory of Mīrā. This draws attention to the very important fact that the works attributed to women (and men) devotees have survived, and possibly been enriched because they have been cherished. This has happened in spite of the absence of obvious institutional support (especially in the case of women). In other words, even as these women may appear to us as isolated individuals, we need to locate them within contexts of support. It is

obvious that such attempts can enrich our understanding of the meaning assigned to the existence and voice of these women through history. There are other dimensions of the complex relationship between gender and religion which we can merely point to. These include the construction of gender identities through rites of passage (e.g. Roy 1985). While we have examined some aspects of the goddess tradition, Śāktism and Tantrism in particular have been investigated at length elsewhere (e.g. Bhattacharyya 1996) and are variants which require detailed analyses. At another level, while we have focused on some texts attributed to or generated by women within specific religious traditions, other texts such as the *Therīgāthā* (Rhys Davids 1909) or even texts focusing on manifestations of the goddess (e.g. Coburn 1991) require attention. The contexts of their composition, preservation and transmission are diverse. While even attempting to summarize such varied themes is beyond our present scope, it is to be hoped that a recognition of their existence will provide an understanding of the complex two-way relationship whereby religious meanings and symbols are gendered, and gender relations are expressed through religious symbolism.

Finally, I would like to emphasize the interconnectedness which seems to be absolutely crucial for meaningful understandings of gender relations in the context of early India. Although we have focused and selected apparently distinct themes and sub-themes, it is important to bear in mind that they are in fact interwoven. For instance, procreation can be analysed in material terms, but it acquires meaning through religious and social constructs of motherhood (and fatherhood). Conversely, the patronage of religious institutions is obviously linked to notions of appropriate expressions of piety. At the same time, it can be viewed as an expression of women's (and men's) social, political and economic identities. At another level, each of the sub-themes acquires meaning from broader, related contexts—an understanding of polyandry, for instance, demands that we explore other contemporary forms of marriage, as well as kinship systems and proprietary relations. While I have highlighted some of the connections, others remain implicit or relatively unexplored. If the present endeavour stimulates further investigation into such relationships in terms of substantiating, qualifying, refining or contesting them, it will have served its purpose.

SECTION I
Issues and Perspectives

The Position of Women in Hindu Civilization: Retrospect and Prospect

A.S. Altekar

Women once enjoyed considerable freedom and privileges in the spheres of family, religion and public life; but as centuries rolled on, the situation went on changing adversely. On the other hand the proprietary rights went on gradually expanding in spite of the growing tendency to regard women as unfit for independence.

It will be convenient to divide the period we have to survey into four divisions:
1. The Age of the Ṛgveda, from c. 2500 to c. 1500 BC.
2. The Age of the Later Saṁhitās, Brāhmaṇas and Upaniṣads, from c. 1500 BC to c. 500 BC.
3. The Age of the Sūtras, Epics and early Smrtis, from c. 500 BC to c. AD 500.
4. The Age of later Smṛtis, Commentators and Digest Writers, from c. AD 500 to c. AD 1800.

The periods of the last two epochs are chronologically definite; those of the first two are, however, rather vague, and there is as yet no unanimity about their precise duration. The limits suggested for them above are, however, the most probable ones, and are usually accepted by the majority of scholars.

For the purposes of the proposed survey, period by period, it is unfortunately not possible to divide the history into smaller and more numerous periods. The data at our disposal are too scanty for the purpose. The difficulty is further increased by our inability to know the precise dates of many of our authorities. Some of the works are further composite ones; there can be, for instance, no doubt that the present *Mahābhārata* and *Manusmṛti* contain ideas popular in epochs, which were separated from each other by more than half a millennium. The period-wise survey is therefore beset with considerable difficulties, but has to be, nevertheless, attempted for the general reader in the interest of clarity.

THE ṚGVEDIC AGE (*c.* 2500 BC TO *c.* 1500 BC)

The position of women in the Vedic age was far from being analogous to what it usually is in early uncivilized societies. In communities that have not yet emerged from barbarism, there hardly exist any checks on the tyranny of man over woman. Ill-usage, underfeeding and overworking are pushed to the greatest limit, compatible with the preservation of the race. Women are divorced, abandoned, sold or killed at the mere whim of men. They have to carry about children, and also serve as beasts of burden, when the tribe moves from one place to another. The treatment thus meted out to them need not cause any surprise; in primitive life the muscle was an indispensable element in success and the man was stronger in it than the woman. He fought with the animals and enemies to protect women and children; he chased the big game to feed the family. Physical prowess, bodily vigour and muscular strength thus naturally established man's permanent superiority over woman, who, besides lacking these qualities, was periodically in a most helpless condition a few weeks before and after her frequent confinements. Man had not yet developed sufficient culture and sensibility to make him feel and realize that women undergo these trials and tribulations for the sake of the race, and therefore deserve to be treated with utmost sympathy and consideration. It was taken for granted everywhere that women as such can have no rights and privileges. They were inherently inferior to men and therefore must be always subordinate to them. The archaic Roman law granted to the husband the power over the life and the limbs of the wife, and for many centuries matrons with several children continued to be under the tutelage of their male relations. In ancient Palestine the woman was a piece of property to be bought and sold.

The position which women occupied in Hindu society at the dawn of civilization during the Vedic age is much better than what we ordinarily expect it to have been. There are, no doubt, a few indications to show that brides were sometimes sold in marriage or even carried away by force. But the better conscience of society had already begun to assert itself, and condemn these practices as unholy and unworthy. The ideal marriage of the Vedic period was a religious sacrament, which made the couple joint owners of the household. The old tradition that the wife was the property of the husband had not yet completely died down; the famous hymn about gambling in the *Ṛgveda* (X.34) shows that sometimes confirmed gamblers would

THE POSITION OF WOMEN IN HINDU CIVILIZATION 51

stake away their wives to their opponents. The advice given to the gambler in this hymn, however, shows that social conscience had already begun to disapprove this practice.

On the whole, the position of women was fairly satisfactory in the Vedic age. Ordinarily girls were no doubt less welcome than boys, but we must add that there were also some parents in society who would perform special religious rituals for the good luck of getting learned and capable daughters. Girls were educated like boys and had to pass through a period of *brahmacarya*. Many of them used to become distinguished poetesses, and the poems of some of them have been honoured by their inclusion in the canonical literature. The marriages of girls used to take place at a fairly advanced age, the normal time being the age of 16 or 17. Educated brides of this age had naturally an effective voice in the selection of their partners in life. Very often there were love marriages, which were later blessed by parents. There was no seclusion of women; they used to move freely in society, often even in the company of their lovers. In social and religious gatherings they occupied a prominent position. Women had an absolute equality with men in the eye of religion; they could perform sacrifices independently and were not regarded as an impediment in religious pursuits. Marriage in fact was a religious necessity to both the man and the woman; neither could reach heaven without being accompanied by his duly married consort. The position of the wife was an honoured one in the family. In theory she was the joint owner of the household with her husband, though in actual practice, she was the subordinate partner. In rich and royal families polygamy prevailed to some extent, but ordinarily monogamy was the rule. If a wife had the misfortune to be widowed, she had not to ascend her husband's funeral pyre. The *satī* custom was not in vogue at all; the widow could, if she liked, contract another marriage, either regularly or under the custom of *niyoga*. The main disabilities from which women suffered in this age, as well as in the next one, were proprietary ones. They could hold or inherit no property.

Landed property could be owned only by one who had the power to defend it against actual or potential rivals and enemies. Women were obviously unable to do this and so could hold no property. The transition from the communal to the family ownership of land was just taking place; the conception of the rights of the different members of the family, even when males, was yet to crystallize. Naturally, therefore, women, like many other male members of the

family, were incapable of owning property; the patriarch was its sole owner and guardian.

We also do not come across any queens reigning independently or as regents. Considering the general position of women as delineated above, these disabilities come as a great surprise to us, but a little reflection will show that they were natural and inevitable. The Āryans were gradually establishing their rule in a foreign country surrounded on all sides by an indigenous hostile population that considerably outnumbered them. Under such circumstances queens ruling in their own rights, or as regents, were naturally unknown.

The position of women on the whole was fairly satisfactory. In the Vedic literature there are no doubt a few observations like 'Women have a fickle mind', 'Women can be easily won over by one who is handsome and can sing and dance well'. They, however, reflect the light-hearted cynicism of some poets, and do not embody the considered views of the leaders of society. The community as a whole was showing proper concern and respect for women, allowing them considerable freedom in the different activities of the social and political life.

THE AGE OF THE LATER SAṀHITĀS, BRĀHMAṆAS AND UPANIṢADS (c. 1500 BC TO c. 500 BC)

The changes which took place during this period in the position of women were gradual. Their proprietary rights continued to be unrecognized, the only exception being in favour of marriage gifts of movable property. In the higher sections of society, the sacred initiation (*upanayana*) of girls was common, and they subsequently used to go through a course of education. Some of them used to attain distinction in the realm of theology and philosophy, and a considerable number of women used to follow the teaching career. There was, however, a gradual decline in female education as the period advanced. The system of sending out girls to famous teachers or centres of education came to be discouraged; it was laid down that only near relations like the father, the brother or the uncle should teach them at home. Naturally, therefore, religious and secular training became possible only in the case of the girls of rich and cultured families. As a consequence, there arose a tendency to curtail the religious rights and privileges of the average woman; many functions in the sacrifice, which formerly could be performed

by the wife alone, now came to be assigned to male substitutes. Some sacrifices like *rudrayāga* and *sītāyāga* continued to be performed by women alone, and when the husband was out, the service of the sacrificial fire continued to be entrusted to the wife. In cultured families, women used to recite their Vedic prayers every morning and evening, and perform sacrifices on their husband's behalf, when they were otherwise preoccupied.

The marriage age of the bride continued to be about 16. In practice, if not in theory; brides had some voice in the selection of their partners in life, and *svayaṁvara* was fairly common in kṣatriya circles. The marriage ideals and the mutual relations and rights of the parties continued to be more or less the same as they were in the earlier age. Divorce was permitted to the wife, though the permission was not extensively availed of. The *satī* custom was altogether unknown, and the widow had the option of remarriage either with her brother-in-law or with an outsider. Naturally, there was no tonsure of widows. Purdah was altogether unknown, but women had ceased to attend public meetings.

Before we proceed to delineate the picture of the condition of women in the next periods, let us pause a while to consider the causes of this phenomenon of a relatively better condition and status of women in these early centuries, as compared to what it became in subsequent epochs. There took place a continuous and gradual deterioration in the position of women as a whole during the next two thousand years (*c.* 500 BC to AD 1500). How are we to explain this phenomenon? Usually we find that the condition of women improves as society advances to modern times. How is it that there is an exception in the case of the position of women in Hindu civilization?

The relatively more satisfactory position of women in the two epochs we have just surveyed was due, partly to political and partly to religious causes. As a rule in a community, which is civilized and is moving in search of pastures fresh and new, women occupy an honourable position. Men are mostly engrossed in military or semi-military activities, and they have to rely to a very great degree on the help and cooperation of women in the normal spheres and activities of family life. Under such circumstances, women can clearly and convincingly demonstrate to men that they are not parasites, but very useful members of society, whose cooperation is very valuable in securing prosperity in peace and victory in war. It is well-known how the First World War worked as a miracle in winning over the most

deadly opponents of women's franchise. The valuable part which women had played in the prosecution of the First World War had disarmed all opposition.

It would appear that the general freedom and better status which women enjoyed in the Vedic age were largely due to men being engrossed in the work of conquest and consolidation. Women used to take an active part in agriculture, and the manufacture of cloth, bows, arrows and other war material. They were thus useful members of society, and could not be therefore treated with an air of patronage or contempt. The cheap or forced labour of the enslaved population was not yet available to the Āryans for the tasks aforesaid.

The exigencies of the political situation in the Vedic period were responsible for the abolition of the prehistoric *satī* custom and the sanctioning of *niyoga* and remarriage. Like Hitler and Mussolini, Vedic chiefs were anxious for heroes, more heroes, and still more heroes. The gospel they preached to the householder was not of eight sons of the later days, but of ten. The non-Āryans were probably outnumbering the Āryans, and they were anxious to have as strong and numerous an army as possible. Under these circumstances, it would have been a suicidal policy to encourage the revival of the obsolete custom of *satī* or to prohibit widow remarriages. Society came to the definite conclusion that its vital interests demanded that the custom of *satī* should be interdicted, and that widows should be allowed and encouraged to marry and multiply the stock.

Another factor responsible for the relatively satisfactory position of women was the influence of religion. Asceticism was at a discount in the Vedic age. Maidens and bachelors had no admission to heaven; gods accepted no oblations offered by the unmarried. It was essential to offer the ordained sacrifices to gods for procuring happiness and prosperity, both here and hereafter, and they could be properly performed by the husband and the wife officiating together. Wife was not an impediment but an absolute necessity in the religious service. This circumstance naturally helped to raise her status. To enable her to discharge her religious duties properly, it was necessary to ordain that her *upanayana* should be duly performed; this ensured a proper training and education to girls. It required at least half a dozen years to complete the educational course; that naturally rendered early marriages impracticable. When girls were properly educated and married at the mature age of 16 or 17, a considerable regard had naturally to be shown to their own likes and

dislikes at the time of marriage. Love marriages were also inevitable when girls remained unmarried to that advanced age and were moving freely in society.

It will be thus seen from the above discussion how down to about 500 BC the custom of *satī* and child marriage did not exist to embitter the lot of the woman, how she was properly educated and given the same religious privileges as man, how she could have a voice in the settlement of her marriage and occupy an honoured position in the household, how she could move freely in family and society and take an intelligent part in public affairs, and how it was possible for her to take to a career, if urged by an inclination or a necessity.

THE AGE OF THE SŪTRAS, EPICS AND EARLY SMṚTIS (*c.* 500 BC TO *c.* AD 500)

The position of women deteriorated considerably in this period, and its causes may be conveniently discussed here. Some centuries before the beginning of this period, the Āryan rule had become well established over the greater part of India. The Āryan conquest of the indigenous population and its loose incorporation in the social structure of the victors as members of the fourth śūdra class, had given rise to a huge population of a semi-servile status. Women, however, did not suffer merely because they ceased to be productive members of society. A greater calamity awaited them from the presence of śūdra women. In the earlier period of their expansion, the Āryans followed the traditions of ruthless warfare. Indra, we are told, trampled upon the *dasyūs* in their cave retreats. When, however, the Āryans reached the upper Gangetic plain, they found that the indigenous civilization there was too deep-rooted to be completely wiped out by them. They had to remain content merely with imposing their sovereignty, very often merely a nominal one, over the original inhabitants, variously described as dāsas, śūdras, or nāgas. When the two races proceeded to live together peacefully, inter-marriages became inevitable. In the age of the *Ṛgveda*, we do not come across any cases of Ārya-śūdra marriage. The Brāhmaṇas and the epics, however, supply ample evidence to show that the Āryan chiefs were freely marrying non-Āryan princesses in the later period. Arjuna married Uḍupī, a nāga princess-regent. Bhīma married Hiḍimbā, a sister of a *rākṣasa* chief. The sage Kavaśa, who plays an important part in the *Aitareya Brāhmaṇa*, was the son of a slave girl. These examples

are only typical and would show that in the concluding half of the later Saṁhitā period (*c.* 1000 BC to *c.* 500 BC), the marriages of Āryan men with non-Āryan women were becoming common. It is important to note that the early Dharmaśāstra writers have no objection to an Āryan marrying a śūdra woman, provided he had another Āryan wife; it is only later writers who proceed to interdict such a procedure with a great vehemence.[1]

The introduction of the non-Āryan wife into the Āryan household is the key to the general deterioration of the position of women, that gradually and imperceptibly started at about 1000 BC, and became quite marked in about 500 years. The non-Āryan wife, with her ignorance of Sanskrit language and Hindu religion, could obviously not enjoy the same religious privileges as the Āryan consort. Association with her must have tended to affect the purity of speech of the Āryan co-wife as well. Very often the non-Āryan wife may have been the favourite one of her husband, who may have often attempted to associate her with his religious sacrifices in preference to her better educated but less loved Āryan co-wife. This must have naturally led to grave mistakes and anomalies in the performance of the ritual, which must have shocked orthodox priests. The first remedy they must have thought of was to declare the non-Āryan wife to be unfit for association with her husband in religious rituals. 'The black non-Āryan wife may be her husband's associate in pleasure, but not in religious rituals' say several authorities.[2] But a mighty king, mad with love for his non-Āryan beloved, was not to be dictated to by a priesthood dependent upon him for its subsistence. He would insist upon having his own favourite wife by his side at the time of his sacrifices, no matter what her race or caste.

How then was the situation to be retrieved? Eventually, it was felt that the object could be gained by declaring the whole class of women to be ineligible for Vedic studies and religious duties. There would then be no question of rejecting admission to a non-Āryan wife and granting it to an Āryan one; all would be ineligible and none need be offended. It is Aitiśāyana who is seen advocating this view by about 200 BC. It is, however, almost certain that he is merely a typical representative of a powerful school reaching back to a fairly great antiquity. It is not impossible that his school may be as old as 500 BC, if not even earlier.

The growing complexity of the Vedic sacrifices was another factor that tended to make the wife's association in religious rituals a more

and more formal affair in course of time. In the Vedic age, a young maiden would take a *soma* stalk and proceed straight to offer it to Indra in a sacrifice performed by her all alone. In course of time, the sacrifice became a very complex affair, and the slightest mistake in its performance or in the recitation of its hymns and formulae was regarded as fraught with very grave consequences. It required a long training to get the necessary capacity to follow intelligently the minute details of the complicated sacrifice, and the average woman had not so much time to devote for the purpose. In the Vedic age, she was married at about the age of 16 or 17; she could thus devote six or seven years to her Vedic studies before her marriage. During this period, a girl could equip herself fairly well for her post-marriage participation in sacrifices, as the Vedic literature was then not extensive and could be studied as popular religious poetry. The sacrificial ritual was also simple. Towards the end of the period of the later Samhitās and Brāhmaṇas, a maiden could hardly hope to get a full and adequate knowledge necessary for the purpose, unless she remained unmarried till about the age of 22 or 24. This was an impracticable proposition for the average girl. There were new forces in society which were clamouring for early marriages. The Āryans had settled down in a rich and prosperous country and their political supremacy had become unquestioned. Naturally, they took to an easy and luxurious life, and the marriageable age of boys and girls began to be lowered. In the Ṛgvedic age the father was anxious to have strong and numerous sons more for secular than for religious purposes; in the days of the later Samhitās, the son became a religious rather than a secular necessity. A man comes to this world, it was pointed out, saddled with a threefold debt; the most important one of these was the debt to the manes which could be liquidated only by the birth of a son. Why then not marry a girl as soon as she attains maturity and is in a position to present a son to her husband? Why wait for three or four years unnecessarily? It may be noted that when Kaṇva learns that his daughter had contracted a love marriage with Duṣyanta, a passage later interpolated in the *Mahābhārata* represents him as blaming himself rather than his daughter. He practically admits that it was his mistake not to have married his daughter earlier; so many months had passed away uselessly since the time she could have got a son.[3]

Owing to the different causes narrated above, at the beginning of this period (*c.* 500 BC), there arose a tendency to lower the

marriageable age of girls, and as a consequence, to discourage their *upanayana* and education. Down to about the beginning of the Christian era, in cases of difficulty, parents were permitted to keep their daughters unmarried to the age of 16 or 17, but it was emphasized that it would be advisable to get them married soon after the attainment of puberty. The view that women should not be at all allowed to participate in sacrifices was no doubt not accepted by society, but its vigorous advocacy by one school, along with the general lowering of the marriage age, tended to a growing and inevitable neglect of the Vedic education of girls. During the first half of this period, a few maidens continued to specialize in Vedic studies and rituals, but the majority of girls used to go merely through the formality of *upanayana* just before the celebration of their marriage. It is doubtful whether they were in a position to recite their morning and evening prayers. At about AD 200, it was felt that this meaningless formality should be discontinued. It was declared that marriage was the substitute for *upanayana* in the case of girls; they need not have any separate sacred initiation.

Upanayana was usually performed at about the age of 9 or 10, and the same age now came to be regarded as the ideal time of marriage for girls. Towards the end of this period (*c.* AD 500), parents could not usually keep their daughters unmarried after the age of 12.

The discontinuance of *upanayana*, the neglect of education and the lowering of the marriage age, produced disastrous consequences upon the position and status of women. Early marriage put an effective impediment in the higher education of girls. Brides being too young and inexperienced, ceased to have any effective voice in the settlement of their marriages. *Svayaṁvara* continued to be in vogue in kṣatriya circles, but it came to be condemned by brahmanical writers. Love marriages became a thing of the past. Child wives, with no education worth the name, became the order of the day, and they could not naturally command respect from their husbands. Not infrequently, parents had to marry their daughters in a hurry, lest the girls should attain puberty before their marriage. The matches arranged under such circumstances were often ill suited, and women were thus often compelled to spend their lives with unsuitable or unworthy partners. It is painful to find that Smṛti writers should have come forward to preach the gospel that a wife should always revere her husband as God, even if he were a moral wreck.

During the first half of this period, widow remarriages and *niyoga*

continued to be permitted, but the volume of public opinion against these customs was increasing, and they came to be eventually interdicted at about AD 500. Marriage was regarded as a religious sacrament in the Vedic period also, and yet society was permitting divorce and remarriage in exceptional cases. During the period under review, marriage became an irrevocable union, irrevocable, however, only so far as the wife was concerned. The husband could discard his wife for the grave offence of not being sufficiently submissive. The wife, however, could not take a similar step and marry a second time, even if her husband had taken to vicious ways and completely abandoned her. This differential treatment was due to the simple fact that women were no longer able to effectively oppose these absurd theories and claims, most of them being uneducated and quite ignorant of their former status and privileges.

The age of city or small states had gone, and the Hindu kingdoms in this period became fairly extensive. The splendour of royal courts naturally increased, and kings began to keep a much bigger harem than what was ever dreamt of in previous epochs. Their example was imitated by their numerous feudatories and rich subjects. This produced a very unfavourable consequence upon the condition and status of the vast majority of women of the upper classes, and it had its natural repercussions on the status of wives in ordinary families. The dictum, 'The wife ought to revere her husband as a god, even if he were vicious and void of any merit', was probably written with a particular reference to the unfortunate denizens of the harems in rich families; subsequently the advice came to be extended to the whole sex. One can hardly excuse Smṛti writers for having enunciated this absurd and inequitable doctrine, though one can understand that their motive may have been partly to discourage a hasty tendency to sever the marital tie. They have, however, never dreamt of preaching a similar gospel to the husband; they permit him to discard his first wife on the most flimsy grounds.

The growing harems of the mighty kings naturally made them jealous, and some of them sought to keep their wives in seclusion. The purdah system, however, was yet confined only to a very small section of the royal families; majority of kings did not care to adopt it.

The period of 500 years between 200 BC and AD 300 was a very dark and dismal one for northern India. The fertile plains of the Punjab and the Gangetic valley were subjected during this period to one

foreign invasion after another. First came the Greeks, who under Demetrius and Menander (*c.* 190-150 BC) were able to penetrate right up to Patna in Bihar. Then came the Scythians and the Parthians (*c.* 100 BC to AD 50), whose frightful wars of conquest reduced Hindu population by one half, 25 per cent being killed and 25 per cent being enslaved and carried away.[4] These barbarians were followed by the Kuṣāṇas, who succeeded in overrunning practically the whole of northern India by the middle of the second century AD. Political reverses, war atrocities and the decline of population and prosperity naturally produced a wave of despondency in society. It facilitated the spread of the ideal of renunciation (*saṁnyāsa*), which though held before society by Upaniṣadic, Buddhist and Jain teachers, was meeting with stubborn opposition in Hindu community. Thus Kauṭilya prescribes a punishment for a person who would renounce the world before his old age, and without providing for his dependents.[5] Early Dharmasūtra writers regard renunciation as a positively anti-Vedic custom.[6] The despondency prevailing in society at about the beginning of the Christian era began to wear down the opposition to the *saṁnyāsa* ideal. There is no doubt a good deal of truth in the observation of Bhīma at one place in the *Mahābhārata* that renunciation appeals only to those who are unsuccessful in life.[7] Just as the renunciation philosophy of the *bhakti* school appealed to Hindu society in medieval times owing to the political setback which it had received at the time on account of the rise of Islam, so also the ascetic ideal of Upaniṣads, Jainism and Buddhism began to get a real hold over the social mind only at about the beginning of the Christian era owing to the prevailing wave of political and economic despondency.

The new development affected the position of the widow adversely in various ways. It strengthened the hands of those who were opposed to *niyoga* and widow remarriage. Both customs, therefore, fell gradually into disrepute. *Niyoga,* no doubt, deserved to be stamped out, but not so widow remarriage. It, however, could not escape a similar fate. It began to be argued that the world was a mirage, and its pleasures were mere snares. Fate was undoubtedly cruel to the widow in carrying away her husband. It had, however, given her a new opportunity to secure spiritual salvation. It is true that the Vedas have declared that a son was necessary for securing heaven; the childless widow, however, should not think of remarriage in order to get heaven through a son. She ought to aim at the higher

ideal of salvation (*muktī*) and not at the lower one of heaven (*svarga*). The former can be best attained by leading a pure and chaste life, as was done by hundreds and thousands of monks and nuns, who had entered the *samnyāsa* stage direct from the *brahmacarya*, without passing through the married life. The widow should, therefore, never think of remarriage. This advice was, however, a one-sided one; Smṛtis do not offer it to the widower. On the other hand, they permit him to remarry immediately after the death of the first wife,'lest the sacred fires should remain unlit'.

A greater calamity that overtook the widow in this period was the revival of the *satī* custom. In the beginning, it was confined to the warrior class. It, however, began to spread wider in society in course of time, as the action of the *satī* came to be regarded as a great religious sacrifice, which deserved to be imitated. A school of rationalists opposed the custom vehemently, pointing out its utter futility and stupidity. Its efforts partly checked the spread of the custom for a while.

The only direction in which the position of women improved in this period was in the sphere of proprietary rights. Society had begun to discourage widow remarriages. As a consequence, there began to arise a class of childless young widows. In the earlier period, practically speaking, this class did not exist, as *niyoga* and widow marriages were then in general vogue. Now, when both these practices were prohibited, society had to devise an honorable means to enable the widow to maintain herself. She could, of course, live in the joint family and receive maintenance along with others; but this was not an advisable step in the transition period during which *niyoga* was being gradually stamped out. Some writers have laid down that a woman should not be compelled to submit to *niyoga* against her wish.[8] It is clear that in uncultured families some of the male relations like the brother-in-law would occasionally force an unwilling widow to submit to their vicious wishes under the specious plea of *niyoga*. The childless widow could be saved from this calamity by sanctioning her a life estate in her husband's share, and by permitting her to stay separately.

It thus came to happen that the proprietary rights, which were not recognized in the Vedic age when women were better educated and enjoyed greater freedom, came gradually to be recognized during this period. It is true that the doctrine of perpetual tutelage of

women became popular at this time, and it should normally have proved fatal to the recognition and development of their proprietary rights. But men do not always seriously believe in the solemn theories they haughtily enunciate, nor do they care to draw all possible corollaries from them. Such was the case with the theory of women's perpetual tutelage. Jurists felt no self-contradiction in declaring that women were unfit for independence, and yet investing them with new proprietary rights. They thought that sufficient regard would be shown to the theory of perpetual tutelage by laying down that women could enjoy only the income of their inheritance, but not dispose of its corpus.

It is further true that the tendency to regard women as fragile and of a weak moral fibre was getting stronger in this period. It was, however, only the woman in the abstract that was so regarded. In society, however, the woman in the abstract did not exist; there was the wife or the daughter or the mother, and for everyone of them Hindu society felt very tenderly. The daughter and the wife had the father and the husband to provide for them, but there was no such guardian of natural affection to look after the childless widow. A school of jurists therefore arose at the beginning of the Christian era, which advocated that the widow should be recognized as an heir to her husband, if the latter had effected his separation before the time of his death. The new reform was, as usual, vehemently opposed by vested interests, but eventually it began to find greater and greater support in society.

THE AGE OF LATER SMṚTIS, COMMENTATORS AND DIGEST WRITERS (*c.* AD 500 TO *c.* AD 1800)

The only sphere in which the position of women improved in this age was the one of proprietary rights; otherwise she continued to lose all along the line. The right of the widow to inherit the share of her husband came to be eventually recognized all over the country by *c.* AD 1200. In Bengal, the position was further improved by conceding her this right even when her husband had not separated from the joint family at the time of his death. The scope of the *strīdhana* was further extended by the Mitākṣarā school by including in it the property acquired even by inheritance and partition. The widow's estate continued to be a limited one, but in some parts of south India

she was allowed to gift it away for religious purposes without the consent of the reversioners.

Proprietary rights apart, in all other spheres the position of women continued to deteriorate in this period. Most of the causes responsible for women's degradation during the last period continued to operate in this age also. The *upanayana* of women went completely out of vogue. From the theological point of view, the woman therefore came naturally to be regarded as of the same status as the śūdra. This inflicted an incalculable harm on their general status and prestige. The marriageable age of girls was lowered down still further. Towards the end of the former period, it was recommended that girls should be married just before the time of their puberty. It would appear that this did not exclude the possibility of a few negligent parents failing to marry their daughters before that time. To prevent this possibility, it now came to be declared that a girl becomes mature (*ṛtuprāptā*) not when menses appear at the age of 13 or 14, but at the age of 10 or 11, when some preliminary symptoms of impending puberty manifest themselves. The proper age for marriage was therefore 10. The age of 8, however, was regarded as the ideal one; marriage in the case of girls corresponded to *upanayana* in the case of boys, and the proper age for the latter was 8. In kṣatriya families, however, girls continued to be married at about the age of 14 or 15. Widow marriages had become prohibited at this period. The *satī* custom had become common in the fighting classes. The kṣatriya father, therefore, did not think of marrying his daughter at a tender age, when there was always the possibility of his son-in-law dying before his beloved daughter had come of age in the frequent warfare, that had become common at this time. Many kṣatriya ladies were often called upon to assume the reins of government as regents; so training in administrative duties and military exercises had to be given to them. This also necessitated the postponement of their marriage to a somewhat advanced age.

In the case of non-kṣatriya girls, who were married at the age of 10 or 11, naturally no education worth the name could be imparted. Down to about AD 1200, daughters in rich families continued to receive some literary education through special teachers; a few of them used to distinguish themselves as poetesses and critics down to the tenth century AD. But this tradition died down when the old aristocracy, perished or declined in importance after the establishment of the Muslim rule. In ordinary families, naturally, girls now

began to grow in ignorance; no education worth the name was possible before the age of 10 or 11, which had now become the usual marriageable age. At the advent of the British rule, literacy among women was confined only to the class of dancing girls; women in respectable families felt very uneasy if it was suspected that they were literate. Being generally illiterate and inexperienced, women naturally ceased to inspire respect, and the tendency to pass cynical observations about their weakness and worthlessness became more common.

Brides of 8 or 9 could naturally have no voice in the settlement of their marriages; they could also become no proper companions to their husbands owing to their immense intellectual inferiority. Their position therefore *vis-a-vis* their husbands further deteriorated. The Christian theologians were declaring at this time that the husband was the head of the wife, as Christ was the head of the Church. Hindu Smṛtis advocated an exactly similar doctrine, and maintained that the husband was the wife's god and her only duty was to obey and serve him. The evil example of royal harems made polygamy more and more fashionable. Marital faithlessness on the part of the husband became more common owing to the custom of child marriage. Early marriage was naturally followed by early maternity, which increased the mortality among women between the ages of 14 and 22. Young widowers of 25 or 30 were naturally more eager to follow the rule of Manu, which permitted an immediate remarriage, than to emulate the example of Śrī Rāmacandra, who declined to marry a second time. Widowers of 25 or 30, however, could get brides of 9 or 10 only. This enormous disparity between the ages of the two parties naturally helped the spread of concubinage in society. Its moral tone was affected, and it began to feel nothing objectionable in allowing dancing girls to sing and dance on holy occasions like those of *upanayana* and marriage, or at the time of the religious service in temples. The opposition of purists to this custom proved of no avail, and eventually the association of dancing girls with sacred *saṁskāras* and temple worship became quite common in several parts of the country.

Down to *c.* AD 500, permission was granted to child widows to remarry, though widow marriage in general had come to be tabooed. This permission came to be gradually withdrawn during this period. From about AD 1000, no widow in a respectable family could remarry, whatever her age might have been at the time of her husband's death. In the beginning, only widows in the higher sections of society

suffered from this disability, but in course of time, it came to be extended to the widows of those lower classes also, which were anxious to be considered respectable. The prohibition of widow remarriage came to be regarded as the most important criterion of the respectability of a class down to the beginning of the present century. The prejudice against widow remarriage was so deep-rooted, that the permissive legislation passed in the matter in AD1856 had no appreciable effect on the situation for more than half a century.

We have shown above that at *c.* AD 500, the custom of *satī* was meeting with considerable opposition from the thinking sections of our society. That opposition continued unabated for another 500 years, and the majority of Smṛtis went on averring the custom amounted to a suicide and could bring no spiritual salvation. Eventually, however, owing to the growing appreciation of the ascetic ideals and practices, the custom of *satī* came to be surrounded with a halo and began to make a wider appeal. First it was confined to the fighting classes. Smṛti writers and their commentators down to about the eleventh century declare that it would be sinful for a brāhmaṇa widow to burn herself on the funeral pyre of her husband. Gradually, however, brāhmaṇas also began to follow the custom, as they did not like to be excelled by kṣatriyas in the pursuit of ascetic practices. Widows now had a dismal prospect before them. They could not remarry. Some of them, who were very young, must have felt it to be no easy task to walk straight on the narrow and difficult path of strict chastity. They, therefore, very often preferred the terrible ordeal of the *satī* to the tiresome life of the widow. Most of the widows who ascended the funeral pyres of their husbands did so quite voluntarily. Occasionally, however, an unwilling widow was burnt by her fiendish relatives, who were either afraid that she might eventually misbehave and bring disgrace to the family, or who wanted to appropriate for themselves her share in the family property. The recognition of the right of inheritance was thus not an unmixed blessing to the poor widow.

The tonsure of the widow came into vogue by about the eighth century AD. With the disappearance of Buddhism at this time, the prejudice against the custom gradually disappeared, and it was recommended to the widow as a kind of help and protection to her in her ascetic resolve and life.

We have seen above that women were declared to be of the same

status as that of the śūdras, and so came to be gradually excluded from the study of and acquaintance with higher theology and philosophy. Women, however, are by nature more religious than men, and so a new type of religious literature was evolved to meet their needs and aspirations. This was the remodelled Paurāṇic literature. It enunciated the principles of Hinduism in a homely, easy and attractive manner, illustrating them with a number of edifying stories. Pious people made provision all over the country for the exposition of Purāṇas to public audiences. Women became very well grounded in the culture of the race by habitually listening to this literature. Faith, almost blind faith, was however held up for high admiration in Purāṇas. It was, therefore, well developed in women, to the detriment, however, of rationalism. It must be, however, noted that reason was at a discount at this period among males also, both in India and Europe.

We have seen above that the purdah custom was beginning to get a footing in a few royal families in the last period. There was, however, a staunch opposition to it down to the twelfth century. Many royal ladies used to plainly tell their husbands that they would not stand the nonsense of the purdah. As a consequence, the custom failed to become popular even among royal families down to about AD 1200. The advent of the Mohemmedans, however, changed the situation. The customs and manners of the conquerors were imitated with as much zeal in the thirteenth as they were in the nineteenth century. In the beginning the purdah entered the families of feudatories and nobles, and then it gradually spread among higher classes in northern India. The Muslim influence was weak in the south and so the purdah found no general acceptance there. It got a footing only in a few ruling families.

Down to about AD 800, Smṛtis were emphatic in declaring that women, who were forcibly taken into captivity or dishonoured, should be admitted back to their families. Pseudo-puritanical notions distorted social vision in this matter soon after c. AD 1000. Hindu society began to show a surprising callousness to women, who had the misfortune of being carried away into captivity even for a very short time. An outsider like Alberuni could not understand the stupidity of the Hindu community in refusing to readmit men and women, who had been captured and converted by force. If one's hand gets soiled, he argues, one should proceed to cleanse and not to cut it. But Hindu society could not understand this very reasonable

proposition. From c. AD 1200, it refused to follow the lead of Smṛti writers and declared that once a woman was converted or taken into captivity, nothing would justify her readmission to her old family and religion. This callous and unreasonable attitude has cost Hindu society very dearly. Had the women, who had been forcibly converted or captured, been readmitted into Hindu society, its population would certainly not have dwindled down to 75 per cent of the population of pre-partition India.

The above survey of the position of Hindu women would show that their condition has been on the whole deteriorating during the last two thousand years. It is, no doubt, true that women as a general rule received similar and often worse treatment in contemporary times in several other civilizations, both in the East and the West. But this can hardly be a sufficient consolation or justification for us. For, we had once already evolved a fairly satisfactory standard about the treatment of women and then failed to act up to it owing to subsequent developments, which we ought to have checked. It is true that there was no female education worth the name even in the West down to the middle of the nineteenth century, but that would not condone its neglect by us, when we had once seen its benefits and advantages. It may be that early marriages might have been common in many countries in ancient and medieval times; but that would not justify the conduct of later Smṛti writers in disapproving the earlier custom of post-puberty marriages. It may be that seclusion of women in one form or another was common in several European countries for many centuries; but that would hardly be a sufficient excuse for our resorting to that custom, especially when we were once going on without it.

It has also to be pointed out that some of the grievances, from which women were suffering during the last two thousand years, were either theoretical or common to both men and women. Thus it was only a handful of pandits, who under the influence of theological theories, regarded women as being of the same status as that of the śūdras; to ordinary society, however, women were symbols of purity, religiousness and spirituality. They, and not men, were the custodians of national culture, and determined the details of religious rituals and ceremonies more authoritatively than the professional priest. It is true that literacy among women rapidly declined during the last two thousand years. But the same was the case with men, though no doubt to a lesser degree. Outside priestly and commercial

classes, literacy was not of great use either. The printing press was yet to come into existence. Books were very costly and almost unprocurable to men of ordinary means. The usual way of imbibing national culture and traditional wisdom was to listen to the village preacher (*Kathaka* or *Paurāṇika*), and illiterate women had greater facilities and opportunities to do this than literate men. It is true that owing to the lowering of the marriageable age, brides lost all voice in the settlement of their marriages. But the same was the case with the bridegrooms also, who being only 14 or 15, could naturally have no effective say in the selection of their partners in life. It must be added that parents normally took all possible care to make the best possible choice. Moreover, it was an age when parental authority was instinctively obeyed; not even one bride or bridegroom in a million ever dreamt of nursing any grievance for being denied a voice in the settlement of the marriage.

Even during the last two thousand years, the average woman continued to lead a happy and contented life, fondled by her parents, loved by her husband and revered by her children. It must be, however, admitted that her cup of happiness was more frequently split in this period than ever before by the prohibition of widow remarriage, the revival of the *satī* custom, the spread of the purdah and the greater prevalence of polygamy and supersession. Society's attitude towards her was also one of patronizing condescension. It, no doubt, insisted that she should be properly cared for and attended to, but it did not take any effective steps to check the growing tendency to pass very uncharitable and utterly unjustifiable remarks about her nature and worth. It allowed the husband to trample underfoot the marriage vow quite openly, but insisted that it should be followed by the wife, even if her husband were a moral wreck.

In a society living in an ascetic atmosphere, it may have been thought desirable to prohibit widow remarriage; in the modern age of morbid talkies and four anna novels, to continue to insist upon that prohibition would be suicidal. Polygamy may have had some justification when a son was genuinely believed to be necessary for spiritual salvation; in a society which no longer subscribes to that belief, it becomes an odious institution. In an age when children were married very young and were accustomed to obey the parents instinctively, no one thought of questioning their sole authority to arrange their wards' marriages; in the new epoch when marriages

are taking place at an advanced age and when every adult has begun to claim absolute independence as his birth right, it would be no longer justifiable for guardians to exercise the same powers as before. Hindu society will have to remove a number of cobwebs in its ancient house and change, and even revolutionize, some of its customs and institutions in order to accord the proper place, which justly belongs to women.

The detailed survey of the position of women that we have made in this article would be of considerable use to us in understanding and solving most of the problems that confront us today. Luckily, the need and advantage of female education is now fully understood. Society has now taken to it seriously in towns and cities and rural areas will follow suit in course of time, as the standard of living of our population and the resources of the union and state governments improve. As far as the nature of female education is concerned, it should be a course specially intended for women, calculated to promote a harmonious development of their reason and emotions, enabling them at the same time to become earning members of the family, either as part-time or whole time workers in case of need.

When girls of 17 or 18, equipped with proper education, enter matrimony, they cannot but be treated with instinctive respect and consideration by all the society around. Family responsibility, and not inherent incapacity, would be the normal cause of their not being earning members of their families; they would, therefore, receive the same respect that is instinctively given to the breadwinner. Their practical attainments would add to the beauty of their households, lead to economy in its expenditure and promote sounder education of the children of the family. This would surely ensure for them an equality of status with their husbands in all cultured families.

In the sphere of marriage and marital relations, some reforms are necessary, very urgently.

It is high time now that polygamy should be legally prohibited. There is no doubt that legal recognition of polygamy is working an untold harm to a not negligible number of women, who are superseded by their husbands, especially in uncultured classes.

It is now high time for us to insist, both in the East and the West, that there should be no double standard of morality in sexual matters; husbands should be required to remain as faithful to their

marriage vows as wives. Any transgression in this respect on the part of the husband should meet with instantaneous and severe social opprobrium. Unfortunately, nature's partiality to man renders it very difficult to detect his transgressions, even when numerous; a single lapse of woman, on the other hand, is often betrayed by its consequences.

Marriage should continue to be regarded as a religious bond, normally indissoluble in this life. This world, however, is an imperfect one, and so would be also its most sacred ties sometimes. We must, therefore, frankly recognize that cases may sometimes occur, where religion will have to dissolve the tie it had once created. The conditions of divorce should be very stringent, but its necessity in modern times has to be recognized.

Considerable difficulties are experienced in finding suitable matches for widows willing to marry; public opinion must assert itself and insist that widowers should marry widows alone.

In the realm of the property law, further liberalization is necessary. We hold that a daughter, who is unmarried at the time of the opening of the inheritance, should get a share equal to half that of her brother, inclusive of the amount spent on her education. This share should not be required to be surrendered at the time of her marriage. It should be regarded as equivalent to the marriage portion of the daughter.

As a natural corollary of the joint ownership of the husband and the wife in the family property, and as a recognition of the valuable service of the wife in the management of the household, the law should lay down that 10 per cent of the income of the husband should be converted into a new variety of *strīdhana*, to be entirely at the disposal of the wife. This would remove the difficulties of the sensitive wife by keeping at her disposal a fund of her own in lieu of the share in the patrimony which is denied to her.

A deed of transfer of immovable property should require the joint consent and signatures of the husband and the wife.

Women have already obtained political rights and privileges, more or less coextensive with those of men. They will figure more prominently in public life when there is a wider spread of education and a further improvement in the economic condition of society.

The few changes that are suggested above are not in any way against the spirit of our culture.

NOTES

1. *Manu.*, III, 14, 16.
2. *dvijasya śūdrā bhāryā tu dharmārtha na kvacit bhavet/
 ratyartham eva sā tasya rāgāndhasya prakīrtitā//*

 —*Viṣṇu*, Ch. 26

 Kṛṣṇavarṇā yā rāmā ramaṇāyaiva na dharmāya

 —*V.D.S.*, XVIII, 17.
3. *ṛtavo bahavaste vai gatā vyarthāḥ śucismite/
 sārthakaṁ sāmprataṁ hyetanna ca pāpmāsti te'anaghe//*

 I, 95-65
4. *Gargasaṁhitā*, Yugapurāṇa, vv. 54, 84.
5. II, I.
6. *A.D.S.*, II, 9, 9, *B.D.S.*, II, 6, 20.
7. XII, 10, 20.
8. *nākāmyā samniyojyā syāt*—*B.D.S.*, II.1, 20.
 nākāmā samniyojyā syāt-putrakāmāntu yojayet

 —Yama in *SCS*, p. 225

Beyond the Altekarian Paradigm: Towards a New Understanding of Gender Relations in Early Indian History

Uma Chakravarti

Discussion on the status of women has a unique position in the writing, teaching, and learning of early Indian history. Further, some of the conclusions of this discussion have actually found their way into the syllabi of schools and undergraduate courses. For whatever it is worth, there is some information on women in almost every textbook on ancient India. This kind of information does not occur in any other course of history since there has been no tradition of a separate discussion on the status of women. The uniqueness of the situation made its point while I was correcting examination papers sometimes ago. A question on the main features of later Vedic civilization resulted in a spate of answers dealing with the position of women. It was clear, that to most students, one of the important indices of a civilization was the position that women occupied in it. This general understanding is based on an informal debate that took over 150 years to crystallize and percolate down to a large number of people among the upper classes in India.

The existing material on women in early India however has a seriously limiting dimension to it, especially when we consider the negative effect that such work has had on a *real* understanding of women in history. It might, therefore, be worthwhile to explain why the first historians undertook studies of the status of women, why they remained confined essentially to Ancient India, and also review the state of the existing literature so that one may be able to evaluate the worth of the available studies. This will, in turn, help us outline the kind of work that needs to be done in the future.

The women's question took a central place in the early stages of the national movement. The socio-religious reform movements of the nineteenth century advocated a reform of Hindu society whose twin evils were seen as the existence of caste and the low status of

women. All the major reformers of the time attacked the practice of *satī*, child marriage and enforced widowhood, and this was a common platform whether the reformers belonged to the Brāhmo Samāj in Bengal, the Prārthanā Samāj in Maharashtra or the Ārya Samāj in northern India. The preoccupation with these questions was derived, at least in part, from the dominance of Sanskritic models in the nineteenth century, since the major thrust in the debate came from within the upper sections of the Hindu community. The above-mentioned characteristic has survived in the women's question even in contemporary times where the study of the identity of women is based almost entirely on Sanskritic models and the myths conditioning women.

Another feature which has significant consequences for the general debate on the status of women is that both the proponents of the reform as well as the opponents of the reform looked back to the ancient texts as the source from which both groups took their positions and invoked the sanctions of the Śāstras in putting forward their arguments. This naturally necessitated a study of the position of women over the course of history. The deciding factor in the debate between the liberals or progressives, and the conservatives was the relative antiquity of the source from which they were quoting. The older the source the more authentic and authoritative it was considered. Raja Rammohun Roy, Ishwarchandra Vidyasagar and R.G. Bhandarkar, all quoted copiously from the Sanskrit sources in order to attack the conservatives. There is thus a direct correlation between the concerns of the Brāhmo Samāj, Ārya Samāj, and the Prārthanā Samāj and the writings on the position of women in Hindu civilization.

Since the traditional work on the status of women in India exists entirely within the context of Hinduism, it is heavily preoccupied with religious and legal questions such as the right to widow remarriage, the existence of the institution of *niyoga*, the right to property for women, the origin and development of the institution of *strīdhana*, the right of the childless widow to adopt and so on. On the religious front, there is an obsession with the right of a woman to perform religious sacrifices either by herself or with her husband, as also with her interest and involvement with the pursuit of religious goals. The social position of women is usually concerned with the inclusion or exclusion of women in public assemblies and their right to education. On the whole, the perspective on women is confined

to seeing them within the context of the family. It is the status of women within the family and primarily in the relationship of wives to husbands with which the traditional writers were concerned.

Another feature of the traditional writing on the position of women is that they were based entirely on brahmanical sources. Even if these sources are considered to be reasonably authentic, which I have reason to doubt, they carry the problem of (a) an inherent bias of the brāhmaṇas, (b) reflecting the precepts of the brāhmaṇas rather than the actual practice of the people, and (c) confining themselves to the upper castes. At best, the existing work can be termed as a partial view from above. How unsatisfactory such unconditional reliance upon brahmanical sources has been will be clear further on in this paper.

The analysis of the position of women in ancient India has also been coloured by the fact that almost all the works have been written by scholars who would fall within the nationalist school of history. Writing at a time when Hindu social institutions were being subjected to fierce criticism by a generation that was imbibing Western education and Western values, these scholars worked hard to show that the position of women had been high in the ancient past. The contemporary evils reflecting the low position of women were responsible for the Hindu sense of inferiority in relation to their ruling masters. As a reaction, Hindu scholars argued that the evils were only a temporary aberration and could easily be eliminated. The general thrust of the work has, therefore, been to demonstrate that the status of women was very high in the Vedic period; according to this view, there was a general decline afterwards, reaching rock bottom with the coming of the invaders, especially the Muslims, who abducted Hindu women and violated them, and these circumstances resulted in the development of such evils as purdah, *satī* and female infanticide. This view has become widely prevalent since it appears regularly in popular literature and vernacular journals but we must point out that it is only an extension of traditional academic research.

Here is a fairly representative example from the pen of a woman scholar:

The tenth and the eleventh centuries saw the advent, and later, the firm establishment of Muhammandans in this country. When Hindu culture came into clash with a culture far different from its own, the leaders of society began to frame rules and laws to safeguard their interest—specially the position of women. Rigorous restrictions were placed on them.... We

find at this stage child marriage firmly enforced. The death of a widow was preferred to her falling into evil hands. Hence self-immolation of a widow was enjoined by the law codes giving the unfortunate victim the hope of heavenly bliss. Such and several other customs were introduced which curbed the freedom of women to a very large extent. This was done perhaps to save her from the foreigners and to preserve the purity of the race.[1]

Similarly, R.C. Dutt, the well-known nationalist historian and the first to present a coherent account of ancient Indian civilization and of women, writes:

Absolute seclusion and restraint (of women) were not Hindu customs. They were unknown in India till Mohammedan times.... No ancient nation held their women in higher honour than the Hindus.[2]

Such a sweeping view is untenable if one looks at the past without the tinted spectacles of the present. Even if one were to confine oneself to brahmanical sources, there is enough evidence to show that women of the upper castes did not have access to the public domain by the early centuries of the Christian era, and that Manu and other law-givers recommended early marriage for girls. *Satī* itself was associated with women of the ruling classes, as is evident from the seventh century account of Harṣa's early career. The structure of institutions that ensured the subordination of women was complete in *all essentials* long before the Muslims as a religious community had come into being. The Muslim bogey was a convenient peg to explain the origin of all oppressive practices. It was particularly convenient for those who did not wish to see the structural framework of institutions that governed gender relations in early India, mainly because it was the same framework that governed women even in contemporary society. The term 'patriarchy' was hardly used and even when it did stray into an occasional historian's writing, it was a neutral term, completely divested of the power factor inherent in it; successfully depoliticized, thus it lost its real import.

The cultural encounter between England and India in the nineteenth century, which was the context for the emergence of nationalist historiography, shaped the focus and the thrust of writing on women in early India. The injury to the Hindu sense of superiority resulting from the unfavourable comparison between Hindu women and Western women, which was common throughout the cultural encounter, was so marked that it led frequently to an inversion of the Vincent Smith syndrome. Vincent Smith's position was a general

contempt for everything Indian. If he was faced with visual and incontrovertible proof of something worthwhile in Indian culture, he would immediately attribute it to Greek influence. Historians writing on the position of women in ancient India reversed the argument by invariably trying to point out that nowhere else in the ancient world were women held in such high regard as in the India of 3000 years ago. They specially revelled in comparisons with Greece and Rome as in the passage below:

The historian of India who has studied the literature of the ancient Hindus will have no hesitation in asserting that never in the most polished days of Greece and Rome were women held in such high regard in those countries as in India three thousand years ago.[3]

Similarly, Altekar surveys the condition of women in ancient Greece, Rome, and Palestine, and then reiterates that the position which women occupied at the dawn of civilization during the Vedic age was much better.[4]

The need of the nationalist historians to resurrect examples of the lost glory of Indian womanhood has led to a selective focus on certain aspects of the ancient texts. This has often resulted in a sanitized interpretation of events, best illustrated by the nationalist rendering of the Gārgī-Yājñavalkya debate, the most celebrated example of women's learning. The highlight of the account in Shakuntala Rao Shastri's book is the way the debate concludes. Gārgī's questions to Yājñavalkya have by this time become more subtle and pointed. Yājñavalkya, however, clearly has no intention of allowing Gārgī to win the prize of a thousand cows. At this stage of the debate he arbitrarily threatens Gārgī with dire consequences if she persists in questioning him and so eliminates her from the contest. Despite this, Shakuntala Rao Shastri sums up the episode *without* pointing to the unfairness of this clearly memorable confrontation between two philosophers, one a man and the other a woman. Instead she blithely states:

The persistent and obstinate enquiry of a woman brought forth the finest definition of the Supreme Reality. The motive of Gārgī's enquiry was *not to test Yājñavalkya but to learn from him* [italics mine] about the nature of Brahman.[5]

Thus, Gārgī's fearlessness, independent mind, and her ability to take on a well established philosopher, is watered down in Rao Shastri's account; more importantly the unfairness of the contest is glossed

over in order to present a picture of blissful, harmonious pursuit of philosophical truth.

The best known and most internally coherent nationalist work on women is Altekar's study on the position of women in Hindu civilization. His work is based primarily on brahmanical sources and outlines the position of women from earliest times right up to the mid-fifties of this century when the Hindu Code Bill was under consideration. Altekar's work represents the best that is available to us by way of women's studies in history but it also shows up very sharply the limitations of the traditional approach. Although the work unravels in detail the entire body of opinion of the law makers on such areas as the education of women, marriage and divorce, the position of the widow, women in public life, proprietary rights of women, and the general position of women in society, it is steeped in the nationalist understanding of the women's question. Further, his overwhelming concern is with women in the context of the family and one almost gets the feeling that the status of women needs to be raised in order to ensure the healthy development of the future race of India. In this he was reflecting the opinion of nationalist writers from the second half of the nineteenth century who placed tremendous importance on the physical regeneration of the Hindus.

A study of Altekar's work will indicate the limitations inherent in his approach. His theoretical framework is spelt out in the very first page of his work. According to him:

One of the best ways to understand the spirit of a civilization and to appreciate its excellence and realize its limitations is to study the history of the position and status of women in it. . . . The marriage laws and customs enable us to realize whether men regarded women as market commodities or war prizes or whether they realized that the wife is after all her husband's valued partner whose cooperation was indispensable for *happiness* and *success* in family life [italics mine].[6]

Altekar's own genuine commitment to reforming women's status led him to sometimes making quaint statements which he intended as positive and progressive. Thus he suggests that although

women have low fighting value, they have potential military value. By giving birth to sons they contribute indirectly to the fighting strength and efficiency of their community.[7]

Further, Altekar's programme for women, despite his apparent liberality and sympathy for them, was to view women primarily as

stock-breeders of a strong race. This view is particularly noticeable in his suggestions about women's education. In Altekar's programme of reform, women were to be educated enough but in doing so one had to ensure that no undue strain was placed upon them. He expressed his fears thus:

> As things stand today, girls have to pass the *same* examinations as boys and to learn house-keeping at home as well, all the while having less physical strength than their brothers. This certainly puts too much strain upon them and is *injurious to the future well-being of the race* [italics mine].[8]

Establishing the high status of women was the means by which 'Hindu' civilization could be vindicated. This was the finished version of the nationalist answer to James Mill's denigration of Hindu civilization published a century ago; the locus of the barbarity of Hindu civilization in James Mill's work (*A History of British India*) had lain in the abject condition of Hindu women. By reversing the picture, Altekar was attempting to lay Mill's ghost aside. But it was easier to provide a general picture than to deal with a variety of customs oppressing women that still obtained in the early twentieth century. Altekar was thus forced to provide explanations for existing biases against women. For example, he attempts to explain the Hindu preference for a son over a daughter by advancing a psychological argument as in the passage below:

> If a cruel fate inflicted widowhood upon the daughter, the calamity would break the parent's heart. Remarriage being no longer possible, parents had to see the heart-rending pain of seeing their daughter wasting herself in interminable widowhood ... parents had often to pass through the terrible ordeal of seeing their daughters burning themselves alive on the funeral pyre of their husbands. To become a daughter's parent thus became a source of endless worry and misery.... As a natural consequence ... passages about the undesirability of the birth of daughter become more numerous.[9]

Altekar is particularly weak in his attempts at relating the status of women at a given point of time with social organization as a whole. Thus early Vedic society which did not as yet have noticeable concentration of power, or a well developed institution of kingship, is the context for Altekar's unnecessary explanation for the absence of queens. Since Altekar is convinced about the high status of women in the Vedic period, he feels he has to account for why we do not hear of women as queens. Thus he is constrained to suggest that:

Aryans were gradually establishing their rule in a foreign country surrounded on all sides by an indigenous hostile population that considerably outnumbered them. Under such circumstances queens ruling in their own rights or as regents were *naturally unknown* [italics mine].[10]

Similarly Altekar has a facile explanation for why women did not own property. According to him:

Landed property could be owned only by one who had the power to defend it against actual or potential rivals and enemies. Women were obviously unable to do this and so could hold no property.[11]

In his inability to see women within a specific social organization and recognizing patriarchal subordination of women Altekar was not unique. Like others he was reflecting a deeply internalized belief in biological determinism and therefore in the physical inferiority of women.

Very occasionally, however, Altekar shows flashes of insight into the socio-economic context within which women's subordination was achieved. For example, in his analysis of the causes for the 'fall' of the status of the Āryan women, Altekar suggests a connection with the subjugation of the śūdras as a whole. He argues that the Āryan conquest of the indigenous population and its loose incorporation as members of a separate *varṇa* had given rise to a huge population of semi-servile status. In such a situation Āryan women ceased to be producing members of society and thus lost the esteem of society. But even as he makes this broadly contextual explanation, Altekar is insensitive to the crucial distinction between the participation of women as producers and participation in terms of *controlling production*. Thereafter Altekar's semi-historical insight is unfortunately lost and popular prejudice takes over. Like the ancient brahmanical law givers he appears to have a horror of śūdra women, as in this passage:

The introduction of the non-Aryan wife into the Aryan household is the *key* [italics mine] to the gradual deterioration of the position of women. . . . The non-Aryan wife with her ignorance of Sanskrit language and Hindu religion *could obviously not enjoy the same religious privileges as the Aryan consort* [italics mine]. Association with her must have tended to affect the purity of speech of the Aryan co-wife as well. . . . This must have naturally led to grave mistakes and anomalies in the performance of the ritual which must have shocked the orthodox priests. . . . Eventually it was felt that the object could be gained by declaring the whole class of women to be ineligible for Vedic studies and religious duties.[12]

The facile argument was, in Altekar's view, the key factor in the decline of the status of women. Altekar is completely obtuse to other historical explanations. The possibility that the śūdra woman, whom he regards as a threat, could have contributed to a more dynamic and active kind of womanhood for Hindu society would not even occur to Altekar because his focus is on Āryan women (regarded then as the progenitors of the upper caste women of Hindu society) and in his racist view śūdra women counted for nothing. The most important consequence of Altekar's limited repertoire of biological and psychological explanations was that the logic of the distorted social relations between men and women is completely obscured. The kind of explanations offered by Altekar might appear to be astoundingly trivial to us today but it is important to remember that, by and large, nationalist historians were content to restrict historical explanations to cultural factors while writing about ancient India. This was in contrast to their focus on economic and social factors while discussing British rule in India.

In summing up nationalist historiography on women in early India, we might draw attention to the fact that the Altekarian paradigm, though limiting and biased, continues to, nevertheless, influence and even dominate historical writing. In essence what emerges from the mass of detail he accumulated is the construction of a picture of the idyllic condition of women in the Vedic age. It is a picture which now pervades the collective consciousness of the upper castes in India and has virtually crippled the emergence of a more analytically rigorous study of gender relations in ancient India. There is, thus, an urgent need to move forward and rewrite history, a history that does justice to women by examining social processes, and the structures they create, thus crucially shaping and conditioning the relations between men and women. Just as Altekar displaced Mill in his work, it is time we realized that despite Altekar's substantial contribution, we must lay his ghost aside and begin afresh.

NOTES

1. Shakuntala Rao Shastri, *Women in the Sacred Laws,* Bombay: Bharatiya Vidya Bhavan, 1970, 2nd edn., pp. 172-3, 189.
2. R.C. Dutt, *A History of Civilization in Ancient India,* Delhi: Vishal Publishers, 1972 (rpt.), pp. 168-9.
3. Ibid., p. 171.

4. A.S. Altekar, *The Position of Women in Hindu Civilisation*, Delhi: Motilal Banarsidass, 1987 (rpt.), p. 337.
5. Op. cit., p. 95.
6. Op. cit., p. 1.
7. Ibid., p. 3.
8. Ibid., p. 28.
9. Ibid., p. 5.
10. Ibid., p. 339.
11. Ibid.
12. Ibid., p. 345.

Women Under Primitive Buddhism: Laywomen and Almswomen

I.B. Horner

INTRODUCTION

Oral transmission of learning was the traditional mode in India. Yet this manner of preserving the teaching and discipline was probably not a more reliable way of excluding later interpolations than was transmission by hand-writing.

Another force disruptive of the purity of the original canon was lodged in the followers of Gotama. They, also, were teachers, and not merely passive, docile disciples. They would not necessarily hand on the teaching of the Master exactly as they had received it from him, but would now and again change words in order to emphasise the special points which appealed to them.

Still another inherent difficulty in dealing with the Pāli texts arises from the various editions, glosses, and revisions which they have undergone at the hands of the monks. In consequence it is sometimes impossible to disentangle the original matter from later accretions; and in many places it appears as if much of what Gotama thought, said, and did has become lost or distorted. If the monk-factor be kept in mind, some of the distortion may be accounted for, and in part rectified. It partially explains the views, more favourable to monkdom than to lay-life, more favourable to men than to women, which are usually ascribed to Gotama.

The following survey is an attempt to fill up one of these *lacunae*, and to present the position of the laywomen and of the almswomen in historical focus. The material for the study of the laywomen has been gathered from the Canonical literature, and also from the (later) commentaries, the Jātaka books and the *Milindapañho*. Most of the material for the account of the almswomen is to be found in the *Vinaya Piṭaka*, one of the oldest Buddhist books in existence, and particularly in those portions of it known as the *Bhikkhunī-Khandhaka* (that is the tenth and last *Khandhaka* of the *Cullavagga*) and the

Bhikkhunī-Vibhaṅga. These prescribe the rule and discipline for the outward life of members of the order. The collection of verses known as the *Therīgāthā*, and the commentaries on them, are important sources for the spiritual experiences of some of the almswomen; they also throw light on various contemporary social conditions. Other references to almswomen, scattered throughout Pāli literature, have also contributed to the present account.

No history of the order of almswomen has ever been written. It is impossible to reconstruct it with strict historical accuracy at this distance of time, because not merely is some of the material probably biased, but also because some is almost certainly lacking, not having been recorded: it was most likely thought to be not sufficiently important. Had writing been in vogue during the lifetime of Gotama, it is fairly safe to assume that references to the almswomen would not have been so scanty, and that the purely monkish outlook and business would not have been so predominant as the texts which have come down to us indicate. Further, had records and chronicles been written down at the time by the almswomen themselves, we might have expected a wealth of details throwing light on their daily life and habits.

In spite of the difficulties presented by the revised and incomplete character of the texts, I hope that the following pages may justify my belief that the life of women as nuns, so long ago as the sixth century BC, is worthy of more than the passing attention, which, with a few notable exceptions,[1] is the most that it has ever been accorded in any treatises on Buddhism.

The approximation to equality of women with men indicates the amount done by Buddhism for women. On the other hand, an unprejudiced reading of the Pāli classics throws into high-relief the amount done by women as props and stays of the religion.

The way to the solidarity of this support and loyalty may have been pointed by the Teacher himself. I hope to show that he did not, as is usually said of him, grudge women their entry into the order, but that his compassion for the many-folk included, from the beginning, women as well as men and animals. He saw the potentially good, the potentially spiritual in them as clearly as he saw it in men.

THE LAYWOMEN

In the pre-Buddhist days, the status of women in India was on the whole low and without honour. A daughter was nothing but a source

of anxiety to her parents; for it was a disgrace to them and inauspicious as well if they could not marry her; yet, if they could, they were often nearly ruined by their lavish expenditure on the wedding festivities. Nor was she of any ceremonial benefit to her father, for she was powerless to participate in his funeral rites, and in cases where these had not already been insured by the birth of a son, distress at the birth of a daughter was almost unmitigated.

Since performance of the funeral rites was thought to be essential to a man's future happiness, he usually married chiefly in order to gain this end. Hence he regarded his wife simply as a child-bearer; and except when she took part in certain sacrifices, and was of importance as the wife of the sacrificer, her life was spent in complete subservience to her husband and his parents. She was allowed little authority at home and no part in public activities. If widowed, she became the possession of her father again, or of her son, and relapsed into personal insignificance; though as a mother of sons she was an exception, for as such she occupied a unique position which was due to the respect that she then commanded.

During the Buddhist epoch there was a change. Women came to enjoy more equality, and greater respect and authority than ever hitherto accorded them. Although their activities were confined within certain spheres—principally the domestic, social and religious—their position in general began to improve. The exclusive supremacy of man began to give way before the increasing emancipation of woman. This movement, if a development so nearly unorganised, unvoiced and unled, may be called a movement, was fostered and accelerated by the innate intelligence of the women themselves, until it was acknowledged that they were what they were silently claiming to be—responsible, rational creatures with intelligence and will. It was impossible for the men, steeped as they were in the Buddhist teaching, not to respond to the constant proofs in daily life of the women's powers of devotion, self-sacrifice, courage and endurance. They ceased to regard women as approximating in degree more nearly to the animals than to themselves; and, on the contrary, became more acutely aware of the resemblances between men and women. The Buddha gave the *dhamma* to both; he also gave talks to the householders and their wives.[2] Added to this, the women set fine examples in conduct and intelligence. The men, for their part, appreciated the *dhamma*, and acquiesced—though tardily—in the widening of the field of women's activities. Thus, amid many

currents, intricate but potent, the tide turned; and in its flow the position of women, as manifested in secular affairs, became one which was no longer intolerable and degraded, but one which was honorable and therefore bearable; women were acknowledged at last to be capable of working as a constructive force in the society of the day.

Grief at a wife's death is not a phenomenon which would have been of much interest to the recorders. They would have regarded it as a natural and normal reaction of those who, living in the world, were bound by a mighty fetter; but from their point of view they would have deplored it as denoting a wrong and muddled apprehension of reality. Its very commonness as a strand of human experience made it perhaps inappropriate to record. Hence it is not surprising that records of the grief of only three husbands have been included in this literature. Harita's[3] survives as his reason for joining the almsmen; and Pasenadi's[4] and Muṇḍa's[5] because they were famous kings. Events of Pasenadi's reign are often chronicled; hence it is only to be expected that his lament for his queen Mallikā, beloved too by all his subjects, should also be inserted.

A wife's grief at her husband's death would naturally pass almost unrecorded, and little trace of it survives.[6]

The question of the remarriage of women who were not widows is one for which there is but meagre evidence; but the pieces that exist are direct and important. There is no indication in the texts that the cases which they describe were in fact isolated. Two appear to have been cases of actual remarriage, two others of possible remarriage. Isidāsī[7] married one husband after another. From the lack of contemporary comment on her conduct, it may be concluded that she was acting in conformity with public opinion rather than in opposition to it; that she was not adopting a course which was in any way unusual; and that in all probability there were other women who married again, but who were perhaps more fortunate in finding happiness with the second husband. The other cases bear out this interpretation. For example, the *Dhammapada* commentary, in the sequel which it introduces to the story of Kāṇā[8] says that when her husband married another wife, she was taken as a daughter by the king, and later married by him to a great noble. A Sāvatthi woman 'visited her own people's home, and they wanted to take her from her husband and marry her to someone else whom she did not like'.[9] This clause reads also as if there were no religious or social obstacles

to be overcome in being remarried, but as if it were a step that could quite easily be taken without raising any scandal. So also does a passage in the Jātakas.[10] An old squire who had a young wife, thinking of the days when he would be no more, is described as saying that as soon as he is dead, this girl, his wife, being so young will marry heaven knows whom, and spend all his money instead of handing it over to his son and heir. The dimness that otherwise shrouds this topic cannot be taken to mean that remarriage did not occur; and various reasons might be adduced to account for the sparseness of the data. In the first place, the texts were written down later than the events which they purport to record. In the interval much concerning the lives of women may have been forgotten. Men were the repositories of learning, of stories and legends, and the task of repeating the material to the monks for incorporation into the texts which they were editing would fall mainly, if not entirely, to men. They would tend to remember chiefly events and customs concerning themselves, and to let those concerning their women-folk fall into oblivion. But neither the laymen nor the monks could totally ignore the worth that some of the women forced them to see in them.

Secondly, the monks, in selecting their material, would tend to suppress as unimportant and uninteresting, and possibly also as unedifying, many of the details handed on to them concerning the rules and regulations governing a woman's life.

Hence the mention of these four references to remarriage, but of no more than four, suggests that in all probability the texts are the outcome of monkish elimination. Yet, over and above this, the opening of the order to women must have acted as a partial preventive to remarriage. Several women are recorded to have left the world when their husbands did,[11] but even the strongly religious temperament of the East could not have impelled all virtual widows into the order; and it does not seem impossible that some should have found relief from their loneliness and burden of responsibilities in remarriage.

THE WOMAN WORKER

Among the better classes in Buddhist Indian society, the great majority of women were supported by children, husband, or father. They did not do much, if any, work beyond their household tasks as mother, wife, or daughter. But among the poorer people the case

was different, and there are various records which refer to self-supporting women who were engaged in a trade or a profession.

It is said, for example, that a certain woman was the keeper of a paddy-field ; and she gathered and parched the heads of rice, doing the work herself.[12] Another is described as watching the cotton-fields,[13] where she used to sometimes spin fine thread from the clean cotton[14] in order to while away the time.

Women also appear to have been capable of functioning as keepers of the burning-grounds. Two references are made to the same woman, Kālī, who was engaged in this occupation,[15] although no mention is made of any wage she might have received. She evidently had at heart the welfare of those who came to meditate in the charnel-field, for she provided them with objects suitable for the contemplation of impermanence.

A spirited description of a woman acrobat occurs in the *Dhammapada* commentary.[16] Although it is the only reference to a woman who earned her livelihood by such arts, it is illuminating. For it is probable that some of the five hundred tumblers with whom she was, were also women. They used annually or twice a year to 'visit Rājagaha, and give performances for seven days before the King. . . . One day a certain female tumbler climbed a pole, turned somersaults thereon, and balancing herself on the tip of the pole, danced and sang as she trod the air'. A son of a great merchant fell in love with her, but her father would not give his daughter for money, and suggested that the youth should travel about with them. The people delighted in these acrobatic performances, and 'stood on beds piled on beds' in order to obtain a good view. They tossed up gifts to the tumblers, who also earned 'much gold and money'.

Such were, perhaps, the more unusual ways in which women supported themselves. Far more numerous were domestic female slaves, born to this status of other domestic slaves, like Puṇṇā, in the household of Anāthapiṇḍika.[17] They formed part of the property of most wealthy householders.

There is only one reference in canonical literature to a slave-woman who was maltreated.[18] She had tried her mistress's patience past bearing. Her name was Kālī, and she had endeavoured to find out whether the reputation her mistress, Videhikā, had for gentleness and mildness was true. She, therefore, got up later and later three mornings running. At first her mistress merely questioned her and frowned; the next morning she complained; and the third morning

she struck Kālī on the head with a lynch-pin, and drew blood.
It nowhere appears that slave-women were overworked. There were multitudes of them in the royal establishments, some of whom waited upon the queens, and performed such duties as daily buying flowers for them,[19] and looking after the jewels of the ladies in the royal harem.[20] In other households they pounded rice,[21] an arduous task, and helped with the cooking.

Slave-women could be emancipated, but only with the consent of their master. It is significant that in all recorded cases where such a step was taken, it was in order to enable the freed-woman to enter the order,[22] for slaves were ineligible for ordination.

Khujjuttarā,[23] a slave-woman of Queen Sāmāvatī, did not apparently become emancipated on her conversion to Buddhism. She reformed her conduct insofar as after the first time that she had heard Gotama preach; she spent the whole of the eight pieces of money that the queen had given her for buying flowers, instead of spending only four and keeping the other four for herself. Being asked by the queen why she had brought back so many flowers on this particular day, she said that she had heard the discourse given by the Exalted One, and had acquired understanding of the *dhamma*. She then preached it to the queen, who became a believer, and to all her women-attendants. They begged Khujjuttarā to be to them as a mother and a teacher, and to go to hear every discourse given by the teacher, and then return and teach it to them. In this way she came to know the Tipiṭika by heart, and it is said that the master assigned her preeminence among his female lay disciples, who were learned in the scriptures and able to expound the *dhamma*.

Besides slave-women, some of the more prosperous householders had also in their retinues vast troupes of female musicians. Gotama himself, before he entered on the homeless way, is said to have been 'ministered to by bands of women musicians',[24] and it is recorded of Yasa, the noble youth, that ' in the palace for the rainy season, he lived during the four months (of that season), surrounded with female musicians, among whom no man was'.[25] The instruments played by such women included the flute, lute, tabor and drum.[26]

An almost necessary concomitant of music was dancing. Sound prompted sight to aid in dispelling the tedium of the days of torrential rains, and dancing girls abetted in this work, performing as was their wont upon large woollen carpets,[27] sometimes singing themselves[28] and making music also.[29]

In order to show the highest honour to King Mahājanaka, his subjects prepared a great festival, and when they were presenting their offerings 'a crowd of king's ministers sat on one side, on another a host of brāhmaṇas, on another the wealthy merchants and the like, and on another the most beautiful dancing girls'.[30] But they were not employed solely for entertainment: they were sometimes put to other uses. Queen Sīlavatī, the consort of Okkāka, had no child.[31] The people complained that the realm would perish, and counselled the king to send out a band of dancing-women of low degree into the streets. If no one of these, however, gave birth to a child he should then send a company of women of good standing, and finally a band of the highest rank. The expeditions were to receive religious sanction, but this was not so much to regularise the status of the nautch-girl, for she was already accepted as a necessity to the wealthy, as to insure a successful result. But when the king and the people knew that they were doomed to disappointment, the failure of the women to give birth to a child was attributed to their lack of merit and to their immorality: a Hindu rather than a Buddhist interpretation.

In addition to these, a large part of the female population who did not otherwise gain their livelihood, or who were not otherwise supported, were courtesans. They also were sometimes well versed in dancing, singing and lute-playing.[32] Although the extent of prostitution in ancient India is disputed, it had existed before the Buddhist days,[33] despite the importance given to marriage in the Vedic age: but for some girls who were without protectors,[34] a life of prostitution was an obvious course to pursue.

Some, like Vimalā[35] and Sirimā,[36] appear to have been prostitutes because their mothers were. Yet among this class of women the birth-rate must have been somewhat low. Hence, comparatively few girl-children would be born to enjoy their mother's favour, for courtesans were fully aware, as Sālavatī phrased it, that 'men do not like a pregnant woman. If anyone should find out regarding me that the courtesan Sālavatī is pregnant, my whole position would be lost.'[37] There is no record that female infanticide was ever committed by a courtesan; but if sons were born to them they ran a certain risk of being murdered.[38] Sālavatī and the courtesan of Kosambi[39] and the courtesan of Rājagaha,[40] all gave orders that their sons should be put into an old winnowing basket and cast away on the dust-heap. Sālavatī's was saved by the prince, Abhaya, and lived to become a

famous physician. On the other hand, both Ambapālī and Abhaya's mother each had an almsman son.

Four courtesans, Vimalā, Abhaya's mother, called Padumavatī, Aḍḍhakāsī and Ambapālī, having been converted to Buddhism, entered the order and attained to arahantship. To each of these, too, verses are attributed in the *Therīgāthā* of Vimalā[41] little other mention is made,[42] and none of Abhaya's mother[43]: she was the town-belle of Ujjenī, and her boy, Abhaya, was king Bimbisāra's son. On the other hand, Aḍḍhakāsī[44] is important, as in order to circumvent the difficulties of her ordination a relaxation in the discipline was granted. And Ambapālī[45] became and remained famous as one of the most loyal and generous supporters of the order.

Besides Ambāpālī, other courtesans appear to have benefitted the order in various ways. It is said that at the assemblies of Sulasā the courtesan and of Sirimā the courtesan, eighty-four thousand people penetrated to a knowledge of the *dhamma*.[46]

Yet, in spite of the virtue of all these courtesans and of others less prominent, like the one who kept the five *sīlas* (which would preclude her from plying her trade),[47] and like the one who for three years kept her honour,[48] these were perhaps exceptional cases, and therefore incapable of raising the profession in the eyes of the world or of the almspeople.

Courtesans sometimes lived in groups or went about in groups, and the more famous ones sometimes had others in their train, as it is said of Sulasā[49] and of Kālī.[50] They were often extremely wealthy. Some, as for example Ambapālī, Sirimā, Sulasā, Sāmā and Kālī, put their fee at a thousand pieces (*kahāpaṇas*) each night. Sālavatī asked for a hundred pieces for one night.[51] Mention is sometimes made of their ornaments[52] and their serving-maids.[53] An interesting description of Kālī's brothel is given.[54] 'Now in that house of ill-fame the fashion was this: out of every thousand pieces of money received, five hundred were for the woman, five hundred were the price of the clothes, perfumes and garlands; the men who visited that house received garments to clothe themselves in, and stayed the night there; then on the next day they put off the garments they had received, and put on those they had brought and went their ways.'

Despite the disturbing effect they might have on the almspeople, courtesans are never openly condemned in the literature, being regarded as more piteous and low than blameworthy. Hence, although they come towards the end of a long list of trades and professions

given in the *Milindapañho*,[55] even so they were said to be capable, with brāhmaṇas and nobles, not merely of knowing that a certain new city was regular, faultless, perfect and pleasant, but also that 'Able indeed must that architect have been by whom this city was built.'

According to the outlook of their own times, it would be thought that a woman was a prostitute on account of the working out of her *karma*. It was partly because of the notion of *karma* that the profession was frankly permitted by the social code of the day, and was more openly recognised then than now. Prostitution was regarded as a condition to which a person was reborn as a desert for some offense which, as it was thought, had overtaken her in a previous existence. But she need not remain in this condition. By willing to change, by willing to strive against the stream, and to cultivate the upward mounting way[56] and to live well, a woman could become different, could grow[57] and escape from the prison of sense-desires.

THE BUDDHIST ORDER OF ALMSWOMEN

Admission into the Order

With the growing perception that their life had worth as an end in itself, there was liberated a spirit of independence in women and for women. It sought to express itself in domestic and worldly matters, many of which were also largely religious in character. It also soon became apparent that one of the drifts of this new-found power and freedom was away from purely domestic-religious occupations. In a country where life and religion are practically coterminous, these had been regarded as a woman's normal duties, the amount of religion practised by her coinciding with her domestic functions, and not exceeding them. But now a new drift instead was set exclusively towards religion, towards leading a life devoted entirely to holiness and totally free of worldly interests, impediments and bonds.

As this freedom grew under Buddhism, women fell into two divisions: those who remained in the world as lay-votaries of the religion and those who went forth from the world into homelessness and became *bhikkhunīs*, nuns, sisters or almswomen. They will be called by the last name here on account of their quality of receiving alms.

It has been said,[58] I think extremely unfairly, for there is nothing in the *Vinaya* or in the *Psalms* to support the statement, that women were largely attracted to the order by the personal charm of Gotama. Enough women received the final impetus to join the order from other teachers than Gotama to prove that personal attraction towards him was not a determining factor of any great weight. It was the passion for release (*mokṣa, mokkha*), very great at those times and as widespread as India itself, which largely drew women forward. Freedom was the prize which some of them hoped to win.

Release, as understood in India at that time, implied release from the whole round of becoming, not merely from a rebirth in hell, or in a heaven either for that matter.

In spite of its insistence on transience, and in spite of its replacing those appurtenances and external refuges which had hitherto acted as props to faith by a teaching of reliance upon the self alone, the women were not slow to embrace the *dhamma*. It is justifiable to say that they were in Buddhism from the beginning, and hence affected the initial course of its history.

There were lay-women adherents from the quite early days. The first women to become lay-disciples by the formula of the holy triad were the mother and the former wife of Yasa, the noble youth.[59] Their conversion took place soon after the first sermon, preached in the Deer-park at Isipatana, and just after Yasa's father, the merchant, had become a lay-disciple, and Yasa himself had attained full enlightenment and had become freed from the *āsavas* (cankers). To these women Gotama spoke of exactly the same matters in exactly the same terms as when he was speaking to Yasa and his father.

During the five years that intervened between this episode and the deputation said to have been led by Mahāpajāpatī,[60] no mention is made in the canon of any other women who became lay-disciples, or of any who attained arahantship.[61] It would appear then that Gotama did not speak from experience when he told Ānanda that 'they are capable'[62] of gaining arahantship, but from faith and reasoning, fully justified by later events. On the other hand, there can be little doubt that there was a following of women lay-disciples during the first five years of the ministry, else it is hardly conceivable that Mahāpajāpatī should have been accompanied, as it is recorded, by so large a concourse, so ardent in aspiration.

It may well have been that the idea of entering the order as almswomen originated partly from the sorrow and loneliness of such

women as Rāhula's mother, to all intents and purposes widows or motherless or both, coupled with their old-established right to participate with men in certain religious matters. It was not a novel idea, but more women were ready to renounce worldly ties than there had ever been before. They were even ready to meet the celibacy entailed by the fuller expression of personality which they were demanding. This willingness was but the emergence, on a larger scale, of a phenomenon to which Indians of the sixth century BC were accustomed. The notion of celibacy might be regarded as the first of the stages which had to be accepted by contemporary thought before the practice of women living in a religious community came to be fully adopted.

By the time of the rise of Buddhism the existence of nunneries in India was not without precedent. Mahāvīra did not keep community life as the exclusive privilege of men. He also permitted it to be a right for women. He organized his followers into four orders—monks, nuns, lay-men and lay-women.

According to the Śvetāmbaras at their head was 'Canda, a first cousin of Mahāvīra or, as other accounts have it, his aunt'.[63] If the second alternative gives the true case, there is a curious parallelism to the reputed instigator of the Buddhist order of almswomen, whose foundation, as it is recorded in the *Vinaya*, was due to the initiative of Mahāpajāpatī the Gotamī, the aunt of Gotama. A good deal of uncertainty surrounds the actual foundation of the Buddhist order of almswomen, and its beginnings are wrapped in mists. It is possible that Mahāpajāpatī came late into the order, after her husband had died,[64] and that the woman really to make the order open for women was Yaśodharā,[65] possibly the former wife of Gotama, who in her verse in the *Apadāna*[66] is said to represent many women and herself. This is the merest surmise. But in the *Vinaya* the woman called Mahāpajāpatī is represented as the leader of the women.[67] Whichever one it was, her many attempts and failures to win her heart's desire bear witness to her determination, no less than to the urgency of the need which prompted her.

Gotama is represented as saying that mother and son by following the Noble Eightfold Way are able to overcome the three terrors. There seemed to have been no real doubt in his mind as to the equality of the powers of men and women.

He, therefore, acceded to Ānanda's proposition and opened the order to women, on condition that Mahāpajāpatī should 'take upon

herself the Eight Chief Rules (*garudhammā*)' to be reckoned as her initiation.[68] On her enraptured acceptance of these terms as propounded to her by Ānanda, the faithful disciple returned to Gotama and gave him a report of the interview.

He is recorded to have said:[69] 'If, Ānanda, women had not received permission to go out from the household life and enter the homeless state, under the doctrine and discipline proclaimed by the Tathāgata,[70] then would the pure religion, Ānanda, have lasted long, the good law would have stood fast for a thousand years. But, since, Ānanda, women have now received that permission the pure religion Ānanda, will not last so long, the good law will now stand fast for only five hundred years.'[71] Although this statement is strongly worded, and is usually interpreted to mean that Gotama grudged women their entry into the order, it would be mistaken to let one utterance colour our entire opinion of his attitude towards this situation. It should be remembered too, that monks edited the sayings attributed to Gotama, and they would naturally try to minimise the importance which he gave to women.

Even if many of the first women members of the order were the wives and mothers and daughters of the male members, and if they, therefore, to some extent profited by their membership, yet they also vastly strengthened and consolidated the movement by their devoted adherence and generosity, output as preachers and lives of arahantship. They had determined to enter the order, and once in they determined that both it as well as they should win success. They were not of the stuff that is deterred by hard sayings, for theirs was the cause of freedom, for themselves and for others, both from the drudgery of the world[72] and from rebirth.[73]

THE EIGHT CHIEF RULES

If the life of an almswoman were to be rigorous as compared with that of a laywoman; if she were to be and to remain healthy; if she were to be self-reliant and spiritually competent; if she were to cast no longing backward glances at the world which she had left; and if she were to be disengaged from all the claims which it might have had over her—the examination leading to the admission would necessarily be hard and comprehensive, and the training leading to the examination would be long and arduous and arranged so as to give a foretaste of the heavier demands to follow.

In the examination, after the sixteen questions regarding deformities and diseases (leprosy, boils, dry leprosy, consumption and fits) had been answered, the almswomen candidates had to answer the following ten questions:

(1) Are you a human being?
(2) Are you a female?

This was possibly asked to insure against the admission of eunuchs.

(3) Are you a free woman?[74]

Slaves were not admitted to the order,[75] that is to say they were not even eligible for the *pabbajjā* ordination.

(4) Are you free from debts?[76]
(5) Are you in the king's service?

In spirit it is kindred to the prevalent contemporary outlook: that as slaves and debtors are in some way bound to the world, because they or their money belong to other people, in the same way those in the royal service belong to the king, and are his inalienable property.

(6) Have your father and mother given their consent?

It is difficult to know how much importance the *saṁgha* attached to the necessity for a wife to secure her husband's consent for admission. If the husband's permission had appeared to be as important as the parents', doubtless a question on this point would have been put to the entrants. There certainly came to be the ruling that it constituted a *pācittiya* offence for an almswoman to ordain a girl who had not the consent of her parents or husband.[77] The preliminary step of gaining the husbands' permission appears, so far as the records go, to have been taken by the majority of the married applicants. Mention is frequently made of women who either tried and succeeded or who tried and failed to gain their husbands permission. Wives are never represented as announcing to their husbands, as the husbands sometimes did to them, that they were about to renounce the world, and they seldom slipped surreptitiously away. Hence as no question was put by the *saṁgha* on this matter, it is probable that the husband's consent was rooted in domestic obligations and social convention rather than in religious sanction.

(7) Are you full twenty years of age?

That is older than the normal marriageable age. It was thought desirable that girls should have come to years of discretion before they were ordained. For if they entered the order while still quite children both the physical hardships and the mental strain of a life dedicated to religion would be too great for them and in their fragile youth they would fail and succumb. It is stated that young children are unable to endure the heat and the cold, the discomfort caused by biting animals and creeping things; that they are unable to grasp the doctrines which are difficult to explain; and that bodily pains are hard and bitter for them.

Further, the candidate seeking ordination should have come to years of discretion as a kind of guarantee that she entered of her own considered choice.

(8) Are you duly provided with robes and alms-bowl?

The symbols of a homeless state. Entrants took no dowry with them and presented no money to the order on entering it: no entrance fee was demanded or expected of them.

(9) What is your name?

It became commoner later for entrants to change their name after having been admitted.

(10) What is the name of your proposer?

Probably the intention of this question was to ascertain whether she was one who had been approved by the council.

No entrant was asked to give any reasons for wishing to join, and there were no questions as to the kind or amount of education, religious or secular, that the entrant had hitherto received, and no inquiries as to the manner in which she had hitherto spent her life. These points presumably would be covered by the training in the Six Rules during her two probationary years before she asked for full ordination. If she could answer the twenty-six questions in a satisfactory way the only other hindrances which there appear to have been to her admission were covered by two precautionary rulings. The first of these was to render novices of undesirable character ineligible for application for admission: those who kept company and were disorderly in their habit or speech with men or boys, those who were ill-tempered and those who caused grief in others. These were

obviously unsuited to lead the monastic life and religion was not their true vocation. Thullanandā is depicted as ordaining Caṇḍakālī, a novice characterized by all these attributes, all of them calculated to threaten the internal peace of the order. The second precautionary ruling was designed to prevent women in a certain state from applying for full membership; namely pregnant women and women giving suck. The life of the young for whom they were responsible would certainly rank as a tie, a chain to the world, and could not be countenanced in a life whose aim it was to be composed of members who were freed of human and worldly bondage.

After the almsmen had recounted to the 'newly raised up' almswoman all the facts relating to her spiritual birth, they were to say to the other almswomen, 'You are to teach her what are the three things allowed (*nissayas*)[78] and what are the eight things interdicted (*aṭṭha akaraṇīyāni*).'[79] Almsmen, upon whom the Upasampadā Ordination had been conferred, were allowed four resources or necessaries (*nissayas*): morsels of food given in alms (*piṇḍiyālopa-bhojana*), a robe made of rags taken from the dust-heap (*paṃsukula-cīvara*), dwelling at the foot of a tree (*rukkhamūlasenāsana*), and decomposing urine as a medicine (*pūtimuttabhesajja*). The resource (*nissaya*) not allowed to the almswomen was the dwelling at the foot of a tree. Probably Gotama realized the undesirability of a solitary forest life for women, knowing full well that obvious dangers were to be expected from men of loose life lurking about, and also, presumably, although never mentioned, from wild animals.

The presence of this danger and the need of guarding against it is further emphasized in the story of the rape of Uppalavaṇṇā.[80] 'At that time it was not forbidden almswomen to dwell in the forest.' She entered a dark forest, had a hut built, a bed set up in it, and curtains hung around. But one day a young kinsman of hers, who had been in love with her before she joined the order, hearing that she was gone to Sāvatthi for alms, entered the forest, found the hut and hid under the bed. On her return he overpowered her and worked his will on her and went away. 'The almswoman told the other almswomen what had happened, the almswomen told the almsmen and the almsmen told the Blessed One.'[81] The case naturally gave rise to a great deal of discussion within the order, and Uppalavaṇṇā was commended in verses uttered by the Blessed One for not clinging to the pleasures of the senses. But because it could not be guaranteed

that all the almswomen had rid themselves of the cankers so completely as she had, and because of other possible awkward results, the matter called for serious consideration. Therefore the Teacher summoned King Pasenadi of Kosala and said to him: 'Your Majesty, in this religion young women of family, as well as young men of family, renounce many kinsfolk, and much wealth, and retire from the world, and take up residence in the forest. In case women reside in the forest, it is possible that evil-minded men inflamed by lust may conduct themselves towards them with disrespect and arrogance, do them violence and bring their religious life to naught. Therefore a place of residence for the community of almswomen should be erected within the city.' The king agreed to this and had a place of residence built for the community of almswomen on one side of the city. 'From that time the almswomen resided only within the city.' This was exceptional, for the residence was usually just outside the city walls. That it was actually built inside here at Sāvatthi is confirmed by two pieces of evidence, the one archaeological and the other documentary. The findings of the recent excavations at Sāvatthi revealed the *vihāra*, known as the Jetavana inside the city walls; and in the literature the almswomen are incidentally portrayed as bringing raw wheat for their food from the fields, through the toll at the city entrance, into their *vihāra* at Sāvatthi.

THERĪGĀTHĀ I

Of the seventy-three verses or psalms which form the collection known as the *Therīgāthā*, seventy-one are supposed to have been uttered by individual almswomen, and two are ascribed to two groups of followers of Paṭācāra, all of them contemporaries of Gotama.

Whether the verses originated from something like spontaneous generation, resistlessly breaking forth from the thankfulness and intense joy of each woman as the glorious truth flashed upon her that her mind was freed (*cittaṃ vimucci me*); or whether they were welded together by editors from customary refrains, the whole collection of verses stands as an undeniable justification, if one is wanted, for the permission granted to women to enter the order. They present a living evidence of a set purpose inspiring courageous endeavour, of a fineness of achievement in the desired task, and of a synthesis and

emergence of personality, which would all have lain dormant or fragmentary if the means of expression had been withheld. The verses, enshrining the results of their spiritual venturings, are a valuable addition to the varieties of religious experience; nearly all of them enrich the history of human thought by witnessing to the triumphant vital will in man and woman to overcome circumstances and difficulties.

The word man, *homo sapiens*, includes women as well; one at least of the almswomen, Somā, the reputed author of one of the verses, was convinced of the inherently equal capacity of the sexes to gain arahantship, the nominal goal of all who embraced the religious life. As a verse Somā's is unique in refusing to admit the relevance of sex where arahantship is the aim.

That a woman could be represented as making such an utterance is a proof that the old life of Hinduism in which women were regarded merely as child-bearers and as commodities was, if not suffering a decline, at least not passing entirely unquestioned. It is not unnatural that this appeal should emanate from a woman, for they were always there in the background. However, slight their effect on a religion might appear to be externally, internally they had great influence, moulding it because they were *in* it, actively interested, and in reality colouring any opinions held by their men-folk.

The reasons inducing these women to seek the cloister were as varied as such kinds of reasons always must be, and as dependent on character and circumstances as such motives always are. The chief guiding impulse which supported several of them in coming to their decision to join the order was the hope of freedom, either in the more usual 'phenomenal' sense of escape from worldly troubles, cares, responsibilities, temptations, griefs, from boredom and from the cloying senses; or in the wider, more 'transcendental' sense of release from the round of existences. Entry into the order was in no way dependent on social status, and by the sixth century BC the importance attached to the notion of release had filtered through all strata of society and was not the monopoly, like Plato's philosophy, of a leisured class, but was something which could be understood, striven for and held by high and low alike.

A table is appended showing from what castes the authors of the *Therīgāthā* are said to have come.

Royal and noble entrants	23	i, iv, v.-xiii, xiv, xv, xvi, xviii, xix, xx, xxv, xxxv, xl, xli, lii, lv, lxiii, lxxiii.
Entrants from families of great merchants[82]	13	iii, xii, xxiii, xxviii, xxx, xxxiii, xxxiv, xlvi, xlvii, liii, liv, lxiv, lxxii.
Entrants form eminent brāhmaṇa families	7	ii, xxiv, xxxi, xxxii, xxxvi, lxvii, lxxi.
Entrants from lesser brāhmaṇa families	9	xxxvii, xlii, xliii, xliv, xlvi, xlvi, lix, lx, lxi, lxix.
Entrants from poor brāhmaṇa families.	2	xi, xlix.
Entrants from other castes	4	xxi, lxv, lxviii, lxx.
Entrants from castes not given[83]	11	xvii, xxvii, xxix, xxxviii, xlv, xlviii, l, li, lvii, lviii, lxii.
Courtesans	4	xxii, xxvi, xxxix, lxvi.

Of the twenty-two royal entrants three were particularly famous in the order: these were Mahāpajāpatī,[84] the reputed founder of the order of almswomen, who hence rather naturally ranked as foremost of those almswomen who were of long standing and experience (rattaññu);[85] Kisā-Gotamī,[86] another kinswoman of Gotama, who became chief among those who wear the rough robes (lukhācīvaradharā), since she was apparently unusually ascetic; and Khemā,[87] who had been the consort of King Bimbisāra, and who while in the order became distinguished for her great insight (mahāpaññā) and as a giver of a standard, an honour which she shared with Uppalavaṇṇā.

It is rather a curious coincidence that of the thirteen women who came from great merchant families, one, Dhammadinnā,[88] became perhaps the greatest preacher of them all: she was regarded as foremost among the almswomen who could preach (dhammakathikā).[89] Belonging to this caste were also Sukkā,[90] who was likewise renowned in this art, and Paṭācārā,[91] who became versed in the Vinaya,[92] and who was revered by many women to whom she had shown the way as a saviour of no less persuasiveness than Gotama himself. Had contact with city life and its ceaseless drift of peoples trained them to use the opportunities of estimating and appealing to the differences of outlook and knowledge among their audiences, thereby enabling them to evoke the response on which their hopes were set? Experience of the ways of mankind was probably valuable in the early days of Buddhist missionary enterprise. Partly because women had never been secluded in their lay-life, but had mixed

WOMEN UNDER PRIMITIVE BUDDHISM 101

freely in society, they were able in the propagation of the doctrine to play a sustained and serviceable part.

Of the entrants from brāhmaṇa families, the most eminent were Bhaddā of the Kāpilas,[93] who became famous for her memories of former lives (*pubbenivāsaṃ anussarantīnā*),[94] and who is described as learned, fluent, wise and famed for her religious discourses;[95] Nanduttarā,[96] who was a renowned speaker and a great debater, converted from Jainism to Buddhism by Mahā-Moggallāna; Sakulā,[97] to whom was assigned the topmost place for the gift of the Higher Vision, or the Eye Celestial (*dibbacakkhukā*)[98] as it was often called; and Sundarī[99] who appears to have made a great many converts, including 'all her kinsfolk beginning with her mother, and their attendants.'

It is interesting to notice the proportion of the widowed, the married and the unmarried among those reputed makers of verses who entered upon the homeless way. There is no clue to the status of twenty-one almswomen, although from internal evidence it may be supposed that of these six were unmarried;[100] and no hint is given as to whether the thirty almswomen who entered under Paṭācāra[101] were married or not. The unmarried certainly number thirty-two, a fact highly suggestive of the improved status of women under Buddhism; for they now stand out as having minds, characters and wills of their own, emerging however slowly and laboriously from the old grooves, in which their complete dependence on men shackled their entire life, which was led on the assumption that their whole duty consisted in worshipping their husband as a god and bearing him sons for the performance of his funeral rites.

The number of married entrants was rather more than half the unmarried, namely eighteen, but in addition to these must be reckoned Paṭācāra's five hundred.[102] Of the married, three were widows,[103] and one, Sakulā,[104] judging by internal evidence, was probably a widow. Four were virtually widows, for two of them, Bhaddā of the Kāpilas[105] and Soṇā,[106] renounced the world when their husbands did: one, Cāpā,[107] having by her gibes driven her husband out of the house and into the order, followed him; the other, Isidāsī,[108] finding after three attempts to lead the married life that she had not the qualities of wifehood, gave up the struggle and joined the order.

Strictly speaking, the order asked for the consent of the parents,[109] and the world for the husband's consent; but because the order

wanted to keep the friendship of the world, it also made it a *pācittiya* offence for a woman to be ordained unless she had her husband's permission.[110]

THERĪGĀTHĀ II

There are two distinct lines of development among the women who truly came to feel the desire to leave the world. There are on the one hand eleven[111] who are recorded to have heard the preaching and become first lay-disciples, three of them becoming stream-entrants, but joining the order later, usually after having heard a discourse by Gotama or by some other preacher, famous or obscure. On the other hand there were those twenty-seven,[112] whose destiny was fully ripe, as it is so often said, and of whom it is not recorded that they passed through the intermediary stage of being first a lay-believer, but who on believing straightway joined the order.

But it did not necessarily need the teaching of the greatest of all to awaken women's faith, and although twenty women are recorded to have been incited to join by the words of Gotama himself, others were finally drawn to the order, not by his teaching but by that of some famous woman-preacher.

Outstanding amongst these is Paṭācāra, who was deeply versed in the *Vinaya*, and also deeply versed in human suffering. She was responsible not only for bringing to the order the five hundred women,[113] each of whom was broken by the loss of a child, but also for consoling them and removing the hidden shaft from their hearts. She is also said to have converted a group of thirty women[114] to the faith by her preaching.

Candā[115] was deeply touched by the kindness of Paṭācāra and the other almswomen with her and by their ministrations to her physical wants, when bereft of all her kinsfolk, a beggar for seven years, and starving, she happened to come upon them. They refreshed her in spirit and body, and she was able to listen with such attention and delight to Paṭācāra's discourse after the meal, that she renounced the world. Paṭācāra ordained her and continued to instruct her. Candā found so 'wise and clear our Lady's homily', that she soon acquired the Threefold Wisdom, and her heart was purified from the deadly drugs.

All this conversion of women by women is part of the weighty contribution that they made to the Buddhist religion. As teachers

they exhibit a variety of attracting forces, consequent upon their individual characters and histories. But whatever aspect of the system made a greater appeal to each one of them, and through her to her listeners as she emphasized her particular point, whether it were, for example, impermanence,[116] including the transitory nature of the self,[117] the surrender to spiritual calm,[118] which is the carrying out of the Buddha's will, fundamentally they all taught the same thing. The basic theme of their homilies was development. The notion of the wayfaring, through becoming (*bhava*) to advance through life-span (*āyu*) after life-span to something better and happier than had been experienced before, was always present in the teaching of each one, though sometimes less stressed as a whole than in particular aspects.

But, however, the search was begun; its end, the moment of insight, was a purely intellectual discovery. It was not accompanied by sounds or by visions. The absence of the former may be accounted for partly by the fact that music had no function in the order, either as a pastime, or as an aid to meditation. A low chanting would be all the music that these women would hear.[119] Moreover, all visual impressions were intended to be ignored, for they were regarded as not in any way potent to clarify the unseen, but on the contrary decidedly to obscure it. The rending of the gloom, the thick gloom of ignorance,[120] is the only visual imagery that is noticed. Tactile imagery is equally non-existent, with one exception.

The actual form in which arahantship was conveyed to each one was to a large extent congruent with her circumstances before entering the order. If, for example, the conditions of her life had been difficult and irksome, her finding of *nirvāṇa* would be negatively presented as freedom, comfort, end of becoming, end of craving, or as rest. If, on the other hand, she had entered because she knew that, whatever were her circumstances, she was ripe to lead the religious life, *nirvāṇa* would be presented to her positively as light, happiness, insight, peace or self-mastery.

LIFE IN THE ORDER

In spite of the absence of vows of adherence, in spite of there being no declaration of acceptance of poverty, chastity and obedience, yet these ideas, summed up in the ten precepts, impregnated the order. Poverty was manifested in the possession of only eight belongings (the three robes, the alms-bowl, razor, needle,[121] girdle

and water-strainer) all of them the bare necessities of livelihood, but known by entrants to be henceforth their only legitimate belongings. Chastity was inculcated by the major precepts of morality, and obedience by the the discipline of the order; for if an almswoman could not obey the precepts she was punished.

Of all the almswoman's possessions the three robes were decidedly the most cumbrous. The necessary care bestowed upon them, far more than the washing of pots and pans, throws her into the light of a domestic worker. Since she was allowed a needle, one of the eight possessions, if the robe were torn, presumably like the almsmen, she could use 'slips of cloth inserted bolt-like to hold a torn robe together, patches and darns, and small pieces of cloth sewn on by way of marking, or of strengthening the robes'.[122] And, of greater importance still, the almswoman washed and dyed her own clothes. Yet this was practically the full extent to which she might carry washing operations.

There is no suggestion that one or several almswomen ever washed for the saṃgha as a whole. Each almswoman washed her own three robes. Hence the distribution of labour was perfectly fair; and hence no one almswoman had so much domestic work heaped upon her, or was employed solely for that purpose, as to leave her neither the requisite time nor energy to undertake more important duties. This plan also kept before each almswoman her responsibility for the care of her personal possessions. It also kept before her the responsibility for her share of the care of communal possessions. For after use, each one was, for example, supposed to wash the household overalls, the āvasathacīvara, which were common property, before handing them on.[123]

The three robes over which each almswoman had proprietary rights were long and loose, and were symbolical of the asexuality of the monastic life. They consisted of the cloak or toga, the cīvara, and two others.[124] Of these, the upper or outer robe was called the uttarāsanga, and the lower or inner, the antara-vāsaka. The three together were called the ticīvara. They were the same for the almswomen as for the almsmen,[125] and are the constantly mentioned yellow robes (kāsāva vatthāni) or the patch-work cloth, (bhinnapaṭa).[126] No flowers or cobras' head should be worked on them.[127] The uniformity of the colour was only flecked by the diversity introduced by the dyes, for the almspeople were forbidden to wear robes that were 'all of a blue, light yellow, crimson, black, brownish-yellow, or

dark yellow colour'.[128] But the materials of which the robes could be made were of six different kinds.[129]

In addition to the *ticīvara*, the almswomen appear sometimes to have worn a wrapping cloak, the *tharaṇapāvuraṇa*.[130] It was large enough for two to share, but they were forbidden to do this;[131] in the same way, although they were allowed to use a half-divan,[132] they were forbidden to sleep two together on one couch,[133] the laity having complained that this resembled the conduct of the women of the world (*gihikāmabhoginiyo*, literally, enjoyers of the senses). Presumably the intention was also to discourage too strong an affection from springing up between any two of them. Personal ties might prove to be a hindrance to leading the higher life; hence chances for forming them had to be reduced wherever it was possible.

Almswomen had also to wear a bodice, the *saṃkacchika*, described in the Old Commentary as coming from below the collar-bone to above the navel for the purpose of hiding the breast. At least they should wear it when they went into the villages.

The gift of robes was often made by the pious laypeople, and by inference it would seem that almswomen might receive gifts of robes from almsmen relatives, and have robes made up for them by almsmen relatives, or at their instigation.[134]

The *saṃghas* also acquired robes by the death of one of their members.

It came to be forbidden for an almswoman to wear a loin-cloth, *sanghāṇi*.[135] They were evidently expected to wear their clothes securely without its aid, and to be different in all the details of dress from the women of the world. But they continued to be allowed to wear a girdle (*kāyabandhana*), another symbolical article of dress, if it conformed to a prescribed and modified style. The rules that were drawn up were all monastic in character, their intention being to promote the simple ascetic life; in order to achieve this end, the natural desires of the women to adorn themselves from the primitive means at their disposal had to be quelled. The tongues of the world, all too ready to wag on the slightest provocation, had also to be quelled.

Unlike the women of the world in almost every item of their apparel, unlike them too in being covered from the waist up,[136] the almswomen tried to imitate them in wearing women's ornaments until this also was forbidden.[137]

NOTES

1. Outstanding among these are Mrs. Rhys Davids' translation of the *Therīgāthā, Psalms of the Sisters*, London: P.T.S., 1909, prefaced by an illuminating introduction; and the late Miss Iulius van Goor's *Die buddhistische Non* (Leiden, 1915).
2. E.g. *Aṅg.*, ii, 57.
3. *Theragāthā*, xxix.
4. *Aṅg.*, iii, 57.
5. *Aṅg.*, iii, 57ff. Rhys Davids, *C.H.I.*, vol. I, p. 189, points out that Muṇḍa and his queen Bhaddā are post-canonical, having begun to reign about 40 AB.
6. Paṭācāra mourned for nearly all her dead relatives, not only for her husband.
7. *Therīgāthā*, lxxii.
8. *Dhp. Cmy.* on verse 82.
9. *Majjhima*, ii, 109.
10. *Jātaka*, 39.
11. E.g. *Therīgāthā*, xii.
12. *Dhp. Cmy.* on verse 118.
13. *Jātaka*, 546.
14. Ibid.
15. *Therīgāthā Cmy.* on cxxxvi.; *Dhp. Cmy.* on verses 7-8. This Kālī is not to be confused with the slave-woman of the same name mentioned below.
16. *Dhp. Cmy.* on verse 348.
17. *Therīgāthā Cmy.* on lxv.
18. *Majjhima*, i, 125-6.
19. *Dhp. Cmy.* on verses 21-3.
20. *Jātaka*, 92.
21. Ibid., 45.
22. *Therīgāthā Cmy.* on lxv; *Dhp. Cmy.* on verse 314.
23. *Dhp. Cmy.* on verses 21-3.
24. *Majjhima*, i, 504.
25. *MV.*, i, 7, 1, 2; cf. Dialogues, ii, 170.
26. Ibid.
27. *MV.*, v, 10, 3.
28. *Jātaka*, 529.
29. Ibid., 132, 313
30. Ibid., 539.
31. Ibid., 531.
32. *MV.*, viii, 1, 3.
33. *C.H.I.*, vol. I, p. 97; Macdonell and Keith, *Vedic Index*, vol. I, p. 345; cf. vol. I, pp. 30, 147, 481; vol. II, p. 496.
34. *C.H.I.*, vol. I, pp. 88-9.

35. *Therīgāthā*, xxxix.
36. *Sutta Nipāta*, Cmy., i, 144.
37. *MV.*, viii, 1. 2-4.
38. The putting away of an illegitimate child is referred to in the *Ṛgveda*. Macdonell and Keith, loc. cit., vol. I, p. 395.
39. *Dhp.* Cmy. on verses 21-3.
40. *MV.*, viii, 1,4.
41. *Therīgāthā*, xxxix.
42. She occurs again *Therīgāthā*, verses 1150-7, again being rebuked by Mahā-Moggallāna.
43. *Therīgāthā* Cmy. on xxvi.
44. Ibid., on xxii.
45. *Therīgāthā* Cmy. on lxvi.
46. *Milindapañho*, vi, 4.
47. *Jātaka*, 276.
48. Ibid.
49. Ibid., 419.
50. Ibid., 481.
51. *MV.*, viii, 1, 3.
52. *Jātaka*, 546.
53. *Dhp.* Cmy. on verse 3; *Jātaka*, 318, 481.
54. Ibid.
55. *Milindapañho*, v, 4.
56. *Therīgāthā*, verse 99.
57. *Saṃy. Nik.*, XXXVII., iii, 3, § 34.
58. Eliot, *Hinduism and Buddhism* (London, 1921), vol. I, p. 248.
59. *MV.*, i, 8, 1-3.
60. *CV.*, x, 1-3.
61. Sainthood, ability, worth.
62. *CV.*, x, 1, 3.
63. Sinclair Stevenson, *History of Jainism* (Oxford, 1915), p. 66.
64. *Therīgāthā* Cmy. on lv.
65. *Apadāna*, vol. II; *Theñapadāna*, no. 30, p. 592.
66. Ibid.
67. *CV.*, x, 1, 1.
68. *CV.*, x, 1, 4.
69. *CV.*, x, 1, 6.
70. Derivation uncertain; lit. Thus-come or Thus-gone. Lord Chalmers uses 'Truthfinder'. The term was first used in the Buddha's life-history immediately after he attained enlightenmnent, and was designedly put into the mouth of Mahā-Brahmā himself; cf. *Majjhima*, i, 168; Lord Chalmers' translation, vol. i, p. 118, note.
71. A thousand and five-hundred, not to be taken literally but simply as meaning over a long time.

72. E.g. *Therīgāthā*, xxi.
73. Many of the *Therīgāthā* speak of Insight won: i.e. Insight into the Truth of Becoming, which is the knowledge which sets free from rebirth.
74. According to the *Bhikkhunīvibhaṅga Cmy.* on *V*, iv, p. 224, there were three kinds of slaves: those who were born slaves (*antojāto*), those who were bought for money (*dhanakkīto*), and those who on the field of battle were spared for slavery (*karamarānīto*).
75. *MV.*, i, 47.
76. *MV.*, i, 46.
77. *V.*, iv, p. 334.
78. *MV.*, i, 30, 1; cf. the four requisites (*paccaya*) used by the almspeople in general, *piṇḍapāta* (alms), *cīvara* (robes), *senāsana* (a dwelling-place), and *bhesajja* (medicine). Possibly the *nissayas* were observed only by the stricter almspeople.
79. Cf. *MV.*, i, 78.
80. *Dhp. Cmy.* on verse 401, and cf. Uppalavaṇṇā, *Therīgāthā*, lxiv. Possibly not the same.
81. This is the usual way in which it is recorded that reports reached the Founder. With the exception of Mahāpajāpatī, the almswomen are never represented as themselves going straight to him.
82. This is considered by Winternitz to be the best translation of *seṭṭhi*.
83. This number includes Paṭācārā's thirty and her five hundred. At *V.*, iv, p. 272 it is said that there are four families (*kula*): the *khattiya*, *brāhmaṇa*, *vessa* and *sudda*.
84. *Therīgāthā*, lv.
85. *Aṅg.*, i, p. 25.
86. *Therīgāthā*, lxiii; *Dhp. Cmy.* on verse 395.
87. *Therīgāthā*, lii.
88. *Therīgāthā*, xii.
89. Cf. *Aṅg.*, i, 25.
90. *Therīgāthā*, xxxiv.
91. Ibid., xlvii.
92. Cf. *Aṅg.*, i, 25.
93. *Therīgāthā*, xxxvii.
94. Cf. *Aṅg.*, i, p. 25.
95. *V.*, iv, 290, 292.
96. *Therīgāthā*, xlii.
97. Ibid., xliv.
98. Cf. *Aṅg.*, i, p. 25. These powers are included among the culminating stages of *paññā* or *vijjā*.
99. *Therīgāthā*, lxix.
100. Ibid., xiv, xxiii, xxiv, xxx, xxxiv, xlii.
101. Ibid., xlviii.

102. *Therīgāthā*, l, five hundred is an idiom, meaning dozens and dozens.
103. Ibid., xvii, xlvii, lv.
104. Ibid., xliv.
105. Ibid., xxxvii.
106. Ibid., xlv.
107. Ibid., lxviii.
108. Ibid., lxxii.
109. *MV.*, i, 54; *CV.*, x, 17, 1.
110. *V.*, iv, pp. 334-5.
111. *Therīgāthā*, i, xxxii, xxxiv, xxxv, xxxvi, xxxix, xliv, lxv, lxx, lxxi, lxxiii.
112. Ibid., ii, iii, iv-x, xiii, xiv, xv, xvi, xviii, xxiii, xxiv, xxx, xxxi, xl, xliii, xlviii, xlix, l, liii, liv, lvii, lviii, lxii, lxvii.
113. Ibid., 1.
114. Ibid., xlviii.
115. Ibid., xlix.
116. Ibid., 1.
117. Ibid., xxx, xxxviii.
118. Ibid., xlvi, lviii.
119. Almsmen were allowed to intone the *dhamma* instead of singing it with the abrupt transition of song-singing. *CV.* v, 3, 1.
120. *Therīgāthā*, iii, xxx, xxxv, xxxvi, xlviii, lii, lvii, lviii, lix, lx, lxi, lxiv.
121. Jain recluses must not possess a needle, or anything made of metal. Sinclair Stevenson, *Heart of Jainism*, Oxford, 1915, p. 226.
122. *MV.*, viii, 14, 2.
123. *V.*, iv, p. 303.
124. Rhys Davids and Stede *Dictionary*, '*Santaruttarena*', 'with an inner and an outer garment', cf. *V.*, iv, 281.
125. One of the almsmen's robes was also called the *saṁghāṭī*.
126. *V.*, iv, p. 214; and *CV.*, x, 10, 4.
127. *CV.*, x, 10, 4.
128. Ibid.
129. *V.*, i, pp. 58, 96, 281, *khoma* (linen cloth), *kappāsika* (cotton), *koseyya* (silk), *kambala* (woollen) *sāṇa* and *bhaṅga* (coarse hempen cloth).
130. *V.*, iv, p. 289.
131. Ibid.
132. *CV.*, x, 27, 2, note 2, 'probably a cushion'.
133. *V.*, iv, p. 288.
134. *Pācittiya Dhamma*, 26.
135. Rhys Davids and Stede's translation, *Dictionary*. The Old Commentary describes it as something which goes about the hips. But this might be a petticoat. *V.*, iv, p. 339ff.
136. *Dialogues*, I, p. 130, note 1.
137. *V.*, iv, p. 340. Cf. *CV.*, v, 2, 1, where ornaments are forbidden to the almsmen.

SECTION II
Women and the Economy

Proprietary Rights of Women in Ancient India

N.N. Bhattacharyya

There has been no dearth of work on *strīdhana* or 'woman's property' in India, written from a purely legalistic point of view, since the establishment of the East India Company's rule in India. William Hickey, who came to Calcutta as a legal practitioner during the time of Warren Hastings, observed that the Indians were impressed by the British system of the administration of justice and that the ever-increasing law-suits offered a wide scope of earning to the European legal practitioners who came to seek their fortune in this country. It was for their convenience that need was felt to compose treatises on Hindu and Muslim laws. The first work of this kind was *A Code of the Gentoo Law*, which was an English rendering of *Vivādārṇavasetu*, compiled under the direction of Warren Hastings, by a team of brāhmaṇa legal experts, done by N.B. Halhed and published in the year 1776. The first authoritative work on Hindu law was H.T. Colebrooke's *A Digest of Hindu Law on Contracts and Succession*, with a commentary by Jagannath Tarkapanchanan, which was published in four volumes from Calcutta in 1797-8. This work contains, with other aspects of Hindu law, sections on *strīdhana*. In the list of the earlier publications in the Bibliotheca Indica series, ancient legal texts occupied a leading position. It was probably due to the fact that the European legal practitioners, as well as their Indian counterparts, were required to know the basic contents of the Dharmaśāstras and their commentaries, frankly for their professional interest.

Among the nineteenth century major publications of legal treatises, dealing with *strīdhana* as well, mention may be made of Thomas Strenge's *Hindu Law* which was published as early as in 1830. *The Digest of Hindu Law*, written by West and Buehler and published in 1867-9, was also a landmark in modern legal literature of India. But the most authoritative work was Sir Gooroo Das Bannerjee's *Hindu Law of Marriage and Strīdhana*, which was originally published in 1878

and had undergone numerous editions as had been in the case of J.D. Mayne's *A Treatise on Hindu Law and Usage*, another important legal publication of the nineteenth century. Rao Saheb V.N. Mandlik's *Hindu Law* which was published in 1880 had also been a standard work for many years. The Tagore Law Lectures, instituted by the University of Calcutta, were instrumental in bringing out a good number of legal publications. Among these the lectures on the *Outlines of the History of Hindu Law of Partition, Inheritance and Adoption as Contained in Original Sanskrit Treatises*, which were delivered in 1885 by J. Jolly, came out in a book form in 1888. Next to the work of Sir Gooroo Das Bannerjee it has been the most useful work on *strīdhana*. Another work of Jolly is also important for our purpose. It was written in German and published in 1896 from Strassburg under the title *Recht und Sitte* which was subsequently rendered into English by B.K. Ghosh and published from Calcutta in 1928 under the title *Hindu Law and Custom*. Another important work, having bearing on our subject, was G.C. Sarkar's *Hindu Law of Adoption*, which was published in 1891.

In the present century there has been a multifarious increase in the publication of legal literature in most of which the question of *strīdhana* has been seriously dealt with. Among such publications mention should be made of Priyanath Sen's *General Principles of Hindu Jurisprudence* (1918), K.P. Jayaswal's *Manu and Yājñavalkya: A Comparison and a Contrast* (1930), Radha Binod Pal's *History of Hindu Law* (1938), P.V. Kane's *History of Dharmaśāstra*, vol. II (1941) and vol. III (1946), N.C. Sengupta's *Evolution of Ancient Indian Law* (1953), L. Sternbach's *Judicial Studies in Ancient Indian Law* (1965-7) J.D.M. Derrett's *Religion, Law and State in India* (1968), etc. This abundance of modern studies on the ancient legal tradition of India amply testifies that *strīdhana* or women's property was never a neglected subject. It should also be remembered in this connection that a considerable bulk of the civil suits has always been concerned with women's property and as such the concept of *strīdhana* has been the subject of wide discussion and controversy. So goes a proverb in India that the lawyers fill their coffers with women's money, and this is not without any significance. In fact, all the studies on *strīdhana* have been from a legalistic and professional point of view. The only exception is the work of P.V. Kane, in which there has been an attempt to view the whole thing in an historical perspective. Without much exaggeration, it may be said that most of the wellknown

modern treatises on Hindu law purport in a subtle way to devise endless ways and means to deprive the women, especially the widows, of their property right, and these cunning devices have been given the status of law in the name of the interpretation of the ancient texts rather than what the texts suggest by themselves. As Kane has rightly said:

> It is also to be regarded that owing to the ignorance of Sanskrit on the part of the most judges that had to decide cases of Hindu Law, the opinions of individual learned authors... were followed without personal examination by judges on the authorities on which the opinions of authors were based. (Kane, III, 757 n.)

The best way to deprive a woman of her property-right is to make the scope of *strīdhana* as narrow as possible so that it might comprise no more than a few clothes and ornaments. Thus, while according to the Mitākṣarā, the property inherited by a woman or obtained at a partition should fall definitely within the category of *strīdhana* and pass automatically to her own relations after her death, the modern jurists have taken just a different stand saying that the property inherited by a woman from her parents or parents-in-law or husband or anyone should not fall within the category of *strīdhana* and that it should pass after her death not to her own relations or natural heirs but to the next heir of the person from whom she inherited it.

While dealing with the property rights of ancient India, one should not forget that it took a long time for the primitive customs and conventions, by which the ancient societies were governed, to get streamlined into a widely acceptable legal system, that quite for a long time the whole matter of inheritance was not regulated by any general state power and that different regions of the country had and still have different legal traditions. Even in a single region laws and customs vary from caste to caste, community to community. Everywhere in India, there is a wide gulf of difference between the codified and customary laws. The former consists of the laws and customs as codified in the Dharmaśāstras or Smṛtis and is followed mostly by the dominant section comprising about 20 per cent of the total population of India. Others follow various customary laws and traditions for the study of which we are to depend on the vast mass of anthropological literature including correspondences, notes and queries, gazetteers, memoirs, journals, census reports, surveys and individual monographs on tribes and castes.

Matrilineal inheritance, which is prevalent among various tribes and castes of India, is a typical example of customary laws. P.R.T. Gurdon and A. Playfair have given details of this form of inheritance in their works entitled *The Khasis* and *The Garos of Meghalaya* which were published respectively in 1907 and 1909. Among these tribes the entire property belongs to the mothers and it is transmitted in the female line from mother to daughters, the youngest one having the largest share. Such form of inheritance has been noticed among various tribes and castes of Madhya Pradesh, Karnataka and Kerala, details of which are found in such works as *The Tribes and Castes of the Central Provinces of India* (1916) by R.V. Russell and Rai Bahadur Hira Lal, *The Mysore Tribes and Castes* (1928-35) by H.V. Nanjundayya and L.K. Ananthakrishna Iyer, *The Tribes and Castes of Southern India* (1909) by E. Thurston and K. Rangachari and *The Cochin Tribes and Castes* (1909) by L.K. Ananthakrishna Iyer. In Kerala, the Nayar joint family or *tarwad* consists of a woman, her daughters and grandchildren in the female line, and when it grows unusually big it often splits into smaller family units called *tavazis*. A thorough study of the rules of matrilineal inheritance was made by Baron Omar Rolf Ehrenfels in his *Mother-right in India*, which was published in 1941. The custom of matrilineal inheritance has also been extensively dealt with in Debiprasad Chattopadhyaya's *Lokāyata* (1959), K.M.Kapadia's *Marriage and Family in India* (1966) and the present writer's *Indian Mother Goddess* (1970, 1977). In certain cases again, we come across a transitory phase between matrilineal and patrilineal forms of inheritance in which the sister's son gets the property of his mother's brother. Reference to such a typical system is found in the *Mahābhārata* (VIII.45.13) in which it is stated that this form of inheritance was in vogue among the Āraṭṭas and Bāhīkas. In southern India this system was known as *alia-santāna* which was followed even by the kings of Travancore. What we want to suggest is that, so far as the question of inheritance and ownership of property was concerned, the doctrine of *patria potestas,* so intensely crystallized in the Smṛtis, was never a universal phenomenon in India.

From the internal evidence of the *Ṛgveda*, it appears that the concept of individual ownership was not prevalent in the early Vedic age. References to 'common wealth' or 'collective ownership' are found abundantly in the *Ṛgveda* (cf. I. 141.1; III. 2.12; VI.26.1; VII.76.5; VIII.99.8, etc.). Tribal bond of kinship was an essential feature of the early Vedic society and as such tribal wealth was divided

among the constituent clans and subclans. This is attested by the passages referring to *vārya* and *bhāga* which were the Ṛgvedic terms of division. Land was not any form of property in the early Vedic age, because agriculture was then hardly known. Even when agriculture was introduced in the later Vedic age land was subject to joint or corporate holding, so the question of individual ownership and inheritance of land could not arise at all. The Vedic tribes were mostly pastoral warriors and they counted wealth in terms of cattle. The pastoral societies have, however, greater scope to develop the sense of property and individual ownership since cattle could be preserved and multiplied, used as the best medium of exchange, increased by wars and raids, and divided among clans, families, even individuals. Evidence of some kind of individual possession is found in the later books of the *Ṛgveda*. That in the later period of the *Ṛgveda* even women were entitled to have some share of cattle wealth as marriage gift is suggested in the 'wedding hymn' (X.85.13-38). The term mentioned there is *vahatu* which has been explained by Sāyaṇa as 'cow and other gifts given for pleasing the girl'.

Needless to say that the Vedic society, owing to its pastoral background, was essentially patriarchal which is attested by the abundance of misogynistic passages in the Vedic texts. For example, in the *Śatapatha Brāhmaṇa* (IV.4.2.3) it is stated that 'women own neither themselves nor an inheritancer'. Yāska in his *Nirukta* (III.4) says that women are not entitled to partition and inheritance. But whatever was the attitude towards women, it was not possible in practice to suppress all their property rights, especially owing to the fact that there were parallel traditions everywhere in which women were treated differently and the influence of which could not be ignored by the Vedic law-givers. The term *pāriṇāhya* has been used in the *Taittirīya Saṁhitā* (VI.2.1.1) indicating the authority of the wife on family resources. This recurs in the *Pūrvamīmāṁsāsūtra* (VI.10.10) of Jaimini which has been explained by Śabara in terms of possessing certain forms of property by the wife, and almost in the same sense the term has been used by Manu (IX.11). It should, however, be stressed that although the concepts of property and division are found in the Vedic texts, especially the later ones, in that formative period of economic life there was a natural contradiction between the social and individual ownership. The Dharmasūtras are openly in favour of an extremely patrilineal form of inheritance in which in the absence of sons the property will rather go to the near and

remote agnates (*sapiṇḍa* and *sakulya* relations) of the property-holder than to the daughters of his own seed. The Dharmasūtras of Āpastamba (II.6.14.19), Baudhāyana (II.2.49) and Vasiṣṭha (XVII. 48-9), however, say that the ornaments and such wealth as bestowed upon her by her relations, both agnate and cognate, should be absolutely owned by her.

It is in the Dharmaśāstras or Smṛtis that we come across a distinct codification of the rules relating to ownership, inheritance and partition. The codes of Manu are the first systematic expositions of all these, and his basic approaches to these questions were followed in principle, with certain conservative or liberal reservations, by the later law-givers. The *Manusmṛti* must have been composed before the beginning of the Christian era, while the Smṛtis of Yājñavalkya, Nārada and Bṛhaspati were composed within the limit of the Gupta age, and those of Kātyāyana, Vyāsa and Parāśara in the post-Gupta period. Manu made the Dharmasūtra traditions up to date. But while dealing with the Dharmasūtra injunctions regarding the property-rights of women, he faced two apparently contradictory principles. The first is that Dharmasūtras allow women to become exclusive owners of such wealth as is obtained by them as gifts from their relations. This formed the basis of his famous formulation of the sixfold concept of *strīdhana* (IX.194). The second principle of the Dharmasūtras was rather difficult for him to accept. The Dharmasūtras categorically say that property should be transmitted only through the male line and that women have no right to inherit their paternal property by themselves. Manu was no less patriarchal than the authors of the Dharmasūtras, but as the first universal law-giver he had to take into consideration the existing laws belonging to other popular traditions, apart from the Vedic sources, which speak of women's right to inherit their ancestral property. So he had to make a compromise. Thus, on the one hand, nowhere in his codes he says that sisters are equally entitled to the patrimony as their brothers but, on the other, he says that for the purpose of the marriage of their sisters the brothers should forego one-fourth of their own shares in favour of the sisters (IX.118). Obviously, this does not mean that the daughters are the natural heirs of their father. The father is, however, at liberty to give any amount of wealth as gift to his daughter and such gifts are regarded as belonging to the *pitṛdatta* and *anvādheya* categories of *strīdhana*. Apart from this, if a man is sonless, he can regard his daughter as *putrikā* or 'daughter functioning

as son' who will be his legitimate heir (IX.127). The wealth owned by the mother will pass to the daughter (IX.131). It is surprising to note that Manu is completely silent about the rights of the widow.

The codes of Manu had a tremendous impact not only on the subsequent law-givers but also on others belonging to different disciplines. Even a philosopher like Śaṅkara unconditionally says that in regard to social matters Manu is final. Of course, among the subsequent law-givers some differences from Manu in approach are found. For example, Yājñavalkya supports Manu's insistence on the doctrine of primogeniture, but he holds that the father and sons have equal ownership of ancestral property which subsequently led to the emergence of *janma-svattva-vāda*, peculiar to the Mitākṣarā school. He says, in conformity with Manu's view, that after the father's death the sons shall divide property among themselves, the mother taking an equal share and the sisters a fourth part of the son's share. Like Manu, Yājñavalkya does not make any clear statement whether this one-fourth share, enjoyed by the sisters, is owing to a natural succession or to a moral obligation for which the brothers should forego their one-fourth. So far as *strīdhana* is concerned, Yājñavalkya clarifies the stand of Manu and insists categorically on the exclusive right of women on their *strīdhana*. The husband can make use of it only in case of a famine, or for the performance of some specially efficacious religious rite, or during illness or under such severe conditions when he has no other way to save himself without the help of his wife's money.

Later law-givers like Nārada, Bṛhaspati and Kātyāyana, and their successors follow either Manu or Yājñavalkya with diminishing importance on the doctrine of primogeniture upheld by the earlier authorities. In regard to inheritance and partition, so far as the shares of women are concerned, they also speak of the one-fourth share conventionally without any further clarification. However, in regard to *strīdhana* some of them are more particular. Among them Kātyāyana (594ff., 895-920) makes the most elaborate treatment of *strīdhana* making improvement of what was suggested by Manu and Yājñavalkya and his version has been accepted by all digests including the *Dāyabhāga*. He defines *strīdhana* under the following categories: *adhyāgni* or what is given to a woman at the time of marriage before the nuptial fire; *adhyāvahanika* or what she obtains when she is being taken from her father's house to the bridegroom's; *prītidatta* or what is given to her through affection (to this category Manu includes gifts

from the husband during love-making); *śulka* or what is given to her as the bridal price (which includes household articles as well); *anvādheya* or what is given to her after marriage from the family of her husband or of her own parents (to a certain extent it corresponds to Manu's *pitṛdatta, mātṛdatta* and *bhrātṛdatta* categories, though he refers to a seventh category under the title *anvādheya* meaning 'gift-subsequent'); and *saudāyikā* or what is obtained by a married woman in her husband's house or by a maiden in the house of her father. In other words:

all property (whether movable of immovable) obtained by a woman, either as a maiden, or at marriage, or after marriage, from her parents or from husband and his family (except immovable property given by husband) is included within the scope of *strīdhana*. (Priyanath Sen, 335-6)

From the tenth century onwards there was a qualitative change in the approach towards property and property relations. It was possible after the advent of Jīmūtavāhana (*c.* AD 1100-50) and Vijñāneśvara (*c.* AD 1080-1100). The *Dāyabhāga* of Jīmūtavāhana and the *Mitākṣarā* of Vijñāneśvara became so important that throughout the successive ages these two works and their legal interpretations came to be regarded as almost the sole source of the Hindu laws relating to ownership, partition and inheritance. According to the *Dāyabhāga* of Jīmūtavāhana, ownership implies absolute competence of the owner to dispose of his property at his will. The owner is the sole lord of his property having the right of its alienation without the consent of his sons or relations. Jīmūtavāhana has also brought a significant change in the concept of *sapiṇḍa* relation. He says that there is no reason to hold that this relation should evolve only among the strictly patrilineal agnates. Rather those who are more intimately associated with the family, notwithstanding cognates of different male descent, like the daughter's son, father's daughter's son, maternal uncle, etc., should be regarded as belonging to the *sapiṇḍa* relation. This is a revolutionary departure from the approach of the previous law-givers. Jīmūtavāhana accepts Kātyāyana's definition of *strīdhana* allowing every right to the woman to give, sell or enjoy it independently of her husband. Jīmūtavāhana also categorically says that if the owner of the *strīdhana* does not bestow her property at her own will to her chosen person or persons, the property will devolve equally upon the sons and unmarried daughters.

The *Mitākṣarā* of Vijñāneśvara, which is actually a commentary on

the *Yājñavalkyasmṛti*, is of more complex character than the *Dāyabhāga* of Jīmūtavāhana. Vijñāneśvara, unlike Jīmūtavāhana, does not admit absolute ownership of an individual over the property and holds that certain relations acquire ownership at the moment of their birth. As soon as a son is born, he becomes co-owner of the property enjoyed by the father. In the field of succession, agnates are preferred to the cognates. Vijñāneśvara has given the sonless widow the right to succeed to the whole property of her husband. As between the claims of the daughters he prefers unmarried to the married and unprovided to the endowed daughter. His rule of succession is mainly based upon the principle of propinquity or proximity of relationship and as such he allows the daughter's son to succeed immediately after the daughter and before the mother and the father, and the mother to succeed before the father. According to Vijñāneśvara's concept, the *strīdhana* is that form of property which is acquired by a woman 'by inheritance, purchase, partition, seizure and finding'. Among the six categories of *strīdhana*, in the case of those belonging to *anvādheya* and *prītidatta* categories, daughters are allowed to succeed equally and in their absence the sons. *Strīdhana* belonging to four other categories will be succeeded in the following order—unmarried daughter, unendowed married and endowed married daughter. The *strīdhana* of a childless woman goes to the husband.

Although there was not so much anomaly in the case of *strīdhana* which could be accrued in the hand of a woman through a variety of sources and after her lifetime possession and enjoyment of it, it could be succeeded by her heirs in the female line on the basis of the principle of propinquity, the question of a woman's natural right to succeed her father's property directly, as that happened in the case of her brother's, has not been clearly answered in the Smṛtis and their commentaries. From the bewildering variety of statements found in these texts what actually emerges, as has rightly or wrongly been understood by the present writer, may be reproduced as follows. Regarding direct inheritance of the father's property the Dharmaśāstras or the Smṛtis and their commentaries follow the Dharmasūtra tradition according to which property will devolve only among the sons and in their absence among the agnates in the male line. That the sisters were entitled to get one-fourth of their brothers' share on account of their marriage was more an expression of moral obligation than of a legal compulsion. When all the Smṛtis and their commentaries unanimously say that what a woman obtains through

inheritance becomes a category of her *strīdhana*, it does not mean direct inheritance of her father's property; rather it means the direct inheritance of her mother's *strīdhana*. What she obtained from her father, brothers and paternal relations was gift rather than inheritance, and the wealth thus accrued in the *strīdhana* might be turned into a property to be inherited by her daughters. The question of a daughter's direct inheritance could arise only when the father was sonless. But the Smṛtis and their commentaries are not at all unanimous on the question whether in the case of a sonless person his daughter can be natural heir of her father's property or it will go to the agnates of the paternal line according to the principle of propinquity. Even Manu's concept of *putrikā*, i.e. sonhood ascribed to the daughter by the sonless father, has been subject to keen controversy among the commentators. This remained a floating question, causing innumerable law suits, till the enactment of the Hindu Code. Again, when all the Smṛti writers agree that what is obtained by a woman owing to the partition of a property will form a category of her *strīdhana*, it undoubtedly implies an inheritance, but it pertains to the wife, widow, mother and even grandmother and not to the daughter. The wife, the widow, the mother or the grandmother could not demand a partition by themselves but were entitled to a share when the partition took place. The wife's share in most cases was equal to that of a son. The widow of a deceased coparcener was a member of the coparcenary. Kātyāyana (926) allows a sonless widow to become the sole owner of her husband's property, though this stand is not maintained in all the Smṛtis. The *Dāyabhāga* holds that the widow of a sonless member of a joint family is entitled to have a share of the property while the *Mitākṣarā* allows absolute ownership of the widow over the movable property of her deceased husband.

Turmeric Land:
Women's Property Rights in Tamil Society since Early Medieval Times

Kanakalatha Mukund

As with many questions relating to the status of women in Indian (and specifically Hindu) society, the simple question, 'what rights did women have to property?' becomes an extremely complex one with no uniform answers which are valid for all regions, castes or classes. To begin with, there is no unanimity on this question even among the various Smṛtis and texts of jurisprudence. That there should be a considerable variance between theory and customary practice is understandable. What is difficult to reconcile is the general perception that women have no property rights in Hindu society, even though there have been several legal cases about women's property rights and the *strīdhana* which even went up to the Privy Council.[1] This paper is an attempt to examine the issue of women's property rights in the specific regional culture of Tamil society. Inscriptional evidence and other sources allow us to trace some aspects of how women have controlled and used property since early medieval times. In spite of large gaps in data, this evidence can be related to usage in recent times. Accordingly, we can try to capture, even though imperfectly, the arrangements which were in vogue prior to the Hindu Act of Succession, 1956. To understand the nature of rights in land or other property, we need to examine both customary and legal rights, the extent of direct control, and the power of alienation. Not surprisingly, what comes across is that, in spite of some general, common features there is endless variation in customs and practices.

Thus, what this preliminary investigation reveals is that the diversity of women's property rights across regions/sub-regions/castes/classes/families can be dealt with only through a series of micro-studies. What I have tried to do is to point to the diversities and

hazard some tentative hypotheses which may instigate other scholars to explore these challenging untrodden paths.

WHAT IS WOMEN'S PROPERTY?

In the ancient Smṛtis and Dharmaśāstras (for the most part dating back to 200 BC-AD 400), which were the first systematic treatment of Hindu law, the question of property rights and inheritance formed one of the important aspects of civil law, with the more controversial question of women's rights also being discussed.[2] Even the *Manusmṛti* recognized women's property or *strīdhana*, and the right of unmarried daughters to a share of the father's property. Yājñavalkya, Kātyāyana and Nārada were the important jurists who, though by no means unanimous in their views, further developed and defined women's property rights. To condense their views in the simplest form, women could acquire property in four principal ways: (i) what was given to them at the time of marriage (*adhyāgni*); (ii) gifts given after marriage, either by the parents, husband or husband's family, 'through affection'—often referred to as *saudāyika, prītidāna* or *prītidatta*; (iii) through inheritance, and (iv) by working.

The earliest recognized form of women's property was *strīdhana* or what was given to the bride at the time of marriage. There seems to be a sound basis to believe that this *strīdhana* was originally part of the bride-price or *kanyāśulka* paid by the bridegroom, a part of which was passed on to the bride by her parents. The ready acceptance of this without reservation as the property of the woman also derived from the general disfavour in which the practice of *kanyāśulka* came to be held (so that, by excluding the husband from the right to this property, the habit could be discouraged). Other gifts which were given on the occasion of a wedding were also denoted as *strīdhana*, mainly because they tended to be small in value.

Saudāyika was also included in *strīdhana*. This specific allusion to a *gift* is in itself an indication that a woman had no automatic right to this wealth, as an inheritance right. There was also a further rider that if any immovable property had been gifted by the husband, the wife had only limited, at best usufruct, rights in that property. *Strīdhana*, on the other hand, was the absolute property of the woman and it is a matter of interest that husbands were forbidden to use or sell the *strīdhana*, except in times of dire need.

The earnings of a woman were universally stated to belong to the

family and could not be considered *strīdhana*. In this context it is interesting to note that in present-day Tamilnadu, in common perception, *the only class of women* who were thought to have property rights were the *devadāsīs*.[3] These women and their immediate kin usually constituted self-supporting, female-headed households whose property (in legal language) was acquired by 'self-exertion and mechanical arts'. Courtesans (*gaṇikās*), of course, were certainly prominent on the social scene even in ancient times, but the debates on women's property rights seem to have been located only within the patriarchal system.

The really thorny issue in women's property rights was the question of inheritance rights to family property—of daughters to the father's property and of married women/widows to the husband's property. Again there was no consensus on these rights, but slowly the view gained ground that while daughters were normally entitled only to their marriage portions, they could inherit property when there were no sons in the family or if they were unmarried at the time of the death of the father. Somewhat reluctantly, widows were also accepted as having the right to a share of the husband's property, but, on the death of a widow her share reverted to the heirs of her late husband.

Two major schools of thought on property rights emerged in the early twelfth century—the Dāyabhāga school of Jīmūtavāhana and the Mitākṣarā school of Vijñāneśvara. The Dāyabhāga school gave more comprehensive inheritance rights to widows, while the Mitākṣarā school specified that *strīdhana* went by succession from mother to daughter (the preferred line of succession was unmarried daughters first, married, but not well-off daughters next, married daughters, sons and other heirs). The main significance of these works was that they became the basis of Hindu law on these issues under the British courts, which referred to these authorities for establishing what constituted women's property. They ultimately developed the idea of two kinds of women's property. The first was that of *strīdhana* (as defined in the older texts), which on the death of the woman would pass on to *her* children/heirs—i.e. she constituted an independent stock of descent. Most often, the recognized succession was down the female line, but according to some schools, all children shared equally in the property. The other form of property, termed 'woman's estate', referred to the share of the widow, over which she had no power of alienation (except under extenuating circumstances).[4]

These rights also varied from region to region, depending on whether local usage subscribed to *Mitākṣarā* or *Dāyabhāga*. Thus, traditionally there was no definitive or uniform code relating to women's property rights. Even among the Smṛti writers there was an ongoing debate as to whether customary practice or śāstras should take precedence. We gather that what was being laid down as law tended to be prescriptive and not always a record of what existed in practice; equally, that the modifications which were made in *strīdhana* and widows' rights derived at least in part from *de facto* recognition of customary rights. That the usage varied from region to region was also acknowledged, and even from very early times commentators pointed out that in the *dakṣiṇa* (southern) region women's rights were more broad-based.[5] By the twelfth century, when the *Dāyabhāga* and *Mitākṣarā* texts were being authoritatively codified, there also existed a large corpus of inscriptions in south India. This coincidence in time makes it possible for us to juxtapose the actual with the prescriptive, and to understand the historical experience relating to women's property rights in south India.

INSCRIPTIONAL EVIDENCE

There are many references to women and their use of property in inscriptions in Tamilnadu.[6] Their range and sheer volume indicate that inscriptions can indeed be used as a sound basis for reconstructing social history. The 348 inscriptions used here are very suggestive of local customs in this context. In order to understand the social background of the women, a combined caste/class ordering has been drawn up.[7] By and large, class, rather than caste, is used as the reference point, so that even though most local chiefs and local elite families were *vēḷāḷas*, and occasionally brāhmaṇas, they are designated by the class and not by caste (Tables 1 and 2). In 21 cases it has not been possible to identify either caste or class background. 'Major royalty' refers to dowager queens, or queens and princesses of the imperial dynasties (predominantly Coḷas, Pāṇḍyas and Pallavas). The temple dancers are referred to by their old Tamil name *tēvaraṭiyāḷ* rather than the more familiar *devadāsī*. This has been done intentionally because the word *tēvaraṭiyāḷ* specifically means a servant of god and clearly, the dancer was only one of the many kinds of *tēvaraṭiyār* (the masculine and plural form) who served in the temple in various capacities—in the kitchen, arranging the flowers, keeping

the temple clean, etc. The local chief and local elite were the dominant landowning classes, in modern terminology they might be termed dominant peasant classes. Their power base derived from their landownership and their relationship with the royal families, since most of the queens came from these families.

The inscriptions refer to several kinds of property transactions—gifts to the temple, sales, and assignment of property and/or land revenues to the *tēvaraṭiyāl* for their services. These transactions also indicate that the ownership rights of women with regard to their property extended to the power of alienation through gifts and sales. Women also bought property in addition to acquiring property through inheritance or being employed, so that virtually all the forms of women's property rights were found to operate among the Tamil people, though the Smṛtis did not acknowledge some of these rights.

The temple was the focus of social and economic life of the locality, and was the beneficiary of major patronage and endowments from the royal houses and the state, as well as a variety of more modest offerings, usually for the 'merit' of the donor or a specified beneficiary (such as husband, son, brother, king, etc.). The latter were necessary to finance a variety of routine temple services: lamps which burned day and night (*nantā viḷakku*) or at dawn/dusk (*sandhyā dīpam*), food offering to the various *mūrtis* in the temple, or flowers, etc., to the devotees and brāhmaṇas.[8] Gifts were sometimes made directly in kind—gold and silver jewellery or vessels, lamps, etc., but were more often given indirectly in a two-stage process, in which the service was maintained through the income earned or interest on an asset which was assigned to the temple, or farmed out to specific individuals/groups or local assemblies. For instance, the normal assignment for a specified measure of oil or ghee to be given per day to the temple for burning an eternal lamp was 90 sheep or 32 cattle. The recipient of the livestock would have to ensure that the oil or ghee, as specified, was regularly given to the temple. Similarly money (gold coins or gold) would be donated which would be given out to individuals or groups or even the local assemblies who would undertake to pay 15 per cent interest (or an equivalent value in ghee or oil) to the temple. Strict fines (up to 25 per cent of the value of the endowment) were specified for even one day's failure to keep up the payment and groups which had received the money but had been unable or unwilling to fulfil these terms and conditions would have

to sell some land of equivalent value to the temple. Since the scope for malfeasance was very large under these arrangements, audit committees were often appointed to check the temple accounts.

Against this general background, we can also get a more detailed picture by referring to some specific information in the inscriptions. Coming to the class background of the donors, two groups (Table 2) are predominant—the ruling classes (royalty, local chiefs, local elite and military) account for 63.5 per cent (221) of the donors. Women of the royal families were involved actively in the construction and maintenance of temples. The extent of their endowments precludes the facile assumption that they were only utilizing some kind of a personal 'allowance' made to them. The earliest reference to a queen who constructed a temple was to the Pallava queen Raṅgapatākā in the eighth century.[9] The local feudal chiefs, whose daughters married into the royal families, maintained a steady and continuous tradition of patronage to temples, but the most vigorous and emphatic patronage came from the Coḷa queens and princesses. A look at Table 1, for instance, shows that in Tanjavur district alone there are 73 inscriptions (in the tenth and eleventh centuries) and 13 in Tiruchi district (tenth century) which record their gifts to temples. Since dowager queens and princesses were also actively promoting these activities, it seems reasonable to argue that they must have been making these endowments out of their personal property (most likely inherited on the maternal side from the local landowning elite families).

Three significant personalities in this respect were Cempiyanmā-devī, mother of king Uttama Coḷa, Lokamahādevī (or Olokamahādevī), Dantiśakti, queen of Rājarāja Coḷa, and Kuntavai, his sister. The dowager queen Cempiyanmādevī, in addition to her numerous gifts and endowments, exercized such authority even in the reign of her grand nephew Rājarāja that she could command one of the temple managers to donate money to meet the expenditures incurred in the daily rituals of the temple, besides fixing the emoluments of the temple servants, and arranging for various items of temple expenditures to be met from land assignments.[10] Queen Lokamahādevī not only built a temple in her own name (Lokamahādevīśvaram), but she also took a keen interest in the day-to-day management of the temple. Even as a dowager queen she ordered the reclamation and cultivation of waste lands in a village, the income to be used for special festivals in the temple.[11]

The other important class of women referred to in the inscriptions were the employed women (19.8 per cent). While the most numerous group was the *tēvaraṭiyāl*, it is clear that women were employed in various capacities in the palaces, households of the elite, in the temples and in their capacity as wives of temple servants. In all cases they obviously could exercise ownership rights over their income/property, although this was not accepted by the Smṛtis, once again highlighting the dichotomy between the law in theory, and the practice.

The *tēvaraṭiyāl*, of course, represents a case worth studying in itself. In the early period, the temple dancer had both a secular and religious significance in the social milieu which revolved around the temple. She was clearly regarded as an employee of the state who served in the temple at par with other temple servants. The dancers could be transferred from one temple to another and were paid either by being assigned shares in land, the revenue from specified taxes, or '*kāṇi*' (landholding) rights in temple lands.[12] Paying for a *tēvaraṭiyāl* to dance in the temple was considered to be an act of religious merit even in normal times, and especially when temples had suffered after the Muslim invasions in the fourteenth century and the consequent disruptions in social and political life.[13] There are several references to the property owned, sold and bought by the *tēvaraṭiyāl* which indicate that they had property independent of the temple.[14]

Contemporary consciousness tends to locate the temple dancer within the social structure, primarily with reference to her sex life. The earlier evidence indicates a far more complex reality. There is even a reference to a married *tēvaraṭiyāl*, while the sister of another was evidently a favourite wife/concubine of a local chief.[15] The most common arrangement, as in later times, may well have been that they became the mistresses of the local landed elite. But this seems to have been not only an accepted, but even a respectable social practice, and there are several references to the concubines (*pōkiyār*) of local chiefs who made gifts to temples in their own right. At least one reference shows that property was transferred to the 'unofficial' family as gifts given out of affection or *prītidāna*.[16]

Though we thus have convincing evidence of women's property rights, it is also equally clear that such rights were not universal or uniform for all women. The extent to which women could control their property depended on the usage current in their immediate

TABLE 1: DISTRIBUTION OF WOMEN PROPERTY OWNERS

District	Century	Status	Number
Chingelpet	0	Brāhmaṇa	2
Chingelpet	8	Major Royalty	2
Chingelpet	9		1
Chingelpet	9	Brāhmaṇa	1
Chingelpet	9	Local chief	5
Chingelpet	9	Major royalty	1
Chingelpet	10	Tēvaraṭiyāl	2
Chingelpet	10	Local chief	1
Chingelpet	10	Major royalty	6
Chingelpet	11	Brāhmaṇa	9
Chingelpet	11	Tēvaraṭiyāl	3
Chingelpet	11	Local chief	2
Chingelpet	11	Local elite	1
Chingelpet	11	Maidservant	1
Chingelpet	11	Major royalty	2
Chingelpet	11	Palace maidservant	1
Chingelpet	12		3
Chingelpet	12	Brāhmaṇa	2
Chingelpet	12	Tēvaraṭiyāl	4
Chingelpet	12	Local chief	1
Chingelpet	12	Major royalty	1
Chingelpet	12	Temple servant	1
Chingelpet	13		1
Chingelpet	13	Tēvaraṭiyāl	6
Chingelpet	13	Local chief	1
Chingelpet	13	Local elite	1
Chingelpet	13	Religious/Hindu	1
Chingelpet	14	Tēvaraṭiyāl	2
Chingelpet	14	Local chief	2
Chingelpet	16	Tēvaraṭiyāl	1
Chittoor	9	Major royalty	1
Chittoor	12	Local chief	2
Chittoor	13	Local chief	4
Chittoor	15		1
Chittoor	18	Local chief	1
Chittoor	19	Local chief	1
Coimbatore	11		2
Coimbatore	12	Major royalty	1
Coimbatore	12	Vēḷāḷa	2
Coimbatore	13	Tēvaraṭiyāl	1
Coimbatore	13	Local elite	1
Coimbatore	13	Palace maidservant	1
Cuddapah	12	Local chief	1
Cuddapah	12	Military leader	1

TURMERIC LAND 131

District	Century	Status	Number
Madurai	8	Local chief	1
Madurai	8	Shepherd	1
Madurai	11	Major royalty	2
Madurai	13	Local chief	2
Madurai	18	Local chief	2
Madurai	18	Major royalty	2
Madurai	19	Tēvaraṭiyāl	1
Nellore	17	Local chief	1
North Arcot	9	Local chief	1
North Arcot	9	Major royalty	4
North Arcot	10	Major royalty	4
North Arcot	10	Religious/Jain	1
North Arcot	11	Tēvaraṭiyāl	1
North Arcot	11	Local chief	1
North Arcot	11	Major royalty	1
North Arcot	11	Merchant	1
North Arcot	13		1
North Arcot	13	Local chief	6
North Arcot	13	Local elite	1
North Arcot	14	Tēvaraṭiyāl	1
North Arcot	14	Local chief	1
North Arcot	16		1
North Arcot	16	Local chief	1
North Arcot	16	Local elite	1
Pudukottai	10	Local chief	2
Pudukottai	11	Local chief	1
Pudukottai	12	Tēvaraṭiyāl	2
Pudukottai	13	Tēvaraṭiyāl	1
Pudukottai	13	Local chief	1
Pudukottai	14	Tēvaraṭiyāl	1
Pudukottai	15	Temple servant	2
Ramnad	8	Brāhmaṇa	1
Ramnad	11	Brāhmaṇa	2
Ramnad	11	Tēvaraṭiyāl	1
Ramnad	11	Local chief	1
Ramnad	12	Major royalty	1
Ramnad	14	Local chief	1
Salem	12	Local chief	1
South Arcot	9	Local chief	2
South Arcot	10		2
South Arcot	10	Brāhmaṇa	1
South Arcot	10	Tēvaraṭiyāl	1
South Arcot	10	Local chief	9
South Arcot	10	Local elite	1
South Arcot	10	Major royalty	2
South Arcot	10	Palace maidservant	1

District	Century	Status	Number
South Arcot	11		1
South Arcot	11	Tēvaraṭiyāl	3
South Arcot	11	Local chief	4
South Arcot	11	Major royalty	4
South Arcot	11	Palace maidservant	1
South Arcot	11	Temple servant	1
South Arcot	12	Tēvaraṭiyāl	2
South Arcot	12	Local chief	3
South Arcot	12	Merchant	1
South Arcot	13	Tēvaraṭiyāl	4
South Arcot	13	Major royalty	1
South Arcot	18	Merchant	1
Tanjavur	9	Local chief	2
Tanjavur	9	Major royalty	2
Tanjavur	10	Brāhmaṇa	1
Tanjavur	10	Local chief	2
Tanjavur	10	Local elite	1
Tanjavur	10	Major royalty	36
Tanjavur	10	Military leader	1
Tanjavur	10	Palace maidservant	4
Tanjavur	11	Tēvaraṭiyāl	5
Tanjavur	11	Local chief	2
Tanjavur	11	Major royalty	37
Tanjavur	11	Palace maidservant	3
Tanjavur	12		4
Tanjavur	12	Tēvaraṭiyāl	2
Tanjavur	12	Major royalty	1
Tanjavur	12	Palace maidservant	1
Tanjavur	13		2
Tanjavur	13	Brāhmaṇa	2
Tanjavur	13	Tēvaraṭiyāl	2
Tanjavur	13	Local chief	1
Tanjavur	13	Religious/Hindu	1
Tanjavur	17	Tēvaraṭiyāl	1
Tanjore	11	Brāhmaṇa	1
Tanjore	12	Local chief	1
Tiruchi	0		1
Tiruchi	10	Brāhmaṇa	1
Tiruchi	10	Local chief	2
Tiruchi	10	Major royalty	13
Tiruchi	11	Brāhmaṇa	2
Tiruchi	11	Local chief	1
Tiruchi	11	Local elite	1
Tiruchi	11	Maidservant	1
Tiruchi	11	Major royalty	3
Tiruchi	12	Brāhmaṇa	1

District	Century	Status	Number
Tiruchi	12	Tēvaraṭiyāl	2
Tiruchi	12	Major royalty	1
Tiruchi	13	Local chief	3
Tiruchi	13	Major royalty	1
Tiruchi	13	Temple maidservant	1
Tiruchi	14		1
Tiruchi	14	Local chief	1
Tiruchi	17	Major royalty	2
Tiruchi	18	Tēvaraṭiyāl	1
Tiruchi	18	Local chief	1
Tirunelveli	8	Local chief	1
Tirunelveli	12	Brāhmaṇa	1
Tirunelveli	13	Brāhmaṇa	1
Tirunelveli	18	Major royalty	1
Total			348

Source: *SITI* and VRR.

social circle. Among the well-to-do, land was given as *strīdhanam* to the daughter on her marriage—there is even a reference to land gifted as *strīdhanam* to the goddess in the temple—but, as this gave the husband the status and the right of doing service in the temple and the privileges due to that in local affairs,[17] it was clearly he who was regarded as the landholder.

Two contemporary inscriptions of *c.* 1270 capture the anomalies in women's status very well. One refers to a woman who was a member of the local committee of justice (*niyāyattār*): the other to two brāhmaṇa widows without sons who were forced to sell their land.[18] The latter gives the bare outlines of what was perhaps a fruitless struggle on the part of the widows to retain their land. They were, however, not given any help by their relatives (*jñātis*) and finally had to sell the land. The fact that they were represented by close male relatives—one by her father, the other by her son-in-law who was also her brother—in the sale negotiations indicates that there was strong social and intra-family opposition to their owning land when they had no sons. While the rights of the women of the royal families at one end of the social spectrum, or of the *tēvaraṭiyāl*, a special group, were not questioned, in the middle classes these rights were not equally well protected or accepted.

The inscriptions (Table 1) also throw up some tentative inferences.

TABLE 2: CLASS/CASTE BACKGROUND OF WOMEN PROPERTY OWNERS

Status	Number
Brāhmaṇa	28
Tēvaraṭiyāl	50
Local chief	79
Local elite	8
Maidservant	2
Major royalty	132
Merchant	3
Military leader	2
Palace maidservants	12
Religious/Hindu	2
Religious/Jain	1
Shepherd	1
Temple maidservants	1
Temple servant	4
Vēḷāḷa	2
Total	327

Source: *SITI* and VRR.

One noteworthy fact is that, with the beginning of Hoysala/Vijayanagar rule, there is a sharp decline in the number of references to women (after the fourteenth century). The inescapable inference seems to be that Vijayanagar society was far more restrictive when it came to women's property rights. Even though women probably continued to enjoy the more open traditional arrangements in Tamilnadu, the culture of the rulers discouraged the public display of these rights through recorded endowments, sales, etc. Another point to note is that the inscriptions are most numerous in the heartland of imperial power—Tanjavur, Tiruchi, South and North Arcot and Chingelpet districts. It would be interesting to investigate whether significant sub-regional variations existed within Tamil country.

URBAN PROPERTY, 'MAÑCAL KĀṆI' AND OTHER RIGHTS

The temple economy was primarily structured on the power relations of the agrarian society; from the inscriptional evidence it is not possible to reconstruct the nature of the property rights of urban women. For the more recent period, some scattered evidence exist

which indicate that women did inherit non-agricultural property, both movable and immovable. The records of the mayor's court in Madras[19] contain the details of several cases when women were involved in litigation concerning money given on loan, urban property which was mortgaged, division of property, etc. Just to cite one instance, the widow of Beri Timmanna, the chief merchant of the English at Madras, had sued borrowers for repayment of loans which amounted to more than 15,000 *pagodas*. In another case initiated by her son, the property in contention was a house which she had made over to her daughter.[20] There was also an intriguing case in which a woman claimed the estate of her 'first husband's first wife's son' (which he had inherited from *his* mother) as the natural heir, because the son was mentally deranged.[21] Almost all the more complex cases involving inheritance claims to property were arbitrated by the caste councils, which shows that while customs may have differed from caste to caste, women's rights to inherit, own and manage property were accepted. On the other hand, the almost contemporary diaries of the famous *dubash*, Ananda Ranga Pillai, also record several cases where widows were disinherited, mistreated and denied even maintenance rights.[22] Family customs, local social mores and, in these times, the attitudes of the colonial rulers all seem to have been important in the effective realization of women's rights. The English at Madras, as the eighteenth century progressed, seem to have abandoned their earlier deference to local customs and caste decisions. This probably explains why, at the end of the century, the litigation over the estate of the extremely wealthy merchant and *dubash*, Pachaiyappa Mudaliar, dragged on, though he was survived by two widows and a daughter, until all the claimants to the estate died.[23]

In contemporary Tamil society, one of the most important rights of women is the right to inherit land. This again was *strīdhanam*, which devolved on the female heirs, and passed from mother to daughter. Usually handed over to the girl when she got married, this land was called *mañcal kāṇi* (*mañcal* means turmeric). The origin of this name in itself would be interesting to investigate. I have been told that the reference to turmeric indicates that this was land, probably not a part of the patrilineal property, on which minor cash crops like turmeric could be grown. The more plausible explanation seems to be that this was meant to provide an independent income to the daughter which would be enough at least for personal

expenses (*mañcal* and *kumkumam*). In almost all cases, the income from this land certainly seems to go to the woman; the extent of control or decision-making right that she has over this land would, however, seem to vary from individual to individual, and family to family. It would also be interesting to explore whether the practice of cross-cousin marriage as well as marriage with the maternal uncle was an attempt to keep the property which went to the daughter within the control of the natal family.

How did this line of female property originate? One possibility is that in almost every family at some time there must have been a generation with only daughters, who would accordingly succeed to the property. This is a hypothesis which instinctively I tend to reject. The rights of women without brothers tend more often to be appropriated by other male relatives than to be protected, and there have even been cases which went up to the Privy Council when the male members of a family disputed the right of an only daughter to her father's property. Was this custom then the legacy of a distant, matrilineal social system which existed in this region (as it still does in neighbouring Malayalam country)? These questions need to be investigated in much greater depth. Sadly, many of these practices seem to have degenerated in the past few decades, even before the enactment of the 1956 law. Dowry seems to have replaced traditional *strīdhanam* almost completely, weakening the rights and status of women.

Another form of property over which a woman had absolute control was her jewellery and personal belongings. Jewellery inherited from the mother, almost always, was handed over to the daughters, while jewellery presented by the in-laws or husband could be given to daughters-in-law or their children. The extent to which these norms of preserving the line of descent were adhered to seems to vary, again, from family to family. I have been told of instances when a signed release was obtained from all the granddaughters on the female line by a lady who wanted to gift her *strīdhanam* jewellery to her son's daughters. More often, this seems to have been less rigidly observed; women usually gave their jewellery to their daughters and their daughters' daughters, but not invariably so.

In addition to these inheritance rights, women also have some customary rights in Tamil society. Among all castes and classes in Tamilnadu the bride receives a gift from her mother's family, usually from the maternal uncle, known as the *amman cīr*, which includes the

bride's *sāri*, a gold ring and silver toe rings. Married daughters similarly continue to receive *poṅkal cīr* from their brothers each year, besides having several other claims to ritual gifts from the natal home. These may be small in value, but are important in that they establish a continued claim on the family property.[24]

One community which stand out from the rest are the Nattukottai Chettiars, a traditional mercantile caste, whose activities mainly centred on moneylending and trade. The men would travel extensively in the course of their trading operations, often being away from home for several months or years. The moneylending activity, which was essentially home-based, would be managed by the women. This was particularly common once the Chettiars established themselves in trade in Burma (Myanmar) and Malaysia (in the last decades of the nineteenth century). In the mayor's court records series, there are also extant some account books in Tamil dating back to the 1790s, where the accounts of some Chettiar women are recorded, indicating that this practice is not of recent origin. Yet, the traditional property rights of Chettiar women seem to be particularly weak. Since the community, by and large, was not an agriculture-based community, at the time of her marriage, the girl would receive a large cash settlement which was theoretically her property. In most cases this was absorbed into the business capital of the in-laws' family enterprise, and there does not seem to have been the concept of her individual property rights. In fact, as long as the daughter-in-law stayed in a joint family, her natal family would provide for the personal expenses of the girl and her children. There was a curious case of women managing and controlling large amounts of money and substantial business transactions but without individual property rights.

Another example of a unique locality-specific system is found in Kilakkarai, in southern Tamilnadu.[25] This is a small coastal town where the local population, mostly Muslims, have traditionally been chank divers. Here, there is a strong tradition of property which is passed on from mother to daughter. On marriage, each girl receives a house, household necessities and jewellery from her mother. When there are several daughters, the house property has to be sub-divided. Whatever money is left over after all the daughters are provided for is divided according to the *shariat*. Yet, the entire arrangement of women controlling property and forming the line of descent is entirely at variance with Islamic law.

CONCLUDING REMARKS

It is obviously difficult to conclude with definitive comments or analysis of the nature or basis of women's property rights in Tamil society. A common factor which these women share with women all over India is that the property rights seem to be acquired only on marriage. In traditional society, there are so few instances of women remaining single that the rights of an unmarried woman are, at best, notional. The condition of widows and their inheritance rights is again difficult to capture. The common experience seems to be that few widows actually received their just dues from the husbands' families, though here again the experiences varied from family to family.

One significant feature of the usage in Tamilnadu which needs to be stressed is that, even though the daughter was given her property when she got married, this took the characteristics of an inheritance right and not a marriage settlement or dowry, arrived at on the basis of mutual bargaining between the two families.[26] The notion that a woman has a continued right to small gifts and *cīr* from her father or brother is again not ubiquitous in north Indian society. One can also tentatively link the traditional rights of women to own land in Tamil society with recent research findings which point out that only in Tamilnadu and Kerala do women directly supervise cultivation, for control and management go with ownership. Thus, even as we answer some questions, many unanswered and until now unanswerable ones emerge, which need much more intensive exploration.

NOTES

[I wish to thank all the women who have generously shared their family experiences with me. Special thanks are due in this regard to Sakuntala Jagannathan and Sarojini Varadappan, and to Lalitha Iyer for sharing her research experience and notes.]

1. For the legal background on women's property rights, see Paras Diwan, *Dowry and Protection to Married Women*, New Delhi: Deep and Deep, 1987, Chapter 4: '*Strīdhana*'. An oft-cited legal work on the same issue is Gooroodas Banerjee, *Hindu Law of Marriage and Strīdhana*, Calcutta, 1923.
2. A.S. Altekar, *The Position of Women in Hindu Civilisation*, Delhi: Motilal Banarsidass, 1991 (rpt.), Chs. VIII and IX offer a clear discussion of the

various aspects of women's property rights. See also Diwan, op. cit.
3. This general perception seems to have really crystallized during the debate on the proposed Devadasi Abolition Bill in the 1940s, and has now become part of popular wisdom.
4. 'Women's estate' has also been converted into 'strīdhana'—i.e. with full property rights for the woman—under the Hindu Succession Act, 1956, Diwan, op. cit., p. 121.
5. Both Yājñavalkya and Vijñāneśvara of the Mitākṣarā school, who were more liberal in their views, were from the south, Altekar, op. cit., p. 258.
6. The two sources for inscriptions are: T.N. Subramaniam (ed.), *South Indian Temple Inscriptions*, Madras: GOML, 1953-7, 3 vols. (hereafter *SITI*) and V.R. Rangacharya, *A Topographical List of the Inscriptions of Madras Presidency*, New Delhi: Asian Education Service, 1985 (rpt.), 3 vols. (hereafter VRR). I have taken care to see that the inscriptions which are cited in both—and these are, surprisingly, very few—are used only once. The 'border' districts of Cuddapah, Nellore and Chittoor have been included, partly because during the linguistic reorganization of states some *tāluks* in these districts became a part of Tamilnadu. The original classification of districts, including Pudukottai (in VRR, III) have been retained for simplicity.
7. The basic limitation is that only women of property-owning classes are considered here. There are references to women/families who are 'donated' to the temples for various kinds of service (like husking paddy), etc., but these are not included because of the limited terms of reference of this paper.
8. The terms and conditions of the endowments, as outlined here, were common for male and female donors. However, only the references to the gifts made by women are studied.
9. In the Kailasanatha temple in Kanchipuram. Making a pun on her name, the inscription describes her as an exemplary 'flag (*patākā*) among women'.
10. Inscriptions from Tirumananjeri, in Tanjavur district, VRR, vol. II, Tanjore, 672, 673 and 687.
11. *SITI*, vol. II, 610 and VRR, vol. 1, Chingelpet, 727.
12. VRR, vol. II, Tanjore 1363 and *SITI*, vol. III-2, 1299.
13. VRR, vol. I, Chingelpet, 567.
14. Ibid., Chingelpet, 214, refers to a *tēvaraṭiyāl* who was forced to sell her land by public auction to pay a fine. Such matters were obviously a collective local responsibility for, when neither the local people nor the local assembly would buy the land, the temple management (*tānattār*) had to buy it.
15. VRR, vol. I, Chingelpet, 1016 and *SITI*, vol. I, 537.

16. *SITI*, vol. III-1, 1102, dated AD 1374.
17. *SITI*, vol. II, 1008.
18. VRR, vol. I, Chingelpet, 771 and *SITI*, vol. II, 819.
19. Records of Fort St George, Tamilnadu Archives, Series under mayor's court records, proceedings and pleadings, dating, but not continuously, from 1689.
20. Fort St George, Diary and Consultation Book, 22 March 1694, (Tamilnadu Archives); mayor's court proceedings, 1717-19.
21. Pleadings in the mayor's court, 1744-5.
22. Lalitha Iyer, 'Glimpses of Women's Lives in Eighteenth Century Tamilnadu', paper presented at a symposium on Ananda Ranga Pillai's diaries at Pondicherry in February 1991.
23. K. Srinivasa Pillai, *Kāñcipuram Paciyappa Mutaliyār Carittiram* (Ripon Press Madras, 1911) (Tamil) (from Lalitha Iyer).
24. Louis Dumont (*Affinity as Value*, Oxford, Delhi, 1988, p. 87) comments that the function of gift-giving and gift-receiving come down by one generation. A woman gets gifts from her parents, who are later replaced by her brother. The brother/maternal uncle also becomes the gift-giver to his sister's daughter and other children.
25. Personal communication from Lalitha Iyer, who passed on her research notes to me.
26. It is interesting to compare this with the practices in several parts of Andhra Pradesh. In Nellore district, the women inherit the equivalent of *mañcal kāṇi* which is referred to as *pasupu kumkumamu*, with a striking similarity even in the name. Further north, in coastal Andhra, *pasupu kumkumamu* is the *strīdhanam* which is given as dowry to the bride, but the woman retains complete right to this property.

'Rural-Urban Dichotomy' in the Concept and Status of Women: An Examination (from the Mauryas to the Guptas)

Chitrarekha Gupta

The sixth century BC was a period of remarkable significance in the history of India. The so-called 'second urban revolution' changed the material mode of life by the fruitful use of iron, the introduction of burnt brick, coinage, polished wares and various other things. The age-old model of life in rural setting had to be modified to accommodate the pattern of living in a city. Archaeologists are concerned with the changes brought about in the material aspect of life. But major technological changes in all ages have not only brought in innovations for the enrichment of the material culture of man, but also have been responsible for a new outlook which changes the pattern of society as a whole. In this paper an attempt has been made to see whether or not the shift from an old to a new model of life, ushered in by the second urbanization process, brought with it any significant change in the vision of 'the urban man' regarding the concept of 'woman' and her position in the society.

Let us take the Buddha as the symbol of the 'urban man', with his quest for knowledge and protest against the long-believed socio-religious customs which did not appear to have had any scientific base. And, it was a city, the city of Vaiśālī, where the contemporary liberal minds allowed the women 'to go out from the household life and enter the homeless state'[1] under the doctrine and discipline proclaimed by the Buddha in search of *nirvāṇa*.

But history would show that the Buddha was reformist and not a revolutionary. So, despite his realization that a woman child may prove a better offspring than a male,[2] he could not stand against the age-old tradition of the superiority of men over women and thus was pragmatic in making the nuns subordinate to the monks.[3] Here lies the rural-urban dichotomy of the age—the word 'rural' standing for the values of pre-urban society.

History of the period from the sixth century BC to the third century BC is a long process towards the making of an empire, comprising various types of people living in different stages of socioeconomic development. It is from the third century BC that we get epigraphic documents to be on surer footing about the contemporary attitude towards women. With the help of these inscriptions and corroborative evidence from literature an attempt may be made to trace the development in the position of women from the time of Magadhan imperialism down to the time of the Guptas.

II

There are very few references to women in Aśoka's inscriptions, still they are illuminating. The ideal of the contemporary society is reflected when Aśoka says: *sādhu mātari ca pitari ca sussā*,[4] i.e. one should attend on one's parents. It is noteworthy that in this phrase the word 'mother' comes first.

The Queen's Edict also shows that 'motherhood' was the ideal for women. Had it not been so, the name of Kāruvākī, the king's second wife would have been sufficient to identify her. But here in this special edict she was glorified as a 'mother' and hence the addition 'the mother of Tīvara'.[5] This becomes emphatic when in all other places of Aśokan inscriptions women are found to occupy the second position, viz., *āvāha-vivāha*[6] (wedding of sons and daughters); *upāsaka-upāsikā*[7] (layworshippers—male and female); *bhikṣu-bhikṣuṇī*[8] (monks and nuns).

The earliest epigraphic evidence of polygamy is also provided by the Queen's Edict. Polygamy was practised not only by royalty but also by the common people. There is an element of truth in Strabo's statement that men married many wives, some 'for the sake of prompt obedience and the others for the sake of pleasure and numerous offspring'.[9]

Inscriptions of Aśoka suggest that by his time the surplus manpower was provided as slaves and servants in the houses,[10] obviously of the rich people, many of whom must have flocked to the cities. Utility of women in household affairs thus decreased among this section and women became objects of use and enjoyment as Strabo has said.

Since the contemporary ideal of womanhood was to be a mother, this could only be achieved through marriage, and in marriage it was

the choice of the male which mattered most. Arrian has said that as soon as the girls became of marriageable age they were 'brought forward by their fathers and exposed in public, to be selected by the victor in wrestling or boxing or running, or by someone who excelled in any other manly exercise'.[11] The kernel of truth in the statement should not be overlooked.

Once married, these women are known from Aśoka's inscriptions to have performed trivial and meaningless ceremonies on the occasions of illness, weddings of their sons and daughters and the setting out on journeys.[12]

Thus, Aśoka's inscriptions do not provide a picture of liberated and emancipated woman. We may stop here to analyse why the spirit of women's liberation starting in the sixth century BC did not appear much ahead. The primary reason was that there was no urban revolution in the sixth century BC. Urbanization was a gradual and slow process and rural centres dominated over the urban foci due to the basic rural nature of Indian economy at that stage. It is also to be remembered that Buddhism or Jainism could only give vent to the protestant attitudes but could not replace the brahmanical and traditional views of the society. There was always a tension between the city and the village in the brahmanical fold.[13] The whole focus of the brahmanical law-makers was on ruralism with all its customs and beliefs. Naturally, villages with their norms and modes of life infiltrated even into the urban model of existence.

In spite of these, it may be suggested that the women of urban centres enjoyed some privileges and developed such consciousness as distinguished them from the women of villages. Most of the poetess-nuns of the *Therīgāthā* came from cities like Vaiśālī, Śrāvastī, Rājagṛha, Kauśāmbī, etc. The nuns and the *upāsikās* of Aśoka's inscriptions may also be grouped in this category.

The Queen's Edict of Aśoka[14] is particularly important because through it he has given formal recognition to woman's freedom to make gifts of both movable and immovable properties belonging to her.

On the basis of this inscription it may be suggested that upper class women, by virtue of their *strīdhana* could enjoy some sort of freedom or position, which were denied to ordinary women in the contemporary social milieu.

The donative records of Bhārhut, ascribed to the Śuṅga period, reveal that religious gifts were made by many a woman, both nuns

and female lay worshippers.[15] It is interesting that most of these women did not care to introduce themselves with reference to someone else. Out of about thirty such donors (excluding the nuns) only seven have been introduced through their husbands or sons. We may call it the reflection of the conscious urban mind, since these women are known to have come from cities and towns like Vidiśā, Pāṭaliputra, Nāsika, Nandīnagara, Karahakaṭa, etc.[16] These inscriptions also speak of physical mobility of urban women, who came a long way from Pāṭaliputra or Nāsika to pay homage to the Buddha.

III

By the first century BC/AD India entered into a new phase of urban development backed by brisk mercantile activities with China on the one hand and the Roman world on the other. Mathurā during this phase became an important centre not only of Śaka-Kuṣāṇa administration but also of economic activities. It has been suggested that from the economic point of view Mathurā's special feature lay in not possessing a strong rural base. Whatever importance it enjoyed in crafts, commerce and urbanization was derived mainly from certain economic and technological developments which characterized almost the whole of northern, western and a good part of coastal India.[17] So, a survey of Mathurā inscriptions will be helpful in determining the position of women in urban society during this phase of productive economy. Whether or not they served as models for rural women as well may be known by comparing and contrasting literary evidence with that of the inscriptions.

In the Mathurā inscriptions also we get references to two types of women—those who became nuns and those who remained at home. In the first category there were, till then, renowned nuns who had great influence upon housewives and could induce them to make religious gifts. Two inscriptions deserve special mention in this connection. One records the setting up of a Bodhisattva image at Madhuvana by the nun Dhanavatī. She proudly introduced herself as the sister's daughter of the nun Buddhamitrā, who had mastery over the *Tripiṭaka* and was the pupil of the monk Bala, who was also famous for his knowledge of the *Tripiṭaka*.[18] The other inscription records the dedication of an image of Vardhamāna by Kumārabhaṭi, who was a trader in perfumes. He introduced himself after his

mother as the son of Kumāramitrā, who was the female disciple of Ārya Baladatta. It was at her request that he made the gift.[19] These inscriptions suggest that women of noble character and learning left their impressions on society and earned respect.

But such women must have been very few and they could not ameliorate the general status of ordinary women. In sharp contrast to the inscriptions of Bhārhut those of Mathurā reveal a new trend in introducing woman donors. In Mathurā they are almost invariably introduced after a male relation: for example, Naśāpriyā, the daughter of Śurāna[20] or the lady of unknown name, a daughter of Kala and sister of Sinaviṣu.[21] But usually she was like Vasu, the daughter of Nādi, daughter-in-law of Jabhaka and wife of Jayabhaṭṭa.[22] The relationship could be extended still further as in the case of Vijayaśrī, who was the daughter of Bubu, *dharmapatnī* of Rājyavasu, mother of Devila and paternal grandmother of Viṣṇubhava.[23] Thus, women among the affluent communities of the urban sector are found to be stereotyped as daughters, sisters, wives, daughters-in-law, mothers and grandmothers. A woman was to be viewed in her family perspective. Along with these inscriptions we may read, without any comment, the oft-quoted dictum of Manu that a woman is never free.[24]

The names of father, husband, father-in-law or son not only served the purpose of identification, but also brought into relief the halo of family prestige, which was determined by the wealth and position derived from their respective professions. So, often with the names of male relations their callings are also noted. Thus, in a donative record, Mitrā was the daughter-in-law of an ironmonger and the daughter of a *maṇikāra*.[25] Kumāramitrā, in another record, was the *dharmapatnī* of a *sreṣṭhī*.[26] Similarly Jitamitrā was the mother of a *gandhika*.[27] Thus, quite consistent with the age of urban growth, power and prestige went with productive activities and affluence. And, women without having any share in this productive activity could only be proud in the reflected glory of the males.

It has been suggested by some scholars that freedom of women was curtailed during this period due to the advent of the foreigners in society as rulers, administrators, and traders.[28] Manu has advised a man to guard carefully his wife, otherwise she would be a cause of sorrow both to her paternal and in-law families.[29] The Purāṇas also betray their anxiety to check the laxity of women caused by the foreigners.[30] The male-dominated society thus guarded their women

against the foreigners and others; and placed them in inner apartments of houses to play their roles therein. It is during this period that we get from Mathurā a donative inscription of one Kaṭhika, who was the *abhyaṁtaropasthāpaka*,[31] i.e. a special servant for the interior.

There were in the cities other types of women too, whom we may call working women. Kauṭilya has referred to some of them.[32] An inscription from Mathurā records the donation of one Mitrā, who was the nurse (*dhātrī*) of Indrāgnibhadrā, the daughter of king Viṣṇumitra.[33] In a graded society, based on wealth, these working women also were in different levels of social hierarchy, no doubt; nevertheless, their role as 'free women' may be conceived. That the number of such working women was not negligible is suggested by the fact that the law-makers had to ponder over their incomes and Kātyāyana suggested that these should not be included within *strīdhana*.[34] Thus the family encroached upon their income and in such houses these women probably had greater voice.

From the time of the emergence of cities in the sixth century BC courtesans have received a special position in Indian society. The best among them were highly accomplished and had knowledge of the sixty-four arts. During the period of urban affluence at Mathurā also these courtesans flourished and made rich donations to religious groups. One such inscription is available for study. Vāsu, the *Nādā gaṇikā* and daughter of *Ādā gaṇikā* Loṇaśobhikā constructed a shrine for Vardhamāna, set up an *āyāgasabhā*, dug a tank (*prapā*) and placed a stone slab in the Arhat temple of the Nirgranthas.[35]

Thus the inscriptions of Mathurā give a picture of a complex urban centre where there were women of various categories in different levels of social status. Numerically greater must have been the ordinary household women. They, as we have seen, were dominated by the males, who reserved the right to protect them like other protectable properties, though they themselves might be attached to *gaṇikās* like Vāsu or Loṇaśobhikā.

Now, what was the condition in a village? Vātsyāyana has painted a picture of the toiling rural sector, where the peasant woman was enslaved by the powerful village headman under whose order she had to perform various types of unpaid work. Such women filled up his granaries, took things in and out of his house, cleaned and decorated his residence and worked in his fields. They took from him cotton, wool, flax or hemp for preparing apparel. They also transacted with him sale, purchase or exchange of various articles.[36] Thus, while

in the affluent urban sector women were protected within the four walls of the house, in the rural sector they were made to work for the households where there was inflow of urban money. In a Mathurā inscription the *dharmapatnī* of *grāmika* Jayanāga and daughter-in-law of *grāmika* Jayadeva is found to make religious donations[37] in the same fashion as was done by other urban women and their life pattern also might have been the same.

In the background of the economy of contemporary age we may re-study in this connection the Jogimara cave inscription of Sutanukā, the *devadāsī* of Vārāṇasī, who used to love *rūpadakṣa* Devadatta.[38] It is needless to say that their love did not receive its natural fruition in marriage because a *devadāsī* or slave of god had no freedom to bestow her love on any one else except the deity to whom she had been given. However, we need not be more pitiful towards Sutanukā than to any other housewife, because the latter had no better position in contemporary society than a *devadāsī*. A wife is enjoined by Manu to respect her husband as a god 'even though he might be destitute of virtue, or seeking pleasure elsewhere or devoid of good qualities'.[39] Thus, she was unto her husband what Sutanukā was to her god.

The position of women does not appear to have changed during the time of the Guptas. The Basarh Seal of Dhruvasvāminī is a case in illustration. She was the wife of Mahārājādhirāja Candragupta and mother of Mahārāja Govindagupta.[40] The role of Kumāradevī in Gupta administration is highly hypothetical. Prabhāvatīgupta's assumption of power as regent of her son was demanded by exigency of the state.

Freedom of women was curtailed further during this age. Nuns ceased to be admitted into the Buddhist order.[41] Women were still objects of enjoyment. Mere physical attractions of feminine beauty were described in the *praśastis* of the kings.[42] It was during this age that the dreams of getting charming heavenly damsels were infused into the hearts of men.[43] And, to conclude, the first epigraphic evidence of *satī* comes from this age. It is known from the Eran inscription that Goparāja, a chieftain of Bhānugupta (sixth century AD) was killed in a battle and 'his devoted, attached, beloved and beautiful wife clinging to him' entered into her husband's funeral pyre.[44] The assemblage of adjectives given to the *satī* in a semi-official record shows how the custom was glorified and gradually it came to be intimately associated with the ideal of a devoted wife.

So, even if we assume that Kumāradevī or Prabhāvatīgupta had

real power in their hands, we cannot conclude that the status of women was high during the Gupta period, the so-called 'Golden Age' of Indian history. The study made above shows that urbanization by itself could not be an instrument of upliftment of the position of those, including women, who did not have the reins of production in their hands. There was no rural-urban dichotomy in case of oppression. There were only variations in the outer surface of their modes of physical existence.

NOTES

1. Max Müller, ed., *Sacred Books of the East*, henceforth *SBE*, vol. XX, p. 322.
2. *Samyutta Nikāya*, III, 2. 6.
3. *SBE*, XX, pp. 322-6.
4. D.C. Sircar, *Select Inscriptions*, vol. I (Calcutta, 1965), 2nd edn., henceforth *SI*, p. 19.
5. Ibid., p. 69.
6. Ibid., p. 28.
7. Ibid., p. 74.
8. Loc. cit.
9. R.C. Majumdar, *The Classical Accounts of India* (Calcutta, 1960), p. 270.
10. Sircar, op. cit., pp. 28, 31.
11. Majumdar, op. cit., p. 231.
12. Sircar, op. cit., p. 28.
13. A. Ghosh, *The City in Early Historical India* (Simla, 1973), pp. 53-6.
14. Sircar, op. cit., p. 69.
15. *Lüders' List*, nos. 687-903.
16. For identification of the places, see P. Gupta, *Geography in Ancient Indian Inscriptions* (Delhi, 1973) and P.K. Bhattacharya, *Historical Geography of Madhya Pradesh from Early Records* (Delhi, 1977).
17. R.S. Sharma, 'Trends in the Economic History of Mathurā', in *Indologica Tauriensia*, vols. VIII-IX, 1981, p. 426.
18. *Lüders' List*, no. 38. This Buddhamitrā is also known from the Kosam image-inscription of the time of Kaniṣka (see *SI*, I, p. 136) and the Sārnāth Buddhist image-inscription of Kaniṣka (cf. *SI*, I, pp. 136-7).
19. *Lüders' List*, no. 39.
20. Ibid., no. 136.
21. Ibid., no. 112.
22. Ibid., no. 32.
23. Ibid., no. 50

24. *Manusmṛti*, V. 148; IX.3.
25. *Lüders' List*, no. 29.
26. Ibid., no. 24.
27. Ibid., no. 37.
28. V.P. Thapliyal, 'Foreign Invasion in ancient India : Impact on the Life of Women', *Journal of Ganganath Jha Kendriya Sanskrit Vidyapith*, vol. 32, pp. 93-101.
29. *Manusmṛti*, IX.5.
30. R.C. Hazra, *Studies in the Puranic Records on Hindu Rites and Customs* (Dacca, 1940), p. 231.
31. *Lüder's List*, no. 98.
32. Kauṭilya's *Arthaśāstra*, 1.21.1; 1.12.4; 1.12.13; 2.25.15; 2.23.2, etc.
33. Lüders, *Mathurā Inscriptions*, p. 207. This king Viṣṇumitra is also known from his coins; see Bela Lahiri, *Indigenous States of Northern India* (c. 200 BC to 320 AD) (Calcutta), pp. 103, 153.
34. *Kātyāyanasāroddhāra*, V.736.
35. *Lüders' List*, no. 102.
36. H.C. Chakladar, *Social Life in Ancient India—A Study in Vātsyāyana's Kāmasūtra*, 2nd edn. (Calcutta, 1954), p. 124.
37. *Lüders' List*, no. 48.
38. Ibid., no. 921.
39. *Manusmṛti*, V. 154.
40. *Corpus Inscriptionum Indicarum*, vol. III (rev.), p. 261, henceforth *CII*.
41. A.S. Altekar, 'Ideal and Position of Indian Women in Social Life', *Great Women of India*, ed. by Swami Madhavananda and R.C. Majumdar, (Mayavati, 1982), p. 37.
42. *CII*, vol. III (rev.), pp. 326-7.
43. Ibid., p. 264.
44. Ibid., p. 353.

Aspects of Women and Work in Early South India

Vijaya Ramaswamy

The Caṅkam literature of south India makes a significant contribution towards our understanding of the role of women in the early south Indian economy. Although in Caṅkam literature, as elsewhere, women are extolled for their beauty, modesty and chastity, aspects which characterize the traditional role perception of women, the Caṅkam works also refer to women planting seeds, husking paddy and keeping watch over the corn besides spinning thread or making and hawking commodities. In early medieval times, they are also referred to as holding responsible jobs like accountants, judges and local administrative officers.

The evidence in Caṅkam texts, early medieval literary works as well as inscriptions is widely scattered and meagre, but what is interesting is that it is there. Thus, this paper will examine, in turn, the various occupations where women played a role. Since the dates of this literary collection range from the first century BC to around the sixth and seventh centuries AD, this can also be taken to be the main time span of this paper. (But later references from the seventh to the thirteenth century which are much more scarce, in contrast to the earlier Caṅkam phase, will be used to provide a picture of women and work in early south India up to the thirteenth century.)

Caṅkam literature essentially consists of two major collections of songs—the *Eṭṭutokai* and the *Pattuppāṭṭu*. The *Eṭṭutokai* comprises the following eight anthologies: *Naṟṟinai, Kuṟuntokai, Aiṅkuṟunūṟu, Patiṟṟupattu, Paripāṭal Kalittokai, Akanāṉūṟu, Puṟanāṉūṟu.*

The other major collection, the *Pattuppāṭṭu*, comprises the following ten: *Tirumuṟukāṟṟuppaṭai, Porunarāṟṟupaṭai, Ciṟuppāṇāṟṟuppaṭai, Perumppāṇāṟṟuppaṭai, Mullaippāṭṭu, Maturaikkāñci, Neṭunalvāṭai, Kuṟiñcippāṭṭu Paṭṭinappālai, Malaipaṭukaṭām.*

It is estimated that these two major collections together consist of roughly 2300 songs. The Caṅkam literature gets its name from a

ASPECTS OF WOMEN AND WORK IN EARLY SOUTH INDIA 151

college or Caṅkam of Tamil poets who flourished under the patronage of the Pāṇḍya kings of Madurai. The literature is divided into three phases—the beginning (*Mutal Caṅkam*), the middle (*Iṭai Caṅkam*) and the end (*Kaṭai Caṅkam*). The *Cilappatikāram* and *Maṇimekalai*, the two great Tamil epics, are post-Caṅkam works. The Caṅkam texts have been used by historians of ancient India to study a wide variety of themes—love, war, the valour of kings and the lives of the common people. While *Akanāṉūṟu* deals with human emotions and inner reactions, the *Puṟanāṉūṟu*[1] concerns itself with outer actions like war. In spite of the extensive use of the Caṅkam texts, most modern historians, with the exception of scholars like P.T. Srinivasa Iyengar[2] have continued to stress the traditional role perception of woman as wife or mother or, contrarily, the prostitute. It is, however, the particular aim of this paper to reconstruct the economic activities of women on the basis of Caṅkam literature, an aspect that has suffered comparative neglect even at the hands of such eminent historians as T.N. Subramanian.

WOMEN IN AGRICULTURE

Among the low caste Vēḷāḷas called *kaṭaiyār*[3] meaning 'the last in society', women shared in the task of cultivating the fields. These women were known as *kaṭaicciyār*.[4] The distinction between the superior non-cultivating Vēḷāḷas and the inferior group of cultivating Vēḷāḷas is made in the fourth century grammatical work called *Tolkāppiam*. The inferior caste of cultivators eventually came to be called pallar. The *Peruṅkatai* states that the women cultivators were particularly skilled in planting paddy seeds and in weeding.[5] The *Perumppāṇāṟṟuppaṭai* gives a detailed description of *eyiṟṟiyār* women smoothening and weeding the fields with furrows which had an iron tip (*koṉku*).[6] In the *Tolkāppiam* the farmer is referred to as *uḻavar* and his wife as *uḻatti*.[7] A poem from the *Naṟṟiṇai*[8] (sixth century AD) describes the life of the *uḻavar* or ploughmen: they wake up at dawn and have a hearty meal consisting of rice mixed with fish soup, then they and their wives go to the fields where the women plant the seedlings in the wet clay. Thus the ploughmen who have yoked the buffalo and are ploughing the field, built up many stacks of paddy which look like paddy hills, the poem concludes. In fact, the *Tolkāppiam* asks in one verse as to how would Vēḷāḷas subsist if they did not till the land, meaning that agriculture was their sole livelihood.[9] However,

the term *uḻatti* was not applied not only to the farmer's wife, but even to a woman working as agricultural labourer. This is the sense in which Cekkiḻār uses the word in the thirteenth century work *Periyapurāṇam* where in the story of the Paraiya saint Nantanār, the *uḻatti* is described as resting under a *marutu* tree while her baby slept on a leather sheet.[10]

Besides the planting of seeds and weeding of plants, husking and winnowing of the paddy were also done entirely by women. The image of two women standing face to face pounding paddy with a big pestle (*ulakkai*) is a recurrent theme in Caṅkam literature. The *ural* or stone mortar would be fitted into the ground in the courtyard of the farmer's house.[11] In the reference from the *Perumppāṇāṟṟuppaṭai* the peasant woman is referred to as *eyiṟṟiyār*. The *Malaipaṭukaṭām*[12] and the *Kuṟuntokai*[13], both belonging to the fifth or sixth century AD, refer to the women singing as they rhythmically pound the grain. This style of folk song is known as *vallai pāṭṭu*. The *Malaipaṭukaṭām* uses the epithet *kuṟamakaḷ* or women of the hills (these days taken to be gypsies) for these *kuriñci* women. The most beautiful examples of *vallai pāṭṭu* are to be found in Kapilar's *Kuriñcikalai* which is part of the *Kalittokai*. Here the mortar is of wood, not stone, and the pestle is made of the heartwood of a tree. In one song the heroine and her foster sister discuss the lover and hero, alternately praising or condemning him. The foster sister says, 'Let us sing, my friend, as we like' and the maiden replies, 'Let us pull the mature spikes of the millet whose heads are bent like shy girls with fair eyes and glad speech; raise alternately the pestle made of ivory full of pearls, pound the grains in a mortar made of sandalwood and sing as we like in praise of the hill which belongs to the man who has caused the disease of love (in me) for which there is no remedy.'[14] It is noteworthy that numerous examples of *vallai pāṭṭu* have survived into the present-day. Not only the *uḻatti* and the *iṭaicciyar* but also the low caste *pulatti* (*pulaya* womenfolk) engaged in the task of husking paddy, most probably as paid agricultural labourers. The *Periyapurāṇam* refers to the *pulatti* woman singing while husking paddy, while her husband went to the fields to work.[15] Here the word used to denote them is *kaṭaiyanār* or the lowest, confirming that they worked as agricultural labourers.

While the women undertook the more heavy tasks of planting, weeding and husking, young unmarried girls were employed to keep a watch over the paddy and millet fields and drive off the parrots and

other birds and also stray animals. A pretty girl driving away the parrots from the fields is a cliche in Caṅkam poetry. They stand on a raised platform and use either a *kāvan* or a *talal*, a device fitted on a bamboo stick which produces a loud sound, when rotated fast, or a *taṭṭai* to drive away the birds. Sometimes they just beat the drum or throw stones at them.[16] The *Akanāṉūṟu* writes that the time young girls kept watch over the ripe corn just before harvest was the occasion for romantic dalliance called *kaḷavu*. The girls would raise the cry of *puḷi, puḷi* (tiger, tiger) which would immediately bring the youth.[17] This *kaḷavu* or courtship was an accepted aspect of social life and suggests that in Caṅkam society girls exercised considerable choice in their marriage. It appears that it was only with growing brahmanical influence that south Indian society tended to become conservative and closed.

DAIRY FARMING

Caṅkam literature is based to some extent on the typology of lands called *kuṟiñci, marutam, mullai, pālai* and *neytāl*. While agriculture predominated in *kuṟiñci* and *marutam, mullai* was known for its green pastures and dairy farming. Cattle breeding and dairy farming was a sector of the economy in which women played a leading, possibly even a dominant part. The *Perumppāṇāṟṟuppaṭai* which can roughly be ascribed to the fourth century AD gives a detailed description of the work of a shepherdess. In a somewhat clumsy simile it compares the rhythmic churning of the curds by the shepherdess to a tiger's roar! The shepherdesses in the southern country are known by such names as *āyicciyar, kovicciyār, iṭaicciyār*, etc. Starting her day early in the morning the shepherdess churns the curds to take out butter. She then sells the buttermilk from door to door in the *kuṟiñci* region and with the money she gets she buys foodgrain for her household.[18] Elsewhere in the *Puṟanāṉūṟu* it is stated that curds were directly exchanged with the farmers for foodgrains.[19] The shepherdess also prepared ghee and hawked it. She does not accept the gold which is offered in exchange but gets a good milch buffalo, a good cow and another black buffalo in exchange.[20] This judicious capital investment enables her to expand her business. The process of setting curds by curdling the milk is used as a simile in the *Puṟam* where it says 'like the curd being squirted on a pot of milk from the fingers of a tired shepherdess'.[21] The *Puṟam* also says that in the Pāṇḍya country the

prosperous housewife exchanged paddy for the goat meat brought by the shepherdess.[22] At home, the *kōvalar* woman prepared red *tinai* rice which was consumed with milk and also offered to guests.[23] They also ate meat (especially venison)[24] as did almost all lower castes. The *Perumppāṇāṟṟuppaṭai* says that in front of their thatched huts the hides of skinned goats were spread on wooden cots to dry.[25] In the *Cilappatikāram* it is said that Kōvalan and Kaṇṇaki stayed in the house of a shepherdess called Madari who naturally was a worshipper of Kṛṣṇa. In the *Tiruppāvai* of Āṇṭāḷ (seventh century AD) the image of the dusky shepherdess, with her heavy chains and clinking bracelets, churning the curds at dawn, occurs repeatedly.[26]

THE HANDLOOM INDUSTRY

Among the domestic industries, the most important was the handloom industry. Spinning in south India was done, and is still done, entirely by women while in the north, especially in the hills, men can also be seen spinning on a spindle. While the spinning of thread was also done by housewives, it was by and large the sole occupation of widows and unmarried or destitute women. Such female spinners are referred to in the Caṅkam literature as *parutti peṇṭukal*. The *Puṟanānūru* uses the expression *parutti peṇṭīr paṇṇuvāl* for the thread carded by spinning women.[27] The verse goes 'Let us eat bits of meat soaking in oil which reduces the anger of the fire and makes them soft like the carded cotton thread used by women for spinning and drink large pots of toddy together'. The *Naṟṟinai* says that widows spun fine thread.[28] While here the word *ālil peṇṭīr* (literally 'without man') is used for widows, they are also elsewhere referred to as *kaimai peṇṭīr*.[29] References to women spinners continue into the early medieval period. In the thirteenth century, the Vīra-Śaiva movement began under Bāsava and absorbed into its fold many of the lower castes like craftsmen, weavers and oilmen. The śūdra Liṅgāyat (Vīraśaivaite) saint Jedara Dasimayya belonged to the professional caste of weavers and it is said that his saintly wife Duggali spun the thread which he wove into cloth.[30] Remmavve, another Śaiva devotee, acquired the nickname of *kadire Remmavve* because of her profession of spinning yarn. That women spinners continued right into the Vijayanagar period is attested by Śrīnātha (fifteenth century) in his *Palnattu Vīracaritra* where he says that in Palnad while the farmers ploughed the field, their wives spun thread.[31]

Right up to the present times women are actively engaged in spinning and dyeing. The evidence of south Indian literary texts in this respect is bolstered by the evidence of Vedic texts. The Śatapatha Brāhmaṇa states *tat vai etat strīnām karma yad ūrṇasūtram* that is spinning is the work of women.[32] Another Vedic text—the *Kṛṣṇa Yajurveda Taittirīya Saṁhitā* makes the curious statement that women engaged in spinning and weaving were considered impure.[33] Women also engaged in the work of dyeing cloth and the Vedic texts refer to them as *rajayitrī*.[34] Going by the evidence of Vedic texts weaving seems to have been the occupation of many women, although there are also references to male weavers. The weaving women are referred to as *vayatrī*. *Gnās tva krantann apaso tanvata vayitrīyo vayan* says the *Pañcaviṁśa Brāhmaṇa*,[35] meaning that the women have cut the cloth, the fingers of the women have stretched the cloth on the looms and the female weavers have woven the cloth. The weaving was generally done by them in their homes. In south India, however, one fails to come across any reference to women weaving. Perhaps this was for reasons of ritual purity. In the oral traditions of south Indian weavers the various parts of the loom are named after various gods[36] and the loom is touched by the men of the traditional weaving castes like the ceṅkunta-kaikkōlār, the caliyar or the tevaṅkar only after performing the necessary rituals.[37]

There is another profession which is also associated with the handloom industry—the bleaching and washing of cloth. This was again a sphere of work in which women engaged independently or actively assisted their husbands in the task. The washerwoman was known as *pulatti*. The Caṅkam texts are replete with references to her. The *Puṛanāṉūṛu* says that the *pulatti* washed the clothes in the particular area called *kaḻar* whose mud was a good purifying and whitening agent.[38] The *Naṟṟinai* says that she prepared starch from rice[39] and the cloth was dipped in the starchy solution.[40] Finally, with her long tapering fingers she removed the lumpy or excess starch from the cloth.[41] The *Akanāṉūṛu* also refers to washing and starching of the cloth by the *pulatti*.[42] It is repeatedly stated that the *pulatti* washed impure clothes. The *pulayan* was the one who was asked to handle the dead body and clean the house of death with cowdung, etc.[43] At the time of cremation the task of offering food to the dead was performed by a *pulaya*. It was but natural that the *pulayar* should have been regarded among the lowest in society and treated as untouchables. In the *Nālāyira Tivyappirapantam*

Toṇṭaratippoṭi āḻvār says that the high caste people who insult true devotees are *pulayar*.[44] It was the duty of the *pulaya* to beat the drum on funeral occasions[45] and because they beat the drum (*paṟai*) they also came to be called *paraiyar*. The *pulatti* women are said to have indulged in heavy drinking and in drunken dancing, in the thirteenth century work Cekkiḻār's *Periyapurāṇam*.[46] Perhaps because of their association with the dead and with the cremation ground, it was believed that the *pulaya* women became possessed by spirits and that they had to be placated to ward off evil. When so possessed, says the *Puṟanāṉūru* they wildly jumped about like cattle.[47] In spite of her low caste and low social status, the *pulatti* or washerwoman remained a very essential component of the village community.[48]

References to women in any of the other handicrafts are very sparse. Thus a cautious reconstruction of the women's role in these crafts or professions has to be attempted on the basis of the limited evidence available.

POTTERY AND BASKET WEAVING

One might assume that women would have played an active part in the potter's craft. Women must surely have been involved in smoothening the clay or baking the pots and yet there is no clear indication to this effect. There is one striking reference in the *Puṟanāṉūru* to the *Veṇṇi kuyattiyār*, that is, the potter woman of Venni who was a poetess and who composed a poem on the victory of Karikāla at the battle of Venni[49] in Tanjore district.

The references to basket weaving by women are somewhat more frequent. In a Caṅkam reference pertaining to the sixth century AD, it is said that besides washing, it was the job of the *pulatti* to make baskets out of reeds called *kōrai*.[50] In fact, oral tradition makes it clear that the *kōrai* pickers were women. In one Tamil folk song, the *kōrai* picker sings:

> As I come to cut the *kōrai* growing around my house, my Lord,
> Growing around my house
> You threaten me as a foolish slut, my Lord,
> You come to threaten me
> Even as I go to pick the *kōrai* around the lake, my Lord,
> Around the lake

You should know I am heavy with child, my Lord,
You should know.

In the Andhra and Karnataka regions, the basket weavers belonged to the *medara* caste. There is a reference to women basket weavers whose work is known as *kantakara vṛtti* in the fourteenth and fifteenth centuries in Vallabharāya's *Kreeḍabhirāmamu*.[51] The reference to basket weaving as women's work is also said to be found in the Vedic texts.[52] The work was apparently very low paid and the *medara* women were poor because the *Kreeḍābhirāmamu*[53] says that many of these women basket weavers took to prostitution out of compulsion. Besides *kōrai* mats and baskets, baskets were also made of *panai ōlai*[54] or palm-leaf or bamboo called *mōṅkil*. Baskets were known by various names such as *kuṭai, vatti* and *puttil*.[55] The old type of baskets and coconut leaf or palm-leaf umbrellas are still a common sight in south India and these are still being made largely by women. Basketry is the specialized craft of the *parava* (fisherwoman) of Kerala and in Tamil country the women of Ramanathapuram are known today for their intricate basket work.

PITH-WORK

A craft in which women are said to be as skilled as men is pith-work, called *neṭṭi* in south India. The plant known as *shola* has soft flexible stems with spongy cellular tissues in them and also in the branches. The reference to pith-work is found in the Caṅkam and post-Caṅkam literature. The *Cilappatikāram* refers to the *neṭṭi* work done in Pumpuhar and the sale of *neṭṭi* products in the markets of Pumpuhar.[56] With *neṭṭi* were made flowers, toys, hair decorations especially marriage coronets, etc.[57] The Caṅkam texts however do not make any reference to the people who did *neṭṭi* work but since this is still an important craft in south India, one may presume that as now so then, women must have played an active role in this craft. In Karnataka among the *gudagaras*, an ancient caste of craftsmen, the men carve wooden figures while the women engage in pith-work.[58]

EXTRACTION AND SALE OF OIL

Extraction of oil from gingelly seeds and also fish was an important industry. While there is evidence as to the use of gingelly oil in the Caṅkam age in texts like *Naṟṟinai* and *Puṟanāṉūṟu*,[59] there is no

evidence as to whether women participated in the extraction of oil. However, the extraction and sale of fish oil seems to have been done by fisherwomen. The *Porunarārrupaṭai*[60] says that fish oil and toddy were exchanged for honey and edible roots. There are a few medieval references to women extracting oil from the *campaṅki* (highly scented flower) and selling it.[61] The *Kreeḍabhirāmamu* of Vallabharāya says the *teliki* women extracted and sold *campaṅki nūne*, i.e. campangi oil.[62]

PRODUCTION AND SALE OF SALT

The production of salt from the sea was the work of those castes who lived in the *neytāl* or coastal region. Saltmakers were known as *umanār* and their wives played an important role both in the making and the marketing of salt. The *Narrinai*[63] says that the *umanār* led a nomadic life. They generally travelled in groups and the *Akanānūru*[64] says that the movement of their vast caravan would appear as if an entire township was moving. Salt producers were also known by the name *alavar* and the place of salt (*uppu*) extraction as *alam*.[65] The *Perumppāṇārruppaṭai* describes how the husband and wife extracted the salt and heaped it on the sea shore. It was loaded into a cart and hawked from door to door. The wife drove a pair of additional bullocks to be harnessed in case the ones driving the cart got tired. They hunted animals on the way and ate their meat. Besides salt, the *umanār* also appear to have sold pepper bags which were loaded onto the cart and jars of pickles hung beneath the cart.[66] Women also carried headloads of salt and sold them from door to door. The *Akanānūru*[67] says that the beautiful *neytāl* women used to exchange salt for paddy from the peasant women. The *Kuṟuntokai*[68] also refers to the exchange of paddy for salt.

FISHERY

The *paraṭaiyār* or fisherwomen caught and sold fish. Young girls of this caste kept watch over the fish dried in the sun.[69] The *Akanānūru*[70] refers to these fisherwomen as *paṇimakaḷ* and says that they sat in street corners selling their fish. There are also references to the fisherwoman exchanging the fish for paddy. The *Aiñkuṟunūṟu* says that the *valaya* women sold the *varal* fish (regarded as a delicacy) and got year-old white rice in return.[71] The *Puṟam* also describes the *paraṭaiyār* or fisherwomen as hard drinkers who

drank a liquor made out of palm, sugar cane and coconut juice.[72]

EXTRACTION AND SALE OF TODDY

The coastal women are also said to have processed and sold toddy made from palmyra juice or from rice. Wine was also prepared from honey or from fruits. The *valaiyār* caste was very highly skilled in preparing liquor. Women however are specifically associated only with the making of rice toddy.[73] The *Perumppāṇāṟṟuppaṭai* clearly states that they enjoyed the *kaḷḷu*, that is toddy made of rice which was prepared at home called *toppi*. First a kind of rice starch was prepared which was then allowed to ferment for the day. Finally, impurities were drained from it.[74] This liquor is referred to as *naṟumpiḻi*. A mild toddy prepared from the palmyra was known as *peṇṇai* while the preparation from honey was called *tekkal-tēnal*. It is interesting that women of lower and upper strata (perhaps with the exception of brāhmaṇas) consumed liquor as reference to this practice in *Paṭṭinappālai*[75] and other Caṅkam texts show. The *Paṭṭinappālai* says that the *paraṭavār* (fisherfolk) of the *neytāl* (coastal) region, first offered the liquor to the gods and then drank it.[76] The *Takkayākapparaṇi*, a text pertaining to the tenth century roughly, says that women consumed the strong rice liquor called *naṟuvu*.[77]

There are also quite a few references to women hawkers selling toddy. The *Akanānūṟu* says that the *aṟiyāl* girls sold toddy which they carried on their heads in pots.[78] Like oil the toddy was also exchanged for rice.[79]

GARLAND-MAKING AND FLOWER-SELLING

Garland-making and flower-selling were, by and large, the occupation of women. The *Akanānūṟu* says that the *vēṭṭuva* girls gathered the flowers in bamboo pipes and went to the villages to sell the flowers.[80] Garland makers were generally attached to temples in the medieval period. An eleventh-century record from Tiruvamattur in South Arcot district says that women were employed in the Abhirāmeśvara temple at Tiruvamattur (South Arcot) to pick flowers and make garlands.[81] Vallabharāya's *Kreeḍabhirāmamu*[82] makes a similar statement. The Tiruvamattur record states that while men were paid at the rate of 8 *nāḻis*[83] of rice per day for the tasks of lifting water, irrigating the fields, gathering flowers and making garlands, women

were paid only at half the rate, that is 4 *nāḷis* for performing the same work!

HAWKERS AND COOKS

Women hired themselves out as cooks, either in private homes or temples. They also made pancakes or hoppers and '*appam*', a kind of sweet, and hawked them in the streets according to the *Maturaikkāñci*.[84] The *Cilappatikāram* also refers to the same practice.[85] There are references to the appointment of female cooks in the medieval period. An inscription from Talagunda in Karnataka dated 1158 AD states that three female cooks were appointed to cook food for the students in an *agrahāra* (brāhmaṇa settlement) and they were paid money as well as given clothes.[86] The famous story from the *Periya Purāṇam* called *Puṭṭukku Maṇ Cumanta Perumān* meaning 'the Lord who carried mud (for construction work) in return for the delicacy *puṭṭu*' refers to the old lady who made a living by making *puṭṭu* and selling it. The *Kreeḍabhirāmamu* refers to women who maintained *Pootakulla Illu* or small inns, where the usual charge per meal was one *ruka*.[87] Female cooks were also employed in the temples as the Tirupathi Devasthanam inscriptions show.[88] Poor women also seem to have sold cowdung cakes (used as fuel) for a living. A Kannada text refers to an old woman Pittave who prepared and sold '*tocai*' (similar to pancakes) while another woman, Ammave, sold cowdung cakes.[89] One lively Tamil folk song refers to these as the occupations of destitute old women.

While the granny prepared the cowdung and came to make the gruel
The young girl came to polish off the curds and the milk
While the granny came to bake white sweet cakes to sell
The young girl came to buy flowers out of the money of the sales.

NURSES AND FOSTER MOTHERS

Caṅkam literature also refers to the employment of women as wet nurses and foster mothers. The term used is *cevilittāi*. Though probably only indigent women took to the profession, the nurse seems to have enjoyed the respect as well as affection of the family she

served. A beautiful poem from the *Naṟṟinai* has a mother reminiscising about her daughter who had just got married. 'Is this my child behind whom the nurse used to run, with a golden cup of rice mixed with honey and milk in her hands, coaxing and threatening the child in turn.[90] In the *Kuriñcippāṭṭu*[91] the daughter of the house first confides her love affair to her nurse or foster mother who then convinces the mother and the marriage takes place. The *Akanānūṟu*[92] also refers to women adopting the profession of wet-nurse or fostermother. The *Perumppāṇāṟṟuppaṭai*[93] lists the duties of the nurse which included amusing the child, feeding it and soothing it to sleep, etc.

BARDS AND DANCERS

Women bards and dancers called *viṟaliyār* occupied a very important place in Caṅkam society. In fact, there is a separate poem called Viṟaliyāṟṟuppaṭai composed by Neṭumpālḷiyāṭanār and contained in the Akanānūṟu which refers to the great beauty and accomplishments of the *viṟali*. *Viṟali* were the women of the *pāṇār* community who were wandering minstrels. The *viṟali* were very graceful dancers,[94] while the women who sang were known as *pattini*. The Caṅkam work known as *Patiṟṟuppattu* (the ten poems) is a collection of the panegyrics composed by the *pāṇar* men and women. The songs are in praise of their patrons. The work also casts light on the social life of the age, especially of their community. In the *Patiṟṟuppattu* the bard clearly says that the *viṟaliyār* sang of the military glory of the Ceramān kings and in return the king plied them with liquor and loaded them with jewels so that when decked in them they appeared like the *vēṅkai* tree in bloom.[95] The bard says that being used only to abject poverty, some of his kinswomen had put on the ornaments wrongly and looked as ridiculous as the red-faced monkeys with Sītā's jewels (a reference to an incident from the *Rāmāyaṇa*). The king even gifted the *viṟal* with elephants[96]. The *Puṟanānūṟu*[97] says that the Coḷa chief, Kiḷḷivalavan, sat down with the *pāṇars* to a great feast of *varaku* (millet), honey, meat and pots of toddy after which he gave them rich presents. The *pāṇar* also seem to have performed the duty of carrying the shields of the kings in the battlefield[98] and enthused the army with their stirring songs.

MENIALS

Besides these classes, there were women who worked as menials. The servants were referred to as *aṭiyār* or *paṇimakkaḷ*. They worked as sweepers and cleaners in private homes as well as the temples. Carrying water and taking the cattle to graze was a part of their duties.[99] They also went as construction workers. One Coḷa inscription says that both men and women worked as daily labourers but women were paid only half of what the men got.[100] The Tiruvamattur inscription cited earlier also says that women workers were paid less than men.[101] A thirteenth-century Pāṇḍyan inscription refers to a curious case involving a murder where the lands of the male and female servants of the murderer were confiscated by the State.[102] The twelfth-century text *Mānasollāsa* recommends employing women for such menial tasks as serving food, washing feet, massaging, dressing hair, etc.[103] Referring to the lowly job of maidservants Sant Bāsava says that it is far better to be a *toṭṭi* (maid) in a devotee's house than a queen in the palace.[104]

The *vaḷaiyār* women called the *vaḷaiyaci* also seem to have earned a living by participating in death obsequies. An inscription from the Pudukkottai State says that when death occurred in any household, the *vaḷaiyaci* women put a cloth over their heads, and mourned the dead with loud wails.[105] Cleaning the house of the dead with water the next day was also their job. They were paid for both the services.

TEMPLE EMPLOYEES

In medieval times, the temple came to occupy an important place in the context of women's economic activities. Women were employed in various capacities in the temple, both as paid and unpaid workers. The *tēvaraṭiyār* (literally servant of God), by and large, seem to have been sold to the temple and as a mark of their slavery they had a trident called '*cūla*' stamped on their forehead. A record dated 1119 states that an army captain called Aḷakiya Pallavarāyar gave the girls of his family to the Tiruvallaṅkoyil after branding them on the forehead with the trident mark.[106] An inscription dated 1201 from Tanjore states that a vēḷāḷa farmer sold himself and his two daughters as slaves (*aṭimai*) to the temple. It states that the time was very bad, that paddy sold at 3 *nāḷi* for one *kācu* and consequently he borrowed 110 *kācu* from the temple and sold himself and his daughters to the

temple.[107] Again a record dated 1175 says that four women were sold as *tēvaraṭiyār* to the Tiruvālaṅkaṭu temple for the sum of 700 *kācu*.[108] A Coḷa inscription from Tiruvaorriyur in Chingleput district states that five women were gifted to the temple for the specific purpose of husking paddy.[109] Besides singing and dancing before the deity (*geetam* and *cantikunippam*) it was their task to clean the temple with cowdung (*tiruvalaku tirumilukku*) clean the rice (*tālikai vilakku*), etc. A Tiruvarriyur inscription[110] lists the other tasks of the temple women. It refers to the hierarchy among the temple women with the *patiyilār* (literally, those without husbands) occupying the foremost rank, the *tēvaraṭiyār* second and the *iṣṭabhaṭṭāliyar* (servants beloved of the Lord?) the last rank. The record also indicates that not all temple women were slaves and that quite a few enjoyed status, position and property.[111] The record clarifies that the main dancing in the temple was to be done by the *patiyilār* and *tēvaraṭiyār* while the *iṣṭabhaṭṭāliyar* provided the music (*akamārkam*). The *tēvaraṭiyār* carried the flower plate (*pushpataligai*) and *tirunirkappu* (?) while the *iṣṭabhaṭṭāliyar* decorated the floor with rice flour (*varikkōlam*). The *patiyilār* got 30 *kalams* of paddy per year while the *tēvaraṭiyār* got 1 *nāḷi* of cooked rice everyday but the wages of the *iṣṭabhaṭṭāliyar* are not mentioned, perhaps because they were not paid for their services. Holding the mirror before the deity, fanning the deity[112] with the fly whisk and in Vaiṣṇavite temples, holding the *Śrīpadam*[113] (the golden feet of the Lord) were all performed by women and sometimes the wages for such services are also given. There are a few rare instances when women seem to have been employed as accountants by the temple. In 1255 in the Kuñjeśvara temple at Hiriyur[114] massive donations were made by one Kunje Setti and his close relative Kanambi. His daughter Chandeve referred to as *gaṇa kumārī* was made *utayāḷi* or trustee of the temple, and the *vipūtipaṭṭa* or crown of authority was given to her entrusting her with all the accounts of the temples. The *mahā-gaṇangalluo*r temple management gave into her charge all the dues and imposts. In another inscription from the Malleśvara temple at Mavanur in Hole Narsipur *tāluk* in Mysore dated 1282 detailed reference is made to a lady, Devavve, the wife of Appayya, the *oḍeyar* of Mavanur, and her daughter, Pārvatī Devī who was the chief superintendent of the temple. Devavve herself built a temple in Mavanur, and the Hoysala King Narasiṁha III conferred upon her the village of Tavanidhi for the maintenance of the Deveśvara and Appeśvara temples. She divided

the land into 20 *vṛttis* (*vṛtti* or *nivṛtt* is an unit of land and at times administrative division) and gave them to *mahervaras* in return for an annual sum of 2 *gadayanas* (coin weighing 50 to 60 grains of gold) and 5 *paṇams*. Devavve was also the paymaster for the numerous temple servants and her daughter Pārvatī Devī became the superintendent and administrator of the temple funds.[115]

WOMEN'S GUILDS

The inscriptions make very intriguing references to the functioning of women's guilds in the medieval period. They are called *śāni munnuru*, i.e. *śāni*, 300 (*śāni* is a term of respect for women). No explanation is given as to why the figure 300 is associated with these women's guilds although the practice of associating a number with a guild such as the Teliki, 1000 or the Ayyavole, 500 was a typical medieval practice. The *śāni munnūru* (i.e. 300) were considered so important that they were quite often entrusted with temple management jointly with the *tānapatis* (temple managers or trustees) as in the case of the temple in Krishna district (in Peddakallepalle village) referred to in an inscription dated 1292.[116] In another record these women trustees are referred to as *nibandhakārulu*.[117] This collective women-organization is called *Sanula Sampradāyam*, i.e. hereditary women workers of the temple in other inscriptions from the Narasimha temple at Simhachalam[118] (in Waltair) and elsewhere.[119] However, there are no epigraphical details as to the activities of these women's guilds.

WOMEN OFFICIALS

Whether in the Caṅkam age or in the early medieval period, references to women in very high positions are few and far between. Several women seem to have held positions of power and responsibility in the medieval temples but reference to women in key administrative positions or in the army, are an exception. T.N. Subramaniam, the historian of the Caṅkam age, points out that women bodyguards of the king called his *urimai curram* are referred to as being 'beautiful, courageous and alert'. These women belonged to the courtesan class.[120] It was however more common to find women in the armoury as cleaners of weapons or as lamp-lighters to which reference is made in the *Mullaippāṭṭu* which also says they carried shining spears[121] (one

does not know whether they actually fought with them). But the *Puranānūru* does clearly refer to *muṭinmakaḷīr* or women of the warrior class.[122] A few other references to women fighters and commanders occur in the early medieval period. One such person was Akkādevī, the sister of Cālukya King Jayasiṁha, who ruled over Kisukadu, Banavasi, Torgale, Masiyavadi and a few other divisions. One of her epithets was *raṇa-bhairavī* meaning one who is most proficient in battle. Among her famous victories was the defeat of the rebel chief of Gokak in Belgaum district.[123] The bravery of women in the battlefield is also referred to in some other insriptions.[124] Karnataka inscriptions also refer to a few eminent women administrators like the Kākatīya queen Rānī Rudrambā (1262-96) and Mailadevī the queen of the Cālukya king Someśvara I who ruled in the eleventh century.

In the Tamil country, the very foundation of the Pāṇḍyan kingdom is attributed to a woman according to a curious legend narrated by Megasthenes.[125] Although the tale is unbelievable, there are a few instances of women administrators, especially justices of peace. An inscription from Manamai, near Kunnattur, speaks of a woman who served on the judicial committee of the village assembly.[126] In the time of Sundara Pāṇḍya, the lady Perumkarunaiyatti *alias* Tevarkaḷammai was one of the *niyāyattār* of Uttaramattur[127]. The reference to Lakkadevi as headman (*mahāpraviṇi*) of a village and Revakabbarasi as an officer in the royal household comes from the Karnataka country.[128] But as stated earlier references to such women in high places are to the exception rather than the rule.

CONCLUSION

Certain broad conclusions can be drawn from the evidence presented on the nature of woman's work in early south India. Right from the Caṅkam age onwards till the present times, the peasant women have played a key role in agricultural activities—in seeding, planting, weeding and irrigation. Dairy farming was another sphere of activity where women were actively involved and, now as then, women making and selling curds, ghee and butter are a common sight in the Indian countryside. Spinning from the earliest times to the present has exclusively been the work of women and while the weaver weaves, his wife prepares the yarn. Spinning was especially the occupation of destitutes and widows. Although women are likely to have played a

complementary role in craft production, references to their participation are few and far between. In fact, in crafts like blacksmithy and goldsmithy there are no references to women. However, women played an active part in pith-work, basket making, mat weaving, etc. Nursing again seems to be a profession natural to women as evidenced by the Caṅkam texts as well as modern experience. At the lowest rungs of the economy, as domestic workers and agricultural labourers women seem to have participated equally with men although they were paid only half as much.

The evidence presented so far does definitely indicate that it was rural women rather than urban women who were co-sharers with men in all major economic activities. It is noteworthy that the land type (*tiṇai*) classification made in Caṅkam literature refers to pastoral, coastal, forest, desert and mountain regions and the lives of the villagers within each ecotype but not to towns. Even the crafts where women played an active part are predominantly rural crafts. Later evidence suggests that women probably played a subordinate and, in fact, inferior role in urban society. Romila Thapar makes a similar conjecture with reference to Mauryan society in the context of the statement of Megasthenes that while most women were concerned solely with child-bearing, others assisted their husbands in their work, she remarks.[129] 'The latter category would apply more to the cultivators than to any other class, since it is possible that women worked in the fields, but it is highly unlikely that they would be permitted to assist in any other kind of work, particularly in the towns.' However, in Mauryan India spinning and weaving were two industries where women worked in large numbers.[130] Caṅkam literature evolved in a predominantly rural setting but the theme of women and work in the context of the urban-rural dichotomy is well worth further exploration.

NOTES

1. It was the convention of that age to classify all literary expressions as *akam* (inner) and *puram* (outer).
2. *History of Tamils* (Madras, 1930).
3. *Tolkāppiam* of Tolkāppiyar, *Poruḷatikāram* (henceforth *Poruḷ*) Naccinārkkiniyār commentary (Madras, 1923), verse 20.
4. *Puranāṉūru* (henceforth *Puṟam*), ed. by U.V. Swaminathaiyyar (Madras, 1935), song 61: line 1 (henceforth to be written as 61:1).

ASPECTS OF WOMEN AND WORK IN EARLY SOUTH INDIA 167

5. *Peruṅkatai*, ed. by U.V. Swaminathaiyyar (Madras, 1924); p. 507, I, 413, p. 234, I.163-4 and cited in K.R. Hanumanthan, *Untouchability, a Historical Study* (Madurai, 1979), p. 100.
6. *Perumppāṇārruppaṭai* in *Pattuppāṭṭu*, ed. by U.V. Swaminathaiyyar (Madras, 1931), lines 90-7.
7. *Tolkāppiam, Poruḷ Nūrpa* 20. Also *Pattuppāṭṭu passim*.
8. *Narriṇai*, ed. by A. Narayanaswami (Madras, 1952), 60: 1-8.
9. *Tolkāppiam: Marappiyal*: 82.
10. *Periyapurāṇam*, in Nilakanta Sastri, *The Coḷas* (Madras, 1975), 5: 22-4 and 6: 206-7, cited in pp. 568-9.
11. *Perumppāṇārruppaṭai* which is among the earlier of the *Pattuppāṭṭu*, ed. by U.V. Swaminathaiyyar (Madras, 1931), lines 95-7.
12. *Malaipaṭukaṭām* also from the *Pattuppāṭṭu*, 342.
13. *Kuṟuntokai*, ed. by U.V. Swaminathaiyyar (Madras, 1937), 89:1.
14. The translation of this *vallai pāṭṭu* is from P.T. Srinivasa Iyengar, *History of the Tamils* (rpt.) (New Delhi, 1983), p. 576.
15. Nilakanta Sastri, *The Coḷas*, op. cit. In pp. 568-9 he gives a brief translation from the *Periyapurāṇam* of the description of Adanur, the city where Nantanar lived.
16. *Akanāṉūṟu* (henceforth *Akam*) commentary by N.M. Venkataswami Nattar and R. Venkatachalam Pillai (Madras, 1943), 188: 11-13. Also *Kuṟiñcippāṭṭu* in *Pattuppāṭṭu*, 41-4.
17. *Akanāṉūṟu*: 48.
18. *Perumppāṇārruppaṭai*, 156-60.
19. *Puṟanāṉūṟu*, 33: 1-6.
20. *Perumppāṇārruppaṭai*, 164-5.
21. *Puṟam*, 276: 4-5
22. *Puṟam*, 33.
23. *Perumppāṇārruppaṭai*, 166-8.
24. Ibid., lines 440-5.
25. Ibid., 148-54.
26. *Tiruppāvai* of Āṇḍāḷ songs 7, 8, 12, etc.
27. *Puṟam* 125:1. Also 326: 5.
28. *Narriṇai*, 353: 1-2.
29. *Puṟam* 25:12. Also *Maṇimekalai*, ed. by U.V. Swaminathaiyyar (Madras, 1931), XX: 122, etc.
30. *Saranacharitramu*, p. 223 cited in J.K. Kamat, *Social Life in Medieval Karnataka* (New Delhi, 1980), p. 119.
31. Śrīnātha, *Palnattu Viracaritra*, in *Further Sources of Vijayanagar History*, K.A. Nilakanta Sastri and N. Venkataramanayya (Madras, 1946), 3 vols., vol. III, p. 52.
32. *Śatapatha Brāhmaṇa*, 12, 7, 2, 11 cited in *Weben und Flechten in Vedischen Indien* by Wilhelm Rau (Weisbaden, 1970) p. 16. I am grateful to Prof. R.P. Jain of the Centre for German Studies, Jawaharlal Nehru

University, for translating the relevant portions from German.
33. *Kṛṣṇa Yajurveda Taittirīya Saṁhitā,* 25, 1, 7 cited in ibid., p. 17.
34. *Śukla Yajurveda Saṁhitā,* 3, 12 and *Kṛṣṇa Yajurvedīya Taittirīya Brāhmaṇam,* 34, 7, 1 cited in Wilhelm Rau, ibid., p. 27.
35. *Pañcaviṁśa Brāhmaṇa,* 1, 8, 9 cited in Wilhelm Rau, ibid., p. 16.
36. One such folk song of the ceṅkunta weavers had been cited by me in my article 'Weaver folk Traditions as a Source of History', *Indian Economic and Social History Review,* Jan.-March 1982, vol. XIX, no. 1, p. 56.
37. This information was conveyed to me in interviews with weavers in the course of my fieldwork in south India in 1985-6.
38. *Puṟam* 311: 1-2. Also *Akam* 89 which says that the washermen were called *kaḷaiyār* because of the mud they used for washing.
39. *Naṟṟinai,* 90: 2-4.
40. *Kuṟuntokai,* 330: 1.
41. *Akam,* 34: 11-12.
42. Ibid., 34 and 387.
43. *Puṟam,* 360: 15-20, 363: 10-16, etc.
44. Cited in K.R. Hanumanthan, *Untouchability, A Historical Study,* (Madurai, 1979), p. 153.
45. *Peruṅkatai,* line 159, cited in ibid., p. 76.
46. *Periyapurāṇam,* cited K.A. Nilakanta Sastri, op. cit., pp. 568-9.
47. *Puṟam,* 259: 5-6.
48. According to a reference in the Mackenzie Collection, in the nineteenth century a village collectively paid the *pulatti* three sheep and three rupees as her wages. Mackenzie, 'The Village Feast', *Indian Antiquary,* III, pp. 6-9 cited in A. Appadorai, *Economic Conditions in Southern India, 1000-1500 AD* (Madras, 1936), vol. I, p. 280.
49. *Puṟam,* 66.
50. *Kalittokai*: Naccinārkkiniyār commentary, ed. by E.V. Anantharaman (Madras, 1925), *Marutam,* 13-14 and also 117.
51. *Kreeḍabhirāmamu* of Vallabharāya, ed. by Vetturi Prabhakara Sastry (Muktiyala, 1952), verse 67.
52. R.K. Mukherji, *Ancient India* (Allahabad, 1956), p. 76.
53. *Kreeḍabhirāmamu,* op. cit., verses 101-5.
54. *Puṟam,* 177: 16.
55. *Kuṟuntokai,* 155: 2 *Kalittokai,* 117: 8-9 and *Akam,* 121: 12.
56. *Cilappatikāram,* 4: 45-51 and 5: 28-34.
57. *Ciruppāṇāṟṟuppaṭai,* lines 50-4.
58. Kamaladevi Chattopadhyay, *Handicrafts of India* (rpt.) (New Delhi), 1985, p. 111.
59. *Naṟṟinai,* 328:8 and *Puṟam,* 41: 5-6.
60. *Porunarāṟṟupaṭai,* 214, 215 cited in T.N. Subramanian, *Caṅkam Polity* (Bombay, 1966), p. 232.

ASPECTS OF WOMEN AND WORK IN EARLY SOUTH INDIA 169

61. J.K. Kamat, *Social Life in Medieval Karnataka* (New Delhi, 1980), p. 119.
62. *Kreedabhirāmamu*, verse 103.
63. *Naṟṟinai*, 138: 1-3.
64. *Akam*, 17: 11-13.
65. *Maturaikkāñci* in *Pattuppāṭṭu*, line 117.
66. *Perumppāṇāṟṟuppaṭai*, 50-65.
67. *Akam*, 390: 8-10, also verse 140.
68. *Kuṟuntokai*, 269: 5.
69. *Akam*, 9, 20.
70. Ibid., 126.
71. *Aiṅkuṟūnanūṟu*, ed. by U.V. Swaminathaiyyar and S. Kalyana Sundarayyar (Madras, 1944), 47: 1-3 and 48. Also *Puṟam*, 343: 1
72. *Puṟam*, 24: 1-16.
73. *Perumppāṇāṟṟuppaṭai*, line 142.
74. Ibid., lines 275-81.
75. *Paṭṭinappālai* in *Pattuppāṭṭu*, op. cit., line 108.
76. Ibid., lines 80-5.
77. *Takkayākapparaṇi*, commentary, cited in M. Rajamanikkanar, *Pattuppāṭṭu Araichi* (Madras, 1970), p. 507.
78. *Akam*, 157.
79. *Porunararruppadai*, lines 214-15.
80. *Akam*, 231.
81. 18 of *Annual Report of Epigraphy*, 1922 AD 1030.
82. *Kreedabhirāmamu*, 174.
83. A *nāzhi* is a grain measure, roughly half a kilo.
84. *Maturaikāñci*, 405-6.
85. *Cilappaṭṭikāram* 13: 122-3.
86. *E.C.*, vol. VII, Sk. 185.
87. *Kreedabhirāmamu*, 158-60. A Telugu *ruka* is the same as the Tamil *param*, roughly 0.15 or 0.16 of the seventeenth-century rupee.
88. .Tirumalai-Tirupati Devasthanam Inscriptions, vol. II, no. 135, dated AD 1496.
89. *Vacanadharmasāra*, p. 223 cited in J.K. Kamat, op. cit., p. 118.
90. *Naṟṟinai*, 110.
91. *Kuriñcippaṭṭu* in *Pattuppāṭṭu*, 1-26.
92. *Akam*, 105.
93. *Perumppāṇāṟṟuppaṭai*, 247-53.
94. *Ciruppāṇāṟṟuppaṭai* in *Pattuppāṭṭu*, 13-31. Also line 62 which refers to their faultless dancing.
95. *Patiṟṟupattu*, ed. and tr. by A.V. Subramanian (Madras, 1980), stanza 40, fourth song.
96. Ibid., stanza 43, fifth song.
97. *Puṟam*, 34: 8-15, 325: 1-13, etc.
98. Ibid., 285.

99. Early medieval references to this are found in *Tattvasāram* and *Bāsava Puranamu* cited in J.K. Kamat, *Social Life in Medieval Karnataka*, p. 63.
100. *A.R.E.*, 223 of 1917.
101. *A.R.E.*, 18 of 1922.
102. *A.R.E.*, 301, 302 and 303 of 1923 and Pt. II, para 77.
103. *Manasollāsa* of Someśvara III, ed. by Shrigondekar (Baroda, 1939), verses 1817-18.
104. *Bhakti Bhandara Basavannavara Vachanangalu* (Dharuar, 1968), verse no. 335 cited in J.K. Kamat, op. cit., p. 118.
105. *Inscriptions of the Pudukkottai State*, no. 601.
106. *A.R.E.*, 230 of 1921-2, Pt. II, para 19, etc.
107. *A.R.E.*, 86 of 1911-12, Pt. II, para 29.
108. *A.R.E.*, 80 of 1913. See also *SII*, vol. IV, AD 1384, etc. Although there is abundant material on women being sold into slavery especially to temples, but this is beyond the scope of this paper.
109. *A.R.E.*, 122 of 1912.
110. *A.R.E.*, 200 of 1912-13.
111. To give just one instance the famous inscription of Rājarāja I dated AD 1011 (*SII*, vol. II, 66) refers to the lands and houses given to the temple dancers attached to the Brihadīśvaram temple at Tanjore.
112. *SII*, vol. XI, no. 1035, AD 1396 from Simhachalam (modern Waltair).
113. Nos. 373 and 380 of 1919, nos. 358 and 369 in T.N. Subramanian, *South Indian Temple Inscriptions* (Madras, 1957).
114. *Epigraphia Carnatica*, vol. V, Ak. 108.
115. *Mysore Archaeological Report*, 1913, pp. 39-40.
116. *SII*, vol. VI, no. 84.
117. *SII*, vol. X, no. 10.
118. *SII*, vol. VI, nos. 950 and 954, dated AD 1427 and 1441 respectively.
119. See *SII*, vol. VI, no. 704, etc.
120. T.N. Subramanian, *Cankam Polity*, op. cit., p. 289.
121. *Mullaippāṭṭu*, 45-9.
122. Cited in T.N. Subramanian, *Cankam Age*, op. cit., p. 286.
123. *Bombay-Karnataka Inscriptions*, I, i, no. 117, dated AD 1076 *Epigraphia Indica*, vol. XVII, p. 1223, dated AD 1047, etc.
124. *B.K.I.*, I, Pt. ii, no. 188 (AD 1106); *E.C.* I., no. 75 (i.e. AD 1264, etc.) V.V. Krishna Sastry in his paper 'Position and Status of Women in Medieval Andhra Desa' presented at a seminar in Benares on 'Position and Status of Women in Ancient India', March 1988, refers to women warriors and officials.
125. 'Megasthenes', in *Foreign Notices of South India* by K.A. Nilakanta Sastry (Madras, 1972), p. 41.

126. *A.R.E.*, 259 of 1909.
127. *A.R.E.*, 1910, Pt. ii, para 35.
128. J.K. Kamat, *Social Life in Medieval Karnataka*, p. 106.
129. Romila Thapar, *Asoka and the Decline of the Mauryas* (New Delhi, 1961), p. 87.
130. Ibid., p. 86.

SECTION III
Socio-sexual Constructions of Womanhood

Polyandry in the Vedic Period

Sarva Daman Singh

The *Ṛgveda* depicts the Āryans as a dynamic race full of verve and vigour, hope and adventure. They fight as inveterately as they love and proliferate; and pray for power and progeny, long life and good health; for profusion of food and drinks; for victory and the extermination of their foes.

The *Ṛgveda* is fully cognisant of marriage as attested in the expression, 'the wife is the home'.[1] Indeed, marriage leads to a life of piety and rectitude;[2] and to procreation, a divine function, instanced by the union of *dyāvā-pṛthivī*, the heaven and the earth, styled as *pūrvaje pitarā*[3] or the primeval parents. The *Avestā* in Iran also knows marriage, and tells us that the oblations offered by a maiden or a bachelor are unacceptable alike to the gods and ancestors.[4]

Thus we do not find promiscuity in the *Ṛgveda*, even though we have unmistakable evidence of considerable sexual freedom amongst the Āryans. There are clear references to an epoch when sexual relations between brother and sister, father and daughter, were neither impermissible nor unheard of. The famous dialogue between Yama and Yamī (X.10) visualizes the union of brother and sister despite the remonstrance of Yama, who refuses to oblige his sister. Yamī's words emphasize the antiquity and desirability of brother-sister marriage; but those of Yama mark the prohibitive morality of a new age. To cite Yamī:

> I, Yamī, am possessed by love of Yama, that I may rest on the same couch beside him.
> I as a wife would yield me to my husband. Like car-wheels let us speed to meet each other.[5]
>

Yama replies:

> Thy friend loves not the friendship which considers her who is near in kindred as a stranger.

Sons of the mighty Asura, the heroes, supporters of
the heavens, see far around them.[6]

.

Shall we do now what we ne'er did aforetime? We who
spake righteously now talk impurely?[7]

.

I will not fold mine arms about thy body: they call
it sin when one comes near his sister.
Not me,—prepare thy pleasures with another: thy
brother seeks not this from thee, O fair one.[8]

Yamī speaks of the sanctity of custom upholding the marriage of twins, and accuses Yama of violating a holy ordinance. The latter seeks refuge in the evolving concepts of incest taboos and exogamy. He is afraid of 'public opinion', of the laws of Mitra and Varuṇa; of the unwinking eyes of gods' sentinels. The fear of detection and censure is the greatest deterrent.

We have quoted extensively from *R̥V*, X.10 to bring out the growth of exogamous practices in Āryan society. The spirited assertion of a woman's right made by Yamī to unite in the fullness of desire with whomsoever she likes, is as candidly reiterated in the later texts, and is doubtless symptomatic of a society where women enjoy social and sexual freedom. There are other examples of incest in the *R̥gveda*, between father and daughter, mother and son. The R̥gvedic poet can, with impunity, imagine such relationships between the Vedic deities. We hear of the love and union of Prajāpati and his daughter,[9] of Pūṣan wooing his mother,[10] of Sūryā following Uṣā, aglow with the light of her lover,[11] as a young man chases a maiden.[12] A beloved here, Uṣā is called the mother of Sūryā elsewhere.[13] One hymn makes her the daughter,[14] and another the sweetheart,[15] of heaven. All these passages cannot be dismissed as fanciful descriptions of deified nature, as, indeed, poetic fancy cannot be unrelated to the mores of its given society. That no impropriety is felt to be committed, let alone blasphemy, in conjuring up these incestuous relationships, shows that a mode of behaviour acceptable to the gods must have had its basis in known human parallels.[16]

The *R̥gveda*, however, represents an age of transition, when the rules of incest and exogamy definitely come to the fore. But despite assertions to the contrary,[17] the *R̥gveda* does attest the existence of polyandry in Āryan India. It is known alike to the gods and men, who

would be mystified by the negative constructions put upon their candour by the moralists of succeeding ages.

We begin our investigation with the twin Aśvins and their bewitching bride Sūryā, the daughter of Savitā. If the number of hymns addressed to them serves as an indication, the Aśvins are the most important Ṛgvedic gods after Indra, Agni and Soma. Called the 'sons of Dyaus'[18] they are 'horsemen' as their very name Aśvinau signifies. They personify the luminous glow of early dawn, heralding the transition from darkness to light. They are young, handsome and ever so brilliant, and ride a resplendent chariot made for them by the Ṛbhus according to the Ṛgveda.[19] The Ṛgveda describes how the Aśvins win the hand of the refulgent Sūryā, the sun-god's daughter. They are repeatedly referred to as wooing Sūryā or competing in a divine chariot race for her hand[20] or as driving her triumphantly home.[21] The beaming bride, 'the youthful daughter of the sun, delighting in you (Aśvins), ascends there your chariot, heroes'.[22] Elsewhere, 'she also came for friendship, maid of noble birth, [and] elected you as *husbands*, you to be her lords'.[23] The meaning is unambiguous; the Aśvins are at once her 'husbands' or *patis*, the divine practitioners of adelphic polyandry. We find it impossible to agree with the suggestion that they are the 'groomsmen'[24] of Soma, who is also the husband of Sūryā in another context. The original Ṛgvedic passage from the well-known marriage hymn has no word that could be rendered as 'groomsmen'. It only tells us that the Aśvins chose (*varā*) Sūryā, which is also stated in the preceding passage. The word *varā* comes from the root *vṛ*, which means 'to choose', in the present context, for marriage. Soma is an additional husband, in the sense that he is called the first husband of every maiden a little later in the same hymn.[25] The suggestion that Sūryā is the light of the sun transferred to the moon or Soma through the evening twilight identifiable with the Aśvins, is ingenious, if also speculative.[26] It is 'very doubtful', according to Macdonell and Keith,[27] whether the *Ṛgveda* recognizes the truth of the moon shining by the borrowed light of the sun. But in the passages that may be construed to signify such awareness,[28] there is no trace of the Aśvins or Sūryā. Where the Aśvins are called the 'husbands' (*patī*),[29] and Sūryā their 'wife' (*patnī*),[30] there seems no room for doubt or disagreement. Abstruse explanations apart, the evidence is quite straight and clear. Had polyandry been anathema to the ordinary Āryan, his poets and priests would have refrained from perpetrating this allegorical

sacrilege in poetry. The practice was known and not yet viewed with disapprobation; hence the gods, too, could be innocently described as polyandrous. The poet could certainly not invent a non-existent equation to drive home even a mythological or symbolic proposition.[31]

The Aśvins' chariot has three seats[32] and is said to have three supports fixed in it to lay hold of [33] certainly to secure the riders' balance when the vehicle is in rapid motion. It is quite appositely made for three, the twin Aśvins and their consort Sūryā, a happy union perhaps symbolically signified by the three wheels of their chariot.

If then, the Nāsatyas or Aśvins practise polyandry without compunction, we need neither be shocked nor surprised. They are indeed likened to bulls,[34] who rush to the aid of eunuchs' wives.[35] There are repeated references to their positive response to the call of Puraṁdhi Vadhrimatī, whom they bless with a son.[36] Celestial healers, they help alike with love, potion and benediction.

What the Aśvins do is by no means unexampled or solitary. The *Ṛgveda* refers in vivifying verses to the *sādhāraṇī* wife of the Maruts, Rodasī, who with her hair dishevelled and mind fixed on her lords, woos them to unite with her, like Sūryā mounting the chariot of the twin Aśvins.[37] And the bright Maruts cling to their young wife, who belongs to them all.[38] 'Upon their chariot the youths have set the maiden wedded to glory.'[39]

Another Ṛgvedic verse thus addresses the Maruts: 'Go ye heroes, far away, ye bridegrooms with a lovely spouse.'[40] Rodasī is called their common wife more than once.[41] She is their beloved,[42] their young and radiant wife.[43]

The Maruts are in fact the most numerous among the gods,[44] and are apparently thought of on the analogy of commoners on the earthly plane. And if they are described as having a common wife, the analogy points back to the common people.[45] The explanation that the Maruts are the storm-gods or clouds, and that Rodasī is the lightning associated with them,[46] fails to satisfy the question why she is called their common beloved and wife. The association could indeed have been brought out in other inoffensive similes that would not lend themselves to blasphemous or immoral interpretations. The thought of blasphemy or immorality in such a description does not in fact even occur to the poets in question. The erotic predilections of the Maruts are on the other hand frankly emphasized in the Ṛgvedic verses.[47]

Polyandry in the divine sphere does not end with the Maruts and Rodasī. The Viśvedevas, too, follow suit. 'Two with one dame ride on with winged steeds and journey forth like travellers on their way.'[48] Mythological features such as these[49] mirror the persistence of the polyandric tradition in the early Āryan society. And it is to that society that we now turn to find proof of the practice of polyandry among men.

RV, VII.33 refers to the celebrated sage Vasiṣṭha as the son of Mitra and Varuṇa from the nymph Urvaśī. The legend clearly suggests that prominent ṛṣi families saw nothing improper or unseemly in the idea of two persons sharing a wife, and in tracing their ancestry to such a union. Indeed, the Ṛgveda repeatedly refers to the plurality of husbands in relation to a single wife.[50] Reluctant to accept the existence of polyandry, Macdonell and Keith admit that 'it is difficult to be certain of the correct explanation of each separate instance of this mode of expression'[51]. Is the plural here a so-called plural of majesty?[52] They doubt it themselves, but tell us that the mythological explanation proposed by Delbrück[53] is 'probably right'.[54] The plural 'husbands' actually occur at a number of places in the Vedas and the Sūtras; and the assertion that the expression is 'simply generic' does not carry conviction. RV, X.85.37 is quite explicit when it says:

Send, O Pūṣan, her, most propitious, in whom men scatter seed; who, eager, shall part her thighs for us;
in whom, we, eager, may insert the member.[55]

The bride is candidly described as 'desirous of', or 'loving her brothers-in-law' in some verses,[56] which seem to hint at their status as her secondary husbands. The very word for brother-in-law, devṛ = devara, is derived from the Sanskrit root div, meaning 'to play', emphasizing the free and flippant familiarity of the devṛ with his sister-in-law.[57] The reference to 'fathers-in-law'[58] elsewhere points to the polyandry of the groom's parents, thus indicating the time-honoured, hereditary character of the custom.

We do not know if the three previous divine husbands of the maiden, Soma, Gandharva and Agni, may 'be best understood as a relic of a gradually disused custom of polyandry, which was transformed into an allegory, most probably representing the life stages of a maiden till marriage'.[59] Says the Ṛgveda:

Soma obtained her first of all; next the Gandharva was her lord. Agni was thy third husband. Now one born of woman is thy fourth.[60]

Soma gave thee to the Gandharva, the Gandharva gave thee to Agni, and Agni has given thee to me for wealth and sons.[61]

The commentator Sāyaṇa explains:

While yet the desire for sexual intercourse has not arisen, Soma enjoys a girl; when it has just begun, the Gandharva takes her, and at marriage transfers her to Agni, from whom man obtains her for producing wealth and sons.[62]

These gods are, then, the mythical husbands or guardians of the girl before her marriage to a man. They betoken the Āryan belief that a girl is always married to the gods before she is to man; and also the principal roles visualized for her, of wifedom and maternity. The sexual imagery employed in conjuring up these successive 'matrimonial' relationships in the Ṛgveda and later literature, making man the fourth husband of the girl, finds nothing repugnant or reprehensible in the thought of many husbands in theory, if not in practice.

Ṛgveda, X.109 refers to the wife of a brāhmaṇa taken to a kṣatriya's home, and later returned. Its expanded version found in the Atharvaveda, to be discussed a little later, attests the existence of polyandrous practices.

While some scholars tell us that niyoga or levirate has nothing to do with polyandry,[63] others are equally insistent that it typifies an attenuated relic of polyandry.[64] The appointed kinsman performs niyoga for the restricted purpose of begetting a son; but the Vedic devṛ-marriage knows no such limits. When a man's funeral rites are performed, the didhiṣu (wooer) brother-in-law claims the widow as full wife for love, property and progeny. Thus the priest addresses her:

Rise, come unto the world of life, O woman,
come, he is lifeless by whose side you lie.
Wifehood with this your husband was your
portion, who took your hand and wooed you
as a lover.[65]

The brother of the deceased also takes from the latter's lifeless hand the bow it carried, so that 'it may be our power and might and glory.

There are you, there: and here with noble heroes may we overcome all hosts that fight against us.'[66] The alarums and excursions of inevitable warfare dictate the need for able-bodied men and brave sons to fight shoulder to shoulder against their ubiquitous foes; and widows of child-bearing age are incompatible with the whole pattern of early Āryan existence. The widow therefore grasps the hand of her brother-in-law and becomes his wife even before the obsequies end; there is no formal ceremony of marriage, for none is required. Their relationship is taken for granted; and the ease of transition prompts the presumption that the brother-in-law had been a secondary husband of the woman even during his departed brother's lifetime. The funeral notwithstanding, the poet declares: 'We have come forth for dancing and for laughter.'[67] They take death in their stride, for life must go on. As their warriors fall, many more are born to take their places. They defeat the designs of death by their virility and irrepressible will to live. And as we know from later examples down to the present-day, polyandry prospers among people whose men are preoccupied with war, leaving the care of their women to those males who are obliged to stay behind. The early Āryan scene doubtless illustrates a classic combination of circumstances conducive to the practice of polyandry in some sections of a migratory society.

Another verse, addressed to the Aśvins, thus interrogates them:

Where were you at night, where during the day?
O Aśvins, where do you do the necessary things,
Where do you dwell? Who takes you to bed
in a dwelling place, as a widow bedward
draws her husband's brother, as the
wife attracts the husband.[68]

It clearly shows that the Aśvins are polyandrous and share a common bed with a common partner. The homely simile of the widow drawing her husband's brother to bed reminds us of the bride desirous of mating with her brothers-in-law (*devṛkāmā, devakāmā*), and of the *didhiṣu* character of the *devara*. Yāska comes to our aid in understanding the true purport of this allusion, and tells us that the *devara* or husband's brother is called the second husband of a woman, as his designation itself suggests one who indulges in amorous frolics with her.[69] Our thoughts quite naturally go back to the common Indo-European custom of *niyoga* or levirate, which was

also practised by the Hebrews,[70] and is still practised by others.[71]

Thus the *Ṛgveda* reveals the Āryans as a free and easy, fun-loving people, fully conversant with the uses of marriage, which they sanctify with due ritual and ceremony. We find evidence of great variety of conjugal relationships including monogamy,[72] polygyny[73] as well as polyandry. And if monogamy is approved in a few passages,[74] polyandry is alike acceptable and present in circles both human and divine. The reference to the well-known sage Dīrghatamas[75] by his metronymic, Māmateya,[76] alone, in many passages of the *Ṛgveda* strongly suggests the use of metronymics particularly in relation to the offspring of polyandrous households. He is also called Aucathya or 'son of Ucatha'.[77] The *Bṛhaddevatā*[78] tells us his interesting story woven out of fragments of *ṚV*, I.140-64, attributed to him:

There were (once) two seer's sons, Ucathya and Bṛhaspati. Now Ucathya's wife was Mamatā by name, of the race of Bhṛgu.[79]

Bṛhaspati, the younger (of the two), approached her for sexual intercourse. Now at the time of impregnation the embryo addressed him.[80]

'Here am I previously engendered; you must not cause a commingling of seed.' Bṛhaspati, however, could not brook this remonstrance about the seed.[81]

(So) he addressed the embryo: 'Long darkness shall be your lot.' And (hence) the seer, Ucathya's son, was born with the name Dīrghatamas (Long Darkness).[82]

He when born distressed the gods, having become suddenly blind. The gods, however, gave him (the use of) his eyes (*tannetre*); so he was cured of his blindness.[83]

The story is retold in the *Mahābhārata*. The present account is quite categorical, inasmuch as it establishes that though Mamatā was known as the wife of Ucathya, his younger brother Bṛhaspati had free and rightful access to her. The latter could indeed force himself upon her despite her physical condition or remonstrance. This is a clear case of fraternal polyandry, in which the legitimacy of the progeny is properly assured by Mamatā's nuptial knot with the elder brother. What is significant is that the text finds no fault with the conduct of Bṛhaspati. There is not a word of expostulation or condemnation, for his kind of behaviour is expected and accepted in his society.

The Ṛgvedic evidence also shows that a wife desirous of a son in

her husband's absence,[84] or despite his impotence,[85] can have one, if necessary, even through agencies other than the *devṛ* or the husband's brother. The *Atharvaveda* contains some unmistakable references to polyandry, which go far to corroborate the conclusions drawn from the Ṛgvedic material. It is fully conscious of the significance of marriage and family in contemporary society; and it is in the marriage hymns themselves that we find some telling allusions to polyandry. Let us allow the text to speak for itself:

Be thou supreme among fathers-in-law, supreme also among brothers-in-law; be thou supreme over sister-in-law, supreme also over mother-in-law.[86]

... What is lovely (*vāma*) for the fathers who came together here; joy to the husbands for embracing the wife.[87]

The well-flowered (*sukimśuka*) all-formed bridal-car (*vahatu*), golden-coloured, well-rolling, well-wheeled, do thou mount O Sūryā, to the world of the immortal; make thou a bridal car/pleasant to husbands.[88]

For thee in the beginning they carried about Sūryā, together with the bridal car; mayest thou, O Agni, give to us husbands the wife, together with progeny.[89]

Be thou pleasant to fathers-in-law. . . .[90]

The verses are indeed quite revealing. The pointed reference to 'fathers-in-law' in contradistinction to 'mother-in-law' shows that the groom's parents are polyandrous. And where the poet talks of the joy of the 'husbands' in embracing the wife, the implication is obvious. The bridal chariot carries the bride together with her 'husbands', who doubtless enjoy themselves. The prayer to Agni for a wife for 'husbands' for the sake of progeny clearly suggests fraternal polyandry, in which it is not necessary for all the brothers to go through the ritual of marriage together with their elder brother. *Patibhyo* in *AV*, XIV.1.61, instead of *patye* in *ṚV*, X.85.20, of which it is a variant, makes the former a deliberate and meaningful emendation. To go back to the *Atharvaveda*:

Her not brother-slaying, O Varuṇa; not cattle-slaying, O Bṛhaspati; not husband-slaying; possessing sons, O Indra—bring (her) for us, O Savitar.[91]

(As) a soulful cultivated field hath this woman come; in her here, O men, scatter ye seed; she shall give birth to progeny for you from her belly, bearing the exuded sperm of the male.[92]

With an eye not terrible, not husband-slaying, pleasant, helpful, very propitious, of easy control for the houses, hero-bearing, loving brothers-in-law, with favouring mind—may we thrive together with thee.[93]

Not brother-in-law slaying, not husband-slaying be thou here, propitious to the cattle, of easy control, very splendid, having progeny, hero-bearing, loving brothers-in-law, pleasant, do thou worship this household's fire.[94]

Send, O Pūṣan, her, most propitious, in whom men scatter seed; who, eager, shall part her thighs for us; in whom, we, eager, may insert the member.[95]

Language, of course, could not be more explicit. There is no doubt that all the brothers of the bridegroom have fully approved and desired access to the bride. She comes to them as a field, in which they may scatter their seed for the sake of progeny. The simile could not be more apt or appropriate; a field engages many hands for tilling, sowing and reaping, just as the bride engages not only the groom, but also his brothers in love-play for the solidarity and prosperity alike of the family. She should be auspicious to her husband and to his brothers, and should give birth to noble sons. She should indeed be desirous of mating with her husband's brothers, as the word *devṛkāmā* shows. We have here a picture of sibling solidarity promoted by polyandry in a joint family, the household fire of which is tended and worshipped by their common spouse.

Another Atharvavedic passage talks of a maiden 'given to husbands' to enable her to find one according to her wish.[96] The oft-repeated reference to 'husbands' of a girl raises no eyebrows, because it is commonplace; because it does not offend against the norms of the Āryan society. The present passage seems to indicate that the girl will find a man after her heart among her husbands, presumably brothers.

The *Atharvaveda* repeats the Ṛgvedic belief that every girl is always married; that Soma is her first husband; Gandharva the second and Agni the third; and that the fourth husband is of human birth.[97] Soma passes her on to Gandharva, who gives her to Agni; and Agni gives her to man.[98] This mystical allegory is clearly pregnant with the traces of polyandry, and certainly not innocent of it. Later explanatory texts do no describe the three gods as mere guardians; but as enjoying the girls in a most mundane and matter-of-fact manner.[99] That divinity does not taint, must indeed be a comforting thought for the human husband. And if polyandry is permissible without fuss in the divine sphere, is it an ideal of yore, from which men are departing with the passage of time?

There are some truly baffling verses in the *Ṛgveda*[100] and the *Atharvaveda*[101] expressive of the notion that every virgin contains a demon who leaves her with the nuptial blood, causing some risk to her husband. And they have been interpreted to mean that a proxy for the husband took the risk and then disappeared.[102] There are verses,[103] however, that hint at the defloration of the bride by the husband himself and no other person. Be that as it may, the use or otherwise of a proxy has nothing to do with polyandry.

Patent proof of polyandry is provided by other passages in the *Atharvaveda*. *AV*, V.17 takes up the theme of a brāhmaṇa's wife, who was returned to her husband by King Soma after a while.[104] The eighth verse of this hymn makes a preposterous claim for the brāhmaṇa:

And if there are ten former husbands of a woman, not brāhmaṇas, provided a brāhmaṇa has seized her hand, he is alone her husband.[105]

And the ninth repeats it to leave no room for doubt:

A brāhmaṇa is indeed her husband, not a noble (*rājanya*), not a vaiśya; this the sun goes proclaiming to the five races of men.[106]

This extravagant claim is characteristic of the ravenous brahmanical rapacity that comes quite unabashedly to the fore in the *Atharvaveda*. The brāhmaṇa goes out of his way to lay a claim to the wives of others, when he cannot even defend his own. For, the return of the brāhmaṇa's wife is the central theme of the hymn. What, however, these verses clearly show is that a woman may have as many as ten husbands at a time. They must be contemporaries, so that it becomes essential for the brāhmaṇa to stress his supersessive primacy. That polyandry was well-known and being practised in the age of the *Atharvaveda*, cannot be doubted.

Two more verses elsewhere in the *Atharvaveda* deserve notice:

Whoever (fem.) having gained a former husband, then gains another later on, if they shall give a goat with five rice dishes, they shall not be separated.[107]

Her later husband comes to have the same world with his remarried spouse who (masc.) gives a goat with five rice dishes, with the light of sacrificial gifts.[108]

These verses have been taken as proof of widow remarriage;[109] but the original talks only of a twice married woman, not of a widow. The arrival of the second husband does not necessarily mean the death

or departure of the first. According to Keith,[110] the spell secures that a woman married twice may be united in the next world with her second husband, not the first. There is nothing in the original, though, to preclude the presence of the former husband in the life beyond. We must indeed be looking at a potentially polyandrous situation in paradise !!

The funeral verses in the *Atharvaveda*, like those of the *Ṛgveda* discussed earlier,[111] give us a vivid glimpse of the act a widow puts on by lying beside her dead husband, only to get up soon enough to grasp the outstretched hand of her husband's brother:

> This woman, choosing her husband's world,
> lies down (*ni-pad*) by thee that art departed,
> O mortal, continuing to keep (her) ancient duty;
> to her assign thou here progeny and property.[112]
>
> Go up, O woman, to the world of the living;
> thou liest by this one who is deceased; come!
> to him who grasps thy hand, thy spouse
> (*didhiṣu*), thou hast now entered into
> the relation of wife to husband.[113]

The *didhiṣu* brother-in-law's immediate and acknowledged claim on his brother's widow is a significant pointer to the probability that he was a secondary husband even before her widowhood. The husband's brother is always to be loved and desired, as we have already seen. Whitney's translation of the second verse here (*AV*, XVIII.3.2) renders *didhiṣostavedaṁ* as 'thy second spouse',[114] even though there is no word signifying 'second' in this passage. We find reference to this custom in many other texts of the later Vedic period.[115]

It looks as though polyandry was common among the non-Āryans, specially the Austrics;[116] and was also found among the Āryans, the brāhmaṇas and the ṛṣis in particular. The *Atharvaveda* is perhaps the most important testament of the Āryan-unāryan fusion, and records many traditions and practices that go back to earlier antiquity. And the picture that emerges from the examination of many passages in the foregoing discussion proves the presence of polyandry beyond the shadow of any doubt. And we need not be taken aback. Polyandry was a widespread practice among the Indo-European peoples.

The *Taittirīya Saṁhitā* speaks of a woman being given to the Gandharvas. She also goes to the gods, as they sing. 'So if there is in

a family one person who knows thus (i.e. sings), men give their daughters in wedlock to that family, even if there be other (wooers) in plenty.'[117] Keith's opinion that 'there is no real suggestion of polyandry',[118] cannot be accepted, when we view the present passage side by side with later ones which expressly tell us that a girl is given to a family;[119] and some of which call it reprehensible.[120]

Elsewhere,[121] too, the *Taittirīya Saṁhitā* refers, as do the other Samhitās, to 'noble husbands' and 'fair offspring' in relation to a single wife, whatever we may take that to mean.

The Vedic texts often speak of the sale of a daughter,[122] which must be viewed and understood in the context of the Vedic injunction that the younger brothers and sisters should not marry before their elders do so.[123] If the current practices in polyandrous societies including those descended from the ancient Āryans[124] serve as any guide, the younger brothers contribute to the amount of bride-price paid to the girl's father, and enjoy socially sanctioned access to the common wife as her co-husbands. The eldest brother is almost invariably the first to marry; and not all the younger brothers care to contract individual marriages. Among the Khasas mentioned earlier, polyandry, monogamy as well as group marriage are in simultaneous evidence.

Marriages by capture are also known to the Vedas, including the *Ṛgveda* itself,[125] thus anticipating the *rākṣasa* mode of marriage mentioned in the later Dharmaśāstra texts.[126] This is doubtless another form of marriage associated with polyandry in early antiquity. The references in the Vedic literature, though, do not specify whether some of these marriages were polyandrous in character.

Macdonell and Keith believe that metronymics denote sons of maidens (*kumārī-putra*), such as Satyakāma Jābāla in the *Chāndogya Upaniṣad*,[127] and the teachers(?) of the lists (*vaṁśas*) given in the *Bṛhadāraṇyaka Upaniṣad*.[128] But if the Ṛgvedic example of Māmateya is any indication, metronymics may point as much to polyandry as to polygyny or promiscuity. Their suggestion would make most of these ancient teachers sons of maidens, which is on the face of it an absurd proposition.

Twice or thrice in the later Vedic literature, we come across opposition to the practice of polyandry, which only serves to illustrate the incipient morality of a succeeding epoch. Says the *Taittirīya Saṁhitā*:

On one sacrificial post he passes round two girdles, so one man secures two wives; that he does not pass one girdle round two posts, so one wife does not obtain two husbands.[129]

The *Aitareya Brāhmaṇa* once asserts that a man has several wives, 'but one wife has not many husbands at the same time'.[130] And that ends the registration of protest.

Why did brāhmaṇism seek to oppose something that was non-existent? Critical opposition is directed only against an obtaining practice that might become obnoxious or repugnant to certain sections of a given society. When male jealousy asserts itself alongside increasing male dominance, this is the kind of protest males would mouth. These rare voices of opposition indeed presuppose the presence of polyandry.

Polyandry, thus, is neither un-Vedic nor merely un-Āryan. It is true that both before and after their arrival in India, the Āryans were 'in the closest possible contact with populations among whom polyandry was an established social usage'.[131] But to nail polyandry down to the names of the non-Āryan, Tibetan or Dravidian tribes or castes to the exclusion of the Āryans would amount to a falsification of history. They were also likewise polyandrous. This is not to say that they did not know monogamy or polygyny. The trend was undeniably in the direction of monogamy, as many passages testify;[132] and the *Atharvaveda* even compares a pair of human spouses to the inseparable *cakravākas*, the proverbial poetic pair of loving birds:

> Here, O Indra, do thou push together these two spouses like two *cakravākas*; let them, with [their] progeny, well-homed, live out all their life-time.[133]

The marriage hymns of the Vedas consist of *mantras* of different origins, truly reflecting the variety of the usages of marriage in the Āryan society. Not in India alone, polyandry was practised among other members of the Indo-European group as well. It was a well established form of marriage among the Medes of the upland country,[134] as it was common also among the Get-ti of Bactria and Sogdiana, and among the tribes of the Hindu-Kush.[135] The kings of the Medes, according to Strabo[136] were polygynous; but the masses were polyandrous; and the women reckoned it an honour to have many husbands. Indeed, to have less than five was accounted a misfortune.[137]

We know that polyandry was by no means unknown or uncommon around the shores of the Caspian, whence according to the latest

authorities the Āryans came to India. Mayrhofer[138] believes that Central Asia was their original home; and Diakonov[139] agrees. The Soviet archaeologists connect them with the Andronovo culture of Kazakhistan and Southern Siberia.[140]

NOTES

1. ṚV, III.53.4., *jāyedastaṁ.*
2. Ibid., X.85.24. *ṛtasya yonau sukṛtasya loke.* . . .
3. Ibid., VII.53.2; X.65.8, *pitarā pūrvajā*; cf. also I.159.2. They are called *mātarā* in I.159.3; and *janitrī* in I.185.6. *AB*, IV.27.5 speaks of their marriage.
4. *Ashi Yashta*, C, X.54.
5. ṚV, X. 10.7.
6. Ibid., 2.
7. Ibid., 4.
8. Ibid., 12.
9. Ibid., X.61.5-9; *AB*, III.33; cf. *ŚB*, II.1.2.8.
10. ṚV, VI.55.5, *māturdidhiṣu.* He is also called his sister's lover in ibid., VI.55.4, *pūṣaṇaṁ . . . svasuryo jāra ucyate.*
11. Ibid., I.92.11, . . . *yoṣā jārasya cakṣasā vibhāti.*
12. Ibid., I.115.2, *sūryo devīmuṣasaṁ rocamānāṁ maryo na yoṣāmabhyeti paścāt.*
13. Ibid., I.113.1, 2; VII.78.3. She is the wife of Sūryā in VII.75.5, *sūryasya yoṣā*, and in IV.5.13, *patnīḥ sūro.*
14. Ibid., I.30.22, *duhitardivaḥ.*
15. Ibid., I.46.1, *priyā divaḥ.*
16. V.M. Apte assures us that 'the so-called incestuous intercourse between father and daughter in the story of Prajāpati (X.61.5-7), and between brother and sister in the dialogue between Yama and Yamī (X.10) can be satisfactorily explained (in the opinion of the present writer) on a mythological or astronomical basis'. Cf. *The Vedic Age* (Bombay, 1950), p. 394. Such explanations are necessitated only by later morality.
17. Cf. Apte, loc. cit., p. 394: 'Polyandry is not referred to anywhere in the Ṛigveda.' Ram Gopal tells us that it was 'abhorrent to Indo-Āryans even to think of polyandry'. Cf. his *India of Vedic Kalpasūtras* (Delhi, 1959), p. 443. Professor A.L. Basham, *The Wonder that was India* (London, 1971), p. 174, however, holds that the practice was not wholly unknown.
18. ṚV, I.117. 12 . . . *divo napātā* . . . which seems to be the equivalent of Lettic *dēwa deli*, and Lithuanian *dēwo sunelei*
19. ṚV, X.39.12.
20. Ibid., X.39.11.
21. Ibid., I.116.17; 117.13; 118.5; 119.5.

22. Ibid., I.118.5.
23. Ibid., I.119.5, *ā vāṁ patitvaṁ sakkhyāya jagmuṣī yoṣāvṛṇīta janyā yuvāṁ patī.*
24. Ibid., X.85.9, *somo vadhūyurabhavadaśvināstāmubhā varā.* . . . Cf. B.S. Upadhyaya, *Women in Ṛgveda* (Delhi, 1974), p. 121.
25. ṚV, X.85.40, *somaḥ prathamo vivide gandharvo vivida uttaraḥ / tṛtīyo agniṣṭe patisturīyaste manuṣyajāḥ* / Cf. also verse 41.
26. Cf. Upadhyaya, op. cit., pp.120, 121. We must remember that sunset plays but little part in Vedic worship.
27. *Vedic Index,* II, pp. 467, 468.
28. Cf. ṚV, IX.71.9. Also ibid., IX.76.4; 86.32; I.190.3. Cf. Hillebrandt, *Vedische Mythologie,* 3, pp. 467, 468.
29. ṚV, I.119.5, etc.
30. Ibid., X.39.11, *yamaśvinā suhavā rudravartanī puroratham kṛnuthaḥ patnyā saha.*
31. Cf. H.D. Griswold, *The Religion of the Ṛgveda* (London, 1923), pp. 259-60.
32. Cf. ṚV, I.34.9; I.47.2; I.118.1; I.157.3; VII.71.4, etc.
33. Ibid., I.34.2.
34. Ibid., X.39.9, *vṛṣaṇā.*
35. Ibid., VI.62.7, *vi jayuṣā rathyā yātamadriṁ śrutaṁ havaṁ vṛṣaṇā vadhrimatyāḥ.* . . .
36. Ibid., I.116.13, cf. I.117.24, *hiraṇyahastamaśvina rarāṇā putraṁ narā vadhṛmatyā adattaṁ.* Cf. also I.117.19; X.39.7; 65.12. *Vadhrimatī* means the wife of an impotent man. Macdonell and Keith go beyond the warrant of the Ṛgvedic text when they suggest that the Aśvins gave her a son by restoring her husband's virility. Cf. *Vedic Index, s.v., vadhrimatī.* In the *Mahābhārata*, for example, they sire the princes Nakula and Sahadeva on Mādrī through *niyoga*, and not by restoring the sexual efficacy of her husband Pāṇḍu. Cf. also Zimmer, *Altindisches Leben*, p. 398 (henceforth *AL*).
37. ṚV, I.167.5, *joṣad yadīmasuryā sacadhyai viṣitastukā rodasī nṛmaṇāḥ/ā sūryeva vidhata rathaṁ gāt tveṣapratīkā nabhaso netyā.*
38. Ibid., I.167.4.
39. Ibid., I.167.6.
40. Ibid., V.61.4, *parā vīrāsa etana maryāso bhadrajānayaḥ.*
41. Cf. ibid., VI.50.5.
42. Ibid., I.64.9.
43. Ibid., I.101.7; V.61.4
44. Cf. Ibid., VIII.96.8; *SV,* II.IX.3.3.2; *AV,* IV.27.7; *TS,* V.4.7, designates the Maruts as 'the people'. Cf. *ŚB,* II. 5.1.13; IX.3.1.25.
45. The Maruts are repeatedly identified with the people; cf. *TS,* V. 4.7.7; *ŚB,* II. 5.2.27, 34, 36; IV.3.3.6.
46. Cf. Upadhyaya, op. cit., pp. 121-2.

47. *RV*, V.52.3,6.
48. Ibid., VIII.29.4.
49. Pṛthivī is, for example, the wife of Dyaus in the dual compound *dyāvāpṛthivī*. Cf. *RV*, I.159.2; VII.53.2; X.65.8. But she is also sometimes called the wife of Parjanya, the rain-giving cloud, elsewhere (*RV*, VII.102.1) called the son of Dyaus. And in the *Vaitāna Sūtra*, XV.3, Pṛthivī is referred to as the wife of Agni. Of husbands she indeed has more than one. Uṣā also has many lovers. She is the wife of the Sun, *sūryasya yoṣā* in *RV*, VII.75.5, and *patnīḥ sūro* in ibid., VI.5.13. But she is also the beloved or *priyā* of Dyaus in ibid., I.46.1; and of Agni in ibid., I.69.1; VII.10.1; cf.X.3.3. She is often associated with the twin Aśvins, as in ibid., I.44.2; 183.2; III.58.1; IV.52.2,3; VIII.9.17; X.39.12. And she is also once connected with the moon in ibid., X.85.19. Sūryā was wooed by Soma, and chosen by the Aśvins, whom she herself chose (*vṛṇīta*), and whose chariot she then mounted. Cf. ibid., X.85.9; IV.43.6; I.119.5; VII.69.4; V.73.5; VIII.8.10; I.34.5; 116.17; 118.5; VI.35.5; I.117.13; IV.43.2. Though the Aśvins are her 'husbands' (*pati*), the gods elsewhere give her to Pūṣan. Cf. ibid., VI.58.4.
50. *RV*, X.85.37 and verse 38, *punaḥ patibhyo jāyām dā agne prajayā saha.*
51. *Vedic Index*, I, p. 479.
52. Weber, *Indische Studien*, 5, 191; cf. Zimmer, *AL*, p. 326.
53. Delbrück, *Die indogermanischen Verwandtschaftsnamen*, p. 543.
54. *Vedic Index*. I, p. 479.
55. See note 50 above.
56. Cf. *RV*, X.85.44, *devakāmā*. The *AV* mss. are divided between *devakāmā* and *devṛkāmā* in XIV.2.17 and 18. See Whitney's translation, II, pp. 756, 757. According to Sarkar, *Some Aspects of the Earliest Social History of India* (London, 1928), p. 80, the variant reading *devakāmā* 'shows an attempt at conscious emendation'. But *deva*, too, means 'husband's brother'; see Monier-Williams' *Sanskrit-English Dictionary, s.v.*
57. For the etymology of *devṛ* and *devara* see Yāska, *Nirukta*, III.15.
58. Cf. *RV*, X.95.12, *śvaśureṣu*.
59. Sarkar, op. cit., p. 80.
60. *RV*, X.85.40, *somaḥ prathamo vivide gandharvo vivida uttaraḥ/tṛtīyo agniṣṭe patisturīyaste manuṣyajāḥ.*
61. Ibid., X.85.41, *somo dadadgandharvāya gandharvo dadadagnaye / rayiṁ ca putrāṁścādādāgnirmahyamatho imām.*
62. Sāyaṇa on the above verses.
63. Cf. *Vedic Index, s.v.*
64. Cf. McLennan, *Primitive Marriage* (Chicago, 1970), pp. xxv, 81-2, 90, 97; Briffault, *The Mothers* (London, 1952), I, 681-2.
65. *RV*, X.18.8, *udīrṣva nāryabhi jīvalokaṁ gatāsumetamupa śeṣa ehi/ hastagrābhasya didhiṣostavedaṁ patyurjanitvamapi saṁ babhūtha.*

66. Ibid., 9.
67. Ibid., X.18 3, ... *prāñco agāma nṛtaye hasāya*. ...
68. Ibid., X.40.2.
69. Yāska, *Nirukta*, 3.15, *kva svit rātrau bhavathaḥ/kva divā/kva abhiprāptiṁ kuruthaḥ/kva vasathaḥ/ko vāṁ śayane vidhaveva devaraṁ (devaraḥ kasmāt? dvitīyo vara ucyate)/ vidhavā vidhātṛkā bhavati/ vidhavanād vā vidhāvanād vā iti carmaśirāḥ/ api vā, 'dhavaḥ' iti manuṣyanāma/ tadviyogāt vidhavā/ devaro dīvyatikarmā/maryo manuṣyaḥ maraṇadharmā/yoṣā yauteḥ /ākurute sahasthāne//* Cf. M.J. Bakshi (ed.), *The Nirukta of Yāska Muni*, 1st edn. (Bombay, 1930); L. Sarup (ed.), *The Nighaṇṭu and the Nirukta* (Delhi, 1967). According to Sarup, p. 48 of his translation, the passage 'he is so-called because he is the second husband' is an interpolation. We cannot, however, be certain. The etymology of *devara* given by Yāska quite agrees with the meaning of this passage.
70. Cf. David Loth, *The Erotic in Literature* (London, 1961), pp. 47, 48.
71. Cf. Chie Nakane, 'A Plural Society in Sikkim: A study of the Interrelations of Lepchas, Bhotias and Nepalis', in Fürer-Haimendorf (ed.), *Caste and Kin in Nepal, India and Ceylon* (Bombay, 1966), pp. 243-5. She comes to the conclusion that 'the widespread levirate ideology among both Lepchas and Bhotias paves the way for polyandrous marriage'. See p. 244. Cf. also Fürer-Haimendorf, *The Sherpas of Nepal* (London 1964), for a description of polyandry among them.
72. Cf. *ṚV*, I.124.7; IV.3.2; X.71.4, etc.
73. Ibid., I.62.11; 71.1; 104.3; 105.8; 112.19; 186.7; VI.53.4; VII.18.2; 26.3; X.43.1; 101.11. Cf. Muir, *Sanskrit Texts*, 5, 455 *et seq.*; Schrader, *Prehistoric Antiquities*, p. 387. Jolly, *Recht und Sitte*, p. 64; von Schroeder, *Indiens Literatur und Culture*, pp. 430, 431; Delbruck, *Die indogermanischen Verwandtschaftsnamen*, pp. 539, 540; Hopkins, *JAOS*, vol. 13, p. 353; Bloomfield, *Zeitschrift der Deutschen Morgenländischen Gesellschaft*, vol. 48, p. 561.
74. See note 72 above.
75. *ṚV*, I.158.1,6; cf. *Śāṅkhāyana Āraṇyaka*, 14; *AB*, VIII.23.
76. *ṚV*, I.147.3; 152.6; 158.6; IV.4.13
77. Ibid., I.158.1.
78. *Bṛhaddevatā*, IV.11-15; 21-5.
79. Ibid., IV.11
80. Ibid., IV.12
81. Ibid., IV.13
82. Ibid., IV.14
83. Ibid., IV.15, Cf. A.A. Macdonell (ed. and tr.), *The Bṛhaddevatā attributed to Śaunaka; A Summary of the Deities and Myths of the Rig-Veda*, Pts. I and II, *HOS*, vols. 5 and 6, Second Issue (Delhi, 1965). The text and translation are taken from this work.

84. *ṚV*, IV.42.8. If we identify the Ṛgvedic Purukutsa with his namesake of the Purāṇic list, then the son of Purukutsānī was obtained through her *devara*.
85. *ṚV*, I.116.13; 117.24; VI.62.7; X.39.7; of X.65.12.
86. *AV*, XIV.1.44, *samrājñedhi śvaśureṣu samrājñuta devṛṣu*, etc. The translations of the *AV*, are taken from Whitney, who tries to be as literal as possible.
87. Ibid., XIV.1.46, ... *vāmaṁ pitṛbhyo ya idaṁ samīrire mayaḥ patibhyo janaye pariṣvaje*.
88. Ibid., XIV.1.61, *sukiṁśukaṁ vahatuṁ viśvarūpaṁ hiraṇyavarṇaṁ suvṛtaṁ sucakraṁ/āroha sūrye amṛtasya lokaṁ syonaṁ patibhyo vahatuṁ kṛṇu tvaṁ.*
89. Ibid., XIV.2.1, *sa naḥ patibhyo jāyāṁ dā agne prajayā saha*.
90. Ibid., XIV.2.27, *syonā bhava śvaśurebhyaḥ*...
91. Ibid., XIV.1.62, *abhrātṛaghnīṁ varuṇāpaśughnīṁ bṛhaspate / indrāpatighnīṁ putriṇīmāsmabhyaṁ savitarvaha*.
92. Ibid., XIV.2.14, *ātmanvatyurvarā nārīyamāgan tasyāṁ naro vapata bījamasyāṁ/ sā vaḥ prajāṁ janayad vakṣaṇābhyo bibhratī dugdhamṛṣabhasya retaḥ.*
Women are often likened to a field, cf. *Manu*, IX.33ff. Cf. also *Koran*, II.22: 'Your women are your ploughland'.
93. *AV*, XIV.2.17, *aghoracakṣurapatighnī syonā śagmā suśevā suyamā gṛhebhyaḥ/vīrasūrdevṛkāmā saṁ tvayaidhiṣīmahi sumanasyamānā*. Cf. *ṚV*, X.85.44.
94. *AV*, XIV.2.18, *adevṛghnyapatighnīhaidhi śivā paśubhyaḥ suyamā suvarcāḥ/ prajāvatī vīrasūrdevṛkāmā syonemamagnīṁ gārhapatyaṁ saparya*.
95. Ibid., XIV.2.38, *tāṁ pūṣaṁ chivatamāmerayasva yasyāṁ bījaṁ manuṣyā vapanti/yā na ūrū uśatī viśrayāti yasyāmuśantaḥ praharema śepaḥ*. Cf. *ṚV*, X.85.37.
96. *AV*, II.36.7 ... *ete patibhyastvāmaduḥ pratikāmāya vettave*.
97. Ibid., XIV.2.3.
98. Ibid., XIV.2.4 Cf. *ṚV*, X.85.40, 41.
99. *Romakāle tu samprāpte somo bhuṅktetha kanyakāṁ/rajo dṛṣṭvā tu gandharvāḥ kucau dṛṣṭvā tu pāvakaḥ. Saṁvarta* verse 64, quoted by *Sm. C.*, I, p. 79 and *Gr. R.*, p. 46. Cf. Kane, *History of Dharmaśāstra*, vol. II. Pt. I, 2nd edn., Poona, 1974, p. 443.
100. Cf. *ṚV*, X.85.28, 29, 34, 35, etc.
101. *AV*, XIV.1.9, 25, 26, 28, 29, 30; XIV.2.66, 67.
102. Cf. Sumner, *Folkways*, p. 353; Zimmer, *AL*, pp. 313-14.
103. *AV*, XIV.1.27.
104. *AV*, V.17.1; cf. *MS*, III.7.3.
105. *AV*, V.17.8, *uta yat patayo daśa striyāḥ pūrve abrāhmaṇah / brahmā ceddhastam agrahīt sa eva patirekadhā*.
106. Ibid., V.17.9, *brāhmaṇa eva patirna rājanyo na vaiśyaḥ / tat sūryaḥ*

prabruvanneti pañcabhyo mānavebhyaḥ. (I.B. Horner, *Women under Primitive Buddhism*, makes a mistake when she refers her readers to *ṚV*, X.109.89. *ṚV*, X.109 has only seven verses. She probably meant *AV*, V.17.8 and 9, cited here.)

107. *AV*, IX.5.27.
108. Ibid., IX.5.28 Delbrück, *Die indogermanischen Verwandtschaftsnamen*, pp. 553-5, realizes that the first husband is still alive, and surmises that he is probably impotent or *patita*, fallen from his caste. There is no basis for such an assumption. Also see *Vedic Index*, I, p. 477.
109. Cf. *The Vedic Age*, p. 457.
110. Keith in Hastings (ed.), *Encyclopedia of Religion and Ethics*, vol. 8, p. 452.
111. See above p. 180.
112. *AV*, XVIII.3.1.
113. Ibid., XVIII.3.2.
114. Whitney's translation, vol. II, p. 848.
115. *TA*, VI.1.3 The text reads *abhi sambabhūva*, which the commentator explains by *ābhimukhyena samyak prāpnuhi*. Cf. *Kauśika Sūtra*, 80.45; *Āśvalāyana GS*, IV.2.18.
116. Cf. Meyer, *SLAI*, vol. 1, pp. 115-16; Jolly, *Recht and Sitte*, p. 48.
117. *TS*, VI.1.6. Cf. Keith, *The Veda of the Black Yajus School*, Pt. II, *HOS*, vol. 19, p. 493.
118. Ibid., fn. 6.
119. Cf. *Āp. Dh.S.*, II.10.27.2-4 . . . 'A bride is given to a family (of brothers and not to one alone)'. Cf. Kane, loc. cit., vol. II, Pt. I, p. 555.
120. Bṛhaspati quoted in *Smṛticandrikā*, I.10.
121. *TS*, III.5.6.
122. *MS*, I.10.11; *TS*, II.3.4.1; *Taitt. B.*, I.1.2.4; *Kāṭhaka Saṁhitā*, XX.VI.5. Cf. *Manu.*, III.53; VIII.204; IX.98; Megasthenes in McCrindle's translation, p. 70; Weber, *Indische Studien*, 5, p. 407; Hopkins, *JAOS*, 13, pp. 345ff.; Schrader, *Prehistoric Antiquities*, p. 381; Pischel, *Vedische Studien*, 2, pp. 78ff.; Hillebrandt, *Vedische Mythologie*, 3, p. 86n.; Jolly, *Recht und Sitte*, p. 52; *Vedic Index*, I, p. 482. Cf. also *ṚV*, I.109.2.
123. Cf. Delbrück, *Die indogermanischen Verwandtschaftsnamen*, pp. 578ff. Those who break the common rule of conduct are censured as sinful and given derogatory epithets, such as *pari-vividāna* or *agre-dadhus*, meaning the man who, though a younger brother, marries before his elder brother; the latter is then called *parivitta. Agre-didhiṣu* is the man who weds a younger daughter, while her elder sister is yet unmarried. All these epithets have a connotation of disapproval. Cf. *MS*, VI.1.9; *VS*, XXX.9; *Āp. Dh.S.*, II.5.12, 22; *Vedic Index*, I, p. 476.
124. Cf. D.N. Majumdar, *Races and Cultures of India*, pp. 167, 172, 192ff.; 'Some Aspects of the Cultural Life of the Khasas of the cis-Himalayan

Region', *Journal and Proceedings of the Royal Asiatic Society of Bengal,* Third Series, vol. 6, 1940, pp. 1ff.; Y.S. Parmar, *Polyandry in the Himalayas* (Delhi, 1975), pp. 20-4, 54ff. Majumdar, makes an interesting observation in the article referred to above. Polyandry, according to him, enabled the Khasas to retain their racial purity.
125. Cf. *ṚV,* I.112.19; 116.1; 117.20; X.39.7; 65.12. Also see the chapter on the ethics of war in my *Ancient Indian Warfare.*
126. Cf. Hopkins, *JAOS,* 13, pp. 361-2; Jolly, *Recht und Sitte,* pp. 50ff.; Pischel, *Vedische Studien,* I, p. 29; Schrader, *Prehistoric Antiquities,* p. 383.
127. Cf. *Vedic Index,* I, p. 481. Ch. U., IV.4.1,2,4.
128. *Vedic Index.* In fn. 70, on p. 481, they say, 'the custom may be due simply to polygamy', and refer to Keith, *Aitereya Āraṇyaka,* p. 244, fn.2 Had they meant both polyandry and polygyny by polygamy, we would have been in total agreement. But they use the term 'polygamy' for polygyny. We also find the use of metronymics in some early Indian epigraphs, at Pabhosa, Bharhut, etc.
129. *TS,* VI.6.4.3, *yannaikāṁ raśanāṁ dvayoryūpayoḥ parivyayati tasmannaikā dvau patī vindate.* Cf. also *TS,* VI.5.1.4; Kane, *History of Dharmaśāstra,* vol. II, Pt. I, pp. 550-1.
130. *AB,* XII.II, *tasmādekasya bahvyo jāyā bhavanti naikasyai bahavaḥ sahapatayaḥ.*
131. Briffault, *The Mothers,* vol. I, p. 688.
132. Cf., *RV,* I.124.7; IV.3.2; X.17.4.
133. *AV,* XIV.2.64, *ihemāvindra saṁ nuda cakravākeva dampatī / prajayainau svastakau viśvamāyurvyaśnutām//*
134. The Āryan was the ruling race there. Cf. P. Sykes, Sir, *A History of Persia,* vol. I, p. 95..
135. Briffault loc. cit., vol. I, pp. 671, 691-2.
136. Strabo, XI.13.11.
137. Ibid.
138. Cf. M. Mayrhofer, *Die Indo-Arien im alten Vorderasien* (Wiesbaden, 1966).
139. I.M. Diakonov, *Istoriya Midii* (Moscow, 1956), pp. 124-5.
140. T. Burrow, 'The Proto-Indo-Āryans', *JRAS,* 1973, no. 2, pp.123-40.

Prostitution in Ancient India

Sukumari Bhattacharji

The earliest mention of prostitution occurs in the *Ṛgveda*, the most ancient literary work of India. At first, however, we hear of the illicit lover, *jāra* and *jatinī*—male and female lover of a married spouse. What distinguished such an illicit lover from the professional prostitute or her client is the regular payment for favours received. When we merely hear of an illicit lover, there may or may not have been an exchange of gift; in a case of mutual consent, gifts must have been optional. In the remote days of barter economy, when money or currency was yet unknown, such gifts were equivalent to payment in cash. Clearly, even in the earliest Vedic age, love outside wedlock was a familiar phenomenon and unions promoted by mere lust are mentioned in quite an uninhibited manner.

After the earliest Vedic literature between the twelfth and the ninth centuries BC (i.e. *Ṛgveda*, Books II-VII), we have a vast literature which covers the period between the eighth and the fifth centuries BC. In this literature, too, we hear of the woman of easy virtue, of the wife's illicit love affairs.[1]

Extra-marital love may have been voluntary and unpaid but there is the possibility of it being regarded by the male partner as a form of service for which he was obliged to pay in some form. But as long as it was confined to a particular person, it was a temporary contract and was not regarded as a profession. The later Pāli term *muhuttiā* (lasting for an instant), or its Sanskrit equivalent *muhūrtikā* signified such purely temporary unions with no lasting relationship or obligation. Such affairs may have been voluntary or professional, depending on the attitude of the partners.

Gradually, there arose a section of women who, either because they could not find suitable husbands, or because of early widowhood, unsatisfactory married life or other social pressures, especially if they had been violated, abducted or forcibly enjoyed and so denied an honorable status in society, or had been given away as gifts in

religious or secular events—such women were frequently forced to take up prostitution as a profession. And when they did so, they found themselves in a unique position: they constituted the only section of women who had to be their own bread-winners and guardians. All the others—maiden daughters, sisters, wives, widows and maidservants—were wards of men: fathers, brothers, husbands, masters or sons.[2] So, women who took up prostitution had to be reasonably sure of an independent livelihood; their customers had to make it a viable proposition for them.

ECONOMIC STATUS

It is easy to see that all avenues to prostitution did not offer the same kind of economic security. A raped woman had little chance of an honourable marriage and social rehabilitation; so, reduced to prostitution, she had to accept whatever came her way. This also held true for the old maid turned prostitute. But a young widow or a pretty wanton maid or an unhappily married attractive woman could perhaps choose her partner and name her price, at least in the beginning of her career while she still enjoyed the protection of her father's, husband's or in-laws' home. We have absolutely no way of knowing when prostitution in India arose as a recognizable profession or how much the prostitute received by way of payment. Its emergence and recognition as a profession was presumably concomitant with the institution of strict marriage rules, especially monoandry, and the wife being regarded as the private property of her husband. The terms *sādhāraṇī* or *sāmānyā* (common), synonyms for prostitute, distinguish her as a woman not possessed by one man; this is the desideratum. When a woman does not belong to one man but obliges many, as the terms *vārāṅganā*, *vārastrī*, *vāravadhū* and *vāramukhyā*[3] signify, since she is not the responsibility of any one man, she looks after herself. She does by accepting payment from each of the men she obliges; she then becomes *paṇyastrī*, one whose favours can be bought with money.

The process of the emergence of prostitution must have been slow, varying from region to region and from age to age. By the later Vedic age, i.e. around the eighth or seventh century BC, we have references to a more regularized form of prostitution recognized as a social institution. Early Buddhist literature, especially the Jātakas, bear testimony to the existence of different categories of prostitutes,

and incidentally provides some information about their fees as also of their financial position.

Professional prostitution presupposes an economic condition in which surplus was produced, a surplus which also earned prosperity from abroad through trade and commerce. It also presupposes the rise of petty principalities, the breakdown of tribal society, the rise of the joint or extended family and the social subjugation of women in general. In a settled agricultural community, the woman gradually lost social mobility and a measure of freedom that she had been enjoying before. She became man's ward, possession, object of enjoyment. Also, with the accumulation of private property, the wife was more jealously guarded and jealously watched over. Society was now polygamous; polyandry disappeared except in some small pockets.

Whether as an unmarried girl, a wife or a widow, she *belonged* to some man; so other men could not approach her without trespassing on the owner's property rights. Pleasure outside the home, therefore, had to be paid for, hence prostitution had to be institutionalized so that there was an assurance of a steady supply for ready payment. It must have been a long and tortuous process for women of this profession to congregate in a 'red light area', away from the village— and later also from towns—where men could go and seek their company. Social ostracism on the one hand and professional solidarity of the guild type of association on the other, ensured their security and prosperity.

In Vedic literature, especially in the *Aitareya* and *Sāṅkhāyana Āraṇyakas*, the prostitute is mentioned in an apparently obscene altercation with the neophyte (*brahmacārin*). In the *Vrātyasūkta* of the *Atharvaveda*, she follows the *māgadha*. These are clearly part of a fertility ritual. It is in this role that she has persisted in ritual and literature down the ages.

There are various myths and legends regarding the origin of prostitution. The *Mahābhārata* account of the destruction of the Yādavas and Vṛṣṇis[4] ends with the women of these tribes being abducted by barbarian brigands. In the Kuru and Pāñcāla regions[5] inhabited by the Madras and the Sindhu-Sauvīras, the brāhmaṇa sages Dalbhya Caikitāyana and Śvetaketu's nephew Aṣṭāvakra were said to be associated with the teaching of erotics in which prostitution constitutes a section. In the *Mahābhārata*[6] and the *Matsya Purāṇa*[7] we are given fictitious accounts of the origin of prostitution. Kṣemendra

says that wicked mothers gave their daughters, enjoyed and abandoned by men, to others.[8] Vātsyāyana in his *Kāmasūtra* gives detailed instructions on how a chaste girl should be seduced cleverly until she yields to a man's lust.[9] Presumably, when such a man abandoned her she was forced to adopt prostitution as a profession. We also hear of the *jāyopajīvins* or *jāyājīvins*, husbands who lived on the wife's income which she earned by selling herself. This itself was regarded as a minor sin on the husband's part, an *upapātaka* which could be expiated by taking the comparatively mild *cāndrāyaṇa* vow.[10] All these texts reveal to us some of the channels by which women came to prostitution. Another old channel of the supply of prostitutes was young virgins given away as gifts on special religious and secular occasions. The number of such girls given away to brāhmaṇas, guests, priests, sons-in-law is staggering. In later Vedic times we hear of *dakṣiṇās*, sacrificial fees to officiating priests. Such fees included horses, cattle, gold and also women of various categories—unmarried, married without children and married with children. One wonders; what a priest did with hundreds of such women. Some he could marry, others he would enjoy and abandon, still others he would employ as maidservants. Many of these would later find their way to brothels or to slave markets. Yet another source of supply was the royal palace. A king could summon pretty maids to his palace, enjoy them for some days and then send them away. In the Vatsagulma region, ministers' wives had to oblige the king by paying visits (on being summoned) to the palace. In Vidarbha, pretty maids were enjoyed by the king for a month and then sent away. When such women came out of the palace, one obvious solution for their future life was prostitution. Of course, courtiers would sometimes marry some of them but the rest had few alternative courses open to them. Kauṭilya says that prostitutes were recruited from four sources: either they were born as prostitutes' daughters, or they were purchased, or captured in war, or they were women who had been punished for adultery.[11]

Finally, a totally abhorrent manner of procuring women for temple prostitution was buying women and giving them to the temples. Such donors were said to grow rich in this life and live in heaven for a long time. We hear that he who gave a host of prostitutes to the Sun god went to the region of the sun after death.[12]

Temple dancers do not appear before the last few centuries BC and are mentioned frequently in the early centuries AD in some regions.

The Jātakas do not know them, Greek visitors after Alexander do not mention them. Even Kauṭilya does not associate professional dancers with temple prostitution. Evidently, the institution arose in the troubled period of foreign invasion before and after the early centuries AD. Kālidāsa, in the fifth century AD, assumes their existence and function as an established tradition.[13] From the sixth century AD onwards, literature and epigraphy bear many evidences of its existence.

As townships and cities arose along the trade routes in northern India around the sixth century BC, internal and maritime trade flourished in these, and towns and cities became centres where courtesans plied their trade and attracted money from travellers, merchants, soldiers and men of various trades. These courtesans were trained in many arts and if they were young and pretty they could amass a fortune, but evidently only the exceptionally beautiful, young and accomplished among them were so fortunate. Since entertainment was their primary function, they had to provide song, dance, music and various other kinds of pleasure; they had to keep a troupe of artistes in the different fields in readiness for the cultivated customer. To the upper class of courtesans sometimes came men of refined aesthetic sensibilities and intellectual ability; hence they were obliged to provide entertainment like the hostesses of the French salons of the last century or the Japanese *geisha* girls. They themselves were trained in the various arts including literature, for their training was quite lengthy and elaborate. We hear of texts composed for such training; these are called *Vaiśikātantra*. But every courtesan could not herself provide all kinds of aesthetic pleasure, so they had to make an initial and also recurring investment for training and maintaining a troupe of artistes. Occasionally, the royal treasury came to her aid.

Chief courtesans of prosperous cities and towns maintained their own train of singers and dancing girls. Royal courts also patronized such singers and dancers who could be enjoyed by the king and his favourites and who could also be employed as spies.

From the earliest times we have many different names for courtesans. The *Ṛgveda* knows the *hasrā*, a frivolous woman and the *agrū*,[14] and the *sādhāraṇī*.[15] The *Atharvaveda* knows the *puṁścali*, she who walks among men,[16] the *mahānagnī*, she of great nakedness (i.e. who bares herself to many) is mentioned in the *Atharvaveda*,[17] *atiskadvarī* and *apaskadvarī*, women with fancy dress and bare bosoms

are mentioned in the *Taittirīya Brāhmaṇa*.[18] *Rajayitrī*, she who entertains and is given to sensuality, also figures in some texts.[19] *Sāmānyā* and *sādhāraṇī* are generic terms for the common woman.[20] In the *mahāvrata* rite the *puṁścalī*, a prostitute, pairs ritually with a *brahmacārin*.[21] The *Kāmasūtra* in the second or first century BC mentions the *kumbhadāsī* and *paricārikā* maidservants who could also be enjoyed at will. *Kulaṭā* and *svairiṇī*, wanton women, *naṭī* the actress, *śilpakārikā*, she who is engaged in arts and crafts, *prakāśavinaṣṭā*, the openly defiled one, *rūpajīvā* and *gaṇikā*, are courtesans with different social ranks.

The Jātakas mention *vannadāsī*, *veśī*, *nariyo*, *gamaniyo*, and *nagarasobhānī itthī*,[22] *muhuttiā*[23] and *janapadakalyāṇī* are mentioned in several Buddhist texts in the sense of the most beautiful women who can be enjoyed by an entire *janapada*. The *gaṇikā* must initially have connoted a woman at the disposal of all the members of a *gaṇa*, a tribe, and later of the political unit, or constituent of a confederacy. Some later names includes *sālabhañjikā*, who is no other than a prostitute in *Jaṭādhara's* dictionary.

VARIATIONS IN STATUS AND FUNCTIONS

This profusion of synonyms cannot be explained by regional or temporal variations only, it also signifies the social and financial status of the various categories of courtesans.[24] The numerous synonyms also testify to the widespread presence of the institution through the ages.

The *rūpajīvā* was not accomplished in the arts like the *gaṇikā*; her only stock in trade as the name signifies was her beauty and charm. She owed the state two days' income for a month. If a man forcibly enjoyed her he was fined 12 *paṇas*, but in times of crisis half her monthly income could be forfeited to the state.[25] She could also belong to the royal harem[26] and could also be exclusively kept by one man; in which case another enjoying her was fined 48 *paṇas*.[27] Disguised as a wife she could help a man escape and could also be employed by the state as a spy.[28] Vātsyāyana also mentions the *rūpajīvā*.[29] Another name of the mistress of one individual man is *avaruddhā*. The *rūpadāsī* was unaccomplished and was employed in the personal attendance of a wealthy man. Like the *vannadāsī* mentioned in the Jātakas she could entertain customers on her own or serve under some other person.[30] The *gaṇikādāsī* was a female slave

of the *gaṇikā* who could also become independent and set up her own establishment. The *Sāmājātaka* mentions Sāmā, a courtesan of Kasi who had a retinue of 500 *gaṇikādāsīs*.³¹ Other common and late names are *vārāṅgana, vāravadhū, vāramukhyā*, all of which stand for a prostitute while *vṛṣalī*, which originally meant a śūdra woman, later came to mean a harlot; *puṁsūlā* and *lañjikā* are later synonyms of harlots. *Kulaṭā* was a married woman who left home to become a public woman and *vandhakī* was a housewife turned whore; her husband was known as *vandhakīpoṣa*, maintaining or being maintained by a *vandhakī*. A *vandhakī* too had to pay part of her income to the state coffers in times of national crisis. The *raṇḍā* was a low common woman, a mistress to *viṭa*, usually an old hag who pretended to be engaged in penance but was actually out to catch customers.

The *gaṇikā* and sometimes the *rūpajīvā*, too, received free training in the various arts and

> those who teach prostitutes, female slaves and actresses arts such as singing, playing on musical instruments, reading, dancing, acting, writing, painting, playing on instruments such as *vīṇā* (lyre), pipe and drum, reading the thoughts of others, manufacture of scents and garlands, shampooing and the art of attracting and captivating the mind of others shall be endowed with maintenance from the state. They, the teachers shall train the sons of prostitutes to be chief actors (*raṅgopajīvin*) on the stage. The wives of actors and others of similar profession who have been taught various languages and the use of signals (*samjñā*) shall, along with their relatives, be made use of in detecting the wicked and murdering and deluding foreign spies.³²

In a sixth-century Jain work we have an exhaustive list of the prostitute's attainments—writing, arithmetic, the arts, singing, playing on musical instruments, drums, chess, dice, eightboard chess, instant verse-making, Prākrit and Apabhraṁśa poetry, proficiency in the science of perfume making, jewellery, dressing up, knowledge of the signs of good or bad men and women, horses, elephants, cooks, rams, umbrellas, rods, swords, jewels, gems which antidote poison, architecture, camps and canopies, phalanx arrangement, fighting, fencing, shooting arrows, ability to interpret omens, etc. Altogether seventy-two arts and sciences were to be mastered by her.³³

It is clear that the prostitute especially the *gaṇikā*, the most accomplished among them, offered men something which by the early centuries AD had become absolutely rare among the women of the gentry, viz., accomplishment. We read in the *Manusaṁhitā*:

The sacrament of marriage is to a female what initiation with the sacred thread is to a male. Serving the husband is for the wife what residence in the preceptor's house is to the man and the household duty is to the woman, what offering sacrifices is to the man.[34]

This series of neat equations deprive the woman of education, dooming her to household chores only, especially service of her husband and in-laws, but also thereby indirectly doom her to the loss of her husband's attention. With an unaccomplished wife at home the man who cared for cultured female company went to the brothel for it. Manu belongs to the early centuries AD,[35] a steady deterioration in the status of the women and the śūdra followed his codification of the social norm and the brothel flourished because it catered to the cultured man-about-the-town's (*nāgaraka*) tastes in women.

The *gaṇikā* because of her youth, beauty, training and accomplishment belonged to a superior social status. With an extensive, elaborate, and apparently expensive education she could frequently name her price, which, as Buddhist texts testify was often prohibitive. She was patronized by the king who visited her sometimes, as also by wealthy merchants. Because of her high fees none but the most wealthy could approach her. She alone enjoyed a position where as long as her youth and beauty lasted she could not be exploited.

TAXES TO THE STATE

We have seen that the *gaṇika, rupajiva, vesya* and *vandhakī* had to pay taxes to the state but a careful study leads to the conclusion that almost all categories had an actual or potential obligation for paying taxes; the collection, however, depended on the degree and nature of the organization. Organized red light areas paid taxes regularly, at a fixed rate, while it was much more difficult to ascertain the income of the women 'kept' in seclusion by a man or of the unorganized individual women plying the trade in isolated pockets or even, like the *vandhakī*, at home. Similarly, organized brothels enjoyed greater security from the state in lieu of the taxes they paid while individuals who paid 'hush-money' to extortionist officers could hardly demand any protection from injustice, man-handling, coercion and cheating. The *Nammayasundarīkathā*, a twelfth-century text, says that the state received 25 per cent to 30 per cent of the prostitute's income.

We hear of the extremely high fees of some famous *gaṇikās* in the Buddhist texts. *Bhatti*[36] and *parivvayam*[37] denote two different types of fees. Vāsavadattā of Mathurā charged very high rates per night.[38] Sālāvatī of Rājagṛha charged a hundred *kārṣāpaṇas* per night while Āmbapālī's fees led to a dispute between the cities Rājagṛha and Vaiśālī. A Jain text[39] says that a courtesan who had a faultless body and whose attainments were complete may charge 1000 *kārṣāpaṇas* per night. Evidently, only the richest merchants could pay such fees. The play *Mṛcchakaṭika* mentions a thousand gold coins and ornaments being sent in advance to lure a *gaṇikā* to a paramour's house. The *gaṇikā*, says Kauṭilya, was also paid a monthly salary from the royal treasury and the *pratigaṇikā*, her short-time substitute, received half the amount. The *gaṇikā*, however, did not enjoy property rights. 'There is every likelihood that their palatial establishments and gardens were state property with life interest.'[40] On her death, her daughter inherited her property but only for use; she could not sell, mortgage, exchange or donate them. This, of course, is true of the ordinary prostitute living in an organized brothel; many outstanding *gaṇikās* were mistresses of their own property. Hence in Buddhist literature we have many instances where she gave away her property. A *gaṇikā* could be bought out by a sympathetic customer; her redemption money (*niṣkraya*) was 24,000 *paṇas*, a very high sum in view of the fact that her annual salary paid by the state was between 1000 and 3000 *paṇas*. A *rūpajīvā's* fees were 48 *paṇas*, she usually lived with actors, wine-sellers, meat-sellers, people who sold cooked rice and vaiśyas generally. It is obvious that she kept company with people who controlled ready cash.

A man who forcibly attacked a *gaṇikā's* daughter paid a fine of 54 *paṇas* plus a fine (*śulka*) of sixteen times her mother's fees, presumably to the mother herself.[41] The second fine may also be a hush-money paid to the bridegroom at the daughter's wedding. Foreign customers had to pay 5 *paṇas* extra tariff duty to the state apart from the courtesan's regular fees. The *puṁścalī* (a common whore) did not have any fixed fees; she could only demand fees on marks of cohabitation, if she tried to extort money from her customers her fees were liable to be forfeited to the state—also if she threw temper tantrums or refused to oblige the customer in any way. The *Kuṭṭanīmmata* says that the temple prostitute (*tridaśālayajīvikā*) got paid by the temple authorities and that her income was fixed by tradition. Kṣemendra's *Samayamātṛkā* says that they were paid in grain as remuneration and that they were employed in rotation.

If after receiving her fees a prostitute refused to oblige her customer she paid a fine of double her fees; if she refused him before accepting the fees she paid her fees as fine.[42] Apparently it is a fair business deal where the defaulter pays a fine but if we pause and think that a sensible person would not ruin the prospects of gain or income unless she had some serious reason for disobliging her customer, it becomes clear that she did not have the option of refusing to sell herself. In other words, society refused to look upon her as a human being; she was just a commodity, nothing more. If a price had been accepted the commodity was the customer's for use.

Regarding her customers Vātsyāyana is very clear. The ideal one is young, rich, without having to earn his wealth (i.e. born to wealth), proud, a minister to the king, one who can afford to disregard his elders' commands, preferably an only son of a rich father. Born in an aristocratic family, he should be learned, a poet, proficient in tales, an orator, accomplished in the various arts, not malicious, lively, given to drinks, friendly, a ladies' man but not under their power, independent, not cruel, not jealous, not apprehensive.[43] The courtesan is advised not to stick to one visitor when she has offers from many. She should go to the person who can offer the gifts she covets.[44] Since money can buy everything she should oblige him who can afford the highest sum—this, says the text, is what the teachers instruct. When she wants to bring her paramour back from a rival she should be extra nice to him and be satisfied with less payment temporarily. This is to ensure her future . . . she should leave the impoverished lover and never invest in one from whom there is no hope of return.[45] She should be able to read the signs of his disaffection; a long list of such signs are given.[46] Above all, a courtesan should never encourage or entertain a suitor of reduced means. When she has squeezed her customer dry she should remorselessly leave him and search for a rich one. Normally, a *gaṇikā* chose her own customer except when the king forced one on her. Then, if she refused she was whipped with 1000 lashes or was fined 5000 *paṇas*. She did not have any right over her own body where the royal wish was concerned.[47] The punishment for forcing an unwilling *gaṇikā* was 1000 *paṇas* or more. Once she admits a client into her own house to share it with her she could not throw him out. If she did, the fine was eight times her fees. She could only refuse if he was diseased. When the client cheated her of her fees he had to pay eight times the fees.

The prostitute could own ornaments, money, her fees, servants,

maidservants who could be concubines. But other texts indicate that this ownership was not real or ultimate; but merely a right of use. The concubine, however, was obliged to pay the mistress for her own upkeep, plus one *paṇa* per month.

Prostitution in ancient India existed both overtly and covertly. In other words, besides brothels or open establishments run by and for one or more prostitutes, ancient texts give a list of many professions for girls where she could potentially be enjoyed by her employer with impunity. She could act as a substitute for the wife. In the Jain text *Vāsudeva Hindī* we read of Bhārata, a leader of his clan having another woman besides the wife. All the feudatories under him sent their daughters who arrived at the same time. The queen threatened to leave, so it was decided that they would serve him in the outer court and that later they would be handed over to the *gaṇa*, the tribe, to become *gaṇikās*, the text thus explains the origin of the term *gaṇikā*. The *Mahābhārata* tells us that the Pāṇḍava army was followed by a host of prostitutes who went in the rear of the army on baggage carts.[48] Yudhiṣṭhira on the eve of the war sent his greetings to the prostitutes.[49] In the train of the Pāṇḍavas when they left for the forest there were 'chariots, traders' goods and brothels', presumably to entertain the army.[50] King Virāṭa after his victory ordered young girls to dress well, come out[51] and entertain the assembled men. Such a command could only be given to public women. When Krsna went on a peace mission to the Kauravas, Duryodhana's entertainment of the former included a rest house with women; Dhṛtarāṣṭra ordered fair harlots to go with his sons to meet Kṛṣṇa. The later didactic interpolations of the *Mahabharata*, however, are full of imprecations and stigma against prostitutes.[52] The *Rāmāyaṇa* mentions *gaṇikās* and *veśyās* in the list of comforts, luxuries and status symbols. It is quite clear that prostitutes became a symbol of the prosperity concomitant with urban civilization. Like gold and jewellery, like corn and cattle, a rich man desired prosperity and plenty in the number of women he could enjoy freely.

WOMEN AS COMMODITY

The concept of women as chattel or commodity for man's enjoyment is borne out by the inclusion of women—pretty and young—in large numbers in any list of gifts given to a man in return for a favour or as a mark of respect. Thus she is a part of *dakṣiṇā*, fees to a sacrificial

priest. At Yudhiṣṭhira's horse-sacrifice women were sent by other kings as a donation to make up a necessary part of the entertainment.[53] Yudhiṣṭhira himself gives away pretty maids to guest kings,[54] he is even said to have given away hundreds of thousands of pretty girls as did King Śaśabindu of old at his horse-sacrifice.[55] Pretty maids as part of *dakṣiṇā* are also mentioned when King Bhagīratha gave hundreds of thousands of lovely maids, well decked out with gold ornaments.[56] Even at a *śrādha* ceremony brāhmaṇas received thousands of pretty maidens as gifts.[57] These girls could sometimes find husbands but presumably, since prostitution was being looked down upon more and more and maidenhood became an essential prerequisite for marriage in the Smṛti texts, most of them were forced to become prostitutes.

In heaven heroes are rewarded with a large number of beautiful girls.[58] The same idea is also seen in classical Sanskrit literature. In the *Kumārasambhava*,[59] *Raghuvamsa*,[60] *Kiratarjuniya*,[61] and in *Sisupālavadha*,[62] in Subandhu and Bāṇa we have references to courtesans as a prestigious decoration of a royal palace and an indispensable part of city life. Bhāguri calls her *puramandana* an ornament of the city. Thus her status was that of an inanimate object of enjoyment, it was sub-human and subject.

Courtesans sometimes did perform several other functions. In the *Mahābhārata* they participated in the victory celebrations.[63] They even played a political role as spies whose duty it was to seduce important men who were potential sources of vital political information, to collect such information and supply it to the relevant officers through the superintendent (*ganikādhyakṣa*). Their role as temptress is emphasized in the *Vattaka Jātaka*. The names of various types of courtesans gives us an inkling of their roles. Thus the *devaveśyā* was the temple dancer, something like the Greek *hierodoules*; the *rajaveśya* served the king; while the *brahmaveśya* or *tirthagā* visited holy places or pilgrimages. In the *Brahma Purāṇa* we have the description of *Ekāmratīrtha*, where lived many prostitutes[64] presumably to cater to the pilgrims and visitors. In the *samaja* public functions there used to be a separate gallery where sat the courtesans who gave musical performance for the *samāja*. Kauṭilya assigns them the duties of common maidservants at the palace. We hear of a prostitute serving Dhṛtarāṣṭra when Gandhari was pregnant.[65] Uddyotana Sūrī in his *Kuvalayāmala* describes nymphs in Indra's heaven who carried water vessels, fans, fly-whisks, parasols, mirrors,

kettledrums, harps, ordinary drums, clothes and ornaments. In the *Rāmāyaṇa* and the *Mahābhārata* such women followed the king in the palace and served him in his train. The *Lalitavistara* mentions women who carried full pitchers, garlands, jewellery and ornaments, the throne, the fan, jars full of perfumed water, etc. Evidently in all these instances, as also in many references in the Purāṇas and later literature the pretty damsels giving light personal service to the king are projected to heaven where the earthly prostitutes figure as celestial nymphs serving the gods. Whether on earth or in heaven monarchs or wealthy potentates used such women to enhance their glory and pleasure.

The retired temple prostitute was employed by the state for spinning cotton, wool and flax. The *nāgaraka*, man-about-the-town, in his love-intrigues could have assistance from widows, Buddhist nuns, and old courtesans who acted as go-betweens. In the palace the courtesan held positions as the royal umbrella-bearer, masseuse in charge of the king's (also of the royal family) toilet, dress and ornaments, and as the king's bathroom attendant. They also had a place in the royal entourage in hunting and military expeditions, and on occasion entertained royal guests. What is true of her function with regard to the king is also true of the rich courtier merchant and nobles described as *nāgaraka* in the *Kāmasūtra*. In the non-monarchical *gaṇa* states the chiefs gambled and indulged themselves in the company of prostitutes. The keepers of brothels procured pretty women from their establishment for these chiefs entertainment. These aged women, the brothel-keepers, were adept in bringing about and resolving quarrels between rival suitors as and when needed by them or by political agents of the state. Courtesans belonged to kings or wealthy citizens' trains in their amusements and festivals, their garden parties, boat trips, musical soirees, and bathing and drinking sprees. The *Kāmasūtra* describes the different sports and festivals of rich barons to each of which courtesans were invited.[66]

The text goes on to name twenty different sports and festivals[67] which depended on the seasons, the moon and auspicious days of the year. 'Villagers should learn of these sports of the townsmen, describe and imitate them'.[68]

No doubt, the prostitutes occasionally enjoyed themselves at such times, but whether they spied, massaged, bathed, dressed or carried the umbrella we do not hear of any extra payment for these additional duties to which they were certainly entitled because their main task

as prostitutes only earned them a place in the king's or rich man's establishment. In a sense, in the organized brothel prostitutes were better off, because normally they were not expected to do other chores when with their customers, although they sometimes entertained them with minor services. It all depended on the social and economic status of the prostitute. The city's chief courtesan was a wealthy person of a high rank who had a host of servants and maidservants for the menial chores; she herself was too accomplished, rich and respectable to do the chores herself; whereas a poor and common strumpet had to cater to many customers, also indigent and therefore, each able to pay very little. Hence she had to do all the menial chores for herself and her customer for bare subsistence. The *avaruddhā*, a woman 'kept' by a man, enjoyed freedom from manual labour only if her patron was rich; otherwise she had to work for herself and for him. Hers was like a 'contract marriage' and, as in marriage, the status of the woman depended on the man's income.

SOCIAL STATUS

At this distance of time it is difficult to form an adequate idea of the social status of prostitutes. We have seen that not all prostitutes belong to the same category. The accomplished young beauty could name her price, sometimes at an apparently exorbitant rate, because she was in great demand. Speaking of the ranks of royal attendants the *Kurudhamma Jātaka* says that the lowest of the courtiers was the door-keeper, the *dvārikā*; he occupies the last place but one, for he is above the public woman, the *gaṇikā*. Every city had a chief courtesan who was 'an ornament to the city'.[69] The *janapadakalyāṇī* or the *sādhāraṇī* of the non-monarchial state of the Licchavis were in great demand and were often looked up to because of their beauty and culture and so could ask any price for their favours. And they got it as many Buddhist texts testify. The word *janapadakalyāṇī* literally meant the most beautiful woman in a country. The *Dīgha Nikāya*[70] the *Majjhima Nikāya*,[71] and the *Saṁyutta Nikāya*[72] refer to her; Buddhist texts mention many affluent and powerful courtesans who fed the Buddha and his train and gave gifts to the order. We thus hear of Ambapālī giving such a feast to the Lord and his hundred thousand followers. She also gave away her big mango grove to the order.[73] Sālavatī's daughter Sirimā received 1000 *kahāpaṇas* per night.[74] We hear of a banker's daughter who chose to become a prostitute. Her

father set too high a price; few customers came; she reduced it to half and was called *ardhakāsī*.[75]

As looks, age and accomplishments came down the price and social prestige also came down so that middle-aged, unaccomplished or plain-looking women had to agree to mere subsistence rates or even less. Even that they did not always get as many texts on erotics tell us. The *Kuṭṭanīmata*, a major text on prostitution, describes the plight of such discarded prostitutes who were reduced to begging, stealing, and various other tricks. They had no guarantee of the next meal or shelter, no provision against old age, disease and penury. The heart-rending description of an abandoned, unattractive prostitute who takes recourse to becoming a confidence trickster and is pursued by society is occasionally rendered ludicrous by the very comicality of her various moves and the invariable failure of each move. But beyond this comic portrait is the tragic situation of a woman who, after having provided pleasure to many men's lust all through her life, has to fend for herself at a time when she is worst equipped for such a lone battle. In many texts we hear of such retired harlots begging.[76] The classic example is Kaṅkālī, an inn-keeper's daughter, sold at seven as a slave in the market place, who started as an ordinary prostitute and in time lost her youth and whatever charm she had earlier had. So she tried her hand at different professions but since she had no training in any she could not earn a livelihood through them. Then she tried to seduce people at pilgrimages, dressing up and disguising her age and loss of looks, but was eventually caught and summarily dropped. She changed roles frequently, was even imprisoned; in a bid to escape she murdered the warder. She then fled to a monastery where she could not stick it for very long. Later she begged openly until there was a famine and she could not get alms. So she became a nurse to a child whose gold chain she stole one night and escaped. When that money was exhausted she took to selling loaded dice. Then she returned to begging as a profession. But the strain and poor returns prompted her to steal food offered to idols. She next became a wine-seller, a fortune-teller and an actress in turn and finally she went about pretending to be insane. For a time she enjoyed royal hospitality because she gave out that she could paralyse a hostile army. But quite naturally she had to take to her heels before the actual encounter took place. Finally she returned to her native place and became a procuress for a pretty young prostitute, Kalāvatī.[77] This tale, evidently a concatenation of

many disparate episodes, epitomizes the fate of old prostitutes. Their tragedy was not only the lack of social security but also their lack of proficiency in any alternative profession through which they could earn a livelihood. Besides, having known better days, they could not stick to any mean profession which did not provide comfort. Hence they flitted from one profession to another with cunning and the ability to cheat through play-acting—arts they had mastered as prostitutes—as the only stock-in-trade. In the *Deśopadeśa* we hear of a sixty-year-old woman making herself up as a young girl in the hope of catching a customer.[78]

Institutionalized prostitution, however, offered somewhat better prospects for old and retired courtesans. Kauṭilya lays down the rule that *gaṇikās*, *pratigaṇikās* (short term substitutes for the *gaṇikās*), *rūpajīvās*, *veśyās*, *dāsīs*, *devadāsīs*, *puṁścalīs*, *śilpakārikās*, *kauśikastrī* (woman artisan) are to be given pension by the state in old age. Since Kauṭilya was writing for a prince, it is to be assumed that these women were employed by the state and had earlier paid taxes to the state which the state regarded partially as provident fund contributions against old age, disability, retirement and penury. We are not told what the pension was in terms of money, whether it was adequate for sustenance. But a steady income, however small, must have meant some measure of security to elderly women who would otherwise be wholly destitute. But, since women and their labour were exploited in most spheres of life, we may assume that this rule was not strictly observed, because such women were totally powerless to sue the state for non-payment. Yet the few who actually received some pension were lucky to have it. Retired prostitutes were employed as cooks, store-keepers, cotton-wool and flax spinners, and in various other manual jobs, so the state did not have to pay the pension until they were too old and weak to work any more. In old age some prostitutes became *mātṛkās*, i.e. matrons-in-charge of a brothel.

We hear of prostitutes' *anvaya*, family: their mothers, sisters, daughters and sons. The mother looked after her personal possessions, like dress and ornaments; she could not deposit her ornaments anywhere else; the daughter inherited them on her mother's retirement or death, but only for use. The sister could act as her substitute in a commision and the son was trained as a musical artist or an actor. He became a property of the state, almost a slave, and was obliged to hold musical performances for the stage for eight years. The manumission fees for him was higher than that for the prostitute. But

in the play *Mṛcchakaṭika* we hear of *bandhulas* 'who are begotten by unknown clients of the prostitutes'. Without any social identity, these boys lived in a brothel until they could eke out a livelihood for themselves. The pathetic tone of the verse tells us how these boys were looked upon as waste products, like slag in a factory.

A prostitute was obliged to keep the brothel superintendent posted about her income and expenses and he could stop her from being extravagant. She could not sell or mortgage her property at will; for doing so she paid a fine, fifty and a quarter *paṇas*.

Occasionally a prostitute was married. Vātsyāyana lays down a provision whereby a *veśyā* could be given in marriage to one who could provide special musical assistance to the establishment; such a marriage leads to greater prosperity.[79] Otherwise we hear of a notional sort of marriage which was more in the nature of initiation. The man did not have any exclusive claim on her person or services. The *avaruddhā* belonged to her patron exclusively and the law-givers say that his exclusive right to her should be respected.[80] Nārada has no objection to a man having sexual relations with a non-brāhmaṇa *svairiṇī, veśyā, dāsī* and *nikāśinī* (one who did not live a secluded life) of a lower caste if she was not another's wife.

That even a prostitute can fall in love is admitted theoretically by Vātsyāyana even though he says that they are and should always be after money.[81] A prostitute, according to the *Skanda Purāṇa*, belongs to a separate caste: if a man of the same or a superior caste enjoys her he is not to be punished, provided she is not another's concubine. If she is, then he simply performs the *prājāpatya* (a light) penance[82] and gets away with it. In literature we have a few instances of the prostitute falling in love.[83]

VILIFICATION IN LITERATURE

Both institutionally and individually prostitutes depended upon certain categories of middlemen and procurers. Chief among these was the *kuṭṭanī* or *śambhalī*. Now, in a brothel the mother of the chief prostitute was the person-in-charge who watched over her daughter's and the other girls' interests. Her duties included checking the payments, protecting the girl's health and wealth, driving away undesirable customers (i.e. those with depleted coffers), using deceit and delay tactics to spare the girls as much as possible, bargaining for greater emoluments by pretending that other, richer

customers are making bigger offers, varying custom, i.e. to deprive an eager one for a time in order to extort better fees from him.[84] No wonder she was vilified in literature. 'She is like a blood-thirsty tigress, only where she is absent does the client appear as a fox.' 'The *kuṭṭanī* with her ear glued to the door in greedy expectation of money becomes eager even when a blade of grass drops.'[85] The *Kāmasūtra* mentions these procuresses together with beggar women, cultivated women, female mendicants with shaven-heads, *cāṇḍāla* women and old prostitutes.[86] Apparently, she is an old hag with the nature of a vampire. But if one pauses to think, she was the prostitute's only guarantee of safety and fair payment. Without her, if the prostitute had to deal with the customer directly she could be cheated, robbed, insulted, maimed, even killed with impunity. The basis of this surmise is offered by Kauṭilya in his *Arthaśāstra* where we read that the fine for defamation of a courtesan was 24 *paṇas*; for assault 48 *paṇas* and for lopping off her ears 51-3/4 *paṇas* and forced confinement. The *Yajñāvalkya Smṛti* says that the fine for molesting a prostitute is 50 *paṇas*; and if she is gang-raped each assailant had to pay 24 *paṇas* to her.[87] For the safety of her person some laws had to be framed and for graver crimes the penalty varied between 1000 and 48000 *paṇas* according to the degree of the heinousness of the crime and the status of the injured courtesan.

On the other hand, later religious and law books have nothing but contempt for courtesans, and hold them solely responsible for the institution. They go to the length of saying that the murder of a prostitute is no crime.[88] Manu believes that all prostitutes were thieves and swindlers.[89] It is true that the erotic text *Kalāvilāsa* lists sixty-four specified modes in which a courtesan could deceive her customer. It also tells us the story of King Vikramāditya, who when he fell on hard days became the prostitute Vilāsavatī's guest. She showered her own wealth on him and when he gave himself out to be dead, threw herself on his pyre. With her help he regained his kingdom and made her the chief queen. Then she confessed to him her love for a young man who was arrested as a thief. With the king's help he was freed and the lovers were united. Then the king remembered his minister's warning: they are not to be trusted. This innate deceitfulness of prostitutes is a recurring note in all literature. But in this instance the text ignores her contribution: the reinstatement of the king as sovereign, and betrays only a sneer, shared no doubt by the entire community, for the possibility of a prostitute

being in love so deeply that she treads a dangerous and tortuous path to gain her lover appeared totally absurd to them. The text condemns the woman for everything and more so the prostitute, wholly ignoring her client's role, and her own contribution to his career.

We have just seen that their clients also maltreated and manhandled them and these were not isolated incidents or exceptions or there would be no need to frame laws against crimes and stipulate the exact amount of fines for the several kinds of assault. She was often used and then cheated, robbed, mutilated and murdered. If the institution was for society a necessary evil and the state had a vested interest in extracting revenue and espionage service from this 'evil', then it could not afford to ignore a situation when the source of such revenue was harmed so that she could not multiply the revenue. Hence the laws. But the attitude of society was clearly against the prostitute and not against her client.

The *viṭa* was the middleman and/or companion of the courtesan. Because the *viṭa* was a man he could procure customer for her. Technically, a *viṭa* was a worthy spendthrift who, reduced to penury, takes shelter (sometimes with his wife) in a brothel or in similar pleasure resorts.[90] The *viṭas* are counsellors of both the courtesans and their clients and could bring about misunderstandings between them and also reconcile them with each other. The *pīṭhamarda*, on the other hand, was a teacher of the prostitute as also an associate of the *nāgaraka*, the man-about-the-town, who helped his friend achieve his ends.[91] Both, but especially the *viṭa*, looked after the courtesan's interests where she needed a man to help her. In the *Mṛcchakaṭika* he escorts her in a dark night, instructs her when she goes to seek pleasure, has no illusion about the profession but has respect for her as a person. In the four famous Bhāṇas of the late classical period the *viṭas* are helpers, peace-makers, go-betweens, procurers and counsellors of the partners. Evidently, the courtesan was also helpless against certain situations so that she shared her income with a male go-between for protecting her own interests. This and the services of the *kuṭṭanī* already signify that the courtesan was liable to be exploited, cheated, insulted and physically injured. The *viṭa*, apparently a parasite, gave valuable service to her where her sex and social position rendered her vulnerable.

As townships sprang up along trade routes and as rich men long away from home frequented these brothels these became a regular feature with the chief courtesans, beauty queens being regarded

as ornaments of the town or city, *nagaraśobhānī* or *nagaramaṇḍanā*. Because she was in high demand and because she would fetch a rich revenue if she was accomplished and attractive, the state undertook to supervise her education (with quite a heavy and rigorous syllabus) at its own expense, provided she remitted part of her income to the state. Not only was she obliged to pay revenue to the state she often undertook some works for public welfare. Thus we read in the *Brhatkalpābhā*, a Jain text, of a picture gallery set up by a courtesan. The Buddhist texts record Ambapālī as also giving similar services. Other courtesans fed the hungry during a famine, gave away money, land, and property for the Buddhist cause. Many treated the Buddha and monks to sumptuous feasts. Frequently, when the courtesans amassed wealth they set up works of public utility: they sank wells, constructed bridges, temple gardens, *caityas* (sacred mounds), donated money to the needy, gave gifts, and generally served the community through such works for public utility.

Yet we read in the *Mahābhārata* that the prostitutes' quarters should be situated in the south because that is the direction of Yama, the god of death. In the *Mānasollāsa*, a medieval text, we read that houses of ill-fame should be situated on the outskirts of the town. But in Greece the courtesans had a different status; one of the most beautiful sections of any Grecian city was where the richest of the courtesans built their houses. The lyric poem *Pavanadūta* of Dhoyī, describing the temple prostitutes says that it seemed that Lakṣmī, the goddess of beauty has herself descended there. Kalhaṇa, in his *Rājataraṅgiṇī*, mentions an extremely qualified *devadāsī* by the name of Kamalā. In some Purāṇas we read of the *anaṅgavrata*, a rite which signified temple prostitution.[92] The *Kāmasūtra* lays down that she should always be decked out with jewellery and without being fully visible should streetwalk discreetly 'because she is a commodity'.[93] The same text defines her conduct: 'without really getting attached to her client she should act as if she were; she should submit to her cruel and mendacious mother and if the mother is not there she should submit to the matron of the house. She has the right of use of her ornaments, food and drinks, garlands, perfumes, etc.'[94] 'She should pretend the loss of her own and her client's ornaments, should engage in a mock quarrel with her mother on the subject of excessive expenses and having to incur debts, should make the client pay her bills, should pretend to be obliged to sell her ornaments in order to make both ends meet, should report about her rivals'

greater income, etc.'[95] If this long list of deceptions is any index of how society expected her to conduct herself in her profession, one fails to understand the bitter censure society meted out to her when she complied.

The *Rājataraṅgiṇī*, a poetical chronicle of Kashmir, records that King Lalitapiḍa gave out that anyone proficient in courtesan lore and clever at jokes would become his friend. Later literature has no inhibition in mentioning or describing courtesans attached to the palace, to the manor houses of the nobility, especially of merchants, and to temples as well as those who lived in brothels. Such descriptions in Kālidāsa, Bhāravī, Daṇḍin, Bhaṭṭī, Subandhu, Bāṇabhaṭṭa, Śrīharṣa (*Naiṣādacarita*) are totally uninhibited and done with great gusto and skill. Yet, other didactic texts are full of imprecations against prostitutes. The *Viṣṇu Saṁhitā* lays down that he who associates with a courtesan should perform the *prājāpatya* penance.[96] The vituperation against prostitutes begins in the didactic sections of the *Mahābhārata*, the Dharmasūtras (many of which belong to the age of the brahmanical interpolation of the *Mahābhārata*), and continue through the Purāṇas and Smṛti texts. Such texts choose to ignore the fact that courtesans are not born but made; they can only exist as long as society has a demand for them. Therefore, since a section of society calls courtesans into being to cater to their need, the condemnation should be shared by that section as well. But apart from mild half-hearted penalties—more in the nature of not-too-obvious strictures and threats of notional ostracism—the male clients go morally scot-free.

This double standard is not an isolated phenomenon, it is the product of a rooted ambivalence in the society's consciousness. Since the designation of *gaṇikā* was the highest and had to be earned through beauty, charm and accomplishments,[97] it signified the highest social class among prostitutes. Kauṭilya says that the superintendent of prostitutes conferred the title of *gaṇikā* to the pretty, young and cultured hetaira,[98] she drew 1000 *paṇas* from the state presumably for her establishment, and her teachers in the various arts were also paid by the state. She had a measure of social security in the sense that those who harmed her physically, financially and socially were liable to be punished heavily by the state. Needless to say that such a coveted position was not accorded to many; only a handful of the prostitutes were made *gaṇikās* whose favours were enjoyed by kings, princes and the richest of the merchants. It can be

guessed that pretty young women with real cultivated taste and accomplishments flocked to well-governed towns and cities where they could not be molested by rakes and ruffians with impunity and where trade and commerce thrived. Even in such townships as well, as in prosperous villages, women with less beauty and culture and presumably older in age plied their trade as *rūpajīvās* and *veśyās* depending on their age, accomplishments and charm. The *veśyā* may have relied on her clothes and jewellery (*veśa*) for attracting customers. The *avaruddhā*, as we have seen, was the mistress of an individual in the role of a concubine; the relationship was temporary but while it lasted, society respected its rights. The *puṁścalī, vāravilāsinī, svairiṇī kulaṭā,* etc., were free agents who were out to turn whatever charm they had to the best financial capital. Sometimes they employed middlemen to attract customers and sometimes they hawked themselves. From all accounts they had less to offer and, therefore, earned much less. The *devadāsīs* were a class by themselves who, because they were attached to institutions (i.e. temples) governed directly or indirectly by the state, enjoyed some degree of protection.

Just what the social background of these unfortunate girls was is far from clear. Apart from the parents making a devotional gift of their daughters to the temple,[99] there must have been the daughters of *devadāsīs*, or distress sales of girls to the temple, recruitment of local beauties under moral pressure, or girls abducted from helpless parents, girls won as war booty or recruited through superstitious practices. However, they came in, it is quite clear that it was an all-India and age-long phenomenon. Even though the Madras Legislative Assembly banned it by a law in 1929, it persisted there and in the rest of India and still persists in many pockets after it was banned all over India by a legislation in 1947. The overt duty of the *devadāsīs* was to dance at the time of the evening worship in the temple, but they were also treated as concubines by the temple priests. Kālidāsa refers to them as *veśyās* and describes them as enjoying the first drops of monsoon rain as a welcome relief to their tired limbs.

Once inside the temple and under the thumb of the priests they became like slaves with no clear definition of their rights and duties. The *Kuṭṭanīmata* does mention payment from temple authorities but this evidently did not mean anything more than subsistence and clothes and ornaments for them as temple dancers. In the *Samayamātṛkā*[100] we hear of grains being given to *devadāsīs* who danced in rotation. In the third century BC Jogimara inscription we

hear of Devadatta's love for the *devadāsī* Sutanukā. Many other cave inscriptions[101] mention the music and dance provided by courtesans and *devadāsīs*. Since major treatises are nearly all silent on the duties and rights of the *devadāsīs*, it appears that they were completely at the mercy of the temple priest, a specially privileged section in Indian society who enjoyed immunity from the penal code and were thus free to exploit these girls as they pleased. Evidently, here, too, the more talented beauties coming from the upper rung of society enjoyed somewhat fairer treatment than those born to temple prostitutes or recruited from destitute parents or as rich men's gifts or war booty. But because the masters of these prostitutes, the priests, enjoyed privilege both through their sacerdotal office and through royal patronage the *devadāsīs'* position was more abject than presumably of those organized in the brothels regarding whose rights and privileges some rules had been clearly enunciated. The very helplessness of the *devadāsīs* must have led to the widespread distribution of the institution and its prolonged continuation in the name of religion. The violent resistance and opposition of the hieratic section, especially in south India when its abolition was proposed, testifies to the nature and measure of the priests' vested interest in the institution.

What happened to the *devadāsī* when she grew old? Presumably not all of them enjoyed royal patronage. Those who did were employed in the state textile factory as we find in the solitary mention of the *devadāsī* in Kauṭilya.[102] Dancing was the only art she had learned and she could not practise it in old age, so that if she was one of those who did not enjoy royal care she would be reduced to destitution. Her profession prevented her from having a family and her long stay in the temple isolated her from society; therefore, even if she worked in a textile factory for a time she would face penury in real old age when both the temple and the community cast her off as wholly redundant. Thus at the end of a long career of double exploitation—as a temple dancer and as the priest's concubine—she faced complete destitution, for neither the state nor the temple had any obligation to look after her.

It is both rewarding and revealing to turn the pages of dictionaries on the subject of prostitution. Apart from older, i.e. Vedic, and later Vedic terms like *agrū*, *hasrā*, *atiṣkadvarī*, and *vṛṣalī*, each of which emphasized one aspect of the public women, we have a host of later synonyms which varied with time and place. The standard Sanskrit

lexicon *Amarakośa* says that *veśyā, vārastrī, gaṇikā* and *rūpajīvā* are synonyms. Jaṭādhara adds *kṣudra* and *śālabhañjikā*; the *Śabdaratnāvalī* has a few more entries: *jharjharā, śūlā, vāravilāsinī, vāravatī, bhaṇḍahāsinī,* while the *Śabdamālā* adds *lañjikā, vandhurā, kuntā, kāmarekhā* and *vāravatī*. The standard dictionary of Hemacandra has *sādhāraṇastrī, parāṅgaṇā, bhuñjikā* and *vāravadhu* to which the *Rājanirghaṇṭa* (lexicon) adds *bhogyā* and *smaravīthikā*. Even a cursory glance at these names tells us that while some signify the profession itself others (like *kṣudrā, śūlā, kuntā, bhaṇḍahāsinī, bhuñjikā, bhogyā* or *smaravīthikā*) express society's sneer and contempt.

In the *Brahmavaivarta Purāṇa* we read that a woman loyal to her husband is *ekapatnī* (wife to one), if she goes to another she is a *kulaṭā*.[103] If she goes to three she is a *vṛṣalī*, a *puṁścalī* with a fourth, a *veśyā* with a fifth and sixth, a *yuṅgī* with a seventh and eighth. Above that she becomes a *mahaveśyā* whom no one of any caste may touch.[104] Although it appears that all except the *mahāveśyā* may be touched that is not true. The Dharmaśāstras generally lay down that visiting a prostitute is a crime but since they also prescribe mild expiatory rites, it appears that society did not look upon it as either a heinous crime, or an irremediable sin.

As we have seen, there is an evident ambivalence regarding the profession. The *Samayapradīpa*, a late ritual text mentions the sight of a prostitute as an auspicious sign; a man gains his desire if he sees her on setting out on a journey. Other such items are obviously auspicious—like a cow with its calf, a bull, horse or a chariot, fire with its flame turning to the right, a goddess, a full pitcher, garlands, banners, white rice, etc. The only apparently inauspicious item in the catalogue is the prostitute; yet a sight of her is regarded as a good omen. Similarly, soil from near a prostitute's house is an essential item for fashioning the image of Durgā, the goddess of cardinal importance in Bengal. The mystery is solved when we remember the role of the prostitute in the earlier rituals where she had to copulate with a man or engage in a mock altercation with a neophyte, the *brahmacārin*, in an exchange of obscenities. In all of these instances the same incentive is noticeable, viz., fertility. Her very profession involved repeated sexual relations with many men and so potentially symbolized fertility and the power of reproduction. For a community whose prosperity and wealth depended on ensuring fertility of the field and of cattle she symbolized the fertility principle. Hence her place in rituals. This association of fertility of field and cattle with the

sexual act, especially magnified in the prostitute's profession, is not unique to India.

But, apart from this aspect society unambiguously looked down upon the profession. All its efforts at segregation of the rest of the community from contagion through the prostitute's proximity, the rule of allocating an area in the south, Yama's direction, outside the common habitat, for the brothel, the prohibition against eating food offered by her, the rule against touching or associating with her signify this contempt. But this is obviously a later development, for the *Kāmasūtra* describes kings, courtiers, and the mercantile nobility of the cities and towns (and also of villages) as indulging in the company of courtesans. The attitude there is totally uninhibited. The *Arthaśāstra*, too, presupposes the existence of prostitution as an institution and has no value judgement regarding them. Underlying both of these texts is the assumption that this institution has been brought into existence not by the perversity of certain women or by an aberration in any section but by a social need. A society which virtually forbade female education and relegated the woman to virtual subordination under the husband and in-laws reduced her to a chattel who could serve and for a time cater to the man's sexual needs but after children started coming and she became sorely taxed in her strenuous household obligations, nursing and bringing up the children, she was no 'fun' any more.

Apart from this man must have desired companionship in his intellectual and aesthetic pursuits from men friends as well from women. This entirely normal and healthy desire could in no way be satisfied by the wife who, encumbered with household duties and children, soon lost youth and charm and whose husbands were therefore driven to prostitutes. But evidently not all men did so, and those who did, did it in a surreptitious manner. All that charmed a man in a prostitute was forbidden for the wife, who should be uneducated, demure and plainly dressed except on ritual occasions. She was primarily a housewife, busy with her chores, children and in-laws which left her little leisure for the cultivation of either her looks, dress or mental faculties. Society expected her to be good, hard working, devoted and obedient. This was bound to make her less attractive to her husband who craved for charm and companionship in a woman. This very need of combining sexual pleasure with intellectual-aesthetic companionship or simply with the charm of a

good-looking, youthful person tastefully decked out in clothes, and jewellery attracted men to prostitutes. And repelled them, precisely because she could not be exclusively possessed, for she was enjoyed by many. In a society where women became a personal possession, a woman who could not be possessed individually provoked this ambivalence.

WOMEN AS CHATTEL

Woman has been a chattel in India ever since the later Vedic times when she was included in the list of *dakṣiṇā* along with items like cattle, horses, chariots, etc. Such gifts were given to priests. Evidently they were enjoyed and then sold as slaves or prostitutes. Later in the epics we have references to women as gifts.[105] Heroes are said to be rewarded with hosts of beautiful women in heaven; undoubtedly this is a reflection of earthly prizes given to heroes and eminent men. In classical literature too, we meet prostitutes as a decoration to courts, in military and hunting expeditions.[106] Women also came with victories as booty and after serving the victorious generals and eminent military personages they would find their way to brothels. Thus Arjuna brought over the women of the enemy as booty,[107] King Virāṭa also expressed his pleasure of Arjuna's prowess by giving him pretty maidens.[108] In the battlefield Karṇa declared that whoever pointed out Arjuna to him would receive a hundred well-dressed maidens from him.[109] A king who does not give such gifts is branded with the epithet *rājakalī* (a *kalī*, i.e. evil spirit of a king).[110] At Draupadī's wedding a hundred slave girls in the early bloom of their youth were given away.[111] Kṛṣṇa entertained guests with pretty maidens.[112] Also at Subhadrā's wedding no less than a thousand girls were offered to guests for enjoyment in the drinking and bathing sports.[113] Yudhiṣṭhira received ten thousand slave girls.[114] King Śaśabindu at his horse sacrifice gave away to priests hundreds of thousands of pretty girls;[115] so did Bhagīratha.[116] We also hear of thousands of beautiful girls as gifts in *śrāddhas*.[117] Instances can be multiplied.[118] We are told that pretty young girls are natural gifts to brāhmaṇas[119] and that whoever gives this gift lavishly on this earth receives plentiful fruits in heaven i.e., is rewarded with many nymphs there for his enjoyment.[120] In the *Mahābhārata* and in the Purāṇas we have numerous instances where the host entertains his guest by

sending his own wife to him at night and/or other pretty women. In the *Sanatsujātīya* section of the *Mahābhārata* five marks of true friendship are enumerated; one of these is to share one's wife with a friend. Pretty girls also formed part of the dowry.

Two things are clear from these references. First, there must have been an easily available source of pretty young girls, a steady supply for instant enjoyment, or for giving away. One wonders where such girls could be found. Prostitutes' daughters is a ready answer. The *Mahābhārata* has an episode: King Yayāti's daughter Mādhavī was given to Gālava; the father lent her in lieu of money so that she could be hired out to four kings in turn for a year each. The kings gave Gālava handsome rewards with which he paid his school-leaving fees to his preceptor. Clearly here Mādhavī is a money-earner to her father and the latter satisfies Gālava by prostituting her to four different kings. Apart from this kind of distress sale in times of crisis, women as war-booty was another big source of supply. Wives caught in certain cases of adultery were also driven out; such unwanted women congregated in the brothel, as also women who could be bought and kept in palaces as occasional gifts. In the royal courts and rich households where many abducted women were kept for service and as status symbols, these proliferated and became yet another source of supply.

The second point that strikes us is that these women were regarded as inanimate objects of enjoyment. They figure in lists of material gifts, sacrificial fees, donations, entertainment, prizes, rewards and dowry. And after the temporary enjoyment the recipient or donee could not but turn them loose; at least in most cases they did so. Thus there were hosts of women who eventually ended up in the brothel where they catered commercially to men. All along this dismal history we notice that women had very little initiative or choice about their destiny. They were pawned, lost or gained in battles, given as gifts at sacrifices and weddings, were relegated to the position of slaves and chattel in palaces and rich households, sexually enjoyed whenever their owners so desired and discarded when the desire abated.

They got paid only in brothels; in other instances they were only fed, clothed and decked out with jewellery so that their masters would find them attractive. Even in brothels their labour could, and frequently was, exploited, as many rules in the scriptures testify.

Vātsyāyana has a long section on how the harlots could play-act, feign, seduce, cheat and deceive their customers with or without the help of middlemen and procuresses. So does Dāmodaragupta teach novices how to make the best use of youth and charm and extort money from customers by hook or by crook. Other texts also teach similar lessons. None of these texts is authored by women. When after being trained in the art of deception, the prostitutes practised these arts, they are given foul names by the entire community. The very nature of the profession entailed a degree of deceit and the entire social set-up and its attitude encouraged it. Instead of accepting responsibility for it and admitting that prostitutes act as men force them to act and that they exist because they render a service that society needs, the entire blame is loaded on the prostitutes themselves.

The situation was very different in Greece and Rome as Aristophanes, Menander or Terence's plays testify. Here in India the exploitation is redoubled because male customers frequently sought to cheat prostitutes of their rightful wages as the law books bring out clearly. And on top of this they tried to rob them of their rightful place in society. But when literature does not seek to be respectable but truthful in Kauṭilya's and Vātsyāyana's works or the Bhāṇa (which decidedly belongs to a lower, less respectable genre), prostitutes come into their own. The customer looks upon them if not with positive respect yet not with contempt and betrays his awareness of the necessity and significance of their role and profession. But the major, respectable literary tradition is that which reflects the upper class reaction to the institution, a class which is not a bit averse to use their services but is yet too respectable to regard them as human beings. Once this attitude is fostered and becomes prevalent, depriving prostitutes of their fees, man-handling or insulting them is condoned. But this was only true of the common harlot with little charm and no accomplishment. The well-trained and well-preserved beauty, the *gaṇikā*, who belonged to the upper class enjoyed the patronage of royalty or nobility and was comparatively secure and comfortable.

Another proof of the double standard is that although associating with prostitutes or accepting their food was punishable there is no rule against accepting benefits from them. Records in the Tiruvorriyur temple show the the *devadāsīs* there made rich endowments. Evidently such works of public utility were enjoyed by all, i.e. by the community

for whom it was a sin to touch a prostitute or to eat her food. Thus society had no hesitation in using the fruits of her labour while looking down upon her. Presumably, by enjoying such charitable institutions set up by her society was kindly deigning to offer her an opportunity to expiate for the sins of her profession, a profession which could not flourish without the patronage of a section of the male population. This section was punished only notionally.[121]

Society thus created situations in which many women were deprived of the right to remain respectable and be regarded so, so that such women were pushed to this profession. And they could live as prostitutes because a steady supply of male customers was ensured. These men found their wives dull as companions and so flocked to the prostitutes. In return society ostracized the prostitutes, but not their customers. Whether in the palace, or in the temples or in brothels they served men with an uncertainty regarding payment and the fear of molestation, mutilation, torture and death. They had scant provision for old age and infirmity. Their bodies, accomplishments, and gifts and charity were enjoyed by the community which otherwise treated them as untouchables and showered curses and imprecation on the profession itself, as if prostitutes alone could make prostitution viable as a profession. Penalty for maltreatment or deceit is mentioned but one wonders how few wronged prostitutes could actually sue the state for their flouted rights and dues. Such was the precarious existence of prostitutes who could, with a few exceptions of really upper class or outstanding individuals, be exploited by men at will and with impunity.

NOTES

1. Cf. the sacrificer's wife being publicly questioned by the officiating priest regarding her secret lovers at the *varuṇapraghāsa* sacrifice: 'with whom (plural) hast thou had secret affairs?' But though she confessed we hear of no penalty for her transgression.
2. Cf. the terms *svatantrā*, independent, or *svādhīnayauvanā*, she who can freely enjoy her youth, as synonyms for the prostitute. Scriptures lay down that women are wards of their fathers in childhood, of their husbands in youth and of sons at old age.
3. A woman with whom men take turns (*vāra*), i.e. one who can be possessed or enjoyed by different men in turns.
4. Described in the Mausalaparvan.

5. Eastern Punjab and western U.P.
6. VIII.27, 30, 57-9.
7. Ch. 70.
8. *Samayamātṛkā*, III.18.
9. III.5.14-26.
10. *Viṣṇu Purana*, Ch. 37; *Yājñavalkya Smṛti*, 240.
11. *Arthaśāstra*, II.27, X.1-3.
12. *Padma Purāṇa, Sṛṣṭikhaṇḍa* 52.97.
13. Cf. the *Meghadūta*, verse 35.
14. IV.19, 9; 16, 19, 30.
15. I.167, 4; II.13, 12, 15, 17.
16. XV; Also the *Pañcaviṁśa Brāhmaṇa*, VIII.1.10; *Kauṣītakī Br.*, XXVII.I; *Lāṭyāyana Śrautasūtra*, IV.3.II; *Vājasaneyi Saṁhitā*, XXX.22 (henceforth *Vāja. Saṁ.*).
17. XIV.I.36; XX.136.5. Also *Aitareya Brāhmaṇa*, I.27.2.
18. III.4.II.I
19. *Vāja. Saṁ.*, XXX:12, *Tait. Br.*, III.4.7.1.
20. *Vāja. Saṁ.*, XXX:12, *Tait. Br.*, III.4.7.
21. *Jaim. Br.*, II.404 ff, *Kāt. G.S.*, XII.3.6.
22. I.43.
23. *Vinaya Piṭaka* III.138.
24. Cf. the English synonyms: courtesan, prostitute, harlot, strumpet, hetaira, whore, trollop, slut, etc., bearing different connotations and also signifying the social strata to which they belong.
25. *Artha.*, V.2.
26. Ibid., I.20.
27. Ibid., III.20.
28. Ibid., VIII.17.
29. *Kāmasūtra*, VI.6.54.
30. *Arthaśāstra*, II.27; Jātakas mention the *vannadāsī* in II.380; III.59-63, 69-72; 475.8.
31. *Jātaka*, III.59-63.
32. R. Shamasastry (ed.), *Kauṭilya's Arthaśāstra*, Mysore, 1st edn. 1915, 6th edn. 1960, section on the *gaṇikādhyakṣa*, superintendent of prostitutes.
33. *Bṛhatkalpābhā* (ed.) by Puṇyavijayajī (Bhavnayar, 1933-8). Kauṭilya includes reading and writing, Vātsyāyana mentions reading and composing poems, and deciphering code words in her syllabus.
34. *Manusaṁhita*, II.67.
35. Probably to the first century AD.
36. From Sanskrit word *bhṛti*, fees.
37. Sanskrit *parivyayam*, expenses.
38. Cf. *Divyāvadāna*, ed. by P.L.Vaidya, p. 218.
39. *Jñatadharmakathā*, I.

40. Moti Chandra, *The World of Courtesans* (New Delhi: Vikas, 1973), p. 48.
41. *Arthaśāstra*, IV.12
42. *Yājñavalkyasaṁhitā*, II.295.
43. *Kāmasūtra*, VI.1.10,12.
44. Ibid., VI.5.1-6.
45. Ibid., VI.6.31.
46. Ibid., VI.3.28-31.
47. *Arthaśāstra*, IV.13.
48. V.195.18-19.
49. V.15.51-8.
50. III.238ff.
51. IV.64.24-9.
52. XII.88.14,15; XIII.125.9ff.
53. *Mahābhārata*, XIV.85.18.
54. Ibid., XIV.80.32.
55. Ibid., VII.65.6.
56. Ibid., VII.60.1,2, XII.29.65.
57. Ibid., XV.14.4; 39.20; XVII.I.4, XVIII.6.12,13.
58. *Mahābhārata*, III.186-7, VIII.49. 76-8, XII.64.17.30; XII.96.18, 19, 83, 85-6, 88; 106.6ff. Also in the *Rāmāyaṇa*, II.71; 22, 25, 26.
59. XVI.36, 48.
60. VII.50.
61. IX.51.
62. XVIII.60, 61.
63. IV.34.17, 18.
64. XI.30-35.
65. *Mahābhārata*, I.115.39.
66. I.4.34-41.
67. I.4.42.
68. I.4.49.
69. Cf. the important drama *Mṛcchakaṭikā* where the heroine is a beautiful courtesan, accomplished in the various arts; she is described as 'an ornament to the city'.
70. Rahula Sankrityayana's Hindi trans., Benares, 1936, pp. 73-88.
71. By the same translator, Benares, 1964, pp. 321-5.
72. 47.20.23.
73. *Sacred Books of the East*, vol. XVII, pp. 106-7, 171-2.
74. *Dhammapada* commentary, Pali Text Society (London, 1906-14), pp. 308-9.
75. *Vinaya Piṭaka Sacred Books of the East*, vol. XX, pp. 360-1.
76. Cf. *Samayamātṛkā*, VIII.102, 103, 112, *Kuṭṭanīmata*, 532, *Śārṅgadhārāpaddhati*, 4052.
77. *Samayamātṛkā*, II.28-80.

78. III.33.
79. *Kāmasūtra*, VII.23, 24.
80. *Yājñavalkya Smṛti*, II.290, *Narada*, 78, 79.
81. *Kāmasūtra*, I.62-5.
82. II.290.
83. Esp. in Aśvaghoṣa and Sudraka's dramas.
84. All this and much more are taught in the *Kuṭṭanīmata* of Dāmodaragupta and also in the *Deśopadeśa*, IV.12, 19, 30, 36.
85. *Samayamatṛka*, I.40, 45. *Kamasutra*, VII.I.13-17; See also *Dasarupaka*, II.34.
86. I.4.48.
87. II.293.
88. *Gautama Dharmasutra*, XXII.2.
89. IX.259-60.
90. *Kamasutra*, I.4.45.
91. *Dasarupaka*, II.8
92. Cf. *Viṣṇu Purana*, Ch. 70.
93. VI.1.4.
94. A woman in any case, like a child or a slave, was not allowed to own property. *Mahabharata*, I.82.22, II.71.I; V.33.64.
95. VI.2.3-23.
96. 103.4; also in *Atri Saṁhita* 267, *Samvarta S*, 161; *Parasara S.*, 10.15ff.
97. *Kamasutra*, I.3.20.
98. *Arthasastra*, II.27.
99. As a mark of gratitude for divine favours received or as a gift given in faith for favours expected from the temple deity.
100. Ch. VIII.
101. Like those at Nasik, Kuda, Mahada, Junagad, Sitabenga Ratnagiri.
102. *Arthaśāstra*, II.23.
103. The term may have a secondary reference to tarnishing the family's (*kula*) prestige. However, the etymology is not clear.
104. *Prakṛtikhaṇḍa*, Ch. XXVII.
105. Cf. *Ramayaṇa*, II.11, 22, 25, 26; IV; 20.13; 24.34, *Mahabharata*, III.186.7, VIII; 49.76-8, XII.98; 46, XIII.96.18, 19, 82.
106. Cf. *Kumarasambhava*, XVI.36, 48; *Raghuvaṁsa*, VII.50.
107. *Mahabharata*, III.8.27.
108. Ibid., IV.34.5.
109. Ibid., VIII.38.4 ff.
110. Ibid., XII.12.366.
111. Ibid., I.198.16.
112. Ibid., IV.72.16.
113. Ibid., I.221.49, 50.
114. Ibid., II.51.8, 9.52.11, 29.

115. Ibid., VII.65.6.
116. Ibid., VII.60.1, 2 XII.29.65.
117. Ibid., XV.II.4; 39.20; XVII.1.4; XVIII.6;12, 13.
118. Cf. Sagara's gifts to brāhmaṇas.
119. Op. cit., III.315.2, 6.233.4; IV.18-21; XII.68.33,171.5;173.16ff.
120. Op. cit., XIII.145.2.
121. The *prājāpatya* expiatory rite was seldom honoured by actual performance as is borne out by a vast amount of literature.

Woman and the Sacred in Ancient Tamilnadu

George L. Hart, III

We possess in ancient Tamil a large body of poetry which antedates for all intents and purpose the incursion of Sanskrit culture into Tamilnad. This poetry, found in the eight anthologies and the *Pattuppāṭṭu*, dates from the first and second centuries AD. The culture which produced it was a continuation of the megalithic culture which dominated the Deccan for the millennium before Christ. The special importance of early Tamil poetry for cultural history is that it describes this civilization, which according to the Allchins was characterized by a very conservative and unchanging culture,[1] before it was appreciably influenced by Sanskritic culture from the north.

A study of the sources in early Tamil reveals a dual focus of the sacred: the king and woman. The subsequent influence of both of these elements on Indian civilization was very great. This paper concentrates on one of them: woman. It should be remarked here that this dual focus is mirrored in the poems themselves, which are divided into two great branches, *Puṟam*, comprising those poems which deal with life outside the family (and usually with the king) and *Akam*, comprising those poems dealing with life inside the family (and specifically the love between man and woman).

It should also be remarked that the nature of divinity for the early Tamils was primarily malevolent. Spiritual powers were thought to be immanent, lurking within anything imbued with a special sacred importance, and they were thought to be potentially destructive. They had to be propitiated lest they cause harm, but they were never invoked for good, as were the Vedic gods. With this brief introduction, we may turn to the role of woman in early Tamil.

Women in ancient Tamilnadu were strongly tabooed when they were menstruous or when they had recently given birth. *Puṟ.* 299 describes how an enemy's horses 'stand terrified like girls who cannot touch dishes [when they are] in the temple of Murugan'.

Here, the poem refers to the time when they are menstruous. In *Ak*.7, the foster mother describes what she told her daughter when she came of age:

> I told her, 'Your breasts are budding, your sharp teeth shine, your head has a coil on it, and you wear a cool dress [*taḷai*, a dress of leaves worn by girls after puberty]. Do not go anywhere with your wandering girl friends—our ancient city Mutupati has [places] with attacking deities. You are protected [i.e. now that you have reached puberty, we must protect you], and should not go outside. You are no longer a little girl, wise, lovely child—at the time of puberty, you stayed outside [while you were menstruous]'. . . .

The time of ceremonial impurity after giving birth was called *puṉiṟu* and seems to have lasted for ten days, after which the woman bathed at night in the tank.[2] *Puṟ*. 68 compares the Kāviri river to a breast trickling with milk after *puṉiṟu*, showing that the milk was thought to be polluted before that time, while *Ak*. 139 speaks of 'white clouds impure in the days after they have given birth'. It is possible that animals were felt to be impure as well as human beings in the period after they gave birth, for *Ak*.56 says that to get out of the way of a cow which was in its *puṉiṟu* period, the hero's bard dropped his lute and unwittingly ran into the heroine's house. Though it is nowhere stated, it is probable that until *puṉiṟu* was over, the father was not allowed to see the mother of the child, a custom which is common among so-called primitive peoples. Crawley states:

> Separation between husband and wife at birth is often prolonged until the child is weaned, the idea being that milk, a female secretion, is a specially dangerous vehicle for transmission of her effeminate properties. Hence the infant, from contact with the mother, is also 'unclean', that is, 'dangerous' in the taboo sense, no less than it is in danger. . . . Among the northern [American] Indians, the mother is unclean for five weeks after birth and remains in a separate hut—no male may approach her, even the husband.[3]

He also describes the ceremony of the father's first seeing the infant. Among the Basutos, the father is separated from the mother and child for four days, and then the medicine man performs the ceremony at which they are first reintroduced.[4]

Such a ceremony is evidently described in *Puṟ*. 100:

> In his hand is a spear
> and on his feet are battle anklets.
> Sweat glistens on his body

and on his neck is a fresh wound.
Adorning his curly black hair
he wears a *vēṅkai*
together with a large *veṭci* flower
and with needly white leaves
from the top
of the fast-growing young palmyra
which causes foes to flee.[5]
His rage,
like that of an elephant
who dares to fight a tiger,
is still unspent;
none escaped
who angered him.
His eyes which saw foes
are still red
though they see his son.

Here, Turaicāmi Piḷḷai, the subcommentator for the Kaḻakam edition, suggests that at the ceremony when the father first saw his first son, he would appear in war dress so that his son would become a hero. Such a practice would also help to offset the effeminate qualities of the nursing mother. Unfortunately, Piḷḷai does not explain from where he got his information, and U.V. Swaminathaier, the subcommentator of the other chief edition, mentions nothing of such a practice. Nevertheless, it appears to me that this poem is probably a description of the ceremony of the first meeting of father and child after *puṇiṟu*, and that Piḷḷai is correct in his explanation of the father's war dress. There are several poems which describe the husband's avoiding the embrace of his wife while she is nursing their child. In *Ak*.26, the wife complains:

Can I be angry
at him
whose city
has lovely prosperous fields
where girls play
gathering as festival ornaments
dark flowers with white fish-bone stems
fallen from dense clusters

of round-thorned *mulli*?
Friend,
there were times
when at night
he would say in ecstasy,
'Pressing my chest hard,
do not stop embracing me
with your black nipples,'
as they resembled iron rings
on the tusks of an elephant
who attacks great doors.
And when I said,
'Enough,'
he would not listen.
In such manner
would he celebrate these breasts.
But now
when I wanted to embrace closely
his fine-coloured ornamented chest
fragrant with sandal
with these sweet breasts
covered with spots
and sore,
pendulous with milk
for our son,
he feared some sweet milk
might fall on him.
Seeing his hands hesitant,
holding me without closeness,
I looked at our son,
scarcely able to walk,
and said,
'You are fit for your women;
I, for our son,'
and I slowly went to the child.
He replied,
'I love him too,'
and bending over
embraced me from behind.
At that,

my heart melted for him
like much-plowed red earth
in the cool spray
of a heavy shower,
even though I knew well
that I was cheated.

Similarly, in *Aiñ.* 65, the heroine says to her husband, 'Do not embrace my body which has given birth to our son—your chest might be spoiled.'[6] Here, the hero is afraid that his chest might be spoiled by contact with the milk of his wife with its effeminate properties. There are many poems which describe how the hero begins to see his harlot (*parattai*) after his first son is born,[7] probably because his wife is impure—or at least dangerous to his manhood—and he is hesitant to make love to her.

It has been seen that both of the taboos mentioned in the poems concern women at unclean times of their lives. From this fact, it may be inferred that women were thought to possess a latent sacred power which at certain times became dangerous so that they had to be tabooed. If this inference is correct, it is to be expected that elsewhere the sacred power (called *aṇaṅku* in Tamil) of women will actually be mentioned, and such is in fact the case. The chief source of such power was a woman's chastity (*kaṟpu*), a virtue as important then as it is now in south India. *Puṟ.* 198 speaks of a woman's chastity 'which has a god [*kaṭavuḷ*],' while *Kuṟ.* 252 and *Ak.* 184 mention 'chastity [which has the nature of] a god'. In *Ak.*73, the friend describes the heroine as having 'chastity full of afflicting sacred power [*aṇaṅku uṟu kaṟpu*]' as she suffers while her husband is away, and in *Ak.*198, the hero exclaims, 'She was no fine woman with complete chastity, but a goddess [*cūṟmakaḷ*, *cūṟ* meaning demon and *makaḷ* meaning woman] who lives in the spring full of soft flowers.'

Chastity consisted in a sort of asceticism, restraining all impulses which were in any way immodest. Thus *Puṟ.* 196 describes the bard's wife as being 'a tender girl with a shining face and chastity which [knows] only modesty [*nāṇ alatu illāk kaṟpu*],' *Puṟ.* 249 speaks of 'chastity which is restrained [*aṭaṅkiya*]', and *Puṟ.* 361 says that the king's wives are 'women of chastity increased by patience, with sharp teeth which their tongues fear if they talk loudly'. *Puṟ.* 166 speaks of the wife of an orthodox brāhmaṇa as one who has 'chastity hard to get, which banishes all harshness [*maṟam*], with a small forehead,

large wide loins, few words, and much hair, who fits exactly her husband's state'. In *Ak.* 86, girls who have given birth to sons bless the bride saying, 'May you have desire which loves him whom you get, helping with many things, not slipping from chastity.' In *Kuṟ.* 252, the heroine's friend scolds her saying, '[When he returned from his harlot], you, without changing your sweet expression, served him, you with your divine chastity', to which the heroine replies, 'Good men are ashamed when praised to their face—how could they bear abuse?' Another element of chastity besides this restraint of speech and conduct is that the woman is often described as being attractive and fertile, with large loins and breasts.[8] Chastity is also attributed to woman as mother,[9] and the chaste woman's son is called the light of his clan.[10] Chastity was conceived of as an almost tangible quality in the woman who possessed it, producing domestic peace and light. Thus *Kuṟ.* 336 speaks of a woman's 'chastity which shines in her house'. The importance of chastity to a prospective husband may be inferred from Kapilar's insistence that he was a brāhmaṇa and a sage (*pulavan*, a poet, one with knowledge) when he took the daughters of his dead friend Pāri around to kings to marry them off, lest they think he had spoiled them.[11] It was thought degrading for a man to make love to an unchaste woman who did not love him, for in *Pur.* 73, the king exclaims:

> If he would come gently,
> prostrate himself before my good feet,
> and beg saying, 'Give!'
> then it would be a trifle
> to give him my kingdom
> and the right to it
> conferred by the drum.
> And even if it were my sweet life he desired,
> I would give it here and now,
> while still in this world.
> But that fool who mocks my purpose,
> not heeding the strength of the mighty,
> is like a blind man
> stumbling on a tiger
> asleep
> in the plain sight of all:
> he will never escape and return.

If I do not go,
fight him,
and make him suffer just where is
like a long pole
of strong thick bamboo
caught in the feet of a grazing elephant,
then may my garland wither
in the unresponsive embraces
of girls with thick black hair,
who have no love
in faultless hearts.

Several times a woman's chastity is evoked by the star Arundhatī. In *Ak.* 16, for example, the heroine describes how the harlot embraced her son on the street, and then says with irony, 'How could I not love her, lord, thinking her like the mother of your son, who resembles the goddess of chastity full of power in the sky?'[12]

Any woman who had come of age and was sexually appealing was thought to be filled with a sacred power to afflict men. This power was thought to reside in her breasts and to a lesser extent in her loins or any other part of of her body which made her especially attractive. Thus in *Kur.* 337 the hero exclaims, 'The buds of her breasts have blossomed, and from her head thick soft hair falls down. Her compact rows of white teeth are full, [having completely replaced] her baby teeth, and a few spots [on her body, a sign of puberty] have appeared. . . . I know her so she afflicts [*aṇanku*] me.' It has been seen that in *Ak.* 7, the girl who has reached puberty is forbidden to go in the city because it has 'attacking gods' [*tākku aṇanku*] for her.

The dangerous power of such a girl can be well seen in the series of poems on the destruction of the city by suitors whose request has been denied by the girl's relatives. Such poems are well exemplified by *Puṟ.* 345:

Groves are ruined
with elephants tied in them.
Streets are choked with dust
as chariots run.
Paths are frenzied
as horses gallop.
Watering places grow filthy

as weapons are washed.
Because so many fierce warriors stay here,
the earth bends beneath the load.
Hosts of strange kings have come
desiring the girl
with close, hot, black-tipped breasts
and a devastating glance
as they consider
how the secret way is guarded
whose two doors
resemble the iron valves of a bellows
sighing like a cow elephant.
They are to be pitied,
for her relatives
do not wish wealth
but war
and say,
'Never will we give her
to one unworthy!'
This good town
with its paddy fields
and fences of *paṉṉal*
has warriors
who grasp the handles of shields,
whose swords leave scars,
whose unwashed heads
are smeared
with lumps of flesh and blood
and who have long black-shafted spears,
and yet
I do not know
what will become of it.

Many poems on this theme describe especially the girl's breasts. In *Puṟ*. 336 for example, the poet describes the preparations for war and then exclaims, 'Surely the mother without principles is evil who created this enmity and happily brought up so they were beautiful those young breasts, not yet mature, as lovely as the buds of a flowering *koṅku*....' In *Puṟ*. 337, Kapilar asks, 'Even though they are so courageous, who will squeeze her fine young tusklike breasts,

spread over with many spots and marked with ornaments?[13]

The sacred nature of a woman's breasts is described also in other poems. In *Ak.* 161, the friend describes how the heroine weeps 'so coldness spreads on her finely rising young breasts, vexing because a god [*aṇaṅku*] is there', and *Ak.* 177 speaks of 'breasts with *aṇaṅku*'. In *Ak.* 220, the breasts of the heroine are said to be 'as hard for anyone to see as the well-guarded high post . . . of the sacrifice completed by him with an axe . . . at Cellūr.' In *Aiñ.* 363, the hero laments, 'You think there are spots on your breasts, but my afflicted [*aṇaṅku uṟu*] heart thinks it is a god [*aṇaṅku*].' If a woman's breasts can best be described to invoke her beauty, they can also be used to invoke her wretchedness. Thus when the poet wishes to show how poor he is as he pleads for money from a king, he often makes a point of describing the pitiable condition of his wife, mentioning that her breasts are ugly and empty, as in the following excerpt from *Puṟ.* 159:[14]

> My wife,
> her body faded,
> grieves anxiously.
> Her breasts are withered,
> eaten and squeezed
> by the many little children
> she has at her side.

In *Puṟ.* 278, a mother threatens to cut off her breasts, the seat of her sacred power as a woman, if her son is a coward:

> Many said,
> 'The son of the old woman
> on whose soft dry arms
> flesh hangs
> and veins are raised
> and whose stomach
> is like a full lotus leaf
> has failed in battle
> and fled.'
> At that,
> enraged,
> she said,

> 'If he has been routed
> in thick battle,
> I will cut off these breasts
> from which he drank,'
> and,
> sword in hand,
> she turned over fallen corpses,
> groping her way
> on the red field.
> Then she saw her fallen son lying,
> cut in pieces,
> and she rejoiced
> more than the day she bore him.

In *Puṟ*. 295, when a mother sees the valour of her dead son, her breasts give milk again, showing that her joy was so profound that the seat of her sacred power, long since impotent, is suddenly charged with power again.

Another theme which gives insight into the sacred nature of woman is the convention in which the wasteland is transformed by the presence, imagined or real, of the heroine into a paradise, or is at least made bearable, for this is a demonstration of the woman's power to bring her lover through the other world and the almost death he experiences there. Thus in *Kuṟ*. 274, the hero says:[15]

> In the desert
> a cruel man
> his readied arrow fitted to his bow,
> looks for wayfarers
> as he climbs a hill
> to shake down the thick, sapphire-dark fruits
> of an *ukāy* tree,
> its trunk soft
> as a dove's back,
> and he chews bark
> to assuage his thirst.
> Yet even this fearful desert is sweet
> if I go
> thinking of my girl,
> her loins decorated with jewels and gold,
> her breasts lovely.

It is curious that the object most dangerous and filled with sacred power is also the one most threatened by it. It has been seen how in *Ak.*7, the girl who has reached puberty is subject to 'attacking gods' in the city and how menstruous women stand terrified in the temple of Murugan in *Puṟ*. 299. Similarly, in *Aiñ*. 250 it is said that 'the one who afflicts her young breasts which bear ornaments is the lord of the forest . . . not the victorious Murugan'. This shows that sacred power was a phenomenon in which the roles of both parties were similar, each being potentially dangerous to the other. To be afflicted by the sacred power of another person, one must in some measure possess a special power or status himself, often a special relationship to the person who afflicts. It is for this reason that the husband and wife must be extremely careful in their mutual contacts, a subject which will be examined later.[16]

Widows were subject to many restraints. They did not wear ornaments, caked their bald heads with mud, and slept on beds of stone.[17] The widow was supposed to clear off a little place 'the size of an elephant's foot' or of 'a dusty winnowing pan', smear it with dung, put grass on it, and offer *piṇṭam* for her dead husband to eat.[18] According to Turaicāmi Piḷḷai, the widow would perform this rite on the spot where her husband actually died, putting down a leaf under the grass, and then eating the saltless *piṇṭam* herself, but unfortunately he gives no source for this information. It is not surprising, perhaps, that with such an empty life to look forward to, many widows committed suicide to join their husbands in death. In *Puṟ*. 246, a king's widow speaks of such suicide. Pillai suggests that she is addressing those who were dependent on her husband and who urged her not to burn herself so that she might be queen and continue to give them gifts, an idea which appears to be substantiated by her reference to their wicked schemes. It is likely also that those most devoted to the king would take their lives with his widow, and that she is mocking them for their lack of courage:

> Listen,
> all of you good men
> with your wicked schemes,
> who would hinder me
> with words of restraint
> and not urge me to go.
> Listen, you good men!

I am no woman
to suffer austerities,
eating for food
vēḷai leaves
boiled with tamarind
with white sesame paste
and a squeezed ball of rice
untouched by fragrant ghee
whose light color
resembles the seeds of a curved cucumber
with chipmunk lines
split with a sword,
and to sleep on a bed
covered with stones
without even a mat.
Go ahead—spurn the pyre of black wood
heaped on the burning ground.
To me,
since my great-armed husband is dead,
that fire
and a large pond of lotuses
which have loosed from buds rich petals
are the same.

It was not, however, merely dread at the thought of the austerities she would have to undergo or grief at the loss of her beloved which motivated a widow to commit suicide. Rather, she was thought to be full of a sacred power which rendered her dangerous to herself and everyone else. No matter what sort of woman she was, she would have to perform austerities to keep that power under control, but if she were a young, chaste, high-born woman, austerities might not be sufficient, as can be seen in *Puṟ.* 247:

In a place
full of ominous power
a herd of simple deer
slumbers in the light of a fire
kindled by forest men
from dry wood
brought by elephants

and is roused from sleep
by monkeys rooting about.
There,
a girl wanders toward the burning ground,
her hair
streaming with water
spread down her back.
Though she is alone for only a moment
in the vast guarded palace of her husband
where the eye of the drum never sleeps,
her sweet life trembles
fleeing headlong from her youth.

Here, the woman is going to burn herself after her husband has died. The image at the beginning of the poem shows clearly that there is danger to the simple deer sleeping in the light of the hunter's fire. Even today, it is bad luck in south India to see a girl's hair spread out and wet. The image in this poem of the girl with wet hair spread down her back evokes the sacred power which is strongly present in her.

The dangerous power of a chaste widow is exemplified by the story of Kaṇṇaki in the *Cilappatikāram*, who, after her husband has been executed unjustly, tears off her right breast and with it causes the city of Madurai to be consumed by fire. It hardly needs to be remarked that a woman's breasts were the seat of her sacred power, as has been seen. Finally, after she has wept and suffered for fourteen days, she is taken up into heaven to be with her husband, for, the author exclaims, 'Even the gods pay honour to the wife who worships no one but her husband.'

When a hero died, a memorial stone called a *naṭukal* was erected to him. He was believed to actually inhabit the stone, which had to be satisfied with sacrifices and offerings.

Chastity, which has been seen to have been a strong value in south India two thousand years ago, has retained its importance until today. In the Tamil version of the *Rāmāyaṇa* by Kampaṉ (ninth century AD?), Rāvaṇa is put under a curse which does not allow him even to touch Sītā, whereas in the Vālmīki version of the epic, he picks her up bodily and carries her away.

Even the vocabularies of the Sanskrit and Tamil show different conceptions of the role of chastity. The Sanskrit word for chastity is

pativratyam, 'the state of keeping one's vow to one's husband', a word which does not appear in any of its forms until the time of the epics, according to the Petersburg *Wörterbuch*.[19] In Tamil, chastity is *karpu*, from *kal*, 'to learn', a word which besides mere faithfulness signifies the restraint of all immodest impulses, and the sacred power acquired by a woman who has such qualities. Even more revealing is a comparison of the word for rape in the two cultures. In Tamil, the act is called *karpaḷittal*, 'the destroying of chastity', while in Sanskrit, Apte gives in his *English-Sanskrit Dictionary*[20] *balat sambhoga*, 'enjoying [a woman] by force', and *duṣaṇa*, 'spoiling'. This latter word appears like the Tamil word, and is in fact used in much the same way by south Indians today who speak Sanskrit, but in ancient times its signification was quite different, as is shown by its use in the *Mānavadharmasastra*, where a man is said to be 'spoiled' by intercourse with a woman other then his wife.[21]

Much insight is gained into the Tamil attitude towards chastity and marriage from Crawley's analysis of relations between primitive peoples in his study of marriage, *The Mystic Rose*. There, he shows that when primitive people wish to enter into alliance, so that there can be no war or strife between them, they bind themselves by a relation called *ngia ngiampe* by the Narrinyeri of South Australia.[22] To make such an alliance, there is a mutual exchange of some substance or thing which has sacramental value—the two parties may drink each other's blood, for example. After this, the two people become in a sense identical, and mutual intercourse between them must be severely restricted, lest they do harm to each other. Crawley points out that *ngia ngiampe* is a relation between individuals which is 'a breaking of the taboo on connection by making the connection'[23] and that the new connection entails new, very strong taboos. In ancient Tamil society, the central application of this concept was between man and woman. First, when a man became a woman's lover, he gave her a leaf dress called a *talai*, worn chiefly over the loins. He might also give her a flower from his hill or other sacred place, as is shown in *Kur.* 1, where the heroine refuses the gift of *kāntaḷ* flowers:

 Murugan
 the red one
 kills,
 crushing demons

and making the field red
as his anklets whirl,
his elephants red-tusked
his arrows red-shafted.
This is his hill
and it is thick
with blood bunches
of *kāntaḷ*.

A man might also make a doll for his beloved and paint her breasts with sandal.[24] If she were unresponsive, the poetic convention (which almost certainly did not correspond to any reality) called for him to take the extreme step of riding a 'horse' made of *maṭal*, the jagged stems of palmyra leaves, in the street in front of everyone. By doing this, he hoped to shame her into accepting him; but also, he hoped to establish the *ngia ngiampe* relationship with her by shedding his own blood in a perversion of the sexual act.[25] The act had to be public so that society would recognize the initiation of the relationship.

The act of falling in love itself can serve as the exchange which initiates the *ngia ngiampe* relationship. Thus Crawley states, 'All apparently abnormal or unusual states of emotion, such as sudden anger or ecstasy, or the surging of love, when close contact with another attends these states, as for instance, in the case of love ... if ... A is "infected" with B's enthusiasm or love, A is "inspired" with B, then B is transformed to him and so we come to the *kalduke* [the interchanged symbol which effects *ngia ngiampe*] again.'[26] A more binding relation is of course attained by the eventual marriage of the couple—but it should be remarked that in early Tamil, the act of falling in love was wholly binding on the woman, and she was committed to the man forever after, at least in theory. The reason for the resulting taboo after the *ngia ngiampe* relationship has been established is according to Crawley 'that A and B become identical by transmission of personality, and therefore A avoids all physical contact with B, because it is through physical contact ultimately that all personal injury is effected, and by such contact he might injure himself in B. . . . The breaking of the taboo of personal isolation has thus produced a fresh taboo of even greater force.'[27] It is, of course, impossible for a man and his wife to avoid all physical contact, but in most primitive or archaic societies there are many taboos between

them. In Tamilnadu, so far as can be made out, these taboos comprised not eating together,[28] the wife's not calling her husband by name (though this is not mentioned in the texts—see p. 249), and the husband's not being allowed to see his wife or child in the impure period after she had given birth. Because of the symbolic identification of the wife with her husband, when he was away, she was not supposed to wear ornaments in her hair[29] and had to undergo such ascetic practices as offering sacrifices, wearing a string on her wrist, and, according to U.V. Swaminathaier's commentary, fasting.[30] The identification was continued even after the death of the husband. That is the reason why a widow was supposed either to take her life or to live in extreme asceticism.

Of all the implications of the *ngia ngiampe* relation, the strongest for a married woman is chastity. Such an obligation is found in an extreme form all through the history of Tamilnadu. It should be noted that in ancient Tamil society, when tokens were exchanged, the man gave a dress but received nothing in return. He was free to be unfaithful to his beloved, as the poems demonstrate over and over when they describe his affair with the *parattai*, but the woman was entirely committed, and I do not know of one example in all of premodern Tamil literature of a wife who is unfaithful to her husband.

A poem illustrates many of the attitudes held by the ancient Tamils toward the relationship between man and woman. In *Ak*.158, the girlfriend of the heroine replies to the mother, who has seen her daughter meeting her lover:

> Do not frighten me by saying,
> 'At midnight
> when darkness lay thick,
> and the rain
> after pouring down
> from great clouds
> with thunder and lightning
> had stopped,
> its noise stilled,
> I saw her,
> her heavy earrings flashing
> like lightning on high,
> her thick curly hair

let loose,
walking very stealthily
like a peacock coming down from a mountain
as she climbed the platform in the field
and descended.'
Listen, mother:
on the haunted slope
where our garden is,
a spirit [*aṇaṅku*] comes
wearing bright flowers,
taking whatever form it wishes.
There, dreams delude those asleep,
seeming as if they were actually happening.
This girl
trembles even if she is alone
without a light;
and if the owl in the courtyard *marā* tree
hoots fearfully,
her heart seems to break
and she seeks refuge.
And father,
as strong and wrathful as Murugan
is at home
and has let his dogs
like a pack of tigers
run loose.
She is much too afraid
to have done what you say.

Here the poet compares the state of the heroine, who is in love, with things which are charged with the sacred in order to show how extremely sacred her state is. Thus she is like a peacock descending from a mountain. In early Tamil, mountains were thought to be inhabited by sacred forces. The peacock, moreover, associated with mountains, rains, and fertility (because of its connection with the rains), had come to be associated with Murugan, the god of fertility (later, of course, the peacock became the *vāhana* of the god). By comparing the heroine with the peacock coming from the abode of the sacred, the poet hints that the heroine is returning from

an extremely sacred state, which cannot be described. Everything associated with her evokes fertility, also strongly associated with the sacred for the early Tamil: she is on a wet field; her hair is like a cloud (by implication); her earrings are like lightning. Finally, the poet ends the poem with an even stronger evocation of the sacred quality of the heroine's experience: so wonderful are her feelings that what is ordinarily sacred and filled with ominous power fails to frighten her or to have any effect on her. She is not afraid of the owl hooting in the *marā* tree in the courtyard, then, as now, the abode of demonic forces. Then, in a masterly stroke, the poet equates the ordinary forces of the sacred with the girl's family, and specifically with her father, who is likened to Murugan, a god who 'wipes out all who do not bow to him.'[31] By taking a lover, the girl is breaking a strong taboo and unleashing powerful forces, as well as risking the wrath of her father. By entering into the *ngia ngiampe* relationship, she is breaking a taboo. But the state of the new relationship is so wonderful that the old taboos are neutralized. A whole new realm of the sacred, which transcends those things normally considered sacred, is called into play through the initiation of the *ngia ngiampe* relation. The poem makes the point that love between man and woman is the most sacred locus there is. And it shows, further, that it is especially in the woman that the sacred effects of the relationship are most manifest. Thus it is not surprising that through her whole life the Tamil woman was and is enjoined to undertake austerities lest the sacred in her go out of control.

It remains to contrast the Tamil attitude toward woman to its northern equivalent, and to trace the development of the northern attitude. That the chastity of a woman was considered far less important in Vedic times than it was later is proved by the ceremony of *varuṇapraghāsa*, which is described in the *Śatapatha Brāhmaṇa*.[32] This ceremony is described by Keith as follows:

On the first day of the offering, barley is roasted on the *dakṣiṇa* fire, the one used for all ritual acts of an uncanny description: then a number of dishes of a porridge made from the barley are prepared, one for each member of the family with one over, apparently for the members yet unborn. The wife of the sacrificer is then asked by the priest what lovers she has; she must name them, or at least indicate the number by holding up as many stalks of grass as she has lovers, and by this action she purifies herself from her sins in this regard: otherwise, if she does not tell the truth, it will go badly for her connexions. She is then taken to the southern fire, in which she offers the

plates with the words, 'Whatever sin we have committed in the village, in the forest, among men and in ourselves, that by sacrifice we remove here', and further on an offering is made to Varuṇa, who is asked to spare the lives of his suppliants and not be wroth.[33]

In another passage from the Śatapatha Brāhmaṇa, Sukanyā, when married to the old and decrepit sage Cyavana, says, 'I shall not forsake my husband while he is alive, to whom my father gave me',[34] showing that chastity did not demand of her the extreme faithfulness found in Tamil and later Sanskrit, where the wife was expected to be faithful even as a widow.

A view of chastity more like the Tamil one is found in the Mahābhārata. In the Vanaparva, when Damayantī curses by her faithfulness to her husband a young hunter with evil designs on her, he falls down dead.[35] Similarly, in the Śalyaparva, the power of a chaste woman (pativratā) is described: she can, if she chooses, burn the world or stop the motions of the sun and moon.[36] Many similar descriptions appear elsewhere in the Mahābhārata and in the Purāṇas.[37] In the Mahābhārata, however, there are also passages which show an attitude towards chastity more similar to that which obtained in Vedic times than that of the Tamil poems. In the Āraṇyakaparva, for example, when Damayantī does not hear from Nala for a long time, she prepares to hold another svayaṃvara.[38]

There existed without question the practice among the Āryans of Vedic times of allowing a childless woman to conceive by her husband's brother and even, if she was a widow, to marry him.[39] Such practice was called niyoga. The Āpastambadharmasūtra, assigned by Kane to the period of 600-300 BC,[40] states, 'One shall not make over [his wife] to strangers [for a son by niyoga], but only to one who is sagotra. . . .'[41] Similar rules for niyoga are mentioned in the Mānavadharmaśāstra, and the practice is also mentioned in the Mahābhārata.[42] In both the Āpastambadharmasūtra and the Mānavadharmaśāstra, the practice of niyoga, after having been described in the passages mentioned above is condemned.[43] Later writers on Dharmaśāstra invariably forbade niyoga and had recourse to rather desperate ways of explaining away what their predecessors had said[44]. It is clear that in the time of the Vedas, the practice of niyoga and probably even widow remarriage were common and accepted by all. By the time of the early writers on Dharmaśāstra and of the Mahābhārata, the old customs had stiffer and stiffer competition

from the newer norm of perfect chastity among widows. Thus there are found 'bewildering and often conflicting rules about *niyoga* in the Smṛtis'.[45] Finally, a little after the time of Christ, the new customs won out entirely and the practice of *niyoga* was considered debased. It is in this period that the passages were written which are so common in the two epics and the Purāṇas describing the sacred power of a chaste woman.

A similar evolution is found in the development of other practices among widows. There is, unfortunately, no direct evidence from Vedic times, but the practice of *niyoga* and of widow remarriage indicates that the widow was not subject to the excessive ritual restrictions of later times. Manu speaks of the ascetic practices which may be performed by a widow:

A woman, when her husband is dead, may, if she chooses, emaciate her body by subsisting on flowers, roots, and fruits, but she should not even take the name of a stranger male. Till her death, she should be forbearing, observe vows, and be celibate. . . .[46]

By the time of the *Skanda Purāṇa*, the author could write, 'The widow is more inauspicious than all inauspicious things. . . .'[47] In another passage, which Kane shows is probably an interpolation, that same Purāṇa declares:

The tying up into a braid of the hair by the widow leads to the bondage of the husband; therefore, a widow should always shave her head. She should always take one meal a day and never a second. . . . A widow . . . should every day perform *tarpaṇa* with sesame, water, and *kuśa* grass for her husband, his father, and grand-father, after repeating their names and *gotra*. . . .[48]

This passage is extraordinary; it gives virtually every vow expected in the Tamil poems of at least six centuries earlier: tonsure, eating small amounts, not sleeping on a cot, and offering *piṇṭam* to the dead husband.[49] The vows of tonsure and of offering *tarpaṇa* do not appear earlier among the exhaustive references collected by Kane. It is this passage on which the medieval writers relied in order to prescribe the continual tonsure of widows.[50] Kane demonstrates conclusively that the practice of tonsure of widows in Āryan India was late, arising only sometime before the fourteenth century.[51]

Another practice whose beginning in Āryan India may be traced is the taboo on a wife's mentioning her husband's name. Such practice was permitted when the *Rāmāyaṇa* was written, for over and

over Sītā utters the name of Rāma. In one chapter she utters it six times as she talks to Hanumān,[52] while when she is abducted by Rāvaṇa, she calls her husband by name again and again.[53] By the time of Kālidāsa, however, the taboo was observed, for Śakuntalā and her friends refer to Duḥṣyanta as *rājarṣi*, never uttering his name, and when Śakuntalā wishes to address him directly, she says, '*paurava*'.[54] Unfortunately, because the *Akam* poems are anonymous, it is not possible to determine whether this taboo was present in early Tamil. Certainly it is very much present in Tamilnadu today, and, in light of other related elements found in ancient Tamil, it seems quite likely that this taboo was also observed by the Tamils eighteen centuries ago.

The final Āryan practice to be considered here is that of widow burning, or *satī*. Kane states, 'It appears probable that the practice arose in brahmanical India a few centuries before Christ.'[55] It is first mentioned by Strabo, who says that the Greeks under Alexander found *satī* practised among the Cathaeoi in the Punjab.[56] It is mentioned several times in the *Mahābhārata*: Mādrī, the favourite wife of Pāṇḍu, burned herself with her husband,[57] Saurandhrī is ordered to be burned with Kīcaka,[58] and the *Mausalaparva* mentions that some wives of Vasudeva and Kṛṣṇa burned themselves when they were widowed. On the other hand, in the *Strīparva*, no mention is made of widows' burning themselves as the cremations of the Kauravas are described in detail.[59] Winternitz considers that the portions of the *Mahābhārata* which describe *satī* are insertions of later date than the main body of that epic. He points out that *satī* is nowhere mentioned in the *Rāmāyaṇa*.[60] Several texts are cited by Aparārka which apparently forbid self-immolation to brāhmaṇa widows.[61] The earliest epigraphical record of *satī* is AD 510 in the Gupta inscriptions.[62]

From the foregoing evidence, it appears virtually certain that the practice of attributing extreme sacred power to a woman and her chastity, as it is found in early Tamil and in Sanskrit beginning with the epics, was one which originated with the indigenous peoples of India, and probably with the megalithic Deccan-Dravidian civilization, which flourished in the first millennium BC. It is in Dravidian India that it is still strongest and only in Tamil literature that it is consistently and without exception observed. It is, moreover, only in early Tamil literature that the real reason for *satī* and widow asceticism is stated:

that the widow is full of sacred forces which might endanger herself and others unless they are suppressed. Beginning in about the third century BC these practices begin to make their way into Āryan India: instances of *satī*, still uncommon, are found in the *Mahābhārata*, and a woman's chastity begins then to take on the special magical quality which has always distinguished it in Tamil literature. That an influx of Dravidian elements into Āryan culture was occurring during this period is indicated clearly by the fact that great numbers of Dravidian words, probably from now dead central-Dravidian languages, began to find their way into Sanskrit and Indo-Āryan during the period of the epics.[63] It can also be shown that many poetic techniques and conventions employed in the epics come from the oral literature of the Deccan culture. As contact with the Dravidians of south India increased, more and more non-Āryan elements entered north India. Kālidāsa, the greatest Sanskrit poet, relied to an extraordinary extent on conventions and techniques which come from south India and which are found in Tamil before they appear in Sanskrit. Several popular Prakrit metres, which appear in the first centuries after Christ and are adopted into Sanskrit, can be shown to be Dravidian.[64]

As time went on, even more Dravidian elements entered Āryan India. The practice of widow tonsure, for example, did not penetrate into the north until at least six hundred years after it is attested in Tamil, and other elements of widow asceticism accompanied it. It is interesting to note that it is chiefly the brāhmaṇas who practise the tonsure of widows today in Tamilnadu, even though they are more of Āryan origin than the other Tamils. This shows how indigenous customs spread into Indo-Āryan culture: before a group was assimilated, brāhmaṇas would come into it and adopt those values most admired by that group in order to gain respect. Thus the custom would have gained a foothold in the brahmanical religion and would be perpetuated when descendants of the brāhmaṇas wrote law books or copied texts with the appropriate insertions. Today, an ideal of chastity not too different from the early Tamil one pervades virtually all of India. It is, in fact, one of the strongest universal factors of the civilization of modern India, being perceptibly stronger today than in medieval India, where Tantrism was practised. This trait of Hinduism, virtually universal today, spread from indigenous groups, chiefly from the Deccan culture of the Dravidians, and was embraced ever more and more by Āryan society.

NOTES

1. B. Allchin and R. Allchin, *The Birth of Indian Civilization: India and Pakistan before 900 BC* (Baltimore, Md., 1968), p. 232.
2. U.V. Swaminathaier (ed.), *Maṇimēkalai*, Madras, Madras Kapīr Accukkūṭam, 1965, 7.75-6.
3. E. Crawley, *The Mystic Rose*, 2 vols., New York, 1927, vol. 2, p. 198.
4. Ibid., vol. 2, p. 199.
5. The tree causes foes to flee probably because it is a *kāval maram*, that is, a tutelary tree, a tree which is singled out to symbolize the king's connection with the world of the sacred, and which is guarded at all costs from being cut down by enemies.
6. See also *Aiñ.*, 494.
7. For example, *Ak.*, 16, 26, 66, 176.
8. *Puṟ.*, 166, 361.
9. *Puṟ.*, 198; *Ak.*, 16, 184.
10. The word for clan here is *kuṭi. Ak.*, 184.
11. *Puṟ.*, 201.
12. See also *Puṟ.*, 122; *Aiñ.*, 422.
13. See also *Puṟ.*, 341, 350, 352.
14. See also *Puṟ.*, 160, 164, 211, 276.
15. See also *Ak.*, 83; *Aiñ.*, 203, 303, 322, 327, 328, 360.
16. For details see p. 244.
17. *Puṟ.*, 224, 246, 253, 261, 280.
18. *Puṟ.*, 234, 249.
19. Böhtlingk and R. Roth, *Sanskrit-Wörterbuch*, 7 vols., St. Petersburg, 1855-75, vol. 4, p. 412.
20. V.S. Apte, *The Student's English-Sanskrit Dictionary*, Delhi, 1964, p. 377.
21. *Manusmṛti* (Bombay: Nirṇayasāgara edn.), II.61, 2.213.
22. Crawley, op. cit., vol. I, p. 287.
23. Ibid., vol. I, p. 286.
24. *Puṟ.*, 276.
25. *Kuṟ.*, 14, 17, 32, 173, 182, 298.
26. Crawley, op. cit., vol. I, pp. 308-9.
27. Ibid., vol. I, pp. 300-1.
28. *Puṟ.*, 120; *Kuṟ.*, 167.
29. *Kuṟ.*, 192.
30. *Kuṟ.*, 218.
31. *Ak.*, 22.
32. *Śatapatha Brāhmaṇa* (Weber, ed.), London, II.5.2.20.
33. A.B. Keith, *The Religion and Philosophy of the Vedas and Upanishads*, Oxford, 1961, p. 265.
34. *Śatapatha Brāhmaṇa*, op. cit., 4.5.9.
35. *Mahābhārata*, op. cit., 3.61.37-8.

36. Ibid., 9.62.
37. P.V. Kane, *The History of Dharmaśāstra*, 5 vols., Poona, 1930-62, vol. 2, pp. 563ff.
38. *Mahābhārata*, op. cit., 3.68.
39. *Atharvaveda* (V.V.R.I. edn.), 2.615; *Ṛgveda* (Poona edn.), X.40.2.
40. Kane, op. cit., vol. 1, p. 135.
41. *Āpastambadharmasūtra*, Bombay Sanskrit Series, edited by Bühler, II.10.27.5-7.
42. *Manusmṛti*, op. cit., 10.59-61; *Mahābhārata*, op. cit., 1.111, 114.
43. *Āpastambadharmasūtra*, op. cit., II.10.27.5-7: *Manusmṛti*, op. cit., 9.64-8.
44. Kane, op. cit., vol. 2, p. 604.
45. Ibid., vol. 2, p. 604.
46. *Manusmṛti*, op. cit., 5.157-60.
47. *Skanda Purāṇa* (Veṅkaṭeśvara Press edn. Bombay), III, *Brahmāraṇya* section, Chapter 7, verses 50-1.
48. Kane, op. cit., vol. 2, p. 586; *Skanda Purāṇa*, op. cit., *Kāśīkhaṇḍa*, Chapter 4.
49. See p. 239.
50. Kane, op. cit., vol. 2, p. 586.
51. Ibid., vol. 2, pp. 587ff.
52. *Vālmīki-Rāmāyaṇa Critically Edited for the first time* by G.H. Bhatt, etc. (Baroda, 1960), 5.31.12, 13, 15, 16, 17, 21.
53. Ibid., 3.47.
54. *Abhijñānaśākuntalam* (Nirṇayasāgara edn., Bombay), Act 3.
55. Kane, op. cit., vol. 2, p. 625.
56. Strabo, XV.1.30 and 62.
57. *Mahābhārata*, op. cit., 1.90.75; 1.116.29.
58. Ibid., 4.22.8.
59. Ibid., 16.8.18.
60. M. Winternitz, *A History of Indian Literature*, trans. S. Ketkar, Calcutta, 1962-3, vol. 1, p. 444.
61. Kane, op. cit., vol. 2, p. 627; Aparārka on the *Yājñavalkyasmṛti*, Ānandāśrama Sanskrit Series edn., Poona, p. 112.
62. Fleet, *Gupta Inscriptions*, p. 91.
63. T. Burrow, *The Sanskrit Language*, London, 1955, pp. 380-8.
64. G.L. Hart, *Related Cultural and Literary Elements in Ancient Tamil and Indo-Aryan* (A thesis submitted to Harvard University, Cambridge, Mass, 1969). In the second part of this dissertation, I have listed many of the literary conventions and techniques used by Kālidāsa found before in the Tamil anthologies, but not in any Indo-Āryan works which I surveyed. Classical Sanskrit metres which can be shown to be of Dravidian origin include *āryā* and the other *dvipadī* metres based on *mātrās*, and all of the *catuṣpadī* metres based on *mātrās*.

SOURCES

Versions whose texts have been followed are marked with an asterisk.

Aiṅkuṟunūṟu. Commentator: P.V. Cōmacuntaraṇār. Madras, Kazhagam, 1966.

Aiṅkuṟunūṟu. Commentator: Auvai C. Turaicāmipiḷḷai. 3 vols. Annamalai University, 1957-8.

**Aiṅkuṟunūṟu Mūlamum Paḷaiyavuraiyum* [with an old commentary]. Annotator: U.V. Swaminathaier. Fifth edition. Madras, Kapīr Accukkūṭam, 1957.

Akanāṉūṟu. Commentator: N.M. Veñkaṭacāmi Nāṭṭār. Madras, Kazhagam, 1965.

Kuṟuntokai. Commentator: P.V. Cōmacuntaraṇār. Madras, Kazhagam, 1965.

**Kuṟuntokai.* Commentator: U.V. Swaminathaier. Fourth edition. Madras, Kapīr Accukkūṭam, 1957.

**Puṟanāṉūṟu* [with commentary]. Annotator: U.V. Swaminathaier. Sixth edition. Madras, Kapīr Accukkūṭam, 1963.

Puṟanāṉūṟu. Commentator: Auvai C. Turaicāmipiḷḷai. 2 vols. Madras, Kazhagam, 1962, 1964.

SECTION IV

Religious Beliefs and Practices

Urvaśī and Purūravas

D.D. Kosambi

One of Kālidāsa's finest plays, *Vikramorvaśīyam*, has for its theme the love, separations, and final reunion of King Purūravas of the lunar race and the nymph Urvaśī. The *apsaras*, on her way to heaven, is abducted by the demon Keśī, from whose clutches the mortal king rescues her. This led to their falling in love. She finds the divine city of Amarāvatī no longer attractive, and proves her lover's reciprocal sentiment by a masked visit to his park. From the joy of this discovery, she is recalled to heaven, to act the part of Lakṣmī in a play staged before Indra. But the divine stage-director Bharata sentences her to assume human form for mispronouncing Viṣṇu's name Puruṣottama as Purūravas. The curse is no great burden, as it enables her to mate with Purūravas, but the course of their true love is interrupted again and again. The heroine is turned into a vine, because of an unwitting transgression: she stepped into a grove sacred to the six-headed god Skanda-Kārttikeya, where no woman was allowed to tread without suffering metamorphosis because of the taboo. But she is changed back and restored to her husband by a charmed jewel. The jewel is stolen by a bird of prey; the bird is found shot dead by an arrow bearing a legend which tells the king that Urvaśī has borne him a son. This means another reunion, which would be terminated by Urvaśī's restoration to heaven; but Indra, having a war on his hands, allows her to remain on earth till her husband's death.

This crude analysis of a beautiful play by one of the world's great poets and India's great dramatist does no justice to the consummate skill with which the theme is handled and embellished. What interests me here is the theme itself. It can be traced right back to our oldest extant records, namely the *Śatapatha Brāhmaṇa* and the *Ṛgveda*. The oldest report still contains some features of the play, for it is a dialogue between the two principal characters, totally foreign in appearance to anything else in the *Ṛgveda*. The action takes place at a crucial moment when the hero pleads with the heroine and she refuses his request. Thus the happy ending is a much later invention.

As we shall see, there is a greater change than this in the structure of the story. This change reflects precisely the difference between Vedic society and the Gupta period, being in fact a transition from ritual to drama.

KĀLIDĀSA'S TREATMENT

The theme attracted Kālidāsa sufficiently to be treated more than once, being for him simply the reunion of lovers separated by circumstances or by disfavour with the gods. On the purely human level, we have his play the *Mālavikāgnimitram*, which contains some of the most brilliant passages composed by the poet. There, however, the heroine is a princess forced to serve as a handmaid. On the other hand, the *Śākuntala* finds the hero unwilling to recognize either his wife or their son after a period of separation, some petty miracles being needed to bring him back to his senses. However, the lovers are always royal; the entire level is that of the court, but for an occasional scene in the forest or a hermitage. The king is always noble in character with his full complement of courtiers. In each of the three plays, there is at least one other queen between the two lovers, a variety of the eternal triangle that caused no difficulty in polygamous society, for the extra queen could yield gracefully while still remaining a queen. The characters are certainly oriented towards the contemporary reigning family, presumably the Guptas, as is seen from the language, and the title Vikrama. Also, by the fact that Purūravas is the founder of the lunar line of kings while the son of Śakuntalā is Bharata (the eponymous ancestor of the greatest Ṛgvedic tribe) who is again enrolled into the Soma line of descent. The women and servants speak Prakrit, a practice which reflects a situation prevalent to this day in many parts of the country where formal school education has not yet made its way or is still confined to the males of a small upper class.

MODERN INTERPRETATIONS

Before trying our own analysis, let us consider what has been done by scholars of repute. Keith[1] admits that the explanation does not suffice for the earliest stage: the Ṛgvedic hymn is 'of considerable interest and obscurity'. He finds the sun-dawn myth of Weber and Max Müller 'quite unnecessary'. The whole story has no deep significance, according to him:

The hymn clearly refers to one of those alliances of nymphs and men, which are common in all literature as in the stories of Thetis and of the German swan maidens, who often for as long as seven years are allowed to stay with mortal men... the taboo of seeing the hero naked is of interest and primitive in nature.... Purūravas is simply a hero, not necessarily ever a real man, but conceived as one: later tradition derives the lunar race of kings from him.

The trouble with this is that it explains nothing. If the legend is common, and primitive, it has to have some fairly deep significance, particularly in view of its later survival and repetition in different ways.

Max Müller[2] had a very simple formula for these primitive myths, which he succeeded in translating into purely almanac language: Thus 'Urvaśī loves Purūravas' meant 'the sun rises'; 'Urvaśī sees Purūravas naked' meant 'the dawn is gone'; 'Urvaśī finds Purūravas again' meant 'the sun is setting'. Against this sort of fatuous equivalence, as in the *Nirukta* and Kumārila, there is no argument. Müller, however, gives an abstract of Kālidāsa's play, yet only explains the *Śatapatha* legend; for there is no mention in Kālidāsa of the taboo against Urvaśī seeing her lover naked. Just why the simple sun-dawn myth had to undergo all these changes doesn't transpire from a reading of Müller's critique.

This is not to deny either Müller's substantial contributions to Indic philology or the legend's similarity to a sun-myth.

Geldner, whose account represents the heaviest labour of mature German scholarship,[3] saw nothing essential in the earliest version that did not survive in its developments. To him, the whole episode was just one more of many such Itihāsa Purāṇas. The same attitude led Geldner to see a far greater continuity between the Veda and later Sanskrit literature, just as Sāyaṇa did, than the facts (as now exemplified by archaeology) justify. For our purpose, Geldner's main service was a painstaking report on the principal versions of the story; to these we may proceed forthwith, with the remark that Geldner's essay well repays close study in spite of its insufficient explanation of the original legend.

VERSIONS OF THE STORY

Geldner reported upon eight different sources, in his order: (1) the *Śatapatha Brāhmaṇa*, 11.5 1ff. (2) The *Kāṭhakam*, 8. 10. (3) Ṣaḍguru-śiṣya's commentary to the *Sarvānukramaṇī*. (4) *Harivaṃśa* (noting virtual identity with the *Vāyu Purāṇa*, 29). (5) *Viṣṇu Purāṇa*, 4.6.19ff.

(6) the *Bṛhaddevatā*. (7) *Kathāsaritsāgara*, 17.4 (tr. by Tawney-Penzer vol. II, pp. 34-6; and note II. 245, 5). (8) the *Mahābhārata* (Crit. edn. 1.70. 16-22).

Geldner noted that accounts 1, 4, 5 follow much the same lines, 2 is a dry excerpt; 3 adds the story of Ilā, a son of Manu metamorphosed into a woman by stepping into a grove sacred to the mother-goddess Pārvatī, and in that state bearing Purūravas as a son to Budha; 3 also gives a motif to the curse upon Urvaśī by adding the legend of Vasiṣṭha's birth from the combined semen of Mitra and Varuṇa poured into a *kumbha*.

The most important admission made by Geldner is that there are essentially two versions of the latter half of the legend, of which the older was tragic. The lovers never were united, at least in this world. Of course, this can be seen by any translation of the Ṛgvedic hymn, but it is essential to know that it survived in Indian tradition though Kālidāsa could not accept it for his romance. What the German scholar failed to inquire was what was supposed to have happened, in the original version, to the pair after they parted. On this point, the *Ṛgveda* gives no direct information while the *Śatapatha Brāhmaṇa* ends by saying that Purūravas himself became a *gandharva* after performing the correct sacrifice; the *gandharvas* are the superhuman beings assigned as natural consorts to the *apsaras*, but some doubt is added as to exactly what happened by the further statement that anyone who sacrifices in the manner of Purūravas becomes himself a *gandharva*. However, Geldner should have followed the *Mahābhārata* version further in the Purāṇas. The relationship is rather confused, in the absence of any extensive analysis; but specimen legends have shown that the *Mahābhārata* in its critically edited form contains the source of many important Purāṇic stories, though both may be derived from some older common source. The epic says briefly (*Mbh.*, 1.70. 16-22) that:

the learned Purūravas was born of Ilā, WHO WAS BOTH HIS FATHER AND HIS MOTHER, or so have we heard. Ruling over (*aśnan*) thirteen islands of the sea, the victorious one was always surrounded by superhuman powers, though himself human. Intoxicated by (his own) prowess, he crossed the brāhmaṇas, tore their treasures from the brāhmaṇas in spite of their outcries. O king, Sanatkumāra, having come from the Brahmā-world, gave him advice which he did not take. Then cursed by the angered sages he was at once destroyed, he, the king, who had been overcome by greed and lost his reason by force of pride. The same hero brought from the *gandharva*-world, along with

Urvaśī, the fires arranged into three for sacrificial purposes. Six sons were begotten of Aila (Purūravas): Āyu, Dhīmān, Amāvasu, Dṛḍhāyu, Vanāyu, and Śrutāyu, the sons of Urvaśī.

Of these six sons, only Āyu is known at the earliest stage; seeing that the last three have *āyu* as termination of a compound name, it may be admitted that an Āyu tribe derived their descent, from Urvaśī and Purūravas. At least two of the Purāṇas allow this story to be traced, the direct influence being proved by the fact that there the Nahuṣa story follows immediately after, as in the above *Mahābhārata* section. The moral of both epic and Purāṇic narrative is that it is dangerous for any king to rob brāhmaṇas, to tax them, or press them into forced labour. The *Arthaśāstra* 1.6, on the other hand, says that Aila (Purūravas) came to a sad end by squeezing (taxes, mercilessly out of) all four caste-classes. The Purāṇic specialization to brāhmaṇas is a late modification. But the *Vāyu Purāṇa* 1.2.13-21, which is copied with only trifling variants by *Brahmāṇḍa* 1.2.14-23, gives the exact manner in which Purūravas came to die. His greed for treasure was never satisfied. Once, while hunting, he stumbled upon a golden altar made by Viśvakarman at which the seers of the Naimiṣa forest were sacrificing and tried to loot that. The angry sacrificers struck him with the sacrificial grass which had become as Indra's *vajra*; so crushed, the king yielded up the ghost.

Clearly, *Purūravas was killed at a sacrifice*, according to this Brāhmaṇa tradition; that his extortionate greed was the cause is merely a warning to later kings. I submit that the cause may have been invented, but the killing cannot have been wholly divorced from current inherited legend. At this stage, let us repeat the *Śatapatha Brāhmaṇa* (XI. 5.1) version, in Eggeling's translation:

The nymph Urvaśī loved Purūravas, the son of Iḍā. When she wedded with him, she said, 'Thrice a day shalt thou embrace me; but do not lie with me against my will, and let me not see thee naked, for such is the way to behave to us women'. (2) She then dwelt with him a long time, and was even with child of him, so long did she dwell with him. Then the *gandharvas* said to one another, 'For a long time, indeed has this Urvaśī dwelt among men: devise ye some means how she may come back to us.' Now, a ewe with two lambs was tied to her couch: the *gandharvas* then carried off one of the lambs. (3) 'Alas', she cried, 'they are taking away my darling, as if I were where there is no hero and no man!' They carried off the second and she spoke in the selfsame manner. (4) He then thought within himself, 'How can that be (a place) without a hero and without a man where I am? And naked, as he

was, he sprang up after them: too long he deemed it that he should put on his garment. Then the *gandharvas* produced a flash of lightning, and she beheld him naked even as by daylight. Then, indeed, she vanished: 'Here am I back', he said, and lo! she had vanished. Wailing with sorrow, he wandered all over Kurukṣetra. Now there is a lotus lake there called Anyataḥplakṣā: He walked along its bank; and there nymphs were swimming about in the shape of swans. (5) And she (Urvaśī) recognising him, said, 'This is the man with whom I have dwelt.' They then said, 'Let us appear to him.'—'So be it!' she replied; and they appeared to him. (6) He then recognised her and implored her (*RV.* X.95.1) 'Oh my wife, stay though, cruel in mind: let us now exchange words! Untold, these secrets of ours will not bring us joy in days to come';—'Stop, pray, let us speak together!' this is what he meant to say to her. (7) She replied (X. 95.2). 'What concern have I with speaking to thee? I have passed away like the first of the dawns. Purūravas, go home again: I am like the wind, difficult to catch';—'Thou didst not do what I told thee; hard to catch am I for thee, go to thy home again!' this is what she meant to say. (8) He then said sorrowing (X. 95.14), 'Then will thy friend rush away this day never to come back, to go to the farthest distance: then will he lie in Nirṛti's lap, or the fierce wolves will devour him'; 'Thy friend will either hang himself, or start forth; or the wolves, or dogs will devour him'! this is what he meant to say. (9) She replied (X. 95.15), 'Purūravas, do not die! do not rush away! let not the cruel wolves devour thee! Truly, there is no friendship with women, and theirs are the hearts of hyenas;'—'Do not take this to heart! there is no friendship with women: return home!' this is what she meant to say. (10) (*RV.*, X. 95.16) 'When changed in form, I walked among mortals, and passed the nights there during four autumns. I ate a little ghee, once a day, and even now I feel satisfied therewith.'—This discourse in fifteen verses had been handed down by the Bahvṛcas. Then her heart took pity on him.

Thus the *Śatapatha Brāhmaṇa* account is a commentary on the Ṛgvedic hymn, though not explaining its most obscure features. The Brāhmaṇa then goes on (by itself) to say how Urvaśī gave him a night of her company, and gave him his son. The *gandharvas* granted him a boon, which he chose as being one of themselves. Thereto, he received directions for the proper sacrifices. The account ends:

(17) He then made himself an upper *araṇī* of *aśvattha* wood, and a lower *araṇī* of *aśvattha* wood; and the fire which resulted therefrom was that very fire: by offering therewith he became one of the *gandharvas*. Let him therefore make himself an upper and a lower *araṇī* of *aśvattha* wood, and the fire which results therefrom will be that very fire: by offering therewith he becomes one of the *gandharvas*. Kālidāsa retained the heroine on earth till the hero's death, rather than translate him to heaven forthwith.

The last sentence of the *Śatapatha* quotation is meant for any later sacrificer. The similarity of Urvaśī-Purūravas (or for that matter any human coupling) with the two portions of the fire-plough[4] has been noted, the more so because the son's name *āyu* is also used as an adjective for *agni*. This is one more natural interpretation of the whole myth. But let us remark for the time being that a definite locality was recognized for the dialogue, and that the 'happy ending' was not part of the Vedic discourse, being clearly a later addition. The Ṛgvedic hymn is in eighteen instead of fifteen verses, which has been taken by some to denote a difference of version. Finally, what is the original meaning of 'became a *gandharva*'? This could not have happened while Purūravas was alive, for the *gandharva* at the time of the Brāhmaṇas is recognized as a spirit who could possess women, say the spirit that caused their hysteria. Hence, though the *gandharvas* possess a separate minor heaven of their own, a human being can attain it only as a spirit. For a Buddhist the *gandharva* is a condition of existence between death and rebirth.

If we combine the Brāhmaṇa with the Purāṇa account, the common feature is that Purūravas became a spirit, i.e. lost his life, in some way connected with a sacrifice.

ṚGVEDA, X.95

At this stage, let me introduce the original hymn which forms our ultimate source at present, and which will have to be accounted for if some new interpretation of the legend is to be proposed.

1. (Purūravas) 'Alas, O wife, desist from your intentions, O dreadful one, let us discourse together. If our chants remain unuttered, they will bear no fruit for distant days.'

2. (Urvaśī) 'What shall I do with these discourses of yours? I have gone over like the first of the Uṣas. O Purūravas, go back to your destiny; I am as hard to get as the wind.'

3. (Purūravas) 'Like an arrow to the target that wins cattle a hundred fold. Without heroic determination there is no shining; the chorus sets up a keening like (bleating) lambs.'

4. (Extra) That Uṣas giving wealth and nourishment to the father-in-law, as long as wished, reached her destiny (*astaṃ nanakṣe*) from the inner house, which pleased her; rammed night and day by the (lover's) member.

5. (Urvaśī) 'Thrice a day didst thou ram me with the member, and impregnated me unwilling (as I was). Purūravas, I yielded to thy desires; O hero, then wert thou king of my body.'

6. (?) This excited ... line, knotted together, moving, reflected in the pool; these drawn-red ointments flowed; they lowed like cows, the cattle decorated (?).

7. (?Urvaśī) 'As he was born, there sat the gods' wives; the self-made rivers made him grow. Thee, O Purūravas, the gods have raised for the great battle, for victory over the Dasyus.'

8. (Purūravas) 'When I, though human, embraced the superhuman (females) who cast off their clothing, they started away from me like does (? *bhujyus*) or like horses touching the chariot.'

9. (Urvaśī) 'If the mortal lusting after (us) goddesses mingles with the water-nymphs according to their will, then do they display their bodies like swans, nipping each other like stallions at play.'

10. (Purūravas) 'She flashed like falling lightning, bringing me the craved waters—from the water was born a noble lad. May Urvaśī grant (me) long life'.

11. (Urvaśī) 'Thou wert surely born for protection; this power didst thou hand over to me. I, the initiate, warned you on that very day. Thou didst not listen to me, why dost thou (now) speak like an innocent?'

12. (Purūravas) 'When will the son that is born yearn after his father? He will have shed flooding tears, knowing (what happened). Who dares separate the wedded pair in accord as long as the (ancestral) fire burns at the house of the fathers-in-law?'

13. (Urvaśī) 'I answer you, let him shed ample tears, he will not cry, heedful of (my) sacred office; I shall send you that or thine that thou hast with us. Go to thy destiny; thou fool thou canst not reach me.'

14. (Purūravas) 'Let (your) lover (*sudevaḥ*) today drop (dead) uncovered, let him go to the very farthest distance, never to return; let him lie down in the lap of Nirṛti (the death-goddess), let him be eaten by raging wolves.'

15. (Urvaśī) 'O, Purūravas, thou art not to die, not to drop (dead), the unholy wolves are not to eat thee.' (Purūravas) 'There is no friendship with womenfolk, their hearts are the hearts of hyenas.'

16. (Urvaśī) 'When I wandered among mortals in another guise and stayed (with them) for the nights of four years, I ate just a drop of clarified butter once a day; sated with that do I wander here now.'

17. (Purūravas) 'I, the best (of men) submit to the atmosphere-

filling, sky-crossing Urvaśī. May the blessings of good deeds be thine; turn back, my heart is heated (with fear).'

18. (Urvaśī) 'Thus speak these gods to thee, son of Iḷa: inasmuch as thou art now doomed to death, thy offspring will offer sacrifice to the gods, but thou thyself rejoice in heaven.'

There is a great deal in the *Śatapatha* and other Brāhmaṇas which shows to what extent Vedic rites had gained currency and the form in which they were practised. But unconvincing prose stories inserted as explanations—for the whole of the Brahmanic literature is meant as commentary to ritual practice—and fantastic etymologies show that in many cases the origin of the rite (and consequently the real meaning of a hymn) had been forgotten, or was something entirely different from the modes of contemporary society. We must try to unearth for ourselves the original ritual whose lapse had led the *Śatapatha Brāhmaṇa* to account so badly for *ṛks* fixed by the Bahvṛca's memory.

COMMENTARY TO *ṚV*, X.95

The hymn undoubtedly contains the germs of *all* the later stories that developed about Urvaśī and Purūravas, and from which Kālidāsa drew his material with such unrestricted freedom. We have to explain what survives, and to explain it on its own merits with reference to a form of society in which no prose additions were needed.

The primary reason for the survival of any Vedic hymn is its liturgical function. If an odd hymn like this remains, it can only be because it had some very marked significance or utility which was lost after the composition of the particular verses. Of course, during the period of mere survival, all other parallel aspects are of the utmost help, including the fire-drill, the sun-myth, the romantic tale, the psychological image.

My explanation derives from as literal a reading as possible, with the ambiguities left unresolved till the end, and then determined— as far as possible—by taking the sense of the whole. *Purūravas is to be sacrificed after having begotten a son and successor upon Urvaśī; he pleads in vain against her determination.* This is quite well-known to anthropologists as a sequel to some kinds of primitive sacred marriage.

Most of the Ṛgvedic hymns are meant to be chanted by one or more priests. But there are a few exceptions where *the hymn can only*

be explained as what remains of a ritual performance. The dialogue of Urvaśī and Purūravas is likewise meant to be *part of a ritual act performed by two characters representing the principals and is thus a substitute for an earlier, actual sacrifice of the male*. The extra verses are to be chanted by someone else, to round out the action. That is, Kālidāsa's play is very naturally based upon the oldest of plays. This is not a startling conclusion; even modern European drama develops from the mystery plays of the medieval church, which themselves develop from and supplement church ritual. They offer a substitute for pagan, pre-Christian rites of similar purport.

If anything has been omitted, it could at most have been stage-directions for the mime, and not some prose narrative. The original meaning of *nāṭya* is precisely miming, not acting in the modern sense.

It will be seen at once that this explanation serves to remove *all* the major obscurities of the hymn, without doing any violence to the meaning of the words; the explanation fits better than any of the others that have been offered, and shows at the same time why certain divergent accounts with a tragic ending survived in the Purāṇas. Let us look further into the details.

Purūravas addresses his wife as *ghore*, which means the grim or dreaded one, used for gods like Indra; hardly a lover's term, though later this is taken as denoting her hard-heartedness. But he is emphatic that if their *mantras* remain unspoken, there will be no benefit in distant days; that is, the chant (and action) is meant to confer upon the audience the benefits associated with all fertility rites. Urvaśī apparently tells her lover to get back to his home, *punar astam parehi*, and this is supported by similar interpretations of the word *astam* in the fourth ṛk, which is admitted to be an extra verse. But look at the funerary hymn X.14.8 where the dead man is sent back to his ancestors and Yama with the words *punar astam ehi*. There is no doubt that Purūravas is to go to his final destiny, pass from the sight of men (*astam adarśane, Amarakośa* 3. 4. 17). He himself says that he is to die, in 14, where going to a far distance, lying down in the lap of Nirṛti and so on are familiar idiomatic circumlocutions for death. This has, again, been taken as a desire to commit suicide for being bereft of his love—a proposition far too romantic for the *Ṛgveda*, particularly as no word of endearment passes between these two! Urvaśī seems to console him in the next ṛk by assuring him that he is not to die. But look closer, and it is clear only that he is not to die a common profane death, not to be eaten by wolves like any untended

corpse in the Iranian *dakhma* (predecessor of the tower of silence) or the corresponding open corpse-enclosure, the *śmaśāna* described in so many Buddhist works, and even in the *Kathāsaritsāgara*. No, he is to be sacrificed to or by the gods; that was his destiny. Purūravas was raised for the battle of the gods against the demons so it is not straining the sense to see in this (X.95.7) the necessity for sacrificing Purūravas. The assurance 'thou dost not die' is given in almost identical terms to the sacrificed, cooked and eaten horse in *ṚV*, I. 162. 21 *na vai u etan mryase*. In fact, the horse is going to the gods, freed from all his earthly troubles and brings victory to the sacrificers. We should not be surprised to find Purūravas assured at the very end that he is going straight to heaven. That is why he is *mṛtyubandhuḥ*, not an ordinary mortal, but one literally bound to death at the sacrifice. This surely explains why Urvaśī has the heart of hyena (15), why Purūravas's son can never know his father, but must console himself with thinking of his mother's sacred office (12, 13). Even when he asks Urvaśī to turn, *ni vartasva* (17) Purūravas does not ask her to turn back to him, but to turn away from him for his heart quails with dread; quite naturally, seeing what she is about to do to him. Earlier, he had begged her for long life (10) to which her only answer (11) was that he had been amply warned in advance as to what fate awaited him, if he insisted upon mating with her. The light diet admitted by Urvaśī in (16) is perhaps a denial of cannibalism as a motive for killing the hero; the demon wives of the *Kathāsaritsāgara* derive or sustain their supernatural powers by feeding upon human flesh. The *tulasī* (holy basil) plant is worshipped throughout the country, being planted in the courtyard or near the entrance of every devout Hindu household, on square *vṛndāvana* pedestals which are really horned altars almost identical in form with those found at non-Israelite tenth century BC Megiddo, and others still further away from India. The plant goddess is married every year (now to Kṛṣṇa), the reason buried deep in the mass of her legends (*māhātmya*) being given that she is a widow. This can only mean the annual death (by sacrifice) of the husband, which brings us back to Urvaśī and Purūravas.

URVAŚĪ'S ASSOCIATES

There is some doubt still as to the translation of the first half of X.95.6. Are *sujūrṇiḥ... granthinī caraṇyuḥ* to be taken as names, or are they adjectives of *śreṇiḥ*? Taking the latter meaning, we might have

a description of the line of dancers at sacrifice. In the first sense, they are other *apsaras*, companions of Urvaśī. These particular names are not to be found anywhere else, while the peculiar hiatus in *sumnaāpi* can't be explained in either case. The *Atharvaveda* does have several others (*AV*, IV.37.3, etc.). The *Vājasaneyi Saṃhitā* (XV. 15ff, cf. also *Taitt. Sam.* IV.4.3) names a different lot, two by two, to accompany several gods: Puñjikasthalā, Kratusthalā for Agni; Menakā, Sahajanyā for Vāyu, Pramlocantī, Anulocantī (both prone to strip themselves) for Sūrya; Viśvācī, Ghṛtācī; Urvaśī and Pūrvacitti (for Parjanya). As pairs of female attendants for each male god, they are a normal feature of temple-reliefs, especially in the south, and may be studied also in the Ambarnāth Temple (AD 1060). These anticipate the later *śaktis*, or the regular mates of the gods (Lakṣmī for Viṣṇu, etc.), and it is remarkable that they should occur so early. Clearly, the number of these nymphs is legion. Menakā (the name is a pre-Āryan word for 'woman') is known in the Śakuntalā episode for her seduction of Viśvāmitra. Her daughter Śakuntalā is, remarkably enough, herself called an *apsara* in the the *Śatapatha Brāhmaṇa* (XIII.5.4.11). She has some quite extraordinary features, for her name is derived from birds having fed her as an exposed infant; these birds were carrion-eaters, presumably vultures (*Mbh.*, 1.67.10-11) and birds of ill-omen, *śakunta*. But Urvaśī is the most prominent of these, and is unquestionably a water-goddess besides being able to traverse the air as in X.95.17 above.

The *apsaras* as water-goddesses appear in the legend of Vasiṣṭha's birth (*ṚV*, VII.33), where the sage is surrounded by these nymphs (VII.33.9). Vasiṣṭha is apparently clad in the lightning *vidyuto jyotiḥ pari saṃjihānam* (VII.33.10) which recalls the lightning flash of the later Purūravas legend that disclosed the hero in his nakedness. Being born from, or because of the, *apsara* Urvaśī and brought to human beings by the similarly born Agastya was Vasiṣṭha's origin as a brāhmaṇa, obviously un-Āryan as we shall see later.

We may note in passing that several *apsaras* occupy such prominent place near the beginning of some royal genealogy: Menakā (Śakuntalā), Ghṛtācī, Alambusā, etc. The marriage had to be in some way legal for such a genealogy to be valid in patriarchal society, while it was notorious both by actual matriarchal custom and later tradition that the *apsara* could not submit to a husband as permanent lord and master. Thus Rāvaṇa said bluntly in violating the sea-born nymph Rambhā; *apsarāṇāṃ patir nāsti*, and was conscious

neither of sin nor crime. This obstacle was neatly avoided by the *apsara* being cursed to human form and mortality for a period. Kālidāsa found this convenient in ascribing a reborn *apsara* as ancestress to Rāma in the eighth *sarga* of his *Raghuvaṁśa*, though some such tradition must have been current in his day.

There is no doubt that the *apsara* is a water-goddess though her consort, the *gandharva*, is generally in the sky (but again the golden-heeled Gandareva of the deep, in Iranian mythology). In *ṚV*, X.10. 4-5, Yama and his twin sister Yamī, the first humans, are born of the *gandharva* and the water-woman (*apyā yoṣā*), being fashioned by Tvaṣṭṛ, even in the womb, to be husband and wife. In X.85, the *gandharva* seems to have special rights over all women, especially the virgins. This partly accounts for the *apyā kāmyāni* of X.95.10, and the child born from the waters, *janiṣo apo naryaḥ*. Of course, there is a clear physiological erotic factor also present, psychoanalysts have maintained that 'drawn from the waters' is an old representation for just ordinary human birth.

Iḷā is a prominent goddess in the *Ṛgveda*, remembering that goddesses in general are far less important there than the male gods. She is associated with Urvaśī and rivers in V.41.19: *abhi na iḷā yūthasya mātā sman nadībhir urvaśī va gṛṇātu; urvaśī vā bṛhaddivā gṛṇānā abhyūrṇavānā prabhṛthasya āyoḥ*. The Āyu at the end may be Urvaśī's son. The *Mahābhārata* tells us that Iḷā was both father and mother of the hero, and the change of sex in the later accounts is clearly meant to link Purūravas to Manu, in spite of his having no father nor any known parent except Iḷā. Such changes are not unknown when matriarchy is superseded. The implication is that Purūravas is a figure of the transitional period when fatherhood became of prime importance; that is, of the period when the patriarchal form of society was imposing itself upon an earlier one. We shall have to consider whether this happened in India, or represents some extraneous change preserved in Āryan myths brought into India. But it is clear as far as X.95 goes that Purūravas is pleading the newer type of custom in marriage in the twelfth *ṛk* when he asks, who can separate the married pair as long as the ancestral fire burns in the husband's paternal house? That the Purūravas of X.95 is actually the son of Iḷā and not some other character is clear from the appellation Aiḷa in the concluding lines of the hymn.

To return to the birth from the waters, one may point out an episode whose parallelism has been partially recognized, namely,

the story of Bhīṣma (*Mbh.*, 1.91ff.). This great figure dominates the extant *Mahābhārata* even more than the god Kṛṣṇa. He is born of the river Ganges, who assumes human form to woo Pratīpa, but accepts consortship of his son Śāntanu instead. She kills her first seven sons by drowning them one after the other in the river, which is surely her own natural form; hence the sons are sacrificed to her if one ignores the revision. The eighth is saved by the father's pleading, but then the river-queen leaves her husband. That son is Devavrata or Gāṅgeya (with two names, *dvināmā* as we are specially told in *Mbh.*, 1.93.44), later named Bhīṣma. The change of name is occasioned by his strict vow to remain celibate. This leads him to abduct or capture, for his step-brother, the three daughters of the king of Kāśī, named curiously enough Ambā, Ambikā, Ambālikā. *All three names mean 'Mother'*, and are connected with water by the words *ambu* and *ambhas*. One should guess that they might be river-goddesses, even forms of the Ganges, who has a triune image at Elephanta. Their names are particularly notable because of their joint invocation in the horse-sacrifice (*Śat. Brāh*, XIII. 2.8.3, etc.). Of the three, the two younger are married off to Bhīṣma's step-brother Vicitravīrya, who dies without issue. Bhīṣma is asked to beget sons upon them for continuity of the family, but refuses though his vow has no longer served any purpose. The eldest sister finds herself cast off by Śalya, her former chosen one and asks Bhīṣma to take his place, but is also rejected. She vows to kill Bhīṣma, though he has the boon of virtual immortality from his father, being able to live as long as he likes. Ambā commits suicide, is reborn as or is transformed after rebirth into the male Śikhaṇḍin, and ultimately kills the hitherto invincible Bhīṣma in battle because he cannot fight against a woman, not even against a man who had been a woman. Bhīṣma is killed by the river-goddess[5] whom he rejected; the explanation that his opponent was a sexual invert will not suffice.

Other ramifications of river-goddess worship are known (J. Przyluski: *I.H.Q.*, 1934, pp. 405-30), perhaps the Indian custom of *visarjana*, committing images, and at times ashes of the dead to the waters, hearkens back in some way to this tradition. Ritual marriage to mother-and river-goddess was definitely known to be dangerous. The gradual fading of the danger is seen in the *Manusmṛti* injunction (3.19) not to choose a bride with any sort of terrifying name, among them specifically the name of any river. A similar caution is given by the quite practical and generally irreligious *Kāmasūtra*, 3.1.13. Therefore, though the naming of Indian girls after rivers is common

nowadays, and has no effect upon their prospects of marriage, the fashion was definitely frowned upon in earlier days, undoubtedly for very good reasons. On the other hand, the *apsara* and water-goddess cult survives, e.g. near Poona, particularly in the Māval region, the *māmāla-hāra* of Sātavāhana inscriptions at Kārle. These goddesses (Māvalā-devī: 'the mother-goddess') have given their name to the country, are identified with the 'seven *apsaras*' (*sātī āsarā*), and are worshipped only in the plural, always near the water—whether well, pond, or river. But they do not seem to demand blood-sacrifices nowadays, such as other rustic goddesses still require at least once a year. Their aniconic stones are still coated with red minium, or the goddesses themselves are symbolized by red streaks on a rock or tree.

THE DAWN-GODDESS IN THE ṚGVEDA

The most important of Urvaśī's associations has been lost in most translations. This is with Uṣas, the goddess of the dawn and possibly the *bṛhaddivā* of V.41.19. In X.95.2, Urvaśī says that she has passed over like the first of the dawns, and this seems a mere simile. The problem then is to explain away the *uṣo* in 4, and this is done in many different ways, none convincing. The explanation I offer is that Urvaśī has reached the status of an Uṣas, and that this status is that of a mother-goddess[6] not of a mere goddess of the dawn. That was HER destiny, as being sacrificed was her lover's. We proceed to consider this in detail.

In X.95.8.9, we noted that the *apsara* and her companions strip off their clothing; that was also the way in which Menakā and others seduced the sages. Quite remarkably, it is the goddess Uṣas who most often bares herself to the sight of men in this way. In I.123.11, she reveals her body like a young woman decorated by her mother: *āvis tanvaṃ kṛṇuṣe dṛśe kam*. Perhaps V.80.4-6 contain the oftenest repeated mention of this self-exposure of the dawn goddess, but her revealing her bosom and charms to men is quite common. Remarkably enough, this performance is seen often on Syro-Hittite seals (W.H. Ward: *Seal Cylinders of Western Asia,* Ch. L) where the Indian humped bull is shown: at times as her pedestal. There is no shame attached to this: *nodhā ivāvir akṛta priyāṇi*, like a girl with yet immature breasts (*nodhā iva*, after Grassmann's suggestion). We can understand the bewitching *apsara* doing this, for it is her function to attract men. But why Uṣas?

In any case, why should this goddess of the dawn be so specially prominent in the *Ṛgveda*, when she seems to have no important function. There are at least 21 complete hymns dedicated to her, and she is important enough to be invited in the special sacrificial chants known as *āprī*-hymns. In these hymns, with their rigidly fixed structure, Uṣas comes just after the opening of the divine doors, to be mentioned either together with the night (*uṣasā-naktā*) or in the dual, which would again mean the same pair. That is too high an honour for a mere witch, or one who behaves like a hetaera. Clearly, she once had a higher position, for which we must search to explain the survival.

The former high position is not difficult to trace. She is the sun's wife on occasion, as in VII.75.5 *sūryasya yoṣā*, but perhaps his sister and also his mother III.61.4 *svarjanantī*. Yet this is not enough to explain her importance. In I.113.19, she is the mother of all the gods, a numen of Aditi: *mātā devānām aditer anīkam*. Her real status slips out in a most important reference, which is in a hymn dedicated to Agni (IV.2.15):

We seven sages shall generate (or be born) from mother Uṣas, the first men sacrificers; we shall become Aṅgirasas, sons of heaven, we shall burst the rich mountain, shining forth.

Uṣas was, therefore, a high mother goddess, literally *mater matuta*. How did she come to lose this position?

Vasiṣṭha says *abhūd uṣā indratamā maghonī* (VII.79.3), where the aorist past tense seems to me to indicate that Uṣas had once been but was no longer superlatively Indra's equal. The support for this is from the tale of conflict between the two deities. The mention is not isolated, for we find it in II.15.6, X.138.5, X.73.6, but with greatest detail in IV.30.8-11:

This heroic and virile deed didst thou also do, O Indra, that thou didst strike down (or kill) the evil-plotting woman, the daughter of heaven. Uṣas, verily the daughter of heaven, the great, to be regarded as great didst thou crush, O Indra. Uṣas fled from the shattered wagon in fright, when the Bull (Indra) had rammed her. Her wagon lay completely smashed to bits on the Vipāś (river), she (herself) fled to the furthest distance.

There is no reason or explanation given for this conflict. Indra is the young god, one whose birth is mentioned several times, and who takes the lead over all other gods because of his prowess in battle. In fact, he reflects the typical Āryan tribal war-chieftain, irresistible in

strife after getting drunk on Soma. His displacement of Varuṇa is just barely to be seen in a dialogue (IV.42). Indra and the older chief god Tvaṣṭṛ have no such open conflict as this. To Keith, the wagon (*anas*) signified merely that the image of Uṣas was carried around the fields in such a cart, like the Germanic field deities, or Demeter. But why was it smashed up by the new leader? Her fleeing to the furthest distance is equivalent to her death. At the same time, she is an ancient goddess in spite of her virginity and youth, which are preserved by her being born again and again: *punaḥ punar jāyamānā purāṇī* (I.92.10). The only possible explanation lies in a clash of cults, that of the old mother-goddess being crushed on the river Beas by the new war-god of the patriarchal invaders, Indra. That she survives after being 'killed' can only indicate progressive, comparatively peaceful, assimilation of her surviving pre-Āryan worshippers who still regarded her as mother of the sun, wife of the sun, daughter of heaven. Her behaviour is reflected in that of *apsaras* like Urvaśī, who degenerate into the witches of the *Atharvaveda* by natural development of the combined society, which really and finally kills their cult, except for local survivals in villages and the jungle.

The former (probable) role of Uṣas as the mother of creation and certainly of the Aṅgirasas—who claim affinity with the light-deities—can be untangled with some difficulty from the extant *Ṛgveda*. Later mythology takes creation as resulting from the incest of Prajāpati with his own daughter, the root stanzas being found in the *ṚV*. But in I.72.5, it is clear that the father is the sky-god (here a male though often elsewhere a female in the same Veda, hence a later fiction coupled to the original mother-goddess), while Uṣas is emphatically the daughter of heaven as both commentators and translators point out here; the progeny are the Aṅgirasas. In III.31.1. *seq*. we have much the same theme, as also in X.61.7, while in I.164.33, the daughter has become the Earth. This shows heterogeneity among Brāhmaṇa traditions. Her connection with later hetaerism may be seen from Sāyaṇa's comment upon the word *vrā*, which he takes as a name of Uṣas, as for example in I.121.2, and IV.1.16; in the latter hymn, it would make much better sense to take Uṣas as the cow-mother, the goddess whose thrice seven secret names were known only to the initiates.

There is only one more reference to Urvaśī in the *Ṛgveda* (IV.2.18; *AV.*, XVIII.3.23), just after the striking mention of Uṣas with the

seven seers. The Urvaśīs are here in the plural; *āyu* can again be taken as the legendary son, or some adjective. The proper translation would be something like 'The Urvaśīs have taken pity upon mortals, even to helping the later kinsman Āyu'. Presumably, the son and successors of Aila Purūravas were not sacrificed, patriarchy had conquered finally.

The *Ṛgveda* shows fainter traces of a different type of 'hetaerism', which seems related to survivals of Āryan group marriage rather than to the cult of the pre-Āryan mother-goddess, though the two need not be independent. The specific reference may be seen in *ṚV*, I.167.4, where the goddess Rodasī is common to all the Maruts, under the title of *sādhāraṇī* (plus the incomprehensible *yavyā* = fertile?). Whether this indicates fraternal polyandry (as I incline to think) or a form of prostitution is not clear; the question is further complicated by Rodasī (with a displaced accent) being elsewhere equated to the combination of earth and sky, hence two goddesses rather than one. The Aśvins are go-betweens for arranging the marriage of Sūryā with Soma (in X.85.8-9 hence originally of the sun-goddess to the moon-god), which would make them her brothers; but they are clearly her husbands in IV.43.6, which again is not a contradiction in terms of group-marriage of the older sort. We have already noted the identity of Sūryā with Uṣas and Urvaśī in later tradition, while the later hymn reduces Sūryā's marriage to a still current ritual which can only have arisen by a human couple impersonating the divine bridal pair. The bridegroom in X.85.36 takes his bride by the hand at the crucial stage of the wedding, yet in the very next *ṛk*, the woman is spoken of as she who receives the seed of (many) men: *yasyāṃ bījaṃ manuṣyā vapanti*, and it would be odd to have this generic mode of designation unless indeed, in some older days at least, she would automatically have become the bride of several brothers, or clansmen.[7] The later word *veśyā* for prostitute, from the same root as *viśyā*, presumably denotes the woman who dwelt in a house common to all men; the *gaṇikā* clearly derives from group-wives. In most developed societies whose primitive stages can still be traced, it is generally to be seen that prostitution arises as a consequence of the abolition of group marriage. Both are concomitants of a new form of property, patriarchal private property which replaces communal possession of the means of production. *AV*, XV shows the harlot prominent in *vrātya* fertility rites that were not generally fashionable.

ĀRYAN OR PRE-ĀRYAN?

The character of Urvaśī and her higher form Uṣas has been delineated in the foregoing, but we have still to consider whether she was Āryan in the same sense as Indra, Varuṇa, Agni or inherited from older civilizations. The parallelism with Ishtar-Inanna is unquestioned. Of course, the question of some plausible mechanism for the adoption of pre-Āryan cults will be raised; it will also be objected that, after all, the Indus seals portray exclusively male animals, the rare human figures are demonstrably masculine where identifiable. The reasoning is in full agreement with this, for the seals belonged to a different set of people than the female figurines, to the men of the trader class which was destroyed along with the houses behind whose massive, undecorated walls they had piled up their wealth. The women with their cults survived, either as wives or slaves, which would account for all the traces of their cults that we have shown in Āryan documents though at variance with the mode of living (not race) which is denoted by the word Āryan.

The Ṛgvedic references to the dancing-girl are casual, as if the institution were familiar to all; yet temples of any sort could not have been pastoral-Āryan-Vedic, there is no direct mother-goddess worship, and we have seen that the Uṣas cult was smashed up by no less a personage than Indra. In I.92.3 we hear women chanting at their work, presumably ritual: *arcanti nārīr apaso na viṣṭibhiḥ*. In the next ṛk, we have Uṣas wearing decorative clothes like a dancing girl: *adhi peśāṃsi vapate nṛtūr iva*. The patterned cloth appears again in II.3.6 figuratively, as the woven pattern of the sacrifice: *yajñasya peśas*. This profession of weaving clearly belongs to the women, and is in the process of being usurped by men, as I shall now show.

In ṚV, V.47.6, the Mothers weave clothes for their son, the sun. The night weaves the sun's garment for him in I.115.4, and is a weaving woman again in Sāyaṇa on II.38.4: *vastraṃ vayantī nārīva rātriḥ*. Most significant for my main theme, Uṣas is also a weaver with the night: *uṣasā-naktā vayyā iva ... tantuṃ tataṃ saṃvayantī* (II.3.6). Therefore it is again natural to find the *apsaras* in VII.33.9 weaving the garment stretched by the all-regulating god of death, Yama: *yamena tataṃ paridhiṃ vayantas*. In VII.33.12, the sage Vasiṣṭha was born of the *apsara*, the jar, and the lake to take over the work of these nymphs in weaving the pattern of fate. Nevertheless, men other than Vasiṣṭha succeeded to less fateful types of weaving. The *yajña* being

woven is not only a common figure of speech but the male seer of II.28.8 weaves his song, just as the paternal ancestors in X.130.1 weave the sacrifice.

This change over to patriarchal production must have occurred at the time early Ṛgvedic society was formed from pre-Āryan conquered as well as their Āryan conquerors. Men seem always to have monopolized ploughing (IV.57) while Brahmaṇaspati, a male priest-god, swedges the world together like a smith (X.72.2).

We are now in a position to understand why in X.95.4 Urvaśī claimed (as an Uṣas) to have given clothing and food to her father-in-law. That is, though she had a dread ritual to perform as viduṣī in X.95.11, she was initiated into certain arts as well which had been the prerogative of her sex, and weaving was one of them. Thus the Sāyaṇa gloss *vasu* = *vāsakam*, clothing, is quite correct. The word later comes to mean wealth in general, and the brahmanical renaissance with its spicing and embalming of the Sanskrit language makes this synonymous with all other forms of wealth. Nevertheless, the original meanings of the three main terms seem to have been separate: *dhana* would indicate precious metals, loot in general; *rayi* must have originally denoted wealth in cattle and horses, seeing that *gomat* is used as its adjective so often; *vasu*, I take it, meant primarily wealth manufactured and worn, like clothing. At the time of the *Atharvaveda* (*AV*, IX.5.14), weaving must have been a household industry carried on by women, for home-woven garments are there mentioned, along with gold, as a sacrificial gift; spinning, and weaving but not needlework appear in the list of a good wife's accomplishments in the *Kāmasūtra* (4.1.33).

This raises the next question, in what way did Urvaśī supply food to her father-in-law? For the *vayas* in question might have been merely the result of her cooking. Of course, Uṣas is often *gavāṃ mātā*, mother of the cattle and the older ploughless hoe agriculture may have again been a prerogative of the women, as we find it in most primitive societies, but there is no direct evidence before us. However, we may use archaeology and anthropology to solve another riddle, namely the multiple account of Vasiṣṭha's birth in VII.33, where he is born of the *apsara*, the lotus or lotus-pond, and also from the seed of Mitra-Varuṇa poured into a jar, *kumbha*. The answer is very simple, namely that THE KUMBHA IS ITSELF THE MOTHER-GODDESS in spite of the masculine gender of the word. It is known that prehistoric hand-made pottery, before the introduction of the wheel and mass

production, is fabricated by women. To this day, pots made by hand or on the potter's disc in India are made by women, and smoothed by men with paddles and a stone anvil-block; but no woman is allowed to work the fast potter's wheel in India, so far as I know. Moreover, the pots generally represent the mother-goddess, either by their decorations, the oculi or necklaces incised or painted on them as patterns, or by actual additions to complete the image. The *apsara* in general is a mother-goddess, as would appear from the *AV* hymns called *mātṛnāmāni*. Later tradition, mixed as usual, is even stronger. Lakṣmī, like Aphrodite, was born of the sea. She has the name Ramā, Mā and 'mother of the people' (*Lokamātā* cf. *Amarakośa*, I.1.29). This makes her a mother-goddess, as should be all goddesses whose names have a suffix *-mā*: Umā, Rumā, Ruśamā, etc. But there is some reason to think of her as originally an *apsara*, apart from her being born of the waters. Though she is a goddess, wife of Viṣṇu-Nārāyaṇa, she counts as sister to the sea-born demon Jālaṁdhara (*Skanda P,* 2.4.8, 2.4.14-22), husband of the plant-goddess Tulasī-Vṛndā whose story we have already reviewed above. The reader knows that the original 'grove of Vṛndā (*vṛndāvana*) was on Kṛṣṇa's home ground, in the *gokula* at Mathura, according to ancient tradition as well as modern pilgrims' belief. Her cult most obviously has been separate from, and older than that of Kṛṣṇa. So Kṛṣṇa-Nārāyaṇa being married to Tulasī-Vṛndā annually is a comparatively late step in the assimilation of a mother-goddess cult to that of a pastoral god. Certainly, Kṛṣṇa's numerous wives, like the countless wives, mistresses and casually violated nymphs of Herakles must have been mother-goddesses in their own right before the union, the ultimate fusion of cults rounded upon the merger of two entirely different forms of society.

We have already referred to the terracotta figurines that prove the worship of the mother-goddess to have been prominent in the pre-Āryan Indus valley. I now suggest that the 'Great Bath' at Mohenjo-Daro is a ceremonial *puṣkara*. This curious building, situated apart from the city on the citadel-zikkurat mound, could not have been utilitarian seeing that so much labour had to be expended to fill the tank with water. There is no imagery or decoration of any sort, but the tank is surrounded by rooms, which may have been used by living representatives, companions, or servants of the goddess, the *apsaras* of the day; the water need not have been so laboriously drawn, unless for water-deities to whom it was essential. The range of seemingly

unconnected meanings for the word *puṣkara* is highly suggestive: lake, lotus, art of dancing, the sky; the root *puṣ* from which it is derived, like the very close *puṣkala*, denotes fertility, nourishment, plenty. The whole nexus of ideas is connected with the *apsara* though she appears in the classical Sanskrit literature only as dancer and houri. According to the *Dhammapada-aṭṭhakathā*, IV.3 and the preamble story to Jātaka 465, the Licchavi oligarchs of Vesālī had a special, heavily guarded, sacred investiture-*puṣkara=abhiṣeka-maṅgala-pokkharaṇī*. About AD 120 Nahapāna's son-in-law Uṣavadāta went far out of his way to have the *abhiṣeka* investiture performed at the 'Pokṣara [*sic.*] tank' (*EI*, 7, p. 78, inscription at Nāsik). The Cambodian *apsara* dancers of Angkor Vat are portrayed with the lotus flower in one hand and lotus seed-pod in the other, the first symbolizing the *puṣkara* while the second is obviously a fertility symbol. How old the tradition really is may be seen from the Indo-Greek coin of Peukelaotis where the lotus-crowned patron-goddess of the city Puṣkarāvatī is portrayed in precisely the same way, with the name Ambi=mother-goddess. The *Śatapatha Brāhmaṇa*, VII.4.1.11 tells us that the lotus-leaf (*puṣkaraparṇa*) is the womb (*yoni*), and in 13 that the *puṣkara* is the lotus-leaf. Thus Vasiṣṭha's birth has a completely consistent account, multiple only in the symbolism used. The *gotra* lists mention a *Pauṣkarasādi gotra* among the Vāsiṣṭhas. The *gotra* is historical as a brāhmaṇa priest of that gens was priest of king Pasenadi (*Dīghanikāya*, 4), and a grammarian of that name is also known. The name means descendant of *puṣkara-sad*, he who resides in the *puṣkara*, which clearly indicates Vasiṣṭha. So does Kuṇḍin, from which the Kauṇḍinya *gotra* of the Vāsiṣṭhas is derived. Neither the lotus-pond nor the *apsaras* that tarries there could be Āryan in origin. It would be difficult to explain the fundamental and distinctive role of the lotus in all Indian iconography without relating it to pre-Āryan cults, for the Āryan-Vedic [cults] centre about the sacred fire. One may note further that one of the holiest places of pilgrimage is a *tīrtha* named Puṣkara, identified with one of that name in Rājpūtānā, but presumably representing earlier aritificial tanks of the sort. The *puṣkara* is a necessary adjunct to every Hindu temple not actually by a river, even in well-watered regions.

The *Mahābhārata* birth-story of the hundred Kauravas and their sister tells us that they were not born directly of their mother Gāndhārī but from ghee-filled jars into which the undeveloped embryos were placed. Significantly, *kumbhā* is still used for harlot by

lexica like the Viśvakoṣa. The Vidhūra-paṇḍita-jātaka (Fausböll, 545) gives an extraordinary rule for success (*gāthā* 1307), namely that a *kumbha* filled with water must always be reverently saluted with joined hands. The *udakumbha*, urn filled with water does not appear to be particularly important in the Ṛgveda, but has a very prominent position in the Gṛhyasūtras, and in current practice. For example, the bridal pair must circumambulate the sacred fire which is accompanied by the water-jar, though the Vedic god is *agni* alone, without the jar. The fire is addressed in some Ṛgvedic funerary hymns, but again the water-jar plays an important part in modern Hindu cremation rites, symbolizing the whole course of the dead man's life.

THE GODDESSES OF BIRTH AND DEATH

The *Kathāsaritsāgara*, 70.112 equates the *kumbha* or *ghaṭa* explicitly to the uterus. The equivalence may explain why the *navarātra* 'nine-nights' fertility festival to all mother-goddesses begins on the first of Āśvin by establishing a fertility-jar (*ghaṭa-sthāpanā*). The jar is set in some earth in which seed-grain is carefully planted 'to encourage the fields'. The cella of the shrine is decorated with food of all sorts. In the villages, this is the special time for blood-sacrifices to the goddesses. Women are the principal worshippers during these nine nights, even when male priests have taken over the cult, as happens at the more profitable cult-spots. The festival ends officially with a sacrifice (often only symbolic, of flour, but still officially called *bali-dāna*) to Sarasvatī, and the *visarjana* of that goddess. Other parts of the country have their own equivalent observances, such as the Vāralakṣmī worship in the south. Here, the pot is decorated with a painting, or a silver mask of the goddess, filled with grain, set up with due ceremony, and worshipped. The special function of the jar may, account for the remarkable fact that potters rather than brāhmaṇas are in general demand among many lower castes, to officiate at funerals, and some other ceremonies. Their special hand-drums and chants are generally required for prophylactic ritual before a wedding ceremony, and sometimes credited with special power over ghosts.

The *kumbha* as representation of a mother-goddess still survives in many south Indian festivals, of which the Karagā at Bangalore may be taken as a specimen. It is the special annual fertility rite of the Tigaḷas, who seem to have come from North Arcot, and are professional

market-gardeners about Bangalore. The animal sacrifices formerly made to the pot are now reduced to one, the rest being replaced by cutting lemons, or boiled cereals. In the final procession, the main participant (*arcaka*: hereditary Tigaḷa priest) carries the pot on his head, but is dressed as a woman; his wife has to remain hidden from the sight of men all during the festival. The Tigaḷa representatives, at least one from each family, cut themselves with sharp swords, but no blood flows during the ordeal. This festival, which is obviously not Āryan, has been brāhmaṇized only during the last 150 years, is now associated with a temple dedicated to the eldest Pāṇḍava Dharmarāja, and the goddess made into his wife Draupadī, the main content of the sacred pot being a gold fetish known as her *śakti*. An auxiliary brāhmaṇa *purohita* (at present Śrī Veṅkaṭarāya Vādyar, from whom I obtained these details) now attends even at the most secret part of the ritual which is performed in a shelter with two Tigaḷas, one of them the Tigaḷa priest mentioned before, the other a Tigaḷa who leads the way for the procession. Naturally, these secret rites are not divulged, but the whole festival is obviously a women's observance taken over by men. It is to be noted that though the Tigaḷas are a low caste, every temple in Bangalore sends an idol representing its god to follow in the final procession, and on the whole, this may be called the most impressive local festival. The untouchables have a similar one a couple of months later, the real Karagā ends on *Caitra* (April) full-moon after nine days of observances and celebrations. The triple pot which is itself the Karagā is not made by a Tigaḷa nowadays, but by a professional potter. Nevertheless, it must still be made from the sediment of one particular artificial pond; not turned on the wheel but hand-made, and not burnt but sun-dried; the final procession ends with the Karagā pot being thrown into the pond, though the golden *śakti* representing Draupadī is quietly rescued by the priest for use again next year.

There are two different conceptions of death in the *Ṛgveda*, which gives several distinct funerary rites in its later book, namely X.14, X.18, X.35. The earlier concept of death in the *ṚV* is unquestionably going to sleep, the long sleep from which there is no awakening. Many of the demons killed by Indra sink down into this eternal sleep. The Vasiṣṭha hymn VII.55 seems to have begun as a funeral hymn, then mistaken for and further transformed into a lullaby. Correspondingly, we have the lower level of the cemetery H at Harappā with extended burials. The dead sleep peacefully, furnished

with grave goods and supplied with jars that must once have contained the drink of immortality, *soma*. This cemetery is undoubtedly Āryan, and the city itself to be identified with the Hariyūpīyā of VI.27.5-6, though the battle mentioned there might refer equally well to conflict between two waves of Āryan invaders as to the first Āryan conquest of the city. When we come to the top layer of cemetery H, however, the character of the burials changes abruptly. The dead adults survive only in jars, where their remains are placed after the body had been cremated or decarnated by birds of prey. The custom is mentioned in all the major ritual books, such as those of Āśvalāyana, Kātyāyana, and so on, and the jar where the bones are placed is specifically called the *kumbha*. This corresponds to the later Ṛgvedic concept of death (I.164.32, *sa mātur yonā parivīto antar bahuprajā nirṛtim ā viveśa*), namely return to the mother's womb, and is proved very clearly in the case of cemetery H by the crouched position in which dead infants are placed within the jar; apparently, the bodies of children could be sent back to the mother directly, without being stripped of later fleshy accretions by fire or carrion-eaters. Further guesses may be made that the star-like decorations on the jars are developed oculi, but this would need closer proof. Incidentally, we are in a position to explain one peculiar decoration in this later Harappan grave pottery, namely, the peacock containing a recumbent human figure within the disc that forms the bird's body. If the figure were sitting or upright, it might have been taken for some deity. The horizontal position excludes this, and a reference in the *Mahābhārata* (1.85.6) clarifies the situation. There, the dead are represented as having been eaten by birds and insects of various sorts, but specifically by peacocks (*śitikaṇṭha*), whence the figure within the peacock must be the dead man himself. The bird is not the common carrion-eater, so that he must have had a particular sanctity, which is confirmed by his being the companion and hence a totem of the river-speech- and mother-goddess Sarasvatī. With the particular name *śitikaṇṭha*, he is associated with the dread god Rudra-Śiva, and a *vāhana* of Skanda as well.

A little later, as in the *Śatapatha Brāhmaṇa*, XIII.8.3.3, the earth herself becomes the mother, into whose lap the bones are poured out from the *kumbha*, but clearly the original mother or at least her womb was represented by the pot. Therefore, it is clear that Vasiṣṭha and Agastya, in being born from the urn, are giving a good Āryan translation of their birth from a pre-Āryan or non-Āryan mother-

goddess. The effective change is from the absence of a father to the total denial of a mother, a clear Marxist antithesis necessitated by the transition from matriarchy to patriarchy. After all, Āryan means a particular manner of life and speech, not a race. We may conclude, seeing that extended burial comes first, that the Harappan groups of Āryans had not the general habit of cremation, and that the later idea of a return to the womb is acquired from some of their former enemies whose remnants after the conquest were absorbed by comparatively peaceful means, unless, of course, it represents a second wave of invaders. We cannot prove directly that the manufacture of pottery was also a monopoly of women in the earliest stage here, or that Urvaśī Uṣas was a potter. But ritual pots continue to be made by the priest's hand without the wheel, as in Śat. Brāh., XIV.1.2.7ff., and the spade with which the clay is dug is to be formally addressed by the priest 'thou art a woman', as again in Śat. Brāh., VI.3.1.39. I think that this goes back to the period when both digging (for agriculture) and pottery were women's work. That the mother-goddess should weave the pattern of her son's fate and sew or embroider it (like Rākā in II.32.4 *sīvyatvapaḥ sūcyācāchidyamānayā*) is most natural.

Another survival of the mother-goddess cult into later times seems quite clear from the story of Aila Purūravas's parentage. He is the son of a prominent (for the *Ṛgveda*) goddess, Ilā, and the *Mahābhārata* says that Ilā was both his father and his mother. The Purāṇic account then changes Ilā's sex, Ila the son of Manu having become a woman by stepping into a grove sacred to the mother-goddess Pārvatī. In Mahārāṣṭra almost every village mother-goddess has her grove, now usually dwindled to a thicket, though occasionally (as at Phāgṇe near Beḍsā) quite impressive; but there is no longer a taboo on male entry. But this is not merely a later affair, for such initiation appears quite explicitly in the *Ṛgveda*, though its meaning has been obscured by mythological accretions. We have in VIII.33.19:

'Gaze downwards, not up; hold your feet close together; let not your rump be seen; for thou, O priest, art become a woman.' Nothing could be clearer than this, which shows (with the preceding *ṛks*) that a male priest has been initiated as a woman, and told to behave accordingly. And this cannot be Āryan for the mother-goddess plays no part in the warring life of bronze-age pastoral invaders and plunderers, whatever their past might have been. The conclusion is that the *Ṛgveda* shows the absorption of a pre-Āryan stream of

culture, which goes into the very source and origin of brāhmaṇism. Urvaśī's metamorphosis in Kālidāsa's drama is merely a late inversion of the original taboo upon male entry into the Mother-goddess's preserve. To this day women may not approach certain comparatively minor gods such as Vetāla, Bāpūji Bābā, and at some places Kārttika-Svāmin (Skanda).

The ṛk cited above occurs in the Kāṇva family book of the Ṛgveda. The Kaṇvas were demonstrably latecomers into the Vedic fold, like the Kāśyapas, though the latter occupy a much higher position in later brāhmaṇa tradition. The Kaṇva Nārada is reported by several Purāṇas to have become a woman by bathing in a sacred pool; he regains his manhood by another immersion, but only after a considerable period as a woman. Nārada enjoys a very high position as sage, being quoted or addressed from the *Atharvaveda* down; yet he is still called a *gandharva* in the epics. In Buddhist records, he and Pabbata are gods; a Nārada is a Brahmā, another a former Buddha! Most important of all, the Anukramaṇī makes him and his brother or nephew Parvata joint authors of ṚV, IX.104, but with an alternative ascription to 'the two Śikhaṇḍinīs, *apsaras*, daughters of Kaśyapa'. Referring back to the Bhīṣma story where that hero is killed by a Śikhaṇḍinī metamorphosed into a man, one may recognize traces of a very deep layer of myth regarding the tradition of mother-goddess cults, *apsaras*, human sacrifice.

At the end of *Śākuntala* act V, the wailing heroine is taken by a shape of light which carries her off to the *apsaras-tīrtha*. At the beginning of the very next act, the nymph Sānumatī (or Miśrakeśī) comes from that sacred pool to spy upon the hero. She has just finished her turn of attendance upon men at the ritual investiture bath, '*jāva sāhujanassa abhiseakālo*'. Thus Kālidāsa balances the *Vikramorvaśīyam* with another play where the *apsara* heroine (whose name makes her a bird-goddess) is rejected by the hero, directly inverting the original Urvaśī legend. The 'Great Bath' at Mohenjo-dāro, instead of being the 'hydropathic establishment' that Marshall calls it with consistent ineptitude, was probably the prototype of such *tīrthas*; consorting with the (human) *apsaras* was part of the ritual. This would be the Indus valley analogue of Mesopotamian ritual hierodule prostitution in temples of Ishtar.

The origin of the much-discussed *satī* immolation of the widow with her husband's corpse now seems fairly obvious. The first widow in Greek myth to survive her husband and remarry rather than enter

his flaming pyre was Gorgophone, daughter of Perseus. Widow-burning can only have developed from suppression of matriarchal tradition, presumably as a warning or precaution against its surreptitious revival. We must remember that the ordinary tribesman knew only group-marriage in both types of society, not the chief's *hieros gamos*. So, 'husband' denotes some chieftain or sacred king who gained his title to sovereignty (over the new society fused out of two distinct types) primarily by formal marriage to some local high-priestess or 'queen'. If, then, the husband died, there were ample grounds for suspicion that it was the wife's doing, a reversion to the old ritual. The *satī* custom would not only discourage this, but act like a curious inversion of the older sacrifice, and count further as provision for the departed leader in the next world. Yet, the *satī* is herself not on the same level as the dead hero's horse, bow, panoply and accoutrements immolated with him, for she immediately becomes a goddess, with her own cult. The ancient but still recited marriage hymn *ṚV*, X.85.44 admonishes the bride: *a-pati-ghnī edhi* = 'become a non-husband-killer'. This excellent advice is followed up with an invocation to Indra to give her ten sons and to make her husband the eleventh. This would carry the proper meaning only in a society which had not completely forgotten that the husband was once sent to the gods in sacrifice, but never the son.

The Urvaśī faded away, but they are responsible nevertheless for the goddesses of the later pantheon that are married peacefully to the major gods. Their living representatives developed what became— with the rise of a trading society and cash economy before the Mauryan period—commercialized prostitution. Significantly enough, the older, superannuated, state-controlled meretrices of the *Arthaśāstra* (2.22, 2.27) enjoy the position of Madams and supervisors over their younger colleagues, with the title *mātṛkā* used for mother-goddesses. They are also responsible for the unholy institutions associated with temple cults in the least Āryanized parts of India. Finally, they gave birth to two leading brāhmaṇa clans, the Vasiṣṭhas and the Āgastyas. When the jar-born sage Agastya 'nourished both colours', *ubhau varṇau pupoṣa* in *ṚV*, I.179.6 it cannot mean two castes, but both Āryans and non-Āryans, for he belonged to both, and his hymns show clearly the character of the compromise. Only intensive and systematic archaeology can decide whether the Agastyan penetration of the South is pure myth or has some connections with the great megalithic tombs of 'saints'.

NOTES

1. A.B. Keith, *The Religion and Philosophy of the Veda and Upanishads*, Harvard Oriental Series, vols. 31-2 (Cambridge, Mass, 1925), p. 183.
2. Max Müller, *Chips from a German Workshop*, vol. II, 2nd edn. (London, 1868), pp. 117ff, particularly p. 130.
3. In R. Pischel and K.F. Geldner, *Vedische Studien*, vol. I (Stuttgart, 1889), pp. 243-95. Hereafter, *Ṛgveda* references will be indicated with or without the preceding abbreviation *ṚV*.
4. For the fire-drill as Urvaśī and Purūravas cf. *Śat. Brāh.*, III.4.1.22; for the fire-drill and any human procreation, *Bṛhadāraṇyaka Upaniṣad*, VI.4.22, and other places.
5. According to *Mbh.*, 5.187.39-40, Ambā became a river with half her body.
6. The *Bṛhaddevatā* takes Sūryā, Saraṇyu and even Vṛṣākapāyī as forms of Uṣas (*Bṛd.*, II.10, VII.120-1). The speech-goddess Vāc is there equated to Durgā, Saramā, Urvaśī, Yamī in the middle sphere (II.77) and to Uṣas in II.79-80. Urvaśī is derived as *uruvāsinī* (II.5.9). Making all possible allowance for the syncretistic tendency of such post-Vedic explanatory works, it is clear that these goddesses had something in common. This common factor can only have been their being mother-goddesses. For Saramā and all other goddesses whose names terminate in *mā*, we have the clear though late testimony of the *Amarakośa* 1.1.29: *indirā lokamātā mā kṣīroda-tanayā ramā*.
7. *AV*, XIV.2, 14 clearly supplements the Ṛgvedic ceremonial, in the direction of group marriage: 'in her here, O men, scatter ye seed'; the seventeenth *ṛk* hopes that the bride would be 'not husband slaying', and the next that she would be *devṛkāmā*. The collective evidence is overwhelming.

Women's Patronage to Temple Architecture

Harihar Singh

The royal as well as common women, like men, took active part in the temple-building activity in ancient India. They not only patronized it but also inspired and influenced their consorts and relatives in this task, and in fact a large number of edifices could reach their fimal form due to their patronage. This will be clearly reflected from the dynasty-wise survey made below.

At the very outset it may be pointed out that the political condition of north India during the period when the temple-building activities were carried out has been very disturbed. As the earliest relevant records belong to south India, we begin our survey with this part of the country.

THE IKṢVĀKUS OF THE ANDHRA COUNTRY

The excavations at Nāgārjunakoṇḍa have revealed a fairly large number of edifices and inscriptions which afford us useful information about the position and status of women of the Ikṣvāku kingdom during the third-fourth centuries AD. It is interesting to note that while the Ikṣvāku kings patronized brāhmaṇism and performed Vedic sacrifices, their consorts and other ladies of the realm were devotees of Buddhism and erected monasteries and temples in honour of the Buddha.[1] Amazingly enough, 90 per cent donors at Nāgārjunakoṇḍa were women.[2] The most celebrated lady of the Ikṣvāku family was Cāṁtisiri, one of the two uterine sisters of king Cāṁtamūla, the founder of the dynasty. She is known to have founded the Mahācaitya at Nāgārjunakoṇḍa in the sixth year (AD 246) of her son-in-law Mādhariputta Siri-Vīrapurisadata for the benefit of the Masters of the Aparamahāvinaseliya sect.[3] At the Mahācaitya she also founded an apsidal temple (*cetiya-ghara*) (no.1) and a stone *maṇḍapa* (*selamaṃṭava*) surrounded by a cloister

(cātusāla).[4] The Mahācaitya took about a decade to attain its final form and all these years it received the munificence of this pious lady.[5] Another pious lady was Upāsikā Bodhisiri who founded another apsidal temple (no. 2) and various other religious edifices at the Mahācaitya for the benefit of the fraternities of the Ceylonese monks.[6] It was possibly Bodhisiri who first introduced the construction of *caityagṛha* at Nāgārjunakoṇḍa.[7] The third one was Mahādevī Bhaṭidevā who calls herself the daughter-in-law of Vāseṭhiputta Siri-Cāṁtamūla, the consort of Māḍharīputta Siri-Virapurisadata and the mother of Siri-Ehuvula Cāṁtamūla. She is said to have founded a Buddhist monastery with all the essentials for the benefit of the Masters of the Bahusuttīya sect, which is identified with the monastery no. 4 at the site.[8] The fourth lady was Mahādevī Koḍabalisiri, daughter of Siri-Vīrapurisadata, sister of Siri-Ehuvula Cāṁtamūla and wife of the king of Vanavāsa, who founded a Buddhist monastery no. 5 for the benefit of the Masters of the Mahisāsaka sect.[9] Apart from these architectural activities the women of the Ikṣvāku kingdom set up a large number of pillars at Nāgārjunakoṇḍa. One inscribed carved pillar near Stūpa no. 9 was set up by the sisters, mothers and consorts of Vāseṭhiputta Siri-Cāṁtamūla in the twentieth year of the reign of king Cāṁtamūla's son, king Māḍharīputta Siri-Vīrapurisadata. The lady donors are 31 in number and their names are inscribed on the pillar.[10] All the Āyaka pillars at the Mahācaitya have been donated by one or the other of Ikṣvāku queens or princesses.[11]

THE CĀLUKYAS OF VĀTĀPĪ

The Cālukya queens of Bādāmī are known to have been highly religious and charitable; they accompanied the kings in the battlefield; they were well educated and were gifted in many arts; and they were even vested with the responsibility of administration and governance.[12] As a builder too they would have occupied a distinctive place in the royal court. This is clearly evident from the fact that Lokamahādevī, princess of the Haihaya family and the chief queen of Vikramāditya II (AD 733-4 to 744-5), caused the construction of Lokeśvara temple (identified with Virūpākṣa temple) at Paṭṭadakal to commemorate her husband's triple victory over the Pallava king Nandivarman II of Kāñcī. The architect of this temple, the most magnificent among the Cālukyan monuments and the best of its

time in the whole region of south India, Guṇḍa by name, was also honoured by her.[13] Her younger sister Trailokyamahādevī, the second queen of Vikramāditya II, also built a temple, the Trailokyeśvara temple (identified with Mallikārjuna temple) which stands beside the Virūpākṣa on its left to the north-west.[14] Cousens has identified the portraits of this queen and the king carved upon one of the pilasters of the hall of this temple.[15] Another charitable lady was Kuṁkumamahādevī. This Cālukya princess and consort of the Ālupa king Citravāhana I (c. AD 675-700) is credited with the construction of a temple called Anesejjeyabasadi at Lakshmeswar (ancient Purrigere), Dist. Dharwar, at the request of her husband.[16]

THE CĀLUKYAS OF VEṄGĪ

The Eastern Cālukya queen Ayyaṇamahādevī, the consort of Kubja-Viṣṇuvardhana (AD 615-33), was a very pious lady as she founded a Jaina temple known as Naḍumbibásadi at Vijayavāḍa and Kalyāṇavasant and executed a grant in favour of the temple.[17] She must have been held in great esteem by the succeeding rulers of the family; her above temple-grant was renewed in AD 762 by king Viṣṇuvardhana III.[18]

THE RĀṢṬRAKŪṬAS OF MĀNYAKHEṬA

The period of Rāṣṭrakūṭa ascendancy in the Deccan from about AD 753 to 975 was perhaps the brightest epoch in the history of the region. While the names of the Rāṣṭrakūṭa kings like Kṛṣṇa I and Amoghavarṣa are known for their patronage to art and literature respectively, that of Akkādevī is known for her uniting all the principal religions of her time. Indeed, the Belur inscription of Jayasiṁha dated AD 1022 informs that she practised the rituals of Jina, Buddha, Ananta, i.e. Viṣṇu, and Rudra, and built temples to Tripuruṣa, that is Viṣṇu, Brahmā and Śaṅkara. Thus this interesting personality synthesized in her not only the brāhmaṇical cults, but also all the main religious systems of her time, namely Hinduism, Buddhism, and Jainism.[19]

THE CĀLUKYAS OF KALYĀṆA

The royal ladies of the Cālukya dynasty of Kalyāṇa (eleventh-twelfth centuries AD) occupied high positions in administration of the kingdom and enjoyed respectable status.[20] But very little is known of

women who patronized religion and art and built temples. According to an inscription, Rebbaladevī constructed a temple of Keśavadeva in Puvina-posavadangile and made landgrant for its maintenance.[21] Attimabbe, wife of the Cālukya officer Nāgadeva, was a very pious lady. When her husband died in a military campaign she fully devoted herself to the promotion of Jaina faith and built 1500 Jaina temples in different parts of the kingdom.[22] This would have certainly raised her position in the eyes of the people who would have remembered her with great respect. She won the name of Dānacintāmaṇi.[23]

THE GAṄGAS OF TALKĀḌ (WESTERN GAṄGAS)

The ladies of the royal Gaṅga house of Talkāḍ were also of religious temperament and built temples. They had considerable influence on the ruling kings and got donations made by them for the maintenance of these temples. Indeed we learn from the Sūḍī plate of ŚE 860 (AD 938) that 'at Sūṇḍī, the chief (town) of the Suldhāṭavī, the glorious Divaḷāmbā—the one Rambhā of the world—celebrated the sacrificial rites of six female mendicants and caused the famous Jaina temple to be built'.[24] It is also inferred from the grant that Butuga made a donation of land to this Jaina temple.[25] Similarly, an inscription of ŚE 884 (AD 962) reveals that Māra Siṁha II (AD 961-74) granted land to a Jaina temple founded by his mother Padmabbarasi of Koṅguladeśa.[26]

THE ŚĀNTARAS OF PAṬṬIPOMBULCCAPURA

The Śāntaras of Paṭṭipombulccapura (modern Humcha in Shimoga Dist.) built numerous Jaina temples almost exclusively under their royal patronage. In this building activity the ladies of the ruling dynasty did not lag behind. We know that Caṭṭaladevī, sister of Queen Vīramahādevī, who was consort of Vīra Śāntara II, founded the famous Pañcakūṭa-basti (AD 1077) at Humcha in memory of her parents.[27]

THE HOYSALAS AND THE KĀKATĪYAS

The Hoysala king Viṣṇuvardhana with his Jaina Queen Śāntaladevī made a grant to the Śiva temple in full durbar.[28] Likewise, the Kākatīya queen Rudrāmbā granted lands for the upkeep of a Śiva temple.[29]

THE PALLAVAS OF KĀÑCĪ

The Pallava queens, like their consorts, were great patrons of arts and had a commanding influence upon their husbands. This is evident from the fact that Raṅgapatākā, the chief queen of Rājasiṁha (Narasiṁhavarman II AD 695-722), got an independent dedicatory shrine (*nityavinīteśvaragṛham*) built in the celebrated Kailāsanātha temple at Kāñcīpuram founded by her husband.[30] Another queen of Rājasiṁha, whose name is lost, built a similar shrine near that of Raṅgapatākā.[31]

Mādevi, the wife of Kāḍakadiyaraiyar, appears to be a very generous lady as, in the sixth year of the reign of Kampavarman (identified with Nandivarman Tellarrerinda *c.* AD 847-72),[32] she caused the renovation of the Jaina temple (*palli*), the construction of its *mukhamaṇḍapa*, the renovation of the *pāli*, and the construction of a temple for Iyakki-bhaṭāri; she also made the gift of a big bell to the *palli*.[33]

THE IMPERIAL COḶAS

The Coḷas who succeeded the Pallavas in the south carried out a brisk temple-building activity throughout the length and breadth of their empire. This could have been possible due largely to the munificence of such royal ladies as Cempiyanmādevī, Kuntavai and Loka Mahādevī. The most generous and respectable among these was Cempiyanmādevī, queen of Gaṇḍarāditya. Many temples are attributed to her. In the eleventh year of her son Uttama Coḷa (AD 982) she rebuilt the Tirukoṭeśvara temple at Tirukkodikāval. In the twelfth year of his reign (AD 983) she settled a brāhmaṇa colony, established there a village after her name, and built a temple to Śiva which received generous donations and gifts from the royal household. She also constructed in the same year (i.e. AD 983), the *vimāna*, *snāpanamaṇḍapa*, *gopura*, *parivārālayas*, etc., of the Vṛddhagirīśvara temple at Vṛddhācala. In the seventh year of Rājarāja I (AD 991) she built a large temple of Acaleśvara at Tiruvārūr and donated money to meet its daily requirements and repairs. She also built a temple at Tiruvakkaral.[34] In fact, most of the stone temples could attain their final form, during the reign of Uttama Coḷa, owing to the munificence of the queen-mother Cempiyanmādevī.[35]

The pious lady Kuntavai, the elder sister of Rājarāja I (AD 985-

1014) and daughter of Cuntara Coḷa, inspired her brother Rājarāja in performing religious deeds. She has been reverentially mentioned in the great temple at Tanjaur. She herself made a number of gifts to this and other Śaiva temples. Besides, she is said to have founded three Jaina temples, the first at Tirumalai, the second at Dādāpuram and the third at Tirumālavāḍī. Unfortunately they all have disappeared, except for a few *adhiṣṭhāna* mouldings lying in the *prākāra* of the Tirumalai temple.[36] Also at Dādāpuram she erected a Śiva and a Viṣṇu temple in the twenty-first regnal year of Rājarāja I (AD 1006).[37] This generous lady thus built temples irrespective of cult and creed.

Loka Mahādevī, the consort of Rājarāja I, was also a pious lady. She is known to have built the Kṣetrapāla shrine at Tiruvālañjuli in or before AD 1006, and the members of the royal family made donations to the temple.[38]

These munificent religious activities of the Coḷa queens are indicative of the happy position and status which they enjoyed in the royal family. They must have possessed huge amounts of money or rich resources of income which enabled them to finance construction of new temples, renovation of old ones and to make monetary donation for the maintenance and upkeep of functioning temples. The fact that other members of the royal household generally made gifts to the temples constructed by the queens testifies that they genuinely enjoyed a happy and respectable status in the royal family. They must also have been greatly esteemed by the people more so after their munificent religious deeds.

Now, northern India.

THE IMPERIAL GUPTAS AND LATER GUPTAS

Though a large number of inscriptions and temples belong to the Gupta period, we do not know of a Gupta queen who built a temple. From this, however, one should not draw the conclusion that the ladies in the Gupta times did not take part in the temple-building activity. A grant of the feudatory chief Mahārāja Bhūta of the fifth-sixth century AD makes mention of a temple built by his mother Vīrādhyikā.[39] Similarly, the Aphsad Stone Inscription of the Later Gupta king Ādityasena records that Mahādevī Śrīmatī, mother of Ādityasena, founded a *maṭha* (religious college), and Koṇadevī, the queen of Ādityasena, excavated a wonderful tank.[40]

THE PRATIHĀRAS OF KANAUJ

A large number of temples were built during the long and eventful reigns of the Pratihāra rulers of Kanauj.[41] The Pratihāra queens also shared in this activity. At least two temples are safely attributable to them. Queen Jayāvalī built the temple of Parameśvara at Buchkalā-Rājyaghaṅgakam in AD 815 and Queen Citralekhā, the consort of Mahīpāla, constructed the temple of Viṣṇu at Bayana in AD 955.[42]

THE GĀHAḌAVĀLAS OF KANAUJ

Kumāradevī, the Buddhist queen of Govindacandra Gāhaḍavāla of Kanauj (AD 1114-54) seems to be a pious and charitable lady; she restored the image of the 'Lord of the Wheel-of-the-law' (Śrī Dharmacakra Jina) as it existed in the days of Aśoka the Righteous, and placed it in a temple or *vihāra* built by her.[43] This *vihāra* at Sārnāth was a large extensive building stretching more than 700 feet from east to west.[44] The construction and completion of this Buddhist *vihāra* of the aforesaid dimensions is of considerable significance considering the facts that the construction must have involved a huge amount of money and that her husband, Govindacandra, was a Śaiva by faith. Apparently, Kumāradevī was free to adopt any religious faith and possessed much larger amount of money or some regular source of income to spare the sum of money required for the construction and completion of the *vihāra*. Obviously, she had great influence on her husband.

THE CANDELLAS OF JEJĀKABHUKTI

The Candellas of Jejākabhukti were great builders and connoisseurs of arts and letters. One of the finest groups of temples was produced at Khajurāho under their patronage. Some of the Candella rulers like Yaśovarman, Dhaṅga, Vidyādhara, etc., are credited with the construction of some temples there.[45] But not a single Candella lady is so far known who built a temple at Khajurāho. Though the actual evidence is wanting, the Candella queens must have inspired their consorts and themselves participated in this temple-building activity. In fact, the Ajaygadh Rock Inscription of Vīravarman and his wife Kalyāṇadevī of VE 1317 (AD 1259) records the construction of a well, a hall (*maṇḍapa*) and a tank within the fort of Nandipura, by the chief queen of Vīravarman, named Kalyāṇadevī.[46]

THE KESARĪ KINGS OF ORISSA

In Orissa, the evidence of women's patronage to religious architecture goes as far back as the time of King Khāravela when his chief queen excavated the caves known as Svargapurī or Vaikuṇṭhapurī at Udayagiri. Subsequently, we know of four Bhauma or Kara queens ruling the State one after the other.[47] But surprisingly enough, the evidence of women's patronage to temple architecture during the period, when a large number of temples of various sizes and of fine workmanship were being built by the Kesarī rulers, is very meagre indeed. One solitary inscription belonging to the reign of king Uddyotakesarī (c. AD 1055-88) records that the temple of god Brahmeśvara (the present Brahmeśvara temple at Bhubaneswar) was built by Kolāvatī, mother of Uddyotakesarī, in the eighteenth year of the latter's reign.[48] The portrait of this pious lady is probably carved on the southern facade of the *jagamohana* of this temple.[49] As is known from *Mādalāpañji* she probably also erected the *jagamohana* of the Liṅgarāja temple.[50]

THE PARAMĀRAS OF MALWA

The records of woman patronage to temple architecture during the rule of the Paramāras of Malwa are very scanty. There is only one inscription of AD 1042 which mentions that Queen Lāhiṇī, the younger sister of Pūrṇapāla and widow of King Vigraharāja of Vasantgarh restored an ancient temple of the Sun god and excavated a tank at Vasantgarh.[51] This event falls in the reign of Bhoja (c. AD 1000-55) who was a great builder and lover of art.

THE KALACURIS OF TRIPURĪ

The Kalacuri queens exercized considerable political and religious influence in the deliberations of the state affairs. They not only built temples to deities whom they adored but also made landgrants, of course with the consent of the ruling kings, for their proper maintenance. Thus, Nohalā, the queen of Yuvarajādeva I (second quarter of the tenth century AD), built a lofty temple of Śiva under the name of Nohaleśvara and endowed it with the gift of several villages. Similarly, in AD 1155, the dowager queen Ālhaṇadevī, widow of Gayakarṇa, constructed at Bherā-Ghāṭa a temple of Śiva under the name of Vaidyanātha together with a *maṭha* or monastery of wonderful

storeys, and a lecture-hall, and attached to the religious complex a line of gardens and two rows of rooms. For the maintenance of these she granted the income of two villages which were placed in charge of the Pāśupata ascetic Rudrarāśi of the Lāṭa lineage.[52]

THE CAULUKYAS OF GUJARAT

The period of Caulukya sovereignty in Gujarat from about the middle of the tenth century to the end of the thirteenth century AD is marked with a prolific temple-building activity. It was due indeed to the active patronage of the Caulukya rulers and their consorts that such wonderful temples as those standing at Abu, Kumbharia, etc., could come into existence. The Caulukya queens must always have variously prompted their consorts for this activity. An inscription of VS 1297 (AD 1240) informs us that Tejapāla caused the construction of two niches in the Lūṇavasahī at Abu for the spiritual welfare of his second wife Suhaḍādevī.[53] The women in the Caulukya kingdom built independent shrines also. Nīttaladevī built a temple to Pārśvanātha at Pataḍī.[54] Sometime before AD 1136 Hānsī Bāī added a *maṇḍapa* to the extant Neminātha temple at Kumbharia.[55] Sumaladevī, the daughter of Lavaṇaprasāda and the second queen of Bhīmadeva II, erected the Sumaleśvara temple sometime before AD 1239.[56] The Caulukya queens are also known to have excavated some wells and tanks. A lake at Aṇahilapāṭaka was excavated by Udayamatī, queen of Bhīma I (*c.* AD 1023 to 1065), which was regarded better than even the Sahasraliṅga lake excavated by the great Siddharāja.[57] Udayamatī is also credited with the digging of a well at Aṇahilapāṭaka[58] which is still going by the name of 'Rānī kī vāva'. Mayaṇallādevī, the queen of Karṇa (*c.* AD 1065-93) and the daughter of the Kadamba king Jayakeśin of Goa, was not only an able administrator as she acted as a regent for her minor son Siddharāja for sometime but also an interestingly benevolent lady as she caused the excavation of the Mansar lake at Viramgam which resembles a conch and still carries 357 small temples, out of the original 520, along its surrounding *ghāṭ* or flight of stone steps leading down to the water.[59]

Thus, this brief survey of the temple-building activity both in the south and north clearly evinces active participation of women, particularly those of the ruling families, in constructing temples right from the time of the Ikṣvākus down to the rule of the Kākatīyas

in the south and from the days of the Guptas down to the times of the Caulukyas, Candellas, etc., in the north. But for the contributions made by these ladies the religious and artistic activities in the country would not have been so sustained, continuous and richly variegated. As it has been seen, these lady patrons independently undertook construction of large edifices and lofty temples and they were successfully completed. They also made complimentary contributions to large-scale projects undertaken by ruling monarchs. They also added new component buildings to the existing establishments either to fulfil the latter's additional religious requirements or for their beautification. At certain times when the ruling monarch was continuously engaged in various wars the queens appear to have made offerings of temples to various gods both as his consorts deeply concerned with the welfare of the State and also as his representative, considering the magnitude and grandeur of the temples that they have built.

As already noted, a significant point the present survey highlights is that the ladies of the royal houses were free in following any religious faith of their choice which may even be different from that of their husbands or kings (e.g. the Gāhaḍavāla queen Kumāradevī) and further that their independent decision in this respect did not affect their relationship or the position and status in the royal family. Had this not been the case their donations would not have been as munificent and liberal as they were.

Their patronage to temple building art indicates that some of them at least (e.g. the Cālukya queen Lokamahādevī, the Coḷa queen Cempiyanmādevī, the Kalacuri queen Ālhaṇadevī, the Gāhaḍavāla Kumāradevī, etc.) were in possession of huge amounts of money, or controlled such regular and rich resources of income that they could undertake big building projects of great artistic merit and carry them to successful completion.

A consideration of the total evidence on the point suggests that all the ladies must have possessed money and wealth which they could freely use for such works of religious merits as renovation of a temple, addition of a *maṇḍapa* to an existing temple, excavation of a tank, etc.

The patronage of the ladies to temple art may also be taken to reflect their inner personality. They seem to have been well educated women upholding religious and spiritual values and endowed with generosity, liberality and devotion to well-being of all. Considering the successful completion of some of the lofty large temples, one

cannot help feeling that they possessed to some extent capability to manage and control such large projects. Further, when one looks at such a large as well as magnificent temple as the Virūpākṣa at Paṭṭadakal, remarkable for its perfected balance and form and decorated with highly lively and graceful figures and tenderly executed charming creepers and designs, one cannot fail feeling that certain ladies like Lokamahādevī were gifted with artistic genius and refined aesthetic taste, whatever their share in the conception and execution of the temple.

It has been noted that on requests of the queens the kings have granted lands and villages for the maintenance and upkeep of certain temples. This presupposes that the queens enjoyed honorable position and status in the family and in a natural way exercized due influence on the ruling king.

Therefore, it may be concluded that the princesses and girls of higher class well-to-do families received adequate education and training and consequently were nicely accomplished and cultured ladies possessing refined taste and administrative ability. They had a regular source of income and possessed wealth, and they were free to expend it on meritorious and charitable works as they desired. This presupposes their happy position and their respectable status in the family.

NOTES

1. T.N. Ramachandran, 'Nāgārjunakoṇḍa—1938', *Memoirs of the Archaeological Survey of India*, no. 71, Delhi, 1953, p. 5.
2. K. Murthy, *Nāgārjunakoṇḍa—A Cultural Study* (Delhi, 1977), p. 10.
3. J. Ph. Vogel, 'Prakrit Inscriptions from a Buddhist Site at Nagarjunikonda', *E.I.*, vol. XX (1929-30), rpt., Delhi, 1983, pp. 4, 19; J. Ph. Vogel, 'Additional Prakrit Inscriptions from Nagarjunikonda', *E.I.*, vol. XXI (1930-1), rpt., Delhi, 1983, p. 65.
4. Ibid.
5. Murthy, op. cit., p. 5.
6. *E.I.*, vol. XX, pp. 14, 22-3; D.C. Sircar, and A.N. Lahiri, 'Footprint Slab Inscription from Nagarjunikonda', *E.I.*, vol. XXXV, Delhi, 1960, pp. 248-9.
7. H. Sarkar, 'Some Aspects of the Buddhist Monuments at Nāgārjunakoṇḍa', *Ancient India*, no. 16, New Delhi, 1962, pp. 69, 84.
8. *E.I.*, vol. XX, pp. 15, 23-4; *E.I.*, vol. XXI, pp. 61-2.
9. *E.I.*, vol. XX, pp. 15, 24-5; *E.I.*, vol. XXI, p. 65.

WOMEN'S PATRONAGE TO TEMPLE ARCHITECTURE 297

10. *E.I.*, vol. XXI, pp. 63-4.
11. *E.I.*, vol. XX, pp. 13-14.
12. M.S. Nagaraja Rao, 'Chalukyan Queens', *The Chalukyas of Badami* (Seminar Papers), Bangalore, 1978, p. 166.
13. J.F. Fleet, 'Sanskrit and Old Canarese Inscriptions', *Indian Antiquary*, vol. X, rpt., Delhi, 1984, p. 164.
14. J.F. Fleet, 'Paṭṭadakal Pillar Inscription of the time of Kīrtivarman II', *E.I.*, vol. III (1894-5), rpt., Delhi, 1979, pp. 6-7.
15. *The Chālukyan Architecture* (Calcutta, 1926), p. 60.
16. H. Sarkar, in *Encyclopaedia of Indian Temple Architecture* (hereafter *EITA*), vol. I, Pt. II, text, ed. by M.W. Meister and M.A. Dhaky (Delhi, 1986), p. 98; R.S. Gupte, *The Art and Architecture of Aihole* (Bombay, 1967), p. 6; D.C. Sircar, in *The Classical Age*, ed. by R.C. Majumdar (Bombay, 1970), pp. 246-7.
17. K.V. Soundara Rajan, in *EITA*, vol. I, Pt. II, text, p. 163; D.C. Sircar, in *The Classical Age*, p. 251.
18. D.C. Sircar, in *The Classical Age*, p. 253.
19. A.S. Altekar, *The Rāṣṭrakūṭas and Their Times* (Poona, 1934), p. 273; see also A.S. Altekar, in *The Age of Imperial Kanauj*, ed. by R.C. Majumdar (Bombay, 1964), pp. 16-17.
20. U.N. Ghoshal, in *The Struggle for Empire*, ed. by R.C. Majumdar (Bombay, 1966), p. 280.
21. S.L. Shantakumari, 'Women in the days of Chalukyas of Kalyāṇa', *The Chalukyas of Kalyāṇa* (Seminar Papers), ed. by M.S. Nagaraj Rao, (Bangalore, 1983), p. 168.
22. Ibid.
23. Ibid.
24. J.F. Fleet, 'Spurious Sudi Copper-Plate Grant Purporting to have been issued by Butug in Śaka Saṁvat 860', *E.I.*, vol. III (1894-5), rpt., New Delhi, 1979, p. 184.
25. K.V. Soundara Rajan, in *EITA*, vol. I, Pt. II, text, p. 186.
26. Ibid.
27. M.A. Dhaky, 'Śāntara Architecture', *Aspects of Jaina Art and Architecture*, ed. by U.P. Shah and M.A. Dhaky (Ahmedabad, 1975), pp. 191-2.
28. S.K. Aiyangar and R.C. Majumdar, in *The Struggle for Empire*, p. 229.
29. U.N. Ghoshal, in *The Struggle for Empire*, p. 511.
30. E. Hultzsch, 'The Pallava Inscriptions of the Kailāśanātha Temple at Kāñcipuram', *South Indian Inscriptions*, vol. I, rpt. (Varanasi, 1972), no. 20, p. 24.
31. Ibid., no. 30, p. 24. See also K.R. Srinivasan, 'The Pallava Architecture of South India', *Ancient India*, no. 14, Delhi, 1958, p. 135.
32. D.C. Sircar, in *The Age of Imperial Kanauj*, p. 168.
33. K.G. Krishnan, 'Jaina Monuments of Tamil Nadu', *Aspects of Jaina Art and Architecture*, pp. 90-1.

34. M.A. Dhaky, in *EITA*, vol. I., Pt. I, text, ed. by M.W. Meister (Delhi, 1983), pp. 184-5, 191-2.
35. Ibid., p. 196.
36. R. Nagaswamy, 'Jaina Art and Architecture under the Coḷas', *Aspects of Jaina Art and Architecture*, pp. 131-2.
37. Ibid., p. 101; K.R. Srinivasan, *EITA*, vol. I, Pt. I, p. 231.
38. K.R. Srinivasana, in *EITA*, vol. I, Pt. I, pp. 227-8.
39. S. Goyal, *Inscriptions of the Gupta Age* (Meerut, 1984), no. 74, p. 368.
40. J.F. Fleet, *Corpus Inscriptionum Indicarum*, vol. III, rpt. (Varanasi, 1963), p. 208.
41. Krishna Deva, *The Temples of North India* (New Delhi, 1969), pp. 21-7.
42. B.N. Puri, *The History of the Gurjara Pratihāra* (Bombay, 1957), p. 156.
43. D.R. Sahni and J. Ph. Vogel, *Catalogue of the Museum of Archaeology at Sarnath*, rpt. (Varanasi, 1972), Intro. p. 7.
44. N.N. Das Gupta, in *The Struggle for Empire*, p. 422.
45. Krishna Deva, op. cit., pp. 62-4.
46. S.S. Mitra, *The Early Rulers of Khajuraho* (Calcutta, 1958), p. 136, no. 52.
47. K.C. Panigrahi, *Archaeological Remains at Bhubaneswar* (Calcutta, 1961), p. 203.
48. Ibid., p. 43; S.K. Saraswati, in *The Struggle for Empire*, pp. 211 and 546.
49. Panigrahi, op. cit., p. 118.
50. Ibid., p. 248.
51. P. Bhatia, *The Paramāras* (New Delhi, 1970), p. 168.
52. V.V. Mirashi, *Corpus Inscriptionum Indicarum*, vol. IV, Pt. I (Ootacamund, 1955), p. clix.
53. Jayantavijay, *Arbudācala Prācīna Jaina Lakhasaṁgraha, Ābū*, vol. II, (Ahmedabad, 1936), nos. 261 and 262.
54. H. Singh, *Jaina Temples of Western India* (Varanasi, 1982), p. 12.
55. Ibid., p. 192.
56. M.A. Dhaky, 'The Chronology of the Solanki Temples of Gujarat', *Journal of the Madhya Pradesh Itihasa Parishad*, no. 5, Bhopal, 1961, pp. 62 and 81.
57. A.K. Majumdar, *Chaulukyas of Gujarat* (Bombay, 1956), p. 56.
58. Ibid.
59. Ibid., p. 390.

The World of the Bhaktin in South Indian Traditions— The Body and Beyond

Uma Chakravarti

The problem of the relationship of woman to god is an important aspect of understanding gender relations in any society. There is much cultural variation even within India. The need for historical investigation into its past is thus that much greater. The rich tradition of *bhakti* is particularly significant for women both for variations and commonalities in its social and religious implications. Here the dominant brahmanical ritual world is attempted to be turned upside down, boundaries operating in the social world collapse, and the shackles imposed by a rigidly hierarchical social order are stretched to provide breathing space for some men and women.[1]

The dissent movements of the sixth century BC had virtually accompanied the construction of a caste, class, and gender stratified social order. The question of women's place in the search for salvation had surfaced among all religious currents but especially in the dissent movements, and attempts to resolve it had led to a plurality of situations. Buddhism, for example, was forced to concede, somewhat grudgingly, space to women and provide an institutional means for them to pursue their religious goals.[2] However, this accommodation had been made within the social (i.e. non-*gṛhastha*) world of the Buddhist *saṁgha*. In one sense *bhakti* was a continuation of this tradition but it also represented a significant departure because it collapsed the distinction between the world of the *gṛhastha* and the world of the *bhikṣu/saṁnyāsī*. This was another reason why the experience of *bhakti* was vastly different from that of Buddhism.

Our focus here will be on the experience of the *bhaktins* (in the widest sense) in south India. We will draw in particular on the accounts of Āṇṭāḷ, Avvaiyār, Kāraikkāl Ammaiyār and Akkā Mahādevī to consider the nature of the *bhakti* experience and the space it

provided to women to expand both their own selfhood and conventional gender and social relations; finally, we will consider the manner in which the female body shaped and impinged upon the identity of the *bhaktins*. Our text here will be the hagiographies of the women and the songs they created and passed on to us.

The earliest of the four women saints in south India that we will focus on is Avvaiyār. The society in which she lived is identified in south Indian history as the Caṅkam period, during which time a number of major poets flourished. In the closing years of the Caṅkam age seven warrior chiefs are reputed to have provided sustained patronage to the poverty stricken Tamil poets and earned their gratitude, as expressed in many of the compositions of the poets. The political hierarchy in the Tamil region indicates two levels, the hill chieftains and the three great Tamil kings. The Tamil poets of the Caṅkam age are linked to the second tier, the hill chieftains who were hostile to the three great Tamil kings.[3] Some of the poets, including Avvaiyār, seem to have thrown in their lot with the smaller chieftains against the mightier kings.

There is a fairly well established tradition of many Avvaiyārs associated with Tamil literature and it appears that the name may be a generic term used for any elderly wise woman.[4] The earliest of Avvais lived in the Caṅkam age and the legend associated with her birth is important so it is worth recounting in some detail.[5] Avvai was the daughter of an outcaste woman called Ati and a brāhmaṇa named Pakavan. According to a popular legend, when Pakavan was still a baby, his father discovered, through the child's horoscope, that he would some day marry a low caste girl. Horrified at such a prospect, the father left home on a pilgrimage. The mother then tended carefully to the child's education and the boy grew up to be a fine specimen of a learned brāhmaṇa. At this stage Pakavan discovered why his father had left his mother and equally horrified at the prediction, he too left home on a pilgrimage.

On his way he came across a low caste girl. Angry at the girl's intrusion into the place where he was cooking, he threw a stone at the girl's head. The crying girl hastily scurried off to her adopted father, a brāhmaṇa, who lived in the neighbouring village, and Pakavan proceeded on his pilgrimage. By the time he returned the low caste girl had grown into a beautiful and unrecognizable woman. Pakavan was quite willing to accept the brāhmaṇa father's proposal but as the marriage ritual was being completed Pakavan realized that the girl

he was tying himself to was the low caste girl he had encountered earlier. He then tried to escape from the marriage but was persuaded to accept the woman which he did on the condition that she abandon each child born to them wherever they might be in their travels. The woman reluctantly consented and the first of seven such abandoned children was Avvaiyār. Three boys and three other girls were similarly abandoned. As each one was abandoned the mother wailed: 'Oh, who will take care of my babe' and in each case she received a wise and encouraging answer from the infant concerned. These sayings are supposed to have survived as the 'Songs of the Seven.'

Each of the seven abandoned children was adopted by a different family. Avvai was adopted by a family of *pāṇars*, whose traditional vocation was to sing, especially in praise of the king. The next child, a girl, was brought up by a washerman's family and she too, like Avvai, distinguished herself through her poetry on ethics and was deified on her death under the title of Māriyammai. Next to be abandoned was Atiyamān, the eldest of the boys. He is associated with Avvai's life. Atiyamān was known for his patronage of the Tamil poets. The fourth child, a girl named Uruvai, was brought up by a family of toddy dealers and distinguished herself as a dancer and poetess. The fifth child was Kapilar, who was brought up in a brāhmaṇa family. When he was seven, he had to be invested with the sacred thread but the assembled brāhmaṇas refused to do so on the ground that Kapilar was not born a brāhmaṇa. The boy then recited a verse in which he defined superiority in caste as being determined by good deeds. The shamed brāhmaṇas then proceeded with the investiture. The sixth child, a girl, was named Valḷi and was brought up by a family of basketmakers. The last child was a boy who also came to be the most reputed of the seven children. He was brought up in a *Vēḷāḷa* household but as the relatives objected to his presence, he was actually reared by a low caste family. This child named Tiruvaḷḷuvar composed the famous *Tirukkural*.[6]

When Avvaiyār was still a small child she startled her parents by completing half-finished compositions, thus exhibiting a wisdom far beyond her years. When Avvai grew up to womanhood a marriage was proposed. Avvai was dismayed and her girlhood friends expressed the inevitable dilemma of a woman who was immersed in her devotion to her god: how could one serve the lord and a husband at the same time? Avvaiyār resolved the dilemma of young womanhood by seeking a drastic solution in order to avoid marriage: she sought

an end to her youth and beauty. In her own words she stated the problem to Gaṇeśa thus:

> Should I marry and experience family life?
> Why did you give me this charm and beauty?
> Only good things should emanate from my lips
> Grant me the boon of birthlessness. . . .[7]

Immediately, Avvai was transformed into an old woman and was thus released from the requirement of marriage. As she adopted the life of a wandering teacher she told the assembled people that she was not meant for family life; just as her adopted mother had looked after her in her orphaned state, she too must do the same for her people.

Avvai now began to wend her way up and down the land, travelling all alone even at night, going far beyond the limitations of a minstrel expected to sing praises of the king, scattering the gems of her aged wisdom as she went about. One of her special titles was 'she who sang for a meal.' Her forte was education, particularly of the young.

In the course of her career as a woman of wisdom, Avvai is said to have composed thirteen books, including one on materia medica, one a panegyric on a wealthy merchant, and one on metaphysics.[8] The remaining ten works are collections of ethical sayings. One of them, the *Ātticcūṭi*, contains 108 maxims which at the same time teach the Tamil alphabet.[9] From her own statements it is clear that Avvai, famed for her wisdom, placed learning above everything else. Invoking Vināyaka's blessings, Avvai asked for proficiency in the threefold classical Tamil.[10] In consonance with her mixed background, Avvai, along with other poets, was critical of rigid social divisions. Accordingly, she wrote: 'There are on earth only two castes, those who give (alms) are noble, those who do not give, are low.'[11]

The attachment to form also received her attention. On one occasion, a temple priest rebuked her for stretching her feet towards the idol. Avvai's sharp response was to ask in which direction god was not present so that she might stretch her feet in that direction![12]

She is critical too of greed when she states with simple directness: 'A measure of rice per day and four cubits of cloth are all that man needs; but how his thoughts run in crores. Like a mud pot, the life of such blinded men is one misery till death.'[13] Her attitude to

women however was conventional, as indicated in this statement. 'Moderation in food is an ornament to women',[14] or 'The home is truly blessed in all, where wife obeys her duty's call',[15] or 'womanhood by chastity becomes admirable'.[16] Good wives, who are loyal to their husbands, have great powers because they cause the rains to fall, in Avvai's view. The ethics of a household is clearly based on the good wife as its focal point.

The striking feature of Avvai's own life, however, was her association with kings, chieftains and secular power, generally. Her skills in this area were considerable, since she was deputed by her patron, the chieftain Atiyamān as an emissary to the court of Toṇṭaimān of Kanchipuram. According to tradition, she once addressed the three crowned heads of the Tamil country and advised them to do good.[17] The good protective heroic king was a very important theme in her poetry as is evident in one of her poems on Atiyamān (Añci):

. . . Añci, man of many spears,
is at battle . . .
He has the strength
to protect and care
though the times are troubled.
Bless him,
his works.[18]

Similarly, Avvai says:

My king, when rich, freely gives food away
When poor, he messes with his men
He is the head of the family of the poor
Yet great is he with his sharp pointed spear[19]

After the death of her patron Atiyamān (who, according to tradition, was also her brother), Avvaiyār wandered all over the Tamil region. She herself had received the *nelli* fruit, which gave her immortality, from Atiyamān, who had procured it for her from an inaccessible place.[20] The chieftains vied with each other to hold her down to their kingdoms but she refused to be bound thus, saying: 'I hated youth and accepted old age. Is it right to bind me in one place?'[21]

In the course of her travels, she met her brother Tiruvaḷḷuvar and

helped him gain access to the prestigious Caṅkam or gathering of poets at Madurai. She lived the life of a wandering minstrel for 240 years and then voluntarily retired from the earth. On one of her last sojourns, Murugan appeared to her as a young boy and made her aware that despite her deep knowledge, her learning was only a drop in the ocean and that she had much yet to learn. She then made her *mahāprasthānagamana* and ascended to heaven.

Tradition associated with the life of Avvai's brother Tiruvaḷḷuvar is significant as a counterpoint to Avvai's life. While the two shared a common parentage and expressed themselves essentially as poets of an ethical code, their careers were vastly different. Reared by a low caste family, Tiruvaḷḷuvar took to weaving when he grew up and was a firm advocate of the virtues of a domestic life, especially if one could find a virtuous wife.[22] Luckily for him, he found an ideal wife in Vāsukī who was the embodiment of all that was required to help a man in the householder's life.[23] To ensure a perfect arrangement, Tiruvaḷḷuvar put Vāsukī through a test which, in legend, is a common test for brides: he promised to marry her if she could take sand and make it into rice for him. Vāsukī took the sand, feeling sure that what Vaḷḷuvar ordained must be possible, and having power with the gods, succeeded in bringing him the rice he wanted. Having passed the test she became his faithful and obedient spouse.[24]

To those who were confused about the relative merits of the domestic life *vis-à-vis* the life of an ascetic, Tiruvaḷḷuvar provided a demonstration of which was superior. One such inquirer watched a display of a series of instances in which Vāsukī provided evidence of unflinching devotion and unquestioning obedience. The inquirer then understood that 'where such a wife is found domestic life is the best. Where such a wife is not, the life of an ascetic is to be preferred'.[25]

In such an idealised domestic setting, Tiruvaḷḷuvar composed an ethical treatise for the good of the world, focusing on virtue, wealth and pleasure. Persuaded by his friends to present the treatise at the Caṅkam of learned poets, he left Vāsukī at home and wended his way to Madurai. On the way, he met Avvai who accompanied him.[26] Together, he, Avvai and another young poet humbled the conceit of established poets. It was here that Tiruvaḷḷuvar presented the *Tirukkural*, a work considered the perfect code of morals for the universal man as well as for the State. It propounds an ideal monarchy, with ideal householders and true ascetics. The householder leads a

virtuous life doing his duty to every living being and to his ancestors. His wife, the glory of his home, is modest, frugal, adores her husband, and is the guardian of his house's fame.[27] Having established his work, he returned to the adulation of his townsmen and resumed his homely life of 'exemplary virtue' with Vāsukī. The virtuous Vāsukī had, however, silently carried within her, from the day of her marriage, a question which revealed itself in her eyes as she lay on her deathbed. Tiruvalluvar noticed her expression, sought the unspoken question and then gave her the explanation for an action she had performed for her husband everyday in her life without knowing why it was to be done. He had asked her, on their wedding day, always to give him a needle and a glass of water with each meal. This was so that he could use the needle to pick up a grain of rice if it fell, and drink the water before the meal so as to eat in moderation. Satisfied, with the answer, she confidently went to heaven. That night Valluvar recorded his recognition of Vāsukī:

> Sweet as my daily food! O full of love! O wife
> Obedient even to my word! Chafing my feet,
> The last to sleep, the first to rise, O gentle one!
> By night henceforth, what slumbers to mine eyes?[28]

He then buried her 'sacred' body in the sitting posture, a practice normally associated with ascetics. Tiruvalluvar survived his wife for many years and continued to perform many glorious deeds before he too passed away.

The biographies of Avvai and Tiruvalluvar provide an interesting contrast, in that Avvai cannot reconcile a wifely role with that of a wandering teacher, cannot reconcile devotion to a cause with service to the husband. In Tiruvalluvar's case, there is no need to reconcile anything; indeed, his stable sagely existence is predicated upon the unqualified devotion he is given by his wife. There is also a contrast between Avvai and Vāsukī, between the woman who has moral authority outside the home and the woman whose moral virtue within the home releases the creative potential of the greatest sage of his time.

In the second phase of Tamil literature (c. AD 600) an important contribution was made by Kāraikkāl Ammaiyār, a devotee of Śiva. Kāraikkāl Ammaiyār is not known outside the Tamil area, but within

it she has left an enduring imprint, some of which is visible even today in the many images her life inspired. She composed a long poem of 100 verses titled *Arputa Tiruvantāti* expressing her devotion to Śiva, a work which is considered capable of moving people to tears.[29]

She was born, according to the *Periyapurāṇam*, in the famous seaport town of Karaikkal inhabited by wealthy merchants. One such merchant named Tānatattan performed great austerities and was blessed with a beautiful daughter whom he named Punītavatī, meaning the immaculate one. From her earliest days, she was deeply devoted to Śiva, the study of religious literature and the service of *bhaktas*. When Punītavatī reached marriageable age, she was married to a young man from Nagapattinam but since her parents were reluctant to be parted form her, the husband was persuaded to reside in Karaikkal.[30]

Early in the marriage, Punītavatī's absolute devotion to her god was tested when she gave away one of the two choice mangoes sent home by her husband, for his own consumption, to an aged *bhakta*, since she had not yet cooked the midday meal. At lunch time, the husband, having eaten the tasty mango served to him asked for the second one also. Punītavatī was unable to reveal what had become of it, and went in as if to fetch it. Her distressed mind automatically sought the feet of Śiva, who came to her rescue, and Punītavatī found a ripe mango in her hand. She served this to her husband but he noted at once its unique sweetness and sought an explanation from Punītavatī, who revealed the truth to him. Unconvinced by her explanation, the husband mockingly proceeded to test her powers. As Punītavatī provided him with a demonstration by producing yet another mango, he became terrified of her awesome display;[31] obviously a mere housewife could not possess such powers, in his view.

Overawed, and deeply perturbed by his wife's supernatural powers and convinced that she was no 'ordinary' woman, he left home without informing anyone, at the earliest opportunity, to seek an ordinary existence elsewhere. He remarried and named his daughter after his former wife. Punītavatī's family at last discovered his whereabouts and took her to him, but the husband fell at her feet and proclaimed that she was no ordinary woman. Immediately, Punītavatī prayed to Śiva, telling him that her husband needed nothing more from her, and since his words had released her, she now no longer

needed her beauty of form. She besought the lord to transform her into a demoness who could thenceforth 'stand by God in prayer' like the ghouls who worship at Śiva's dancing feet in the burning grounds.[32] Śiva fulfilled her wish and the beautiful Punītavatī was metamorphosed into the emaciated figure thenceforth known as Kāraikkāl Ammaiyār. As she moved about in her new form, the world fled from her presence. No longer encumbered by the weight of her flesh (and beauty of form) she immediately made a trip to mount Kailāsa, the abode of Śiva and Umā. Hesitating to defile holy ground with her feet, she is said to have walked on her hands into the presence of the lord, a strange scene depicted on many stone reliefs.[33] Even Umā, who had been through great austerities to gain Śiva as a husband, marvelled at Kāraikkāl Ammaiyār's devotion. Śiva welcomed her with love and understanding and she responded delightedly, addressing him as Appā (father). She then begged Śiva for an end to rebirth and also requested that in her present birth, she might sing his praises and find her sole refuge at his feet. The lord directed her to go to Tiruvālaṅkāṭu, the sacred banyan forest, where she could see his *tāṇḍava*. After many days of waiting, the lord appeared to her there and danced the *tāṇḍava* with her under his feet, while her songs resounded in the forest.[34]

A selection of her verses in the *Arputa Tiruvantāti*, composed at Alaṅkāṭu, provides an insight into the essence of her devotion and the range of her emotions:

> Ever since I learnt to lisp after my birth
> My love to thee has increased, I reached thy feet,
> O! God of Gods, with throat of shining blue,
> When wilt thou rid me of my pain?
> Even to seven births am I his slave
> Ever my love is fixed on him, nought else,
> To him whose coral braids are covered with buds,
> And to none else shall my service be due.
> My father own so sweet to me, my lord.
> Him I treasured in my heart always.
> Him as my lord I owned and owning him
> My heart rejoiced.[35]

Visualizing the beautiful dancing of Śiva at Alaṅkāṭu Kāraikkāl Ammaiyār sang:

The ground is damp with liquid marrow
Skeletal ghouls with sunken eyes jostle and elbow
looking furtively around them
Extinguishing the fires
they eat half burnt corpses
There in that menancing forest
holding fire in his hands
dances our beautiful lord.[36]

Identifying herself with the ghouls who inhabit the cremation grounds she signs herself Kāraikkāl *pey* (ghoul):

Sagging breasts and swollen veins
protruding eyes, bare white teeth.
Skeletal legs and knobbly knees
has this female *pey*
She lingers, weeps and wails
and wanders aimless in the forest—
There, holding fire but cool of limbs
with matted hair in all directions
Śiva dances his cosmic dance—
this forest
this sacred Alaṅkāṭu
is the home of our supreme lord.[37]

Kāraikkāl Ammaiyār's Alaṅkāṭu poems are not set to music nor are they chanted in temples;[38] they were too strange and forbidding for inclusion in the normal world of worship. But her unique experience has left a tremendous impact upon the average devotee, who could not but be fascinated by the awesomeness of a devotion that led her to reject the beauty of the female body and the external environment, both of which were unnecessary to her in feeling the presence of the lord.

Āṇṭāḷ's origins were mysterious as she appeared in the *tulasī* bushes and was brought up by a bachelor saint named Periyālvār who was a priest in a temple. When she grew up she refused to be married to anyone but Viṣṇu for whom she was already expressing her love in an unorthodox manner which was perfectly acceptable to the lord. When she was 16, her father escorted her to the Srirangam temple,

where Āṇṭāḷ was married to Viṣṇu, and then immediately mysteriously absorbed into a stone replica of her beloved.

Āṇṭāḷ composed two poetic works, one the famous *Tiruppāvai* representing her girlhood sentiments for Kṛṣṇa. This work has been incorporated into Vaiṣṇava temple rituals. The *Nācciyār Tirumoḷi*, on the other hand, is a less known work, where Āṇṭāḷ expresses her feelings for the lord in more explicitly erotic terms.[39] This work has now been marginalized, except for a section that describes Āṇṭāḷ's dream of her marriage with the lord, which has been incorporated in the marriage rituals of the Śrī Vaiṣṇavites. Āṇṭāḷ has come to be regarded as Bhūdevi, consort of Viṣṇu.[40]

Akkā Mahādevī was a great devotee of Śiva and was initiated into worship at a very early age by an unknown *guru*. This, for Akkā Mahādevī, was the real moment of her birth. When she grew up into a beautiful young woman, the chieftain of the land, named Kauśika, saw her and fell in love with her. He was an unbeliever but he managed to become her husband, partly through a show of force. The use of coercion and the attempt to subjugate her will appears to have been a continuing feature of this unsatisfactory marriage, since Akkā Mahādevī set conditions on Kauśika's relations with her. Kauśika comes through in the narrative as the archetype of a sensual man. Matters came to a head when Akkā Mahādevī threatened to leave him if he forced himself on her, and actually walked out on him when he persisted in violating her.[41]

Akkā Mahādevī's future life was consistent with her spirited rejection of existing marital relations. Throwing away her clothing, she braved unwanted male attention as she began her religious wanderings, until she finally found kindred spirits amongst a company of saints. It was these saints who ultimately helped her consummate her love for Śiva by arranging her real marriage, a marriage of her choice, to him. She died in her early twenties, becoming one with Śiva at Śrīśaila.[42]

A reading of the lives and of the poetry of the south Indian *bhaktins* reveals a difference between the experience of *bhakti* for the *bhakta* and the *bhaktin* in the arena of marriage. An important dimension of the *bhakti* movement, as we had stated earlier, had been the breakdown of the householder and renouncer divide that had been an inherent aspect of the earlier dissent movement against brāhmaṇism. In the *bhakti* movement, there was no contradiction in the pursuit of *bhakti* and the life of the *gṛhastha*. In practice, however, the collapsing

of such a boundary operated only in the case of men. For women, the dichotomy persisted and the tension between marriage and devotion to a personal god was never successfully resolved. All the *bhaktins* negotiated the institution of marriage in some way or the other. We have no equivalent among the *bhaktins* of the normal male *bhakta*, of someone like Tiruvaḷḷuvar, for example, who was a great devotee and a good householder at the same time.

Thus, all *bhaktins* protest marriage to a mortal man; some then end up marrying the god of their choice. In an extreme situation, a *bhaktin* like Āṇṭāḷ might even threaten self-extinction if forced into marriage with a mortal man.

The problem posed by marriage in the case of women saints is articulated very early in the south Indian tradition by the *sakhīs* of Avvaiyār. 'Will you serve your husband or will you serve your lord?' ask the girls when there is talk of marriage for Avvai. The possibility of opting out of marriage as a conscious choice made by a young woman does not seem to be available to Avvai because she seeks a drastic solution to marriage and is turned into an old woman. Released thus, Avvai wanders up and down the land much like the *bhikṣus* of the Buddhist *saṁgha* and proceeds to do what she really wants, which is to educate the people. This is something that the male *bhaktas* can do even in their *gṛhastha* situation.

Outside of marriage, and especially as an old woman, Avvai gains a moral authority which is normally the preserve of men. The place that she wrenches for herself is not just one where she can create beautiful songs, recording her devotion to god, but includes the right to teach, to formulate a code of ethics, to assume a position of authority over men.

A crucial aspect of the transformed role Avvai gains outside of marriage is that her world is not circumscribed by religious ends: Avvai retains a hold on the lay world, on the very world of householders from which she has opted out. Her attention is thus focused equally on the inner world of the home, on the everyday relations between people, and finally even on political power. With the last, Avvai transcends the conventional limitations on the *bhikṣu* of having to withdraw from the familial, social and political arena, a limitation which was central to Buddhism. That this was perceived as an unusual role, more so in the case of a woman, is evident from the Coḷa king's rebuke to Avvai when she intervenes on behalf of her patron, one of the chieftains of the Tamil region. The Coḷa king says to her

dismissively: 'Stay out, this is politics.' Avvai's response is significant. She says she acts as she does to ensure justice and righteousness in the land.[43] In this, Avvai is like the Buddha, who came to realise that the moral order could be sustained only through the transformation of politics. Thus, in Avvaiyār's view a withdrawal from the State would imply a withdrawal from righteousness. Avvai is a woman of the world while at the same time she is outside it.

Avvai's place and concerns with the secular political world may have derived from her *pāṇar* background. The conventional role of a bard was that of singing the praises of the king. Avvai invests the conventional role with a moral authority, transforming the conventional function of a panegyrist. But clearly, what Avvai achieves, a moral space in the secular world, would have been impossible in the case of a wife, and was near-impossible in the case of an unmarried, not yet aged woman. As an older woman, Avvai nevertheless succeeds in wresting that space. She then becomes a prototype and so we have the tradition of a series of Avvaiyārs in the Tamil region.

Others, like Akkā Mahādevī and Kāraikkāl Ammaiyār, also have to contend with marriage. They have to handle situations where there is a conflict between unqualified devotion to god and the single-minded service to the husband which is expected. Thus Kāraikkāl Ammaiyār is put into a state of conflict when she gives away the husband's mango to a devotee of the lord. While she is rescued from the situation through unusual devotion to the lord, the fact that she is no ordinary woman in the perception of her husband puts her outside the framework of marriage as far as he is concerned. This resolves the conflict of loyalties for Kāraikkāl Ammaiyār, but it is significant that it was not she who forced the resolution; it was forced upon her by her husband. Once released, she was free to give unrestrained expression to her devotion to Śiva. It is noteworthy that for Kāraikkāl Ammaiyār Śiva is 'father'; she sees herself as his slave but he is not 'husband' or lover, as he is to some other *bhaktins*.

In Akkā Mahādevī's case too, there were acute problems which led her to leave her husband and proceed to devote herself to Śiva. She articulates the basic tension between being a wife and a devotee:

Husband inside,
lover outside.
I can't manage them both.

This world
and that other,
cannot manage them both.[44]

Before the conflict gets resolved the love Akkā Mahādevī feels for god is 'adulterous'. The husband and in-laws function as impediments but Mahādevī gives them all the slip and then speaks of 'cuckolding' the husband with Hara. Immediately afterwards, she speaks of making the lord himself her husband.[45]

The relationship with the mortal husband is utterly unsatisfactory; Akkā cannot go near other men 'because they are thorn under smooth leaf; one cannot go near them or trust them or 'speak confidences' to them.[46] Only the lord who has no death, decay nor form can be her true husband; the mortal husbands she dismisses.

Take these husbands who die
decay, and feed them
to your kitchen fires![47]

she says with stunning contempt.

Once she has dispensed with the earthly husband, Akkā Mahādevī is free—free to roam and seek the real husband. In the meanwhile, hunger and thirst make no impact because the lord is with her:

For hunger
 there is the town's rice in the
 begging bowl.
For thirst,
 there are tanks, streams, wells.
For sleep
 there are the ruins of temples.
For soul's company
 I have you, O lord
 white as jasmine.[48]

Āṇṭāḷ resolves the problem of marriage by refusing marriage to a mortal and insisting on marrying the lord himself. There is thus no conflict in this aspect of her life. She renounces nothing—neither beauty nor wifehood. Everything in her life leads her inexorably to the grand finale—marriage to her chosen lord. Her father, himself a *bhakta*, forces no earthly husband upon her; instead, he travels with

her to Srirangam where she is married to Raṅganātha. Unlike the other three women, Āṇṭāḷ does not negotiate marriage; she chooses it in a direct resolution of the issue.

The manner in which the question of marriage is handled by each woman saint is linked to the deeper question of the sexuality of these women and their explicit attitude to the female body.[49] Avvaiyār, Kāraikkāl Ammaiyār, Āṇṭāḷ and Akkā Mahādevī confront their sexuality in different ways. Avvaiyār, for example, denies her sexuality, by going past the sexually active years into an ascetic kind of situation. With the energy thus released, she wanders about and is accepted by the social order within which she can remain and which she can work with, posing no danger to others and protected from them by her old woman's form.

Kāraikkāl Ammaiyār also transforms her sexuality into an awesome power; her husband and other men are terrified of her. In her new form, which denies her sexuality, she is inviolate—no man will come anywhere near her—she is now the feminine ascetic *par excellence*.

The whole symbolism in Kāraikkāl Ammaiyār's case suggests the release of creative energy; Kāraikkāl Ammaiyār is cast in a Kālī like mould. She inhabits the world of the *pretas* in the cremation ground. Ultimately, her salvation lies at the feet of Śiva. But while her form is awesome like Kālī, her *bhakti* makes her different; it contains her female energies. Thus, while in one version of the Kālī legend, Kālī dances with Śiva under her feet, here, in a reversal of the situation, Śiva dances the *tāṇḍava* with Kāraikkāl Ammaiyār under his dancing feet.

For Āṇṭāḷ and Akkā Mahādevī, their bodies and their sexuality are no embarrassment or impediment to them. The body is the instrument, the site, through which their devotion is expressed. Their relationship with the lord is set within the framework of bridal mysticism. Āṇṭāḷ's devotion quickens her body; she awakens early to the beauty of her body, through her single-minded meditation upon the lord. She says in one poem:

My swelling breasts I dedicated
to the Lord who holds
the sea-fragrant conch. . . .[50]

Longing for the lord so that her love may be consummated, she revels in her body, seeking the pleasure of fulfilment:

Only if he will come
to stay with me for one day
if he will enter me
so as to leave
the mark of his saffron paste
upon my breasts.[51]

The lack of fulfilment itself is expressed again in bodily terms. The unsatiated body and the torment it brings leads to the threat of drastic remedies:

I pine and languish
but he cares not whether I live or die—
If I see that thief of Govardhana
that looting robber, that plunderer
I shall pluck out by their roots
these breasts that have known no gain
I shall take them
and fling them at his chest
putting out the hell-fire
which burns within me.[52]

It is significant that, despite its uninhibited expression, Āṇṭāḷ's sexuality poses no threat at all at any point in the legends that have built up around her. Her unfulfilled longings are undeniably frank and expressive but they are neatly containable within the framework of an impending marriage. The sexuality of Āṇṭāḷ is the sexuality of a young girl who will become a bride, the wife of the lord. It is thus set in the mode of legitimate love and it is this which makes it possible to incorporate Āṇṭāḷ's hymn in the rituals of women. Thus, in the month of Mārkaḷi, the *Tiruppāvai* is sung only by women. Young girls in particular sing it to get good husbands and make happy marriages. Āṇṭāḷ's experience of love is socially contained within the sexuality of the wife.

Akkā Mahādevī's sexuality both shares with and is in complete contrast to that of Āṇṭāḷ. Like Āṇṭāḷ, she does not deny the female body. She confronts it with a directness which is without parallel. But in confronting it the way she does, she forces the world around her also to do so. Her brutal frankness sees no shame in stripping off

conventional notions of modesty. There is nothing to hide, says Akkā:

> You can confiscate
> money in hand
> can you confiscate
> the body's glory' . . .
> To the shameless girl . . .
> where's the need for cover and jewel?[53]

and, again:

> . . . O Siva
> when shall I
> crush you on my pitcher breasts
> O lord white as jasmine
> when do I join you
> stripped of body's shame
> and heart's modesty?[54]

Akkā Mahādevī's experience is, like Āṇṭāḷ's, informed by bridal mysticism. But in Akkā Mahādeyī's case, the legitimacy of the experience is irrelevant. The lord need not be the husband, merely the adulterous lover. Her handling of her own sexuality is much more open, like that of the *devadāsī*, rather than of the wife:

> He bartered my heart,
> looted my flesh,
> claimed as tribute
> my pleasure,
> took over
> all of me.
> I'm the woman of love
> for my lord, white as jasmine.[55]

One may discern an interesting variation in the structure of experiences of Avvai, Kāraikkāl Ammaiyār, Āṇṭāḷ and Akkā Mahādevī in terms of the manner in which the question of marriage features in the narrative, the manner in which they handle their sexuality, and in their relationship to god. Avvai jumps past the stage of

marriage, becomes a mother to the people, her sexuality is transformed into a mother force and the god himself appears to her in her last moments as a child.

Kāraikkāl Ammaiyār is released from marriage, transformed into a *preta*, subdues her sexuality and relates to god as a daughter or a slave (god is both father and master). For Āṇṭāḷ, a beautiful woman full of the unfulfilled longings of a young girl, consummation lies in marriage and the lord is her husband. Akkā Mahādevī on the other hand is a mature woman, who is unwilling to be contained in an earthly marriage. Unashamed of her body, the lord is her lover, even an adulterous lover.

In our review of four women saints, we find two ways in which the female body and sexuality are treated. One way is to deny sexuality and transcend it as Avvai and Kāraikkāl Ammaiyār do. This also resolves the threat that female sexuality poses, especially for a non-*gṛhastha* woman who may wander widely in pursuit of her goal with the same freedom that the male *bhaktas* have.

Another way is to accept the sexuality of woman but channelize it away from mortal men and direct it to the chosen god as lover or husband. In this situation, the female body itself is used to express the *bhaktin's* devotion. In such a situation, there still remains the threat represented by the body of the *bhaktin* in terms of her interaction with the wider world. In the story of Āṇṭāḷ, she is taken to Srirangam by her father, married to the lord's image and disappears into it, so no one can violate her.

Only Mahādevī confronts the crucial problem directly. As someone who has not denied her sexuality but at the same time seeks the liberation that other *bhaktas* have, she adopts a radical measure, and wanders about naked. Mahādevī is the very opposite of Āṇṭāḷ. In a sense, she flaunts her sexuality and defies an onslaught upon it. Her decision to strip off all clothing is a refusal to be circumscribed by the notion of the vulnerability of the female body, a refusal to make compromises because of it. In that sense, she conquers the threat it poses and is the only *bhaktin* to do so. Only Akkā Mahādevī works within the female body, not around it, as others do.

It is possible that she achieves this because she, among our four women saints, had found that in the home one could be violated: what then is unique about the violation that the outer world represents? Thus, Akkā Mahādevī refused to allow the female body to be an impediment in the search for salvation.

Explaining the experience of *bhakti* requires unravelling its complex strands and one must guard against homogenizing it into a neat unified tradition. There is a strong possibility of simplifying *bhakti*, especially in terms of its social content. Thus, its conventional association with marginalized groups, such as women and the low castes, needs to be viewed with a measure of caution, especially since there is evidence of much brāhmaṇa participation, especially in south India. And yet it would not be wrong to see in *bhakti* elements which move away from a highly intellectualized religion and in doing so, make religious experience more accessible and more popular.

Also, even while a noticeable degree of brāhmaṇa participation may be traced in south India, especially in Tamil Vaiṣṇavism, this in itself was a regional resistance to a more Sanskritic penetration of religious forms. Pre-Sanskritic Tamil cults were extended to create, for the first time, a devotional cult which personalized religious experience, eliminated mediators like the priest, and made for a direct relationship with god.

The space thus created provided the leverage women required to insert themselves into the cult of *bhakti*. Denied a voice in normal social and political relations, in *bhakti* poetry they left behind their only record. It is significant that religious poetry is the only place where women's speech has been permitted to survive and has gone on to become the heritage of both men and women. But in evaluating the collective heritage of *bhakti*, we need to ask: what kind of room did the *bhakti* tradition actually provide for women in the world of religion as well as in everyday social relations? To answer this, we need to focus on three aspects in particular: the relationship of the *bhaktin* to god, the relationship of the *bhaktin* to her own body, and the relationship of the *bhaktin* to other men and women. We have not been able to take up all these questions very explicitly or with the depth required, but this exploration may be treated as a small beginning.

The narratives of the *bhaktins*' lives and their poetry indicate that all these women saw god as male but in an idealized version of the conventional relationship of woman to man. Their notion of god was not confined within a patriarchal structure; god was sometimes an equal, as in the case of Āṇṭāḷ, and sometimes the *bhaktin* was subservient, as in the case of Kāraikkāl Ammaiyār. In any case, the object of devotion was not a distant authoritative god but a close

companion, someone you could 'speak confidences' to. In *bhakti*, women indicated the possibility of an alternative model of gender relations.

Through *bhakti*, women also retrieved some of the ground they had lost in the brahmanical ritual order (because of pollution taboos, for example) and in the brahmanical social order, because of their circumscribed role within the household. In *bhakti*, they found the space to break through both these barriers; it enabled women to recite the lord's name even during menstruation and it enabled women to deny the bonds of marriage itself. The *bhaktin* used her devotion as an armour and god as her supporter in her resistance against the priest and the husband.

The escape from an earthly marriage in the case of all four of our *bhaktins* also gave them an escape from the social relations of being female. With no other ties, the *bhaktins* could be completely immersed in their devotion. Further, the *bhaktins* escaped widowhood with its attendant misery. The desire of the *bhaktin* for a marriage with god might even be considered a search for the permanent status of a *sumaṅgalī*, the only woman who was treated as being whole for ritual purposes. *Sumaṅgalī* here should not be seen merely as a married woman, but as a completed selfhood denied to widows. Thus the *bhaktins* circumvented the everyday social relations required of women and transformed the everyday gender relations with which they must otherwise live, as indicated in Akkā Mahādevī's statement that one could not 'speak confidences' to men. This transformation was possible only in the religious arena. Akkā Mahādevī's experiences are inconceivable in any other context except in relation to the lord.

Here, another question that arises is how far *bhakti* dissolved the gender lines. It is clear that some divisions did break down. Men frequently used the feminine mode in their poetry, saw themselves as feminine in relation to god, and so gave up a part of their maleness. But in the narrative of their lives and even in the distinctive nature of their poetry the femaleness of the *bhaktin* remained. The explicit use of the language of the body is a feature of the *bhaktins*' poetry.

Even in envisaging the union with the lord, there is a difference between the *bhakta* and the *bhaktin*. Men achieve the state at a symbolic, metaphoric level: the union is a metaphysical one. In the case of the *bhaktins*, it is envisaged much more explicitly. Āṇṭāḷ and Akkā Mahādevī disappear into the image of the lord at the time of marriage to him. In sum, then, while the *bhaktins* break the social

rules obtaining for women, they do not give up the female identity which is constructed by the female body.

Of our four *bhaktins*, the two who transcend not only socially defined feminine roles (marriage) but also female sexuality, by becoming transformed into old women, are able to move around in society with impunity for substantial periods of time. But the two (Mahādevī and Āṇṭāḷ) who work within the framework of physical femaleness, vividly expressed in their poetry, end their social existence soon after they opt out of the feminine role, Āṇṭāḷ at 16, Mahādevī in her early twenties.

The collapse of the *gṛhastha* and *saṁnyāsī* divide makes for a problem which is more acute for the *bhaktins*. In the earlier monastic tradition, there was an organized community of renouncers into which women could go; in the *bhakti* tradition there is no organized community of *bhaktas* since the men most often led *gṛhastha* lives. There is at best a loose network of devotees which cannot provide much more than minimal support to the *bhaktins*.

In attempting to recover the ethos of *bhakti*, we will need to go beyond what has survived of it in a purged, sanitized and routinized version of the original experience. It might then be possible to capture the totality of the experience of *bhakti* in the lives of the *bhaktins*.

NOTES

I am deeply indebted to Ruth Vanita without whom this paper would never have got started at all. I am also very grateful to Vidya Rao for general support while the paper was being written and especially for refining some of the arguments.

1. An important aspect of social movements in India has been seeking solutions to social problems in the religious sphere. Buddhism was the first major expression of such a venture and *bhakti* may be considered a continuation of such a tradition.
2. Uma Chakravarti, *The Social Dimensions of Early Buddhism* (Delhi, 1987), 'The Rise of Buddhism as Experienced by Women', *Manushi*, no. 8, 1981.
3. A.L. Basham, *The Wonder that was India* (Delhi 1967), p. 464.
4. J.M. Somasundaram, *A History of Tamil Literature* (Annamalainagar, 1968), p. 93.
5. The accountt of Avvaiyār and Tiruvaḷḷuvar's lives has been put together from J.M. Somasundaram's *A History of Tamil Literature*, pp. 64-71, 93-7; and E.J. Robinson's *Tamil Wisdom* (Madras, 1957), pp. xix-lvi, 51-67, 105-7.

6. References to low caste and brāhmaṇa interaction in the context of marriage and the repeated references to stories of foundlings and particularly to women whose origins are mysterious but who are adopted by brāhmaṇa fathers, seem to suggest a mythicization of the process by which brāhmaṇa penetration into the Tamil region and its interaction with a pre-brāhmaṇic Tamil culture is recorded. The legends depict the process of the absorption of a Sanskritic culture.
7. S.S. Vasan's film on Avvaiyār, 1953.
8. E.J. Robinson, *Tamil Wisdom*, p. 61.
9. Some of these maxims are pithy sayings such as 'Do not withhold what you can afford to give', 'Scorn not numbers and letters', 'Learn while young' 'Whatever you do, do well', 'Live for others', 'Associate with the wise', 'Live in harmony with your fellow beings'. In similar works, Avvai's advice ranges over a code of behaviour, for example, 'Talk humbly even to the lowly', 'Mother and Father are the visible Gods', 'No sacred verse is holier than one's father's words', 'No temple is holier than one's mother', 'Better than wealth on hand is learning', J.M. Somasundaram Pillai, *Two Thousand Years of Tamil Literature* (Madras, 1959), pp. 260-3.
10. Ibid., p. 263.
11. Ibid.
12. *A History of Tamil Literature*, p. 99.
13. Ibid., p. 264.
14. Ibid., p. 262.
15. Ibid., p. 266.
16. Ibid., p. 264.
17. *A History of Tamil Literature*, p. 95.
18. A.K. Ramanujan, *Poems of Love and War* (OUP, Delhi, 1985), pp. 129-30.
19. *A History of Tamil Literature*, p. 95.
20. Ibid., p. 94.
21. S.S. Vasan, *Avvaiyār* (film), 1953.
22. *A History of Tamil Literature*, p. 64.
23. Ibid., p. 67.
24. Ibid., p. 68.
25. Ibid.
26. E.J. Robinson, *Tamil Wisdom*, p. xxxiii.
27. *Two Thousand Years of Tamil Literature*, p. 244.
28. *A History of Tamil Literature*, p. 69.
29. *Two Thousand Years of Tamil Literature*, p. 288.
30. Ibid., p. 287.
31. Ibid., p. 288.
32. Ibid.
33. Vidya Dehejia, *Slaves of the Lord* (Delhi, 1988), p. 130.
34. *Two Thousand Years of Tamil Literature*, p. 290.
35. Ibid., p. 291.

36. *Tiruvālaṅkāṭu Tiruppatikam, Tirumurai,* XI, 1971, pp. 6f., cited in *Slaves of the Lord,* pp. 130-1.
37. Ibid., p. 2; ibid., p. 118.
38. *Slaves of the Lord,* p. 132.
39. Ibid., p. 121; see also Friedhelm Hardy, *Viraha Bhakti* (Delhi, 1983), pp. 414-29.
40. *Slaves of the Lord,* p. 128.
41. A.K. Ramanujan, *Speaking of Siva* (Harmondsworth, 1985), pp. 111-14.
42. *Speaking of Siva,* p. 114.
43. 'Should innocent girls suffer under the machinations of emperors? There must be justice and righteousness in the land' (Avvai in S.S. Vasan's film, 1953).
44. *Speaking of Siva,* p. 127.
45. Ibid., p. 141.
46. Ibid., p. 125.
47. Ibid., p. 134.
48. Ibid., p. 132.
49. The discussion in this section owes much to Vidya Rao, without whom it would not be the same.
50. *Slaves of the Lord,* p. 121.
51. Ibid., p. 124.
52. Ibid., p. 126. The metaphor of tearing off the breast is resonant of Kaṇṇaki's action when she is denied justice. There, it is linked with the awesome power of the chaste wife; here, it is the awesome passion of a woman denied consummation.
53. *Speaking of Siva,* p. 129.
54. Ibid., p. 136.
55. Ibid., p. 125.

Bibliography

[Note: The bibliography has been organized along broad sectional heads, corresponding with the themes of the essays included in the volume. However, given the interdisciplinary nature of women's studies, the reader may find readings listed in one section are useful in terms of other sub-themes as well. The bibliography includes (1) complete references to the material included in the volume, (2) references to other books/articles on women in early India connected with the themes under consideration, (3) references to cross-cultural and/or interdisciplinary books/articles on related themes.]

I

Altekar, A.S., 1934, *Education in Ancient India*. Benares: Nand Kishore and Bros.
———, 1958, *State and Government in Ancient India*. Delhi: Motilal Banarsidass.
———, 1987, 1991, *The Position of Women in Hindu Civilisation: From Prehistoric Times to the Present Day*. Delhi: Motilal Banarsidass (rpt., 3rd edn., 1978, 1st edn., 1938).
Archer, Leonie J., Susan Fischler, and Maria Wyke (eds.), 1994, *Women in Ancient Societies: An Illusion of the Night*. Hampshire: Macmillan.
Barrett, Michele and Anne Philips (eds.), 1992, *Destabilising Theory: Contemporary Feminist Debates*. Cambridge: Polity Press.
Bhattacharji, Sukumari, 1994, *Women and Society in Ancient India*. Calcutta: Basumati Corporation Ltd.
Cameron, Averil and Amelié Kuhrt (eds.), 1983, *Images of Women in Antiquity*. London: Croom Helm.
Chakravarti, Uma, 1981, 'The Rise of Buddhism as Experienced by Women', *Manushi*, 8: 6-10.
———, 1988, 'Beyond the Altekarian Paradigm: Towards a New Understanding of Gender Relations in Early Indian History', *Social Scientist*, 16, 8: 44-52.
———, 1993, 'Conceptualising Brahmanical Patriarchy in Early India.

Gender, Caste, Class and State', *Economic And Political Weekly,* 28:579-85.

Chakravarti, Uma, and Kumkum Roy, 1988, 'In Search of Our Past: A Review of the Limitations and Possibilities of the Historiography of Women in Early India', *Economic and Political Weekly,* 23: WS2-10.

———, 1996, 'The Family in Ancient India: Ideal and Reality', *Social Change,* 26: 26-33.

Conkey, Margaret W. (in collaboration with Sarah H. Williams), 1991, 'Original Narratives: The Political Economy of Gender', in Micaela di Leonardo (ed.), *Gender At the Crossroads of Knowledge: Feminist Anthropology in the Post-Modern Era.* Berkeley: University of California Press, pp. 102-39.

Connell, R.W., 1987, *Gender and Power: Society, The Person, and Sexual Politics.* Cambridge: Polity Press.

Cornwall, Andrea and Nancy Lindisfarne, 1994, *Dislocating Masculinity: Comparative Ethnographies.* London: Routledge.

Crosby, Christine, 1991, *The Ends of History: Victorians and 'the Woman Question'.* New York: Routledge.

Das, R.M., 1962, *Women in Manu and his Seven Commentators.* Varanasi: Kanchana Publications.

Diamond, Irene and Lisa Kuppler, 1990, 'Frontiers of the Imagination: Women, History and Nature', *Journal of Women's History,* 1: 160-80.

Gulati, Saroj, 1985, *Women and Society: North India in the 11th and 12th centuries.* Delhi: Chanakya Publications.

Horner, I.B., 1975, *Women Under Primitive Buddhism.* Delhi: Motilal Banarsidass (1st edn., 1930).

Jain, Pratibha and Rajan Mahar (eds.), 1996, *Women Images.* Jaipur: Rawat Publications.

Jaiswal, Suvira, 1981, 'Women in Early India: Problems and Perspectives', *Proceedings of the Indian History Congress,* 42: 54-60.

Kandiyoti, Deniz, 1988, 'From empire to nation state: transformations of the woman question in Turkey' in S. Jay Kleinberg (ed.), *Retreiving Women's History: Changing Perceptions of the Role of Women in Politics and Society,* Oxford: Berg Publishers Ltd., pp. 219-40.

Kelly, Joan, 1984, *Women, History and Theory.* Chicago: University of Chicago Press.

Kumar, Nita (ed.), 1994, *Women as Subjects: South Asian Histories.* New Delhi: Stree.

Law, Bimala Churn, 1981, *Women in Buddhist Literature.* Varanasi: Indological Book House (1st edn., 1927).

Lerner, Gerda, 1979, *The Majority Finds its Past.* New York: Oxford University Press.

———, 1986, *The Creation of Patriarchy.* New York: Oxford University Press.

Manjushree, 1990, *The Position of Women in the Yājñavalkyasmṛti*. New Delhi: Prachi Publishers & Distributors Pvt. Ltd.
Moore, Henrietta L., 1988, *Feminism and Anthropology*. New York: Monthly Review Press.
Newman, Louise M., 1991, 'Critical Theory and the History of Women: What's at stake in Deconstructing Women's History', *Journal of Women's History*, 2: 58-68.
Paul, Diana Y. (with contributions by Frances Wilson, foreword by I.B. Horner), 1985, *Women in Buddhism: Images of the feminine in the Mahayana Tradition*. Berkeley: University of California Press (2nd edn.).
Pomeroy, Sarah B. (ed.), 1991, *Women's History, Ancient History*. Chapel Hill: University of North Carolina Press.
Reiter, R. (ed.), 1975, *Towards an Anthropology of Women*. New York: Monthly Review Press.
Richman, Paula, 1992, 'Gender and Persuasion: Portrayal of Beauty, Anguish, and Nurturance in an Account of a Tamil Nun', in José Ignacio Cabézon (ed.), *Buddhism, Sexuality, and Gender*. Delhi: Sri Satguru Publications, pp. 111-36.
Sangari, Kumkum, 1993, 'Consent, Agency and the Rhetorics of Incitement', *Economic and Political Weekly*, 28: 867-82.
Sangari, Kumkum and Sudesh Vaid (eds.), 1989, *Recasting Women: Essays in Colonial History*. New Delhi: Kali for Women.
Schmitt Pantel, Pauline (ed.), 1992, *From Ancient Goddesses to Christian Saints*, vol. I. A History of Women in the West, Belknap: Harvard University Press.
Scott, Joan Wallach, 1987, *Gender and the Politics of History*. New York: Columbia University Press.
Sharma, Tripat, 1987, *Women in Ancient India* (from c. AD 320 to c. AD 1200). New Delhi: Ess Ess Publications.
Shastri, Shakuntala Rao, 1952, *Women in the Vedic Age*. Bombay: Bhavan's Book University.
Shaw, Miranda, 1994, *Passionate Enlightenment: Women in Tantric Buddhism*. Princeton: Princeton University Press.
Sponberg, Alan, 1992, 'Attitudes Toward Women and the Feminine in Early Buddhism', in José Ignacio Cabézon (ed.), *Buddhism, Sexuality, and Gender*. Delhi: Sri Satguru Publications, pp. 3-36.

II

Acker, Joan, 1988, 'Class, Gender and the Relations of Distribution', *Signs*, 13: 473-97.
Adams, Alice, 1995, 'Maternal Bonds: Recent Literature on Mothering', *Signs*, 20: 414-27.

Agarwal, Bina, 1994, *A Field of One's Own: Gender and Land Rights in South Asia.* Cambridge: Cambridge University Press.

Balasubramanian, C., 1992, *The Status of Women in Tamil Nadu During the Sangam Age.* Madras: Narumarlarp Patippakan (1st edn., 1976).

Bhattacharyya, N.N., 1988, 'Property Rights of Women in Ancient India' in L.K. Tripathi (ed.), *Position and Status of Women in Ancient India.* Varanasi: Benares Hindu University, pp. 62-71.

Caplan, Patricia and Janet M. Bujra (eds.), 1978, *Women United, Women Divided: Cross-cultural perspectives on female solidarity.* London: Tavistock Publications Ltd.

Chakravarti, Uma, 1983, 'The Myth of the Golden Age of Equality—Women Slaves in Ancient India', *Manushi,* 3: 8-15.

Clark, Alice W. (ed.), 1993, *Gender and Political Economy: Explorations of South Asian Systems.* Delhi: Oxford University Press.

Coontz, Stephanie and Peta Henderson (eds.), 1986, *Women's Work, Men's Property: the Origin of Gender and Class.* London: Verso.

Delphy, Christine, 1984, *Close to Home: A Materialist Analysis of Women's Oppression.* London: Hutchinson.

Gero, Joan and Margaret Conkey (eds.), 1990, *Engendering Archaeology: Women and Prehistory.* Oxford: Basil Blackwell.

Gupta, Chitrarekha, 1988, '"Rural-Urban Dichotomy", in the Concept and Status of Women', in L.K. Tripathi (ed.) *Position and Status of Women in Ancient India.* Varanasi: Benares Hindu University, pp. 188-96.

Hartmann, Heidi, 1981, 'The family as locus of gender, class and political struggle: the example of housework', *Signs,* 6: 366-94.

Hartsock, Nancy C.M., 1983, *Money, Sex and Power: Towards a Feminist Historical Materialism.* New York: Longman.

Hennessy, Rosemary, 1993, *Materialist Feminism and the Politics of Discourse.* New York: Routledge.

Jain, Devaki and Nirmala Banerjee (eds.), 1985, *The Tyranny of the Household: Investigative Essays on Women's Work.* Delhi: Shakti Books.

Jeffrey, Patricia, Roger Jeffrey and Andrew Lyon, 1989, *Labour Pains and Labour Power.* London and New Delhi: Zed Books and Manohar.

Kuhn, Annette and Ann Marie Wolpe (eds.), 1978, *Feminism and Materialism. Women and Modes of Production.* London: Routledge and Kegan Paul.

Lebra, Joyce, Joy Paulson and Jana Everett (eds.), 1984, *Women and Work in India: Continuity and Change.* New Delhi: Promilla.

Leibowitz, Lila, 1986, 'In the Beginning: the Origins of the Sexual Division of Labour and the Development of the First Human Societies' in Coontz and Henderson (eds.), *Women's Work, Men's Property: the Origin of Gender and Class,* London: Verso, pp. 43-75.

MacCormack, Carol P. and Marilyn Strathern (eds.), 1980, *Nature, culture and gender*. Cambridge: Cambridge University Press.

Mitra, Manoshi, 1989-90, 'Women in Santhal Society: Women as Property; Women and Property', *Samya Shakti*, 4 and 5: 213-17.

Mukund, Kanakalatha, 1992, 'Turmeric Land: Women's Property Rights in Tamil Society since early medieval times', *Economic and Political Weekly*, 27: WS2-6.

Narang, Bhim Sain, 1990, *Concept of Stridhana in Ancient India*. Delhi: Parimal Publications.

Oakley, Ann, 1984, *The Captured Womb: A History of the Medical Care of Pregnant Women*. Oxford: Basil Blackwell.

O'Brien, Mary, 1981, *The Politics of Reproduction*. Boston: Routledge & Kegan Paul.

Parasher, Aloka and Usha Naik, 1986, 'Temple Girls of Medieval Karnataka'. *Indian Economic and Social History Review*, 23: 63-91.

Ramaswamy, Vijaya, 1989, 'Aspects of Women and Work in Early South India', *Indian Economic and Social History Review*, 26: 81-99.

Roy, Kumkum, 1994a, *The Emergence of Monarchy in North India as Reflected in the Brahmanical Tradition, c. 8th-4th centuries BC*. New Delhi: Oxford University Press.

———, 1994b, 'Defining the Household: Some Aspects of Prescription and Practice in Early India', *Social Scientist*, 248-9: 3-18.

Sayers, Janet, Mary Evans and Nanneke Redclift (eds.), 1987, *Engels Revisited: New Feminist Essays*. London: Tavistock.

Shah, K.K., 1996, 'Legal Rights of Women to Landed Wealth: A Case Study of the Candella Queens' in Kiran Pawar (ed.) *Women in Indian History: Social, Economic, Political and Cultural Perspectives*. Patiala: Vision & Venture, pp. 68-94.

Sharma, R.S., 1983, *Perspectives in Social and Economic History of Early India*. New Delhi: Munshiram Manoharlal.

Sharma, Ursula, 1980, *Women, Work and Property in north west India*. London: Tavistock.

Singh, A.K., 1990, *Devadasi System in Ancient India (A Study of Temple Dancing Girls of South India)*. Delhi: H.K. Publishers and Distributors.

Stanley, Autumn, 1981, 'Daughters of Isis, Daughters of Demeter: When Women Sowed and Reaped', *Women's Studies International Quarterly*, 4: 289-304.

Strathern, Marilyn, 1988, *The Gender of the Gift: Problems with Women and Problems with Society in Melanesia*. Berkeley: University of California Press.

Tyagi, A.K., 1994, *Women Workers in Ancient India*. New Delhi: Radha Publications.

Vishnoi, Savita, 1987, *The Economic Status of Women in Ancient India*. Meerut: Kusumanjali Prakashan.

Whitehead, Ann, 1984, 'Men and Women, Kinship and Property: Some General Issues', in Renée Hirschon (ed.), *Women and Property—Women as Property*. London: Croom Helm, pp. 176-92.

III

Appadorai, Arjun, Frank J. Korom, Margaret A. Mills (eds.), 1994, *Gender, Genre, and Power in South Asian Expressive Traditions*. Delhi: Motilal Banarsidass.

Apte, Usha M., 1978, *The Sacrament of Marriage in Hindu Society (from the Vedic Period to the Dharmaśāstras)*, Delhi: Ajanta Publications.

Ardener, Shirley (ed.), 1992, *Persons and Powers of Women in Diverse Cultures: Essays in Commemoration of Audrey I. Richards, Phyllis Kaberry and Barbara E. Ward*. New York: Berg.

Banerjee, Sumanta, 1993, 'The "Beshya" and the "Babu": The Prostitute and Her Clientele in 19th century Bengal', *Economic and Political Weekly*. 28:2461-72.

Basu, N.K. and S.N. Sinha, 1929, *History of Prostitution in India*. Calcutta: Bengal Social Hygiene Association.

Bennett, Lynn, 1983, *Dangerous Wives and Sacred Sisters: The Social and Symbolic Roles of High Caste Women in Nepal*. New York: Columbia University Press.

Bhattacharji, Sukumari, 1987, 'Prostitution in Ancient India', *Social Scientist*. 15:32-61.

———, 1990, 'Motherhood in Ancient India', *Economic and Political Weekly*, 25:WS 50-7.

Bhattacharyya, N.N., 1975, *History of Indian Erotic Literature*. New Delhi: Munshiram Manoharlal.

———, 1980, *Indian Puberty Rites*. Calcutta: Indian Studies Past and Present.

Burguire, Andre, Christiane Klapisch-Zuber, Martine Segalen, and Francoise Zonaberd (eds.), 1996, *Distant Worlds, Ancient Worlds*, vol. I, A History of the Family, Cambridge: Polity Press.

Chakravarti, Uma, 1983, 'The Development of the Sita Myth: A Case Study of Women in Myth and Literature', *Samya Shakti*, 1: 68-75.

———, 1993, 'Women, men and beasts: the *Jatakas* as popular tradition', *Studies in History*, 9:43-70.

Chatterjee Sastri, Heramba, 1972, *Studies in the Social Background of the Forms of Marriage in Ancient India*. Calcutta: Sanskrit Pustak Bhandar.

Chowdhry, Prem, 1994, *The Veiled Women: Shifting Gender Equations in Rural Haryana 1880-1990*. Delhi: Oxford University Press.

Collier, Jane Fishburne and Sylvia Junko Yanagisako (eds.), 1987, *Gender and Kinship: Essays Towards a Unified Analysis*. Stanford: Stanford University Press.

Das, Ram Mohan, 1993, *Women in Manu's Philosophy*. Jalandhar: ABS Publications.

Demand, Nancy, 1994, *Birth, Death, and Motherhood in Classical Greece*. Baltimore and London: John Hopkins University Press.

Desai, Devangana, 1985, *Erotic Sculpture of India: A Socio-cultural Study*. Delhi: Tata McGraw Hill.

Dikshit, Ratnamayidevi, 1964, *Women in Sanskrit Dramas*. Delhi: Meharchand Lakshman Das.

Dube, Leela, 1988, 'On the Construction of Gender: Hindu Girls in Patrilineal India', *Economic and Political Weekly*, 23: 11-19.

Duby, Georges, 1978, *Medieval Marriage: Two Models from 12th century France*. Baltimore: John Hopkins University Press.

Ehrenfels, V.R., 1973, 'Matrilineal Social Systems in India', in Cultral Department of the Embassy of the Federal Republic of Germany (ed.), *German Scholars on India*, vol. I. Varanasi: Chowkhamba Sanskrit Series Office, pp. 50-68.

Erndl, Kathleen M., 1992, 'The Mutilation of Surpanakha', in Paula Richman (ed.), *Many Ramayanas: The Diversity of a Narrative Tradition in South Asia*. Delhi: Oxford University Press, pp. 67-88.

Foucault, Michel, 1978, *An Introduction*, vol. 1. The History of Sexuality, New York: Pantheon.

———, 1985, *The Uses of Pleasure*, vol. 2. The History of Sexuality, New York: Pantheon Books.

———, 1986, *The Care of the Self*, vol. 3. The History of Sexuality, New York: Vintage Books.

Fox, Robin, 1993, *Reproduction and Succession: Studies in Anthropology, Law and Society*. New Brunswick: Transaction Publishers.

Goldman, Robert P., 1982, 'Matricide, Renunciation, and Compensation in the Legends of Two Warrior-Heroes of the Sanskrit Epics', *Indologica Taurinensia*, 10: 117-31.

———, 1993, 'Transsexualism, Gender and Anxiety in Traditional India', *Journal of the American Oriental Society*, 113: 374-401.

Gonda, J., 1975, 'Reflections on the ārṣa and āsura forms of marriage', *Selected Studies*, vol. IV, Leiden: E.J. Brill, pp. 171-85.

———, 1975, 'Ascetics and courtesans', *Selected Studies*, vol. IV, Leiden: E.J. Brill, pp. 223-47.

Good, Anthony, 1991, *The Female Bridegroom: A Comparative Study of Life-Crisis Rituals in South India and Sri Lanka*. Oxford: Clarendon Press.

Goody, Jack, 1990, *The Oriental, the Ancient and the Primitive: Systems of Marriage and the Family in the Pre-Industrial Societies of Eurasia*. Cambridge: Cambridge University Press.

Grottanelli, Cristiano, 1982, 'The King's Grace and the Helpless Woman: A

Comparative Study of the Stories of Ruth, Charila, Sita', *History of Religions,* 22:1-24.

Gurukkal, R., 1989, 'Forms of Production and Forces of Change in Ancient Tamil Society', *Studies in History,* 15: 159-75.

Hart III, George L., 1973, 'Woman and the Sacred in Ancient Tamilnad', *Journal of Asian Studies,* 32: 233-50.

Hawley, John Stratton (ed.), 1994, '*Sati* The Blessing and the Curse: The Burning of Wives in India', New York: Oxford University Press.

Hopkins, E.W., 1972, *The Position of the Ruling Caste in Ancient India.* Varanasi: Bharat Bharati.

Husain, Shahanara, 1985, *The Social Life of Women in Early Medieval Bengal.* Dhaka: Asiatic Society of Bangladesh.

Jamison, Stephanie W., 1996, *Sacrificed Wife: Sacrificer's Wife: Women Ritual and Hospitality in Ancient India.* New York: Oxford University Press.

Jhanji, Rekha, 1996, 'Women in the Mahabharata', in Kiran Pawar (ed.), *Women in Indian History: Social, Economic, Political and Cultural Perspectives.* Patiala: Vision & Venture.

Joardar, B., 1984, *Prostitution in Historical and Modern Perspectives.* New Delhi: Inter-India Publications.

Kapadia, Karin, 1995, *Siva and Her Sisters: Gender, Caste, and Class in Rural South India.* Boulder: Westview Press.

Kersenboom-Story, Saskia C., 1987, *Nityasumaṅgalī.* Delhi: Motilal Banarsidass.

Leslie, I.J., 1986, '*Strīsvabhāva*: The Inherent Nature of Women', in N.J. Allen *et al.* (eds.), *Oxford University Papers on India,* vol. I, Pt. I. Delhi: Oxford University Press, pp. 28-55.

———, 1989, *The Perfect Wife: The Orthodox Hindu Woman according to the Strīdharmapaddhati of Tryambakayajvan.* Delhi: Oxford University Press.

Leslie, I.J. (ed.), 1992, *Roles and Rituals for Hindu Women.* Delhi: Motilal Banarsidass.

———, 1996, 'Menstruation Myths' in Julia Leslie (ed.)., *Myth and Mythmaking.* Richmond: Curzon Press, pp. 87-105.

Levine, Nancy E., 1988, *The Dynamics of Polyandry: Kinship, Domesticity and Population on the Tibetan Border.* Chicago: University of Chicago Press.

MacCormack, Carol A., 1980, 'Nature, culture and gender: a critique', in MacCormack and Marilyn Strathern (eds.), *Nature, culture and gender.* Cambridge: Cambridge University Press, pp. 1-24.

Marglin, Frederique Apffel, 1985, *Wives of the God-King: Rituals of the Devadasis of Puri.* Delhi: Oxford University Press.

Mathur, Vina, 1985, *Role and Position of Women in the Social, Cultural, and Political Life of Kashmir: 7th to 16th century AD.* Jammu: Doron Publications.

BIBLIOGRAPHY 331

Moti Chandra, 1973, *The World of Courtesans*. Delhi: Vikas Publishing House Pvt. Ltd.

Muir, Edward and Guido Ruggiero (eds.), 1990, *Sex and Gender in Historical Perspective*. Baltimore and London: John Hopkins University Press.

Nagaraja Rao, C.K., 1978, 'Chalukyan Queens', in M.S. Nagaraja Rao (ed.), *The Chalukyas of Badami*. Bangalore: The Mythic Society, pp. 159-69.

Natarajan, Kanchana, 1995, 'Distinctionism of Sāṁkhya: A Clue to Understanding Gender Constructions/Conflicts in the Brahmanical Tradition'. Paper presented at the seminar on *Spinning Knowledge: Feminist Theories, Methodologies and Methods*. New Delhi: United States Educational Foundation in India.

O'Flaherty, Wendy Doniger, 1981, *Sexual Metaphors and Animal Symbols in Indian Mythology*. Delhi: Motilal Banarsidass.

Oldenburg, Veena Talwar, 1991, 'Lifestyle as Resistance: The Case of the Courtesans of Lucknow', in Douglas Haynes and Gyan Prakash (eds). *Contesting Power: Resistance and Everyday Social Relations in South Asia*. Delhi: Oxford University Press, pp. 23-61.

Ortner, Sherry B., 1978, 'The Virgin and the State', *Feminist Studies*, 4:19-35.

Ortner, Sherry B. and H. Whitehead (eds.), 1981, *Sexual Meanings: The Cultural Construction of Gender and Sexuality*. Cambridge: Cambridge University Press.

Ostor, Akos, Lina Fruzzetti and Steve Barnett (eds.), 1982, *Concepts of Person: Kinship, Caste and Marriage in India*. Cambridge: Cambridge University Press.

Otis, Leah L., 1987, *Prostitution in Medieval Society: The History of an Urban Institution in Languedoc*. Chicago: University of Chicago.

Palriwala, Rajni and Carla Risseeuw (eds.), 1996, *Shifting Circles of Support: Contextualising Gender and Kinship in South Asia and Sub-Saharan Africa*. New Delhi: Sage.

Raha; Manis Kumar (ed.), 1987, *Polyandry in India: Demographic, Economic, Social, Religious and Psychological Concomitants of Plural Marriages in Women*. Delhi: Gian Publishing House.

Rajam, V.S., 1986, '*Ananku*: A Notion Semantically Reduced to Signify Female Sacred Power', *Journal of the American Oriental Society*, 106: 257-72.

Rao Shastri, Shakuntala, 1970, *Women in the Sacred Laws*, 2nd edn., Bombay: Bharatiya Vidya Bhavan.

Reynolds, Holly Baker, 1991, 'The Auspicious Married Woman', in Susan Wadley (ed.), *Powers of Tamil Women*. New Delhi: Manohar, pp. 35-60.

Roy, Kumkum, 1988, 'Women and Men Donors at Sanchi: A Study of the Inscriptional Evidence', in L.K. Tripathi (ed.), *Position and Status*

of *Women in Ancient India*, vol. I. Varanasi: Banares Hindu University. pp. 209-23.

———, 1994, 'Marriage as Communication: An Exploration of Norms and Narratives in early India', *Studies in History*, 10: 183-98.

———, 1996a, 'Unravelling the *Kāmasūtra*', *Indian Journal of Gender Studies*, 3: 155-70.

———, 1996b, 'Justice in the Jatakas', *Social Scientist*, 275-7: 23-40.

———, forthcoming, *Women's Place/Women's Space*. New Delhi: Oxford University Press.

Sanger, William W., 1986, *History of Prostitution: Its extent, causes and effects throughout the world*. New Delhi: Inter-India Publications.

Sarkar, S.C., 1928, *Some Aspects of the Earliest Social History of India*. London: Oxford University Press.

Schneider, David M. and Kathleen Gough (eds.), 1972, *Matrilineal Kinship*. Allahabad: A.H. Wheeler & Co.

Schuler, Sidney Ruth, 1987, *The Other Side of Polyandry: Property, Stratification and Non-marriage in the Nepal Himalayas*. Boulder: Westview Press.

Shah, Shalini, 1995, *The Making of Womanhood: Gender Relations in the Mahabharata*. New Delhi: Manohar.

Shantakumari, S.L., 1983, 'Women in the days of Chalukyas of Kalyana', in M.S. Nagaraja Rao (ed.), *The Chalukyas of Kalyana*: Bangalore: The Mythic Society, pp. 165-70.

Sharma, Arvind (ed.), 1988, *Sati: Historical and Phenomenological Essays*. Delhi: Motilal Banarsidass.

Shastri, A.M., 1975, *India as Seen in the Kuttanimatam of Damodara Gupta*. Delhi: Motilal Banarsidass.

Shulman, David, 1992, 'Fire and Flood: the Testing of Sita in Kampan's *Irāmavatāram*', in Paula Richman (ed.), *Many Ramayanas*. Delhi: Oxford University Press, pp. 67-8.

Singh, Sarva Daman, 1978, *Polyandry in Ancient India*. New Delhi: Vikas Publishing House Pvt. Ltd.

Sivathamby, K., 1974, 'Early South Indian Society and Economy: The Tinai Concept', *Social Scientist*, 29: 20-37.

Sohnen-Thieme, Renata, 1996, 'The Ahalyā Story through the Ages', in Julia Leslie (ed.), *Myth and Mythmaking*. Richmond: Curzon Press, pp. 39-62.

Sternbach, L., 1951, 'Forms of marriage in ancient India and their development', *Bharatiya Vidya*, 12: 62-138.

———, 1955, 'Legal position of prostitutes according to Kauṭilya's *Arthaśāstra*', *Journal of the American Oriental Society*, 71: 25-60.

Trautmann. T.R., 1981, *Dravidian Kinship*. Cambridge: Cambridge University Press.

Van Baal, J., 1975, *Reciprocity and the Position of Women: Anthropological Papers*. Amsterdam: Van Gorcum.

Wadley, Susan (ed.), 1991, *Powers of Tamil Women*. New Delhi: Manohar.
Walkowitz, Judith, 1980, *Prostitution in Victorian Society: Women, class and the state*. Cambridge: Cambridge University Press.
Weeks, Jeffrey, 1981, *Sex, Politics and Society. The regulation of sexuality since 1800*. London and New York: Longman.
Yanagisako, Sylvia and Carol Delaney (eds.), 1995, *Naturalizing Power: Essays in Feminist Cultural Analysis*. New York: Routledge.

IV

Atre, Shubhangana, 1987, *Archetypal Mother: A Systemic Approach to Harappan Religion*. Pune: Ravish Publishers.
Beane, Wendell Charles, 1977, *Myth, Cult and Symbols in Sakta Hinduism: A Study of the Indian Mother Goddess*. Leiden: Brill.
Bhattacharyya, N.N., 1977, *The Indian Mother Goddess*. New Delhi: Manohar.
———, 1996, *History of the Sakta Religion*. New Delhi: Munshiram Manoharlal (2nd edn.).
Brown, Cheever Mackenzie, 1974, *God as Mother: A Feminine Theology in India*. Hartford, Vt: Claude Stark & Co.
Bynum, Caroline Walker, 1986, 'Introduction: the Complexity of Symbols', in Bynum, Stevan Harrell and Paula Richman (eds.), *Gender and Religion: On the Complexity of Symbols*. Boston: Beacon Press, pp. 1-20.
———, 1991, *Fragmentation and Redemption: Essays on Gender and the Human Body in Medieval Religion*. New York: Zone Books.
Chakravarti, Uma, 1989, 'The World of the Bhaktin in South Indian Traditions—The Body and Beyond', *Manushi*, 50-2: 18-29.
Chaudhuri, J.B., 1956, *The Position of Women in Vedic Ritual*. Calcutta: the author.
Coburn, Thomas B., 1984, *Devi-Mahatmya: The Crystallization of the Goddess Tradition*. Delhi: Motilal Banarsidass.
———, 1991, *Encountering the Goddess: A Translation of the Devi Mahatmya and a study of its Interpretation*. New York: State University of New York Press.
Dange, Sadashiv A., 1979, *Sexual Symbolism from the Vedic Ritual*. Delhi: Ajanta Publishers.
Das, H.V., 1981, *Tantricism: A Study of the Yogini Cult*. New Delhi: Sterling.
Das, Veena, 1985, 'The Goddess and the Demon—An Analysis of the Devi Mahatmya', *Manushi*, 5: 28-32.
Dasgupta, Shashi Bhusan, 1977, *Aspects of Indian Religious Thought*. Calcutta: Firma KLM.
Dehejia, Vidya, 1988, *Slaves of the Lord: The Path of the Tamil Saints*. New Delhi: Munshiram Manoharlal.
———, 1990, *Āṇṭāḷ and Her Path of Love: Poems of a Woman Saint from South India*. Albany: State University of New York Press.

Desai, Neera, 1984, 'Women and the Bhakti Movement', *Samya Shakti*, 1:92-9.
Diehl, C.G, 1979, '*Matan-Mā* as *Sādhanā* in Bhakti. Notes on the Vaishnava Poetess Antal, of Srivilliputtur', *Indologica Taurinensia*, 7:219-23.
Ganesh, Kamala, 1990, 'The Mother who is not a Mother: In search of the Great Indian Goddess', *Economic and Political Weekly*, 25: WS 58-64.
Gatwood, Lynn E., 1985, *Devi and the Spouse Goddess: Women, Sexuality and Marriage within India*. New Delhi: Manohar.
Goudriaan, Teun and Sanjukta Gupta, 1981, *Hindu Tantric and Sakta Literature*. [A History of Indian Literature, J. Gonda (ed.), vol. 2, Fasc 2]. Wiesbaden: Otto Harrassowitz.
Hawley, John Stratton and Donna Marie Wulff (eds.), 1984, *The Divine Consort: Radha and the Goddesses of India*. Delhi: Motilal Banarsidass.
Jaini, Padmanabh S., 1992, *Gender and Salvation: Jaina Debates on the Spiritual Liberation of Women*. Delhi: Munshiram Manoharlal.
Kinsley, David, 1975, *The Sword and the Flute: Krsna and Kali*. Berkeley: University of California Press.
———, 1987, *Hindu Goddesses: Visions of the Divine Feminine in the Hindu Religious Tradition*. Delhi: Motilal Banarsidass.
Kosambi, D.D., 1962, *Myth and Reality*. Bombay: Popular Prakashan.
Kramrisch, Stella, 1975, 'The Indian Great Goddess', *History of Religions*, 14:235-65.
Kumar, Pushpendra, 1974, *Sakti Cult in Ancient India With special reference to the Puranic Literature*. Varanasi: Bharatiya Publishing House.
———, 1992, *Tara (the Supreme Goddess)*. Delhi: Bharatiya Vidya Prakashan.
Lal, Shyam Kishore, 1980, *Female Divinities in Hindu Mythology and Ritual*. Pune: University of Poona Press.
Layle, P.G., 1973., *Studies in the Devi Bhagavata*. Bombay: Popular Prakashan.
Lerner, Gerda, 1993, *The Creation of Feminist Consciousness: From the Middle Ages to Eighteen-Seventy*. New York: Oxford University Press.
Manushi, 1986, 'I Drank the Wine of my own Verse'—The Life and Work of Lal Ded, Kashmiri Poet and Mystic, *Manushi*, 6: 17-22.
Mukta, Parita, 1994, *Upholding the Common Life: The Community of Mirabai*. Delhi: Oxford University Press.
Mullatti, Leeḷa, 1989, *The Bhakti Movement and the Status of Women: A Case Study of Virasaivism*. Delhi: Abhinav Publications.
Patton, Laurie L., 1996, 'The Fate of the Female Ṛsi: Portraits of Lopāmudrā', in Julia Leslie (ed.), *Myth and Mythmaking*. Richmond: Curzon Press, pp. 21-38.
Ramaswamy, Vijaya, 1996, *Divinity and Deviance: Women in Virasaivism*. Delhi: Oxford University Press.
Rhys Davids, C.A.F., 1909, *Therīgāthā, Psalms of the Sisters*. London: Pali Text Society.

Rosen, Elizabeth S., 1980, 'Buddhist Architecture and Lay Patronage at Nagarjunakonda', in A. Dallapiccola (ed.), *The Stupa: Its religious, historical and architectural significance*. Wiesbaden: Franz Steiner Verlag, pp. 122-6.

Roy, Kumkum, 1985. 'Legitimation and the Brahmanical Tradition: The Upanayana and the Brahmacarya in the Dharma Sutras', in *Proceedings of the India History Congress*, pp. 136-46.

Sangari, Kumkum, 1990, 'Mirabai and the Spiritual Economy of Bhakti', *Economic and Political Weekly*, 25: 1464-75.

Schmidt, H.F., 1987, *Some Women's Rites and Rights in the Veda*. Poona: Bhandarkar Oriental Research Institute.

Sharma, R.K., 1978, *The Temple of the Chaunsatha Yogini at Bheraghat*. Delhi: Agam Kala Prakashan.

Singh, Harihar, 1988, 'Position and Status of Women as Reflected from their Patronage to Temple Architecture', in L.K. Tripathi (ed.), *Position and Status of Women in Ancient India*. Varanasi: Banaras Hindu University, pp. 235-47.

Sircar, D.C., 1973, *The Sakta Pithas*. Delhi: Motilal Banarsidass.

Spencer, George W., 1983. 'When Queens Bore Gifts: Women as Temple Donors in the Chola period', in K.V. Raman *et al.* (eds.), *Śrīnidhiḥ Perspectives in Indian Archaeology, Art and Culture, Shri K.R. Srinivasan Festschrift*. Madras: New Era Publications, pp. 361-73.

Srivastava, M.C.P., 1979, *Mother Goddess in Indian Art, Archaeology & Literature*. Delhi: Agam Kala Prakashan.

Talbot, Cynthia, 1991, 'Temples, Donors, and Gifts: Patterns of Patronage in 13th century South India', *Journal of Asian Studies*, 50: 308-40.

Talim, Meena, 1972, *Women in Early Buddhism*. Bombay: University of Bombay.

Tiwari, J.N., 1985, *Goddess Cults in Ancient India (with special reference to the first seven centuries AD)*. Delhi: Sundeep Prakashan.

Wayman, Alex, 1962-3, 'Female Energy and Symbolism in the Buddhist Tantras', *History of Religions*, 2: 73-111.

Wayman, Alex and Hideko Wayman, 1974, *The Lion's Roar of Queen Srimala*. New York and London: Columbia University Press.

Weigle, Marta, 1982, *Spiders and Spinsters: Women and Mythology*. Albuquerque: University of New Mexico Press.

Witherington III, Ben, 1988, *Women in the Earliest Churches*. Cambridge: Cambridge University Press.

Contributors

A.S. ALTEKAR was Director, K.P. Jayaswal Research Institute, Patna.

SUKUMARI BHATTACHARJI is Retired Professor of Sanskrit, Jadavpur University, Calcutta.

N.N. BHATTACHARYYA is Retired Professor, Dept of Ancient Indian History and Culture, Calcutta University.

UMA CHAKRAVARTI teaches History at Miranda House, Delhi University, Delhi.

CHITRAREKHA GUPTA is Professor, Dept of Archaeology, Calcutta University.

GEORGE L. HART, III is Professor of Tamil and Holder of the Chair in Tamil Studies, University of California, Berkeley, USA.

I.B. HORNER was Librarian, Newnham College, Cambridge, and was associated with the Pali Text Society.

D.D. KOSAMBI was a Marxist historian, Indologist, and mathematician.

KANAKALATHA MUKUND is affiliated to the Centre for Economic and Social Studies, Hyderabad.

VIJAYA RAMASWAMY is Reader, Dept of History, Gargi College, Delhi University, Delhi.

HARIHAR SINGH is Professor, Dept of Ancient Indian History and Culture, Banaras Hindu University, Varanasi.

SARVA DAMAN SINGH is Retired Professor, Dept of History, University of Queensland, Brisbane, Australia.

CUP
1-10-08
Foundation